MW00827137

MISCHIEF MAKING

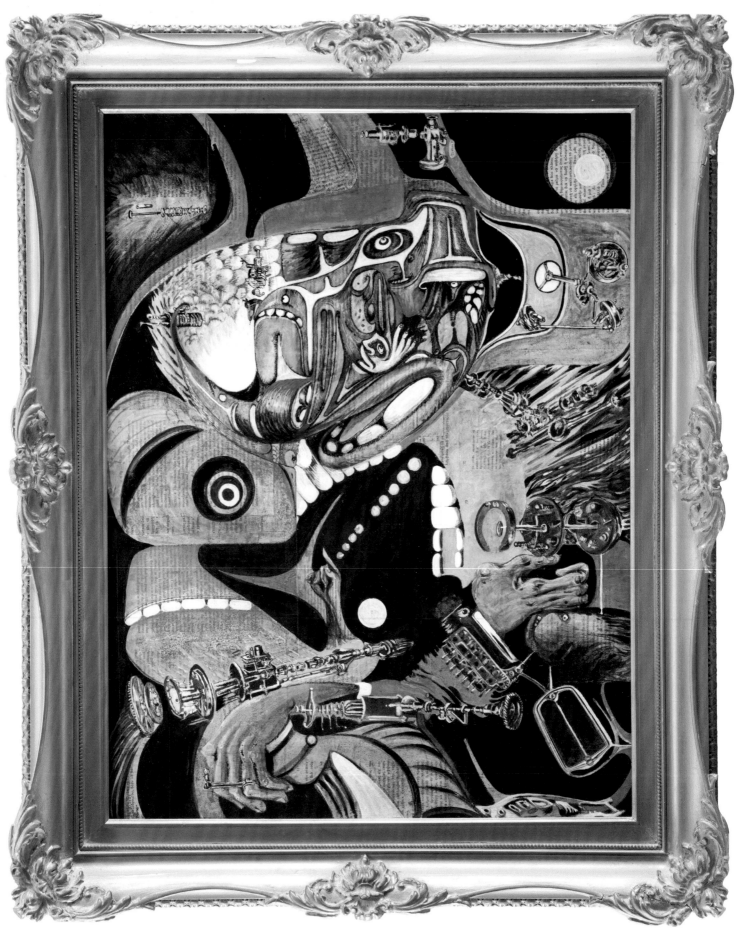

Cerebrum Cosmology, 2020

MISCHIEF MAKING

MICHAEL NICOLL YAHGULANAAS, ART AND THE SERIOUSNESS OF PLAY

NICOLA LEVELL

UBCPress

1971–2021

© UBC Press 2021

All rights reserved. No part of this publication may be reproduced, stored in
a retrieval system, or transmitted, in any form or by any means, without prior
written permission of the publisher, or, in Canada, in the case of photocopying
or other reprographic copying, a licence from Access Copyright,
www.accesscopyright.ca.

31 30 29 28 27 26 25 24 23 22 21 5 4 3 2 1

Printed in Canada on paper that is processed chlorine- and acid-free, with
vegetable-based inks.

Library and Archives Canada Cataloguing in Publication

Title: Mischief making : Michael Nicoll Yahgulanaas, art and the seriousness of
 play / Nicola Levell.
Names: Levell, Nicola, author.
Description: Includes bibliographical references.
Identifiers: Canadiana (print) 20210295783 | Canadiana (ebook)
 20210295821 | ISBN 9780774867368 (softcover) | ISBN 9780774867375
 (PDF)
Subjects: LCSH: Yahgulanaas, Michael Nicoll — Criticism and interpretation.
 | LCSH: Haida artists — British Columbia. | LCSH: Haida art — British
 Columbia — 21st century. | LCSH: Art, Modern — 21st century. | CSH: First
 Nations artists — British Columbia.
Classification: LCC N6549.Y33 L48 2021 | DDC 709.2—dc23

Canadä

UBC Press gratefully acknowledges the financial support for our publishing
program of the Government of Canada (through the Canada Book Fund), the
Canada Council for the Arts, and the British Columbia Arts Council.

This book has been published with the help of a grant from the Canadian
Federation for the Humanities and Social Sciences, through the Awards to
Scholarly Publications Program, using funds provided by the Social Sciences
and Humanities Research Council of Canada, and with the help of the University
of British Columbia through the K.D. Srivastava Fund.

Printed and bound in Canada by Friesens
Set in Berthold Akzidenz Grotesk, Knockout, and DTL Documenta
by Michel Vrana
Proofreader: Deborah Kerr
Cover designer: Jessica Sullivan
Cover images: *(front)* Michael Nicoll Yahgulanaas, *Sinking into the Ocean,* 2020
(detail); *(back)* Michael Nicoll Yahgulanaas, *Milkit,* 2020 (detail)

UBC Press
The University of British Columbia
2029 West Mall
Vancouver, BC V6T 1Z2
www.ubcpress.ca

CONTENTS

FOREWORD

Michael Nicoll Yahgulanaas is a celebrated contemporary Haida artist whose practice is grounded in the Pacific Northwest of Canada. In this thought-provoking book, Nicola Levell explores his varied body of work, which includes large-scale public projects, mixed media sculptures and canvases, acrylics, watercolours, ink drawings, ceramics, illustrated publications and especially what is recognized as 'Haida manga'. Levell examines the characteristics and philosophical and ideological backgrounds of these works to convincingly argue that they represent a unique expression of contemporary Indigenous art; one that reveals a complex and sophisticated mediation of many global artistic and cultural movements.

The Haida Nation, to which Yahgulanaas belongs, is situated on Haida Gwaii (formerly the Queen Charlotte Islands) on the west coast of Canada. The Haida peoples developed a distinctive culture based on the use of rich marine and forest resources, and are especially renowned for their potlatch ceremonies and their sophisticated totem poles, large longhouses, wooden canoes, bentwood boxes, masks and other carved and painted artworks with unique depictions of human and non-human figures. Like other Northwest Coast peoples, the Haida suffered severe hardships due to settler colonial control as well as infectious diseases, such as smallpox and influenza brought by European and American traders during the prosperous maritime fur trade between the late eighteenth and early nineteenth centuries. They were legally banned from holding potlatch ceremonies from 1885 until 1951, and their totem poles, masks and other items used in ritual ceremonies were confiscated by the Canadian government and handed over to museums and other institutions. Furthermore, the government enforced assimilation policies, including residential schooling and Christianization, for all Indigenous peoples in the country. Thus, their cultures and languages faced the threat of extinction during this period. However, the Northwest Coast peoples have creatively rebuilt their traditions through the cultural revitalization movement since the 1950s and the Indigenous rights movement since the 1970s.

As this book reveals, in the 1970s, Yahgulanaas emerged as an activist and artist during the Haida Nation's battle for rights and sovereignty. His ideas about and commitment to the Haida and other worlds as an Indigenous person, environmentalist, politician and Indigenous rights activist have played an important role in shaping the issues and objectives of his art. For example, among other subjects, his oeuvre addresses the collective memory of historical colonization; conflict; war; social, economic and cultural discrepancies; industrial resource development and identity and climate change.

Through a rich body of colour illustrations, Levell incisively examines and interprets Yahgulanaas' different artworks in relation to his life experiences, his engagement with environmental issues and his embrace of traditional and global art production techniques. Yahgulanaas is especially recognized for inventing the genre of Haida manga by mixing and integrating Northwest Coast iconography, Japanese manga, American comic book style, and calligraphic brush strokes. His contemporary Coppers fashioned from car hoods have also garnered a lot of public attention.

Mischief Making reveals how widely Yahgulanaas experienced, learnt and thought about a variety of topics, from art and music to politics and environmental problems, in creating his art. Through it, he questions viewers about the nature of desirable human lifeways and the shape that relationships with other people and non-humans should take, suggesting how we can make our life world better.

One of the most remarkable characteristics of Yahgulanaas's art is its 'hybridity'. Globalization has led to both standardization and diversification, in addition to hybridization of cultural practices worldwide. Yahgulanaas does not regard hybridization as an unfortunate process in which pure cultural traditions become adulterated, but rather as one in which good things emerge. For him, mixing or hybridity is a source of artistic imagination and creativity, and a method to generate a better future. Thus, as an Indigenous person, a Canadian and a creative individual, Yahgulanaas expresses his opinions on contemporary world problems by making hybrid art, using various techniques and media. I believe that by producing such works, he is attempting to create a more inclusive society in which humans and non-humans coexist harmoniously. His strange but impressive art expression, grounded in his opinions, appeals to our hearts and minds empathetically.

Yahgulanaas' art practices imply that hybridity has the potential to give rise to a new art and a new way of life. His work demands that we reconsider the meanings, roles and effects of what we define as art in our globalizing world. This book is a significant and sophisticated contribution to our understanding of global art practices and interculturality and provides an insightful introduction to Yahgulanaas's art world.

Nobuhiro Kishigami
Executive director, National Institutes for the Humanities, Japan,
and professor, National Museum of Ethnology, Japan

INTRODUCTION

——

We must uncover our rituals for what they are: completely arbitrary things, tied to our bourgeois way of life; it is good—and that is the real theatre—to transcend them in the manner of play, by means of games and irony; it is good to be dirty and bearded, to have long hair, to look like a girl when one is a boy (and vice versa); one must put 'in play', show up, transform and reverse the systems which quietly order us about.
Michel Foucault[1]

The idea of putting unconventional character types, ideas and media "in play" as means to expose, stretch and subvert our cultural perceptions is intrinsic to the art of Michael Nicoll Yahgulanaas. On the surface of his works, he signs himself 'mny' with a fish-like flourish. His name has become synonymous with Haida manga, an artform he innovated that reformulates and blends Indigenous Northwest Coast iconographies and formlines with the graphic dynamism of Japanese manga. Through this creative mix or creolization, Haida manga has emerged as a vibrant visual idiom for retelling Indigenous oral histories and other narratives and for offering different ways of seeing and knowing cultural complexes. Its expressive imagery often engages with contemporary social issues concerning the environment and interdependent ecologies, Indigenous thought-worlds and global anxieties, and the materialities of cultural heritage and memory. Yet Yahgulanaas' distinctive Haida manga aesthetic is not restricted to publications and paper-based graphic artworks: it has modulated into a diverse but coherent body of media and forms, including large-scale public art projects forged from steel; repurposed automobile parts covered in metallic leaf; mixed media installations; acrylic and oil painted canvases and boards; watercolours, ink drawings, ceramics and animated forms.

Part of the unique character of this elastic genre is its unflinching commitment to, in Yahgulanaas' words, "hybridity". In his case, hybridity is envisaged as a positive force that opens a space—in Homi Bhabha's postcolonial thinking this is a "third space"—for artistic and public engagement with the politics and poetics of being in the world.[2] For Yahgulanaas, this means being recognized as an artist of Indigenous Haida and European ancestry, with multiple connections to and affinities with other cultures and places.[3] Yahgulanaas is serious about the potential of hybridity, as an identification, aesthetic and strategy, to elicit reaction and challenge established hierarchies, attitudes and stereotypes. Art is mobilized as a form of social empowerment: it seeks participation, dialogue, reflection and action.

opposite *Master Chief*, 2020

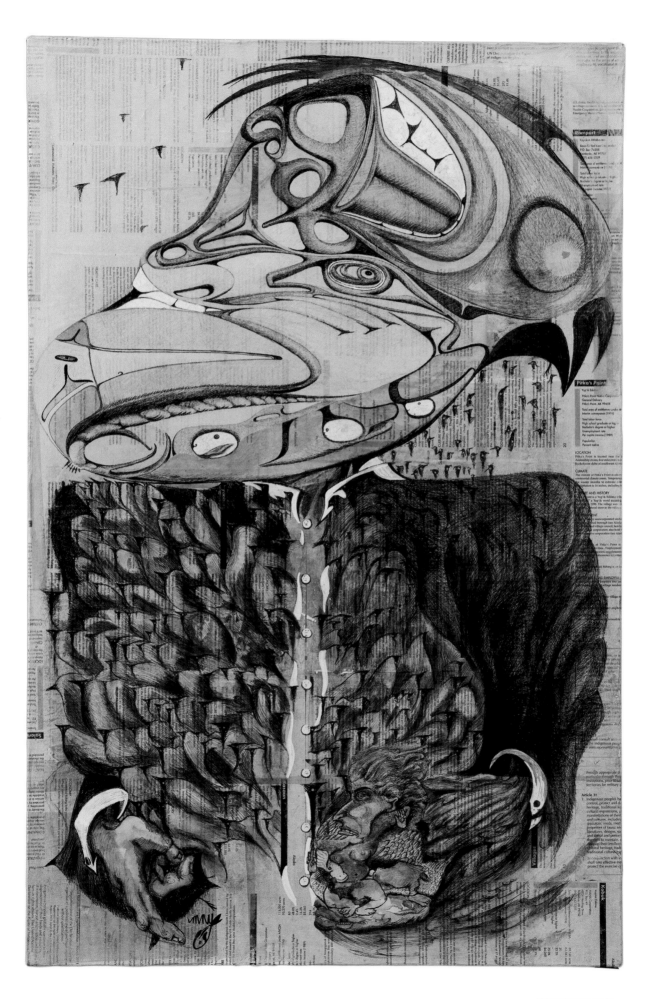

Even the naming of his practice—the purposeful melding of Haida and manga—can be understood as a political act of hybridization that indexes the creation of a third autonomous form, a new art for negotiating new perspectives, positions and identities. By strategically aligning with manga and more generally Asia-Pacific cultural practices, Yahgulanaas consciously set out to subvert dominant Western aesthetic forms and simultaneously signal his cultural and personal familiarity with cultures of the Pacific Rim and especially Japan, which has long featured in Haida oral histories and Yahgulanaas' family memories. He explains, "I was drawn to comics as a way of talking about complex things such as relationships between Indigenous peoples and settler society. I found manga attractive because it is not part of the settler tradition of North America (like Archie or Marvel comics, for example) ... [plus it] has roots in the North Pacific, as does Haida art".[4] While his art always has had a political inflection, it is neither prescriptive nor bound to the local or Indigenous context. Rather it presents itself as an agitation for individual and social engagement:

> Artwork is a personal adventure for the people who create it and for those who choose to participate in the experience. I create work that mostly avoids the idea of dominance and resists the idea that the artist is an ultimate authority ... I like to create work that confounds the observer and requires them to decide where the dominant horizon of the work is. [In the *Rotational* series] I put my name in one corner, a title in another, a date in a third corner, and I usually find something amusing to put in the fourth ... I encourage people to make observations and choices arising from their own experience without relying on the authority of the artist.[5]

These strategies of captivating the viewers' attention, luring them into the artwork, making them think about the characters and the lines, making them twist their heads, literally and metaphorically, to fathom out relations and meanings, are manifest in *Master Chief*, 2020. This complexly textured work is part of a series of collages that includes *Gunit*, 2020, *Milkit*, 2020, *Hooked*, 2020 and *Sinking into the Ocean*, 2020—a detail of which is reproduced on the front cover of this book.

In the case of *Master Chief*, the alluring central figure appears as a fluid, fragmentary and transformative being. Their beak-like side profile is formed by a series of dynamic "framelines", to use Yahgulanaas' term, that contain other features and forms; their cranium appears to be brimming with chatter and movement. The body—accented by the white shirt collar, placket, buttons and cuffs—is like a living tuxedo, comprised of small, blackish bird-like forms, nestled together, with bright pink dot eyes, while others are pictured as small beaked heads suspended on the palimpsestic background. Arguably, this imagery contains clues to Yahgulanaas' Haida worldview wherein multispecies—human and non-human entities including animals and plants—and their identities and kin-relations are interconnected and dynamic.[6] They coexist and interrelate in and among the natural, human and supernatural realms. As the viewers' eyes are drawn closer to focus on the snippets of textual matter that are pasted and patchworked in different reading orientations and washed with ink, they may become aware that the backdrop to *Master Chief* is partially comprised of excerpts from the United Nations Declaration on the Rights of Indigenous Peoples (2007). This document, with its forty-six

articles, lies at the heart of new legislation—Bill C-15, Declaration on the Rights of Indigenous Peoples Act, which received Royal Assent on 21 June 2021 in Canada, and is positioned as the legal and ethical framework for forwarding reconciliation with Indigenous peoples as called for by the Truth and Reconciliation Commission of Canada.[7] In the lower right-hand corner, for example, a vertical slice of Article 31 is apparent. The full article reads:

> 1. Indigenous peoples have the right to maintain, control, protect and develop their cultural heritage, traditional knowledge and traditional cultural expressions, as well as the manifestations of their sciences, technologies and cultures, including human and genetic resources, seeds, medicines, knowledge of the properties of fauna and flora, oral traditions, literatures, designs, sports and traditional games and visual and performing arts. They also have the right to maintain, control, protect and develop their intellectual property over such cultural heritage, traditional knowledge, and traditional cultural expressions.

> 2. In conjunction with indigenous peoples, States shall take effective measures to recognize and protect the exercise of these rights.

By purposefully selecting an incomplete piece or patch of this text, Yahgulanaas invites his viewers to critically engage and cognitively explore different meanings, connections and divergences. To a degree, Yahgulanaas' visual-textual collages can be constructively compared to erasure poetry wherein found texts are creatively redacted and framed to become aesthetic forms that can offer a more directed social and political commentary on the original source. In the case of Indigenous erasure poetry such as Jordan Abel's *The Place of Scraps* (2013), the Nisga'a poet appropriates and erases historical texts, including Canadian ethnographer Marius Barbeau's *Totem Poles* (1950), to present a biting critique of colonialism on the Northwest Coast, with its aggressive drive to appropriate land and cultural heritage and erase Indigenous peoples from the future narrative. The politics of land and erasure are also cleverly layered on Yahgulanaas' collages. In *Sinking into the Ocean*, we see collaged sections of the map of Greater Vancouver showing patches of Langley, the University Endowment Lands, Delta and Coquitlam—places and names imposed on the traditional, ancestral and unceded territories of the *heən̓q̓əmin̓əm̓*-speaking Musqueam, Stó:lō, Kwikwetlem and Tsawwassen peoples. In the top right-hand corner, we may perceive an ancestral figure whose symbolic white tracks erase or ironically white-out the colonial settler topographies of railroads, streets, avenues, parks, golf courses, ferry terminals and the like. Circled in the black, red-rimmed beak that reaches into the mapped pink terrain are the words "Indian Reserve"—the designation given to the small plots of land, over three hundred in total, which were carved out of British Columbia in the nineteenth century to contain the Indigenous population or "Indian Bands" who were violently dispossessed of their rights, heritage and land. Following the right-hand border down below the air bubbles that fizz up the plane and below the partial maps and index, you can spy a portion of a ledger listing "ice cream". Here we have an absurdist collapsing together of diverse worlds from the topographies of unceded territories to the historical accounting of frozen treats. These are drawn together by a gaggle of enigmatic characters with eyes,

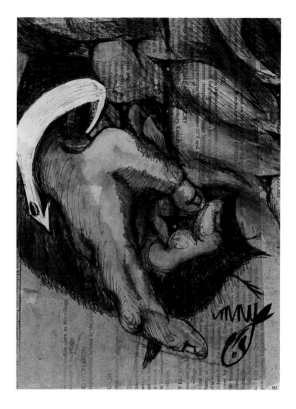

Master Chief, 2020 (detail)

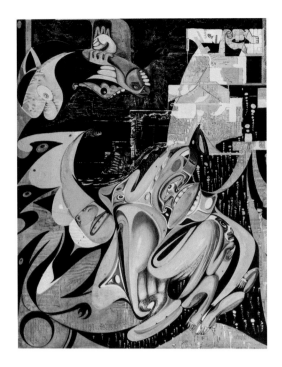

Sinking into the Ocean, 2020 (recto and verso, detail)

tongues, teeth and beaks and bodily appendages wriggling upward
through a watery realm. As with his other recent collages and paintings,
for *Sinking into the Ocean*, Yahgulanaas decorated the back (verso)
of the work. In many cases, the backs of his paintings, including the
stretcher bars, are collaged with maps that the artist has found, and for
him they represent "constructed or imagined geographies".[8] As with
the *Rotational* series, the idea is that we can explore the work, looking
at it from different angles, either portrait or landscape, not only from
the front (recto) but also from behind, maybe with the help of a mirror,
to conjure up different meanings or to trouble established ways of
knowing. In *Sinking into the Ocean*, the back collage is not dominated by
maps, but rather by the pages of a ledger dated 1928 with handwritten
entries documenting diverse expenditures from freight, ferry fares and
laundry to phone calls, national packers and the Pleasant Cafe. Overlaid
on the upper right-hand quadrant is the key to the 1958 map-fragment
of Courtenay, Vancouver Island, on the front. It includes reference to
"Lands alienated [...] Surveyed Timber Lease or License, Indian Reserve
[...], Government Reserve" and more. This key or legend is embellished
with Yahgulanaas' signature, the date and the title of the work. Like all
of Yahgulanaas' works, this two-sided collage is brimming with playful
gestures, political accents and punning quips, revealing mischief to be a
critical attribute of his art.

But what does mischief mean when applied to an artist's practice?
The conceptual artist Joel Rudinow argues that mischief is exemplified
in Marcel Duchamp's ready-mades and in particular in his seminal
piece, *Fountain*, 1917, a porcelain urinal signed "R. Mutt".[9] In 'creating'
and submitting *Fountain* for an exhibition, Duchamp mischievously
set out to expose the authority, discourse and dynamics of the art
world and its consecrating institutions and agents, including artists.
Duchamp wanted to poke, to provoke, to question the apparatus
and its power to define art and determine the aesthetics of taste. In
conversation in 1971, he said the ready-mades were not solely created
to challenge the system but also for "distraction" and "amusement".[10]
Accordingly, mischief can be defined as a particular form of play
that can be entertaining in effect while simultaneously serious

in its intent to disrupt the status quo, to unsettle dominant power relations, to transform and even reverse our cultural categories, our naturalized behaviours and norms, as Foucault implored. Rather than perceiving mischief as a deviant and even harmful mode of behaviour, in Yahgulanaas' art practice, it is embraced as a means of empowerment to trouble, tease and tickle, and open up a space for engagement where new possibilities and understandings can unfold.

A similar strategy is manifest in the paintings and collages of Jaune Quick-to-See Smith, an award-winning artist and curator and Salish member of the Confederated Salish and Kootenai Nation, Montana, whose *I See Red: Target*, 1992, was the first painting created by a Native American artist to be purchased by the National Gallery of Art, Washington, DC. More shocking still, the year of acquisition was 2020. In the artist's opinion, this national institution's slowness to acknowledge and acquire works of contemporary Indigenous artists is that "because of popular myth-making, Native Americans are seen as vanished. It helps assuage the government's guilt about an undocumented genocide, as well as stealing the whole country".[11] In her 1992 *Mischief, Indian Land* series, she appropriates and collages commercial and media images and pithy texts, and paints and works the canvas to critique this violent mythologizing. The Cree artist Kent Monkman also literally and metaphorically harnesses mischief in constructing his revisionist history paintings. More specifically, he positions his alter ego Miss Chief Eagle Testickle (a pun on mischief) in the pictorial frame of action to disrupt and subvert the colonial narratives of the encounters between European settlers and Indigenous peoples in Canada.[12]

Despite the seriousness of the issues indexed in Yahgulanaas' oeuvre, from his early political cartooning of the 1970s to the present there are always elements of mischief and play, from the expressive and sometimes comic images, through punning titles and visual narratives, to interactive components, symbolic materials and more. Thus, *Mischief Making* sets out to explore the dynamic nature, the philosophical underpinnings and plasticity of Haida manga as a uniquely hybrid aesthetic, as it modulates into different media. The book is organized into five chapters. The first chapter offers a biographical portrait of Yahgulanaas and traces the maturation of his visual practice and the advent of Haida manga. Each subsequent chapter focuses on a theme. They cover the aesthetics of hybridization and the revolution in framelines; the significance of words and narrative practices; the materiality of memory and repurposed forms and the effects of rotating matters.

1 Simon, John K, "A Conversation with Michel Foucault", *Partisan Review*, vol 38, no 2, 1971, p 201.

2 Bhabha, Homi, *The Location of Culture*, London and New York: Routledge, (1994) 2004, pp 53–54.

3 Michael Nicoll Yahgulanaas, personal communication, 13 October 2014.

4 Yahgulanaas, Michael Nicoll, "RE ME MB ER: The Hybrid Art of Michael Nicoll Yahgulanaas", *GEIST Magazine*, no 70, 2008, p 54.

5 Sostar McLellan, Kristine, "Mythic Proportions: A Haida Artist Weaves Cultural Traditions into Something New", *SAD MAG: Stories, Art, and Design*, nos 16/17, 2014, p 39.

6 For a critical and expansive theorization of kin relationality among human and non-human or more-than-human beings in Indigenous worldviews, see Todd, Zoe, "Refracting the State through Human-Fish Relations: Fishing, Indigenous Legal Orders and Colonialism in North/Western Canada", *Decolonization, Indigeneity, Education, and Society*, vol 7, no 1, 2018, pp 60–75.

7 "Truth and Reconciliation Commission of Canada: Calls to Action", 2015, accessed 5 July 2021, http://trc.ca/assets/pdf/Calls_to_Action_English2.pdf.

8 Michael Nicoll Yahgulanaas, personal communication, 28 June 2021.

9 Rudinow, Joel, "Duchamp's Mischief", *Critical Inquiry*, vol 7, no 4, 1981, pp 747–760.

10 Duchamp quoted in Rudinow, "Duchamp's Mischief", p 757.

11 Sayej, Nadja, "'It's Like We Don't Exist': Jaune Quick-to-See Smith on Native American Artists", *The Guardian*, 29 July 2020, accessed 2 July 2021, https://www.theguardian.com/artanddesign/2020/jul/29/jaune-quick-to-see-smith-native-american-art.

12 Monkman, Kent, *Kent Monkman: Shame and Prejudice: A Story of Resilience*, London, UK/Toronto, ON: Art Museum, University of Toronto, 2020.

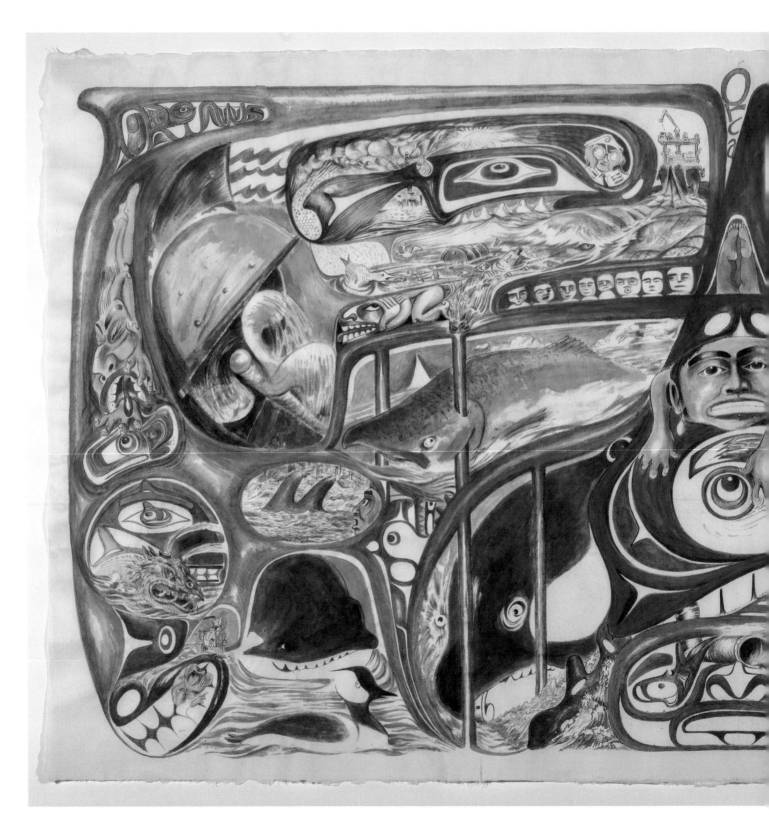

Orcinus, Orca, SKAAnaa, 2019

BACKSTORY

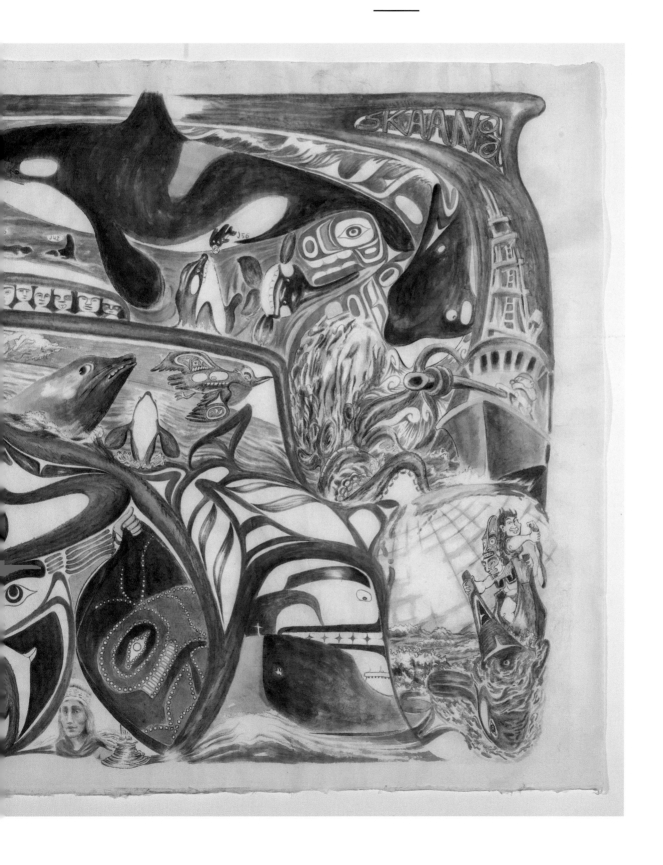

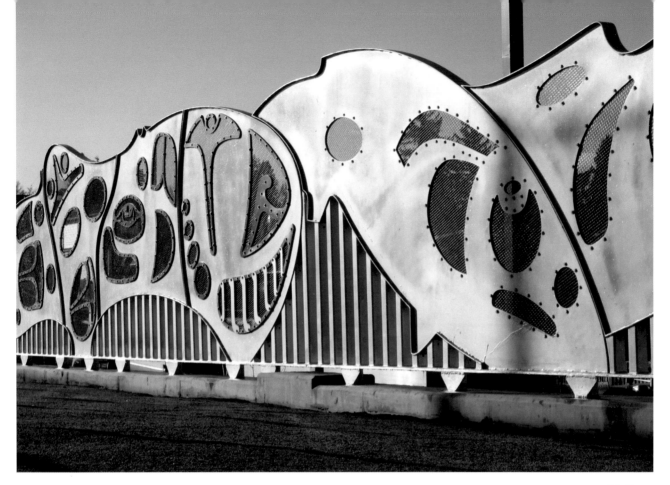

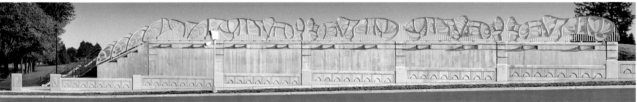

Abundance Fenced, 2011
(detail and landscape)

What's good about these decades of political engagement is how they inform my art ... I am committed to the idea of human hybridity as a good thing: difference is a fertile edge between ocean and river, a delta of possibilities.
Michael Nicoll Yahgulanaas [1]

Shimmering in the sun, glistening in the rain, *Abundance Fenced,* 2011, by Michael Nicoll Yahgulanaas is a monumental piece of public art that commands attention. Forged from steel, it crowns the retaining wall of a six-lane highway and pedestrian path that edges Kensington Park in Vancouver. Its brutalist materiality is tempered by the soft curves of its design. The curvilinear forms, forty-two metres in length, depict "two sets of stylised orca whales facing opposite directions with their tail flukes meeting in the centre and their faces rising up to define a metaphorical passageway. The whales pursue cascading salmon down a slope toward the North Shore mountains. The salmon are welded together in a timeless pursuit to represent a system of interdependence essential to us all". [2] Movement is not only conveyed through formlines—the distinctive fluid outlines and expressive internal curvilinear design elements long associated with the Indigenous art of the North Pacific

Yahgulanaas working
on *Red*, 2008

—but also through the play of light and shadow. The reflections cast by light on steel are redolent of the silvery scales of salmon, thrashing and flashing above and below the water, as they 'run' rivers to their gravelly spawning grounds. The salmon run is a long-established cornerstone of the Indigenous ecosystem and economy. Yahgulanaas' inspiration for *Abundance Fenced* was the Fraser River salmon run in 2010 when an estimated 34 million sockeye salmon migrated from the Pacific Ocean and returned to spawn in British Columbia, the biggest run in almost a century.

Yet *Abundance Fenced* is not positioned as a celebratory monument but as a site-specific intervention in the urban landscape. In its title, material form and location, it invites viewers to reflect on the complex, symbiotic and destructive interactions between humans, other life forms and their environments within a local and global "system of interdependence". Similar concerns are visible in the striking watercolour *Orcinus Orca SKAAnaa*, 2019, which is one metre high and two metres in length and was commissioned by the Royal British Columbia Museum for its exhibition Orcas: Our Shared Future (2021–22). Yahgulanaas explains, "Its overall structure, defined by curving blue framelines, depicts the face of the wealthy Lord of the Sea in a design associated with the islands of Xaadlagwaayaa. Within this framework are scenes of human-orca interactions across time, space and cultures, portrayed in Haida manga style".[3] The multiple interconnecting storylines include the narrative of the young woman, pictured in the central panel, who is being carried away by SKAAnaa, the orca. She is being taken to marry the 7laanaas Auu (town mother) of the undersea village. But before she can be finned and thus transformed into a SKAAnaa, she is rescued by Nanasimget and friends and returns to her Haida village. This Haida story illustrates the intertwined kin relations between human, animal and supernatural beings. In Yahgulanaas' words: "For the Haida and other Indigenous peoples of the northeastern shores of the Pacific, orcas are part of a large inclusive concept of family", and the double-finned killer whale is a crest of the Yahgulanaas lineage.[4] Their habitats and their lives and by extension

top doodle on Christensen Fund letterhead, 2011

bottom Charles Edenshaw, drawing of Wasgo, 1897

ours are being threatened by environmental pollutants, depicted in *Orcinus Orca SKAAnaa,* like the toxic waste, leaking pipelines, plastic bottles and discarded barrels. We see wildlife consuming our poisonous garbage and industrial overfishing that depletes resources, including the precious salmon—valued kin of Indigenous peoples—on whom the orcas feed. Witnessing these destructive activities are ancestral figures whose ghostly presence is figured in the tail flukes of SKAAnaa.

Whereas *Orcinus Orca SKAAnaa* is executed on *kozo washi*—handmade Japanese paper made of mulberry bark that Yahgulanaas sources from Ozu Washi in Nihombashi, Toyko—for *Abundance Fenced*, the vital images of the salmon run are rendered in galvanized steel; their eyes, mouths, fins and other features are cut out from the steel-plate panels and defined with metallic mesh, washers and rivets. This hard industrialized aesthetic echoes the platework and portholes of container ships and the bodies and nets carried by commercial trawlers—maritime vessels that are starkly visible on the Pacific Ocean and the waterways that flank and define the seaport city of Vancouver. It is no coincidence that *Abundance Fenced* is situated on one of the busy industrial corridors leading to Port Metro Vancouver, Canada's largest port and the so-called Pacific Gateway that connects the city and Canada to the global economy. While the immense commercial boats and cruise ships contain valuables of different kinds, they also "pose potentially irreparable risks, exhaling pollutants into the same water from which food is harvested" and from which salmon feed. Captured in *Abundance Fenced* is this delicate and strained balance between different entangled ecologies. As the writer and curator Liz Park eloquently explains:

> The whales and the salmon can also be understood as vessels. Beyond commercial values assigned to each pound of their flesh as consumable goods, their presence in the larger ecology is invaluable. Nutrients from the ocean are brought onto land through their bodies in a cycle of the interdependence of land and water species. By rendering the fish and whales in the material form of the ships that threaten them, Yahgulanaas juxtaposes different ways of understanding the ocean ... [bringing] together what appear to be incongruous elements to question naturalised understandings of human relationships to the environment.[5]

It is the desire to unsettle our "naturalised understandings", our conditioned behaviours and our instituted attitudes, to puncture our everyday realities and provoke us into thinking mindfully about being in the present, that informs the art of Yahgulanaas. While this book, *Mischief Making*, is primarily focused on his visual art practice as it has unfolded and effloresced in the twenty-first century, as a point of introduction, it is necessary to understand the context, media, inspirations and orientations of his earlier artistic output.

A BAROQUE CARTOONED DOOR

Born in Prince Rupert in 1954, Yahgulanaas grew up alongside Delkatla, a slough near the fishing village of Masset on Haida Gwaii, an archipelago off the north coast of Canada's most western province of British Columbia. As a boy Yahgulanaas was an avid comic reader and cartoonist. His mother Babs Hageman Yahjaanaas recalls that he was constantly

drawing and doodling. And his artistic creations were not limited to the medium of paper but extended energetically to other surfaces in the domestic space, including she particularly remembers his baroquely cartooned bedroom door and walls.[6] This proclivity for cartooning is still very much in evidence, as revealed if you dip into Yahgulanaas' archive or spend time in his presence. Always to hand is some kind of drawing implement, from an inexpensive ballpoint pen, sometimes a multi-pen or brush pen from Asia, to an exquisite slender-bodied gold fountain pen that he uses to capture surrounding scenes, images or dreams on whatever paper or surface is around, seemingly like his great-great-grandfather, Charles Edenshaw (Da.a xiigang). Yahgulanaas reflects that when he was about twelve or thirteen years old he had a book of paintings by Henri Rousseau and remembers "being absolutely captivated by Rousseau's use of strong shapes and clearly articulated forms" such as those embodied in jungle scenes like *The Hungry Lion Throws Itself on the Antelope*, 1905.[7] In retrospect, it is interesting that Rousseau's artistic imagination was very much stimulated by illustrated books and especially by the time he spent in the botanical gardens in Paris. Correspondingly, the time Yahgulanaas has spent in the giant old growth rainforests, in the ancient russet-coloured peat bogs and along the coastal shorelines of Haida Gwaii is clearly articulated in his sketches, drawings and paintings. It was the pollution and accelerating destruction of these unique habitats, through an aggressive Canadian policy of deforestation and natural resource extraction and transportation, that acted as a catalyst, provoking a twenty-two-year-old Yahgulanaas to mobilize his graphic art practice, moving it from the private to the public sphere and joining his community and other environmental activists to effect change.

top *Jungle Beach Morning*, 1998

bottom Last one …eh?, 1976

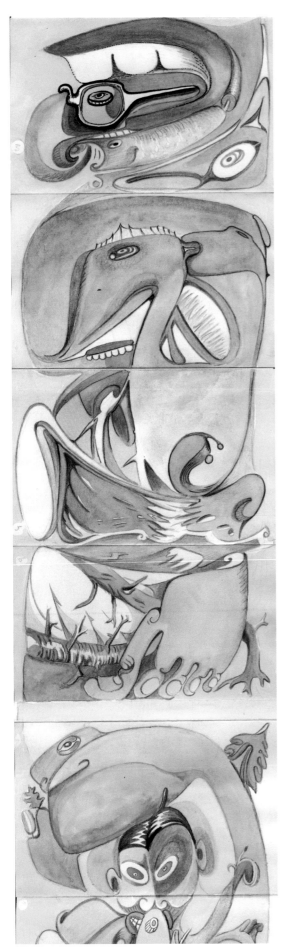
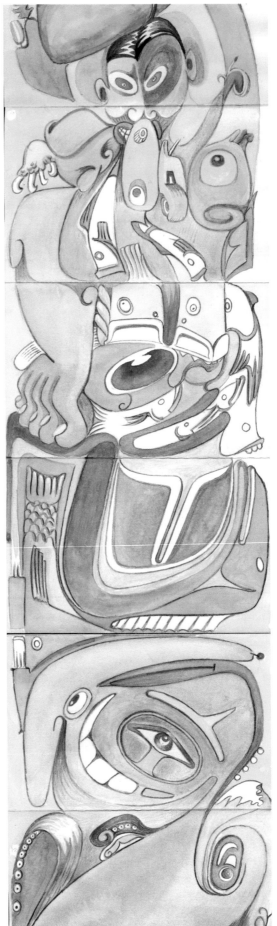
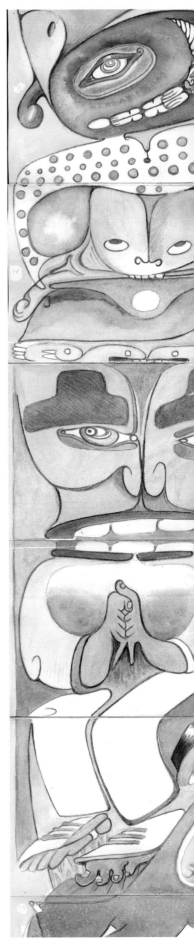

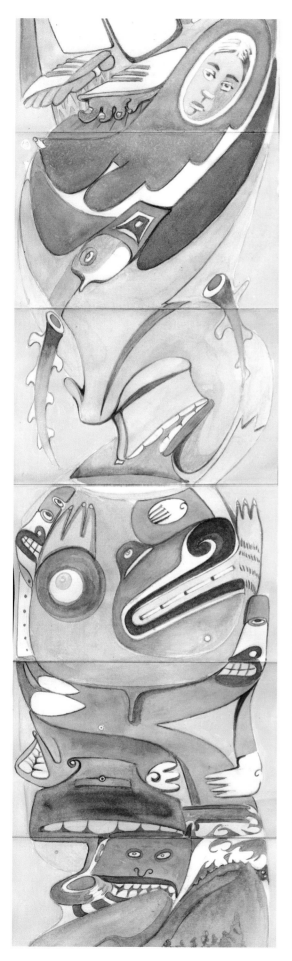
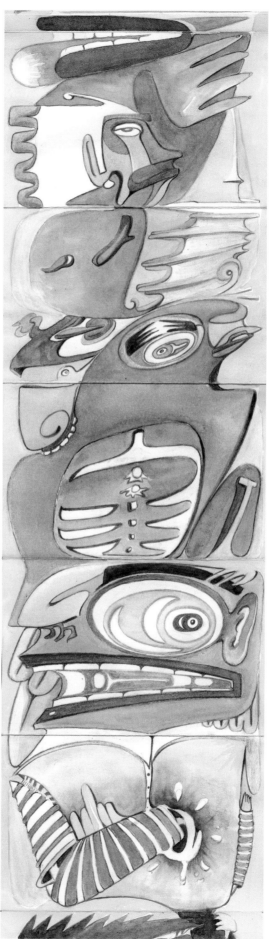

Haida Codex, 2020–2021

TALES OF RAVEN

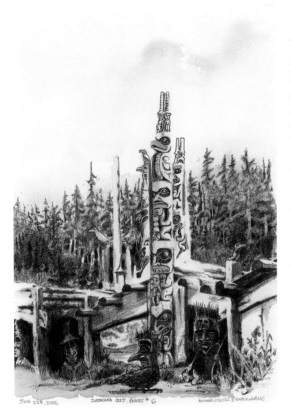

Yahgulanaas' first published full-length comic, *No Tankers, T'anks* (volume one of the *Tales of Raven* series), was produced in 1977 for the Islands Protection Society, which was established in 1974 by Haida and non-Indigenous activists to safeguard the archipelago's natural heritage from the devastating destruction caused by resource-extractive industries. With three thousand copies circulated, *No Tankers, T'anks* was part of the successful COAST (Coalition against Super Tankers) campaign to block the proposal to transport Exxon Valdez crude oil from Alaska through the Hecate Strait, which separates Haida Gwaii from Canada's mainland. Detailed black-and-white cartoons replete with humour and politics depict the apocalyptic effects of oil spillage for the natural environment. Other satirical cartoons by Yahgulanaas published during the same period, from the 1970s and 1980s, often depict government officials as blind men fumbling around oil-polluted or logged environments wearing blacked-out glasses and accompanied by insidious industry representatives. The leitmotif of blindness clearly references the government's undiscerning and nefarious support of the oil and timber industries to the detriment of the environment and its interconnected marine and land ecologies. Another recurring image is the super-sized human being, with a primitive appearance, blank countenance and electrical flex and plug protruding from his coccyx, shown destroying the environment, consuming trees and killing wildlife in his insatiable demand for energy. Again, the caricature makes manifest the impossibility of sustaining current patterns of extraction and consumption. This theme resonates through *No Tankers, T'anks*. There are graphic depictions of super-tankers leaking oil from their ill-riveted hulls and their polluting effects on marine waters full of teeming salmon and other species, which bring to mind the ecologies and concerns embodied in *Abundance Fenced* and *Orcinus Orca SKAAnaa*.[8] Although there is a linearity to the narrative of *No Tankers, T'anks*, the action and dialogue break through and disarrange or displace the borders of the curvilinear panels, offering multiple perspectives and creating a real sense of energy and movement, which is a marked characteristic of Yahgulanaas' later Haida manga works and an indication of the constancy of play.

THE CARVER'S APPRENTICE

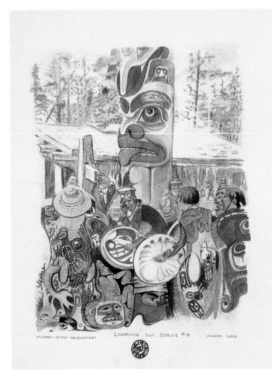

top *Looking Out 1*, 2002

bottom *Looking Out 9*, 2006

Concurrent with his environmental activism and ongoing graphic practice, a year after *No Tankers, T'anks* appeared in print, Yahgulanaas apprenticed with the acclaimed Haida artist and cultural ambassador Robert Davidson (G̲uud san glans) to work with a number of other novice carvers on a totem pole project.[9] He credits Robert Davidson and 7idansuu, Haida chief and master carver James Hart for providing him with a formal introduction to Haida classical art forms.[10] Notably, this was a time of resurgence for Haida peoples, who were proactively working to 'reclaim' their cultural heritage— their art and language— and assert their sovereignty, their rights and title to the land and waters of Haida Gwaii following decades of colonial suppression.[11] In *Raven Travelling: Two Centuries of Haida Art*, 2006, Yahgulanaas recalls:

For generations the Haida Nation was in a period of compression. In the 1970s, when I went to apprentice with Robert [Davidson] on a project in Old Massett, I experienced an expansion. It was a new adventure—poles were being raised, Massett was building a longhouse, and dancing and singing in it. We were laughing. The night I retold an old story at the feast hall, new words came in, 'fast rainbow trout canoe' had become 'an outboard motor on a speedboat'. At a Chiefly inauguration totem poles became five-metre-high paper puppets. People didn't mind the playfulness. We all celebrated together. We were all accelerating and expanding, not just because of the new [art] work but also because our political expression was expanding.[12]

It was in this context that Yahgulanaas, Robert Davidson, 7idansuu James Hart and other artists came together to work on an array of communal projects including the carving of totem poles, the design of canoes and the creation of great halls. Insightfully, these three named artists come from an established line of Haida artists. They trace their common ancestry back to the master carver and artist Charles Edenshaw (ca. 1839–1924), who has been the subject of two major exhibitions and a monograph.[13]

Charles Edenshaw (Da.a.xiigang, 7idansuu, Chinni Charlie) was Yahgulanaas' great-grandmother's father, and this relationship through the female line is of special significance. The Haida Nation is organized according to a matrilineal pattern of descent. Property, including material things as well as intangible cultural expressions such as names, titles, stories, performances and songs, is passed down through the maternal line. The Haida are composed of two social groups or moieties: Raven and Eagle. These moieties are further divided into lineages or family groups with a common ancestry and a hereditary chief. Membership to a moiety is matrilineal and assigned at birth. Traditionally marriage was restricted to a cross-moiety union, wherein Ravens could marry only Eagles and vice versa. In line with this pattern of kinship, Yahgulanaas was born a Raven into the Shark House of the Yahgulanaas clan. His cousin 7idansuu James Hart is one of the current hereditary chiefs: he received his chiefly title and name 7idansuu, which had belonged to Charles Edenshaw, in 1999. Although we have identified Charles Edenshaw as Yahgulanaas' great-great-grandfather, this is an Anglo-European kinship term and its use is a colonial imposition that suppresses the different constellations, categories and meanings of Haida kin relations. As Yahgulanaas explains, "the correct Haida kinship term for Charlie [Edenshaw] is Tsinnii, a male relative who is my opposite moiety lineage and older than my father".[14] Over the years, at different feasts organized by Haida leaders and elders, Yahgulanaas has been gifted other names. He has been named Gu7uu Yahladaas (White Raven) and Waatchesdaa (Fortunate Twin). In terms of his European-settler ancestry, Yahgulanaas traces this back to his paternal grandfather James Nicoll who was "from a clan under a Red Hawk crest from Scotland".[15] Insightfully, he identifies Delores Churchill (Ilskyaalas) Gawa Git'ans—an internationally recognized master weaver and teacher and his maternal grandfather's sister—as his "inspirational guidance" who has encouraged him to push his art beyond the constraints of tradition.[16] It comes as no surprise to learn, therefore, from Terri-Lynn Williams-Davidson (Gid7ahl-Gudsllaay Lalaxaaygans) that

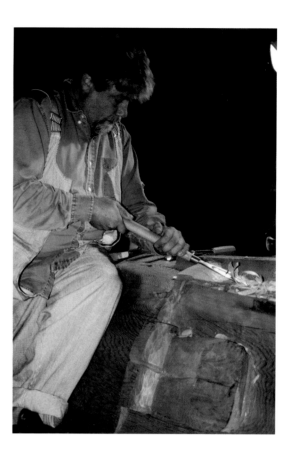

Yahgulanaas carving *The Respect to Bill Reid Pole*, 1999

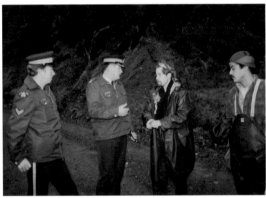

top Guujaaw Nangiitlagada Gidansda, design for xuu.ajii (grizzly drum), 1984

bottom Canadian police talking to Michael Nicoll Yahgulanaas, Athlii Gwaii protest, 1985

Delores Churchill Gawa Git'ans and her daughter April Churchill Gawa Git'ans share an expansive Haida philosophy about the inter-relationality between the past and the present and between human and non-human beings: "Haida people like April and Delores Churchill have talked about the cedar tree being an older sister who provides for all of our needs and takes care of us throughout our life. I told the Supreme Court of Canada about that Haida worldview. I told them that it is the cedar tree that connected us to our neighbours—through the canoes, through the bentwood boxes, through trade".[17] In line with these cedar-human connections, Yahgulanaas identifies Guujaaw Nangiitlagada Gidansda, who is an influential Haida leader, activist and artist, as a lifelong friend and colleague in arms.

ACTIVISM IN ART

From the outset, the comic form offered Yahgulanaas a way of extending social commentary and environmental concerns to a broader audience, with the intention of expanding ways of thinking about being in the world and our shared responsibility as global citizens. Throughout the 1980s and 1990s, Yahgulanaas' graphic practice was very much aligned with his environmental activism on Haida Gwaii. This history of art and activism is superbly documented through archival images, text and an interview in the monograph *Old Growth: Michael Nicoll Yahgulanaas*, 2011, edited by Liz Park. Yet for the purposes of this biographical chapter and monograph, it is worthwhile touching upon some of the dominant events that shaped Yahgulanaas' artistic trajectory and prompted his move from being a multi-tasking environmental activist, illustrator, writer, cartoonist and Haida government councillor to a full-time "arrrrtist".[18]

During the last few decades of the twentieth century, the primary focus of Yahgulanaas' artistic output was the unhalting capitalistic spoliation of Haida Gwaii's natural habitats, through an aggressive system of deforestation and natural resource extraction perpetrated by the collusion between big industry magnates and government officials. Tensions came to a head in 1985, the year clear-cut logging on Haida Gwaii reached its zenith when 2 million cubic metres of the island's old growth rainforests, which date back ten thousand years or more, had been razed to the ground.[19] An illustration from this year, signed "©85 Yaku"—a pen name Yahgulanaas used in the 1980s—satirically communicates the issues at stake for the environment. A logger, with chainsaw in hand, surveys his deforested surrounds and bemoans the fact that he is being forced out of a job. But the comic strip in three distinct panels reveals that his redundancy is not due to the activities of environmental activists but rather the inability of 'mother nature' to replenish the forests that have been sustained for millennia and exhausted within a devastatingly short period of time by clear-cut logging. At this stage, negotiations with the provincial government and legal proceedings against its policies were proving ineffectual, logging was continuing unabated and with no other recourse available the Haida Nation took action.

In a historic event, known as the Athlii Gwaii (Lyell Island) protest, Haida activists, children and elders in ceremonial robes formed a peaceful blockade day after day across a logging road. At stake was not only the indiscriminate and irresponsible decimation of Haida Gwaii's unique natural heritage but also the pressing issue

Packing Old Raven's Pole, 2005

of an Indigenous people's sovereignty and self-determination, their title and right to preserve, sustain and manage their ancestral territory.[20] Archival video footage shows a resolute thirty-one-year-old Yahgulanaas, with Haida blanket, face-paint and drum, on a bleak November day, protesting on the front line.[21] On 16 November 1985, three Haida elders, Chief Gaahlaay, Watson Pryce; Jaadsangkinghliiyas, Ada Yovanovich; and Kamee, Ethel Jones Kunlaanaas were the first protesters to be arrested. They were flown to Sandspit, fingerprinted and "charged with mischief and released on the condition that they not interfere with loggers or use the roadways on Lyell Island".[22] As the protest continued, their charges were upgraded by the BC Crown to breaching a court order, which, if they were convicted, carried a sentence of up to two years in prison. By the end of December, over seventy Athlii Gwaii protesters had been arrested, including Yahgulanaas, who was one of a number of arrestees charged with criminal contempt of court at the Supreme Court of British Columbia in Prince Rupert. However, their sentences were immediately suspended. As Yahgulanaas explains, there was "an incredible degree of public support by citizens and likely other influential people in BC, across Canada and beyond".[23] This included labour unions "with members in the logging industry".[24]

above Bill Reid, *Go to Hell Honky*, 1989

The Athlii Gwaii protest is now regarded as a watershed in the struggle for Indigenous and environmental rights. The area is now registered as part of the Gwaii Haanas National Park Reserve and Haida Heritage Site, ratified by the Haida Nation and the Government of Canada in 1993 as a cooperatively managed conservation area. This change heralded another phase in Yahgulanaas' trajectory. He became the main illustrator, from 1998 to 2002, for *SpruceRoots*, a monthly magazine concerned with future development and sustainability strategies, with a cultural accent and a political edge that cut across all demographics. The managing editor, Simon Davies, explains, "At *SpruceRoots* we wanted to come from a different perspective. We wanted a mix, and Michael certainly provided that with his illustrations and comic work. It always came from a fresh angle, and it made you think. If it was really obscure, it made you think more … I think his work really made people think differently about how we perceive the natural world".[25] In the artwork from this period, Yahgulanaas can be seen again to juxtapose seemingly incongruous elements, mixing, for example, different representational styles, such as realism and cartoon, and playing with words, to question our complacencies and understanding of environmental concerns.

UNPACKING TOTEMS

While experimenting with other techniques and media in his visual practice, in 1999, Yahgulanaas undertook his third and last carving project. He worked on *The Respect to Bill Reid Pole*, which was raised at the UBC Museum of Anthropology in Vancouver, in 2000. This totem pole was commissioned to honour the memory of Bill Reid (1920–1998), the renowned Haida artist. Bill Reid (Iljuwas) was celebrated during his lifetime as the icon of the so-called renaissance of Native Northwest Coast art that took root and flourished in the second half of the twentieth century in Indigenous and non-Indigenous spaces.[26] *The Respect to Bill Reid Pole* is a material testament to his standing in the museum world and the Haida Nation. In general terms, totem poles are a unique property of the Indigenous cultures of the Northwest Coast. They function as bearers of oral histories and genealogies as well as commemorative markers of past events and deceased individuals. Their figurative carvings of stylized animals and anthropomorphic forms are based on an established iconography of crests, symbols and formline designs that are the property of certain individuals and lineages. In the case of *The Respect to Bill Reid Pole*, the design was originated by 7idansuu James Hart in consultation with Haida elders and members of Bill Reid's family. From top to bottom, the figures depict three watchmen, Eagle, Raven and Wolf. Each of these figurative crests references Reid's Haida heritage and genealogical connections.[27]

There is a small watercolour in Yahgulanaas' collection, *Packing Old Raven's Pole*, 2005, that offers an insight into the artist's commitment to create mischief, to experiment with traditional forms, to critique history and to provoke new ways of seeing and thinking about cultural matters. With fluid brush strokes of watercolour on paper, the solidity, solemnity and singularity of the monumental carved form, the totem pole, is disassembled. The vertical, upright structure has fallen apart. In the carnivalesque jumble of figures, we can still decipher the stylized characteristics of crest animals such as Raven, Bear and Wolf. There is

an unmistakable dynamic and liquid quality to the formline structures that reveals Yahgulanaas' expert command not only of the brush but also the principles of Haida art, which he embraces and expands. Rather than retaining their discrete outline shapes and forms, these anthropomorphic figures become entangled in a complex whole. Cycles of life and interdependent ecologies are referenced in the bodies and jaws of the creatures. Their hands and mouths are holding onto a series of elongated phallic poles. A sexual imagery is made explicit in the central horizon of the composition. There a translucent aquamarine condom adorns an amorphous limbed form. From different perspectives, the limbed form may be interpreted as a phallus with testicular bearings or a bizarre proboscis with puzzled eyes. In conversation in 2014, Yahgulanaas disclosed that *Packing Old Raven's Pole* is in fact a reference to Bill Reid or more specifically Bill Reid's penis.[28] This revelation adds yet another level of meaning to the artwork. The dismantling of Old Raven's or rather Bill Reid's pole arguably symbolizes the desire of Yahgulanaas and others to move beyond the weighty legacy of Reid.

Packing Old Raven's Pole also sheds light on what anthropologists have described as the "joking relationship" that in some societies defines intergenerational relationships: "The joking relationship is a peculiar combination of friendliness and antagonism. The behaviour is such that in any other social context it would express and arouse hostility; but it is not meant seriously and must not be taken seriously … To put it another way, the relationship is one of permitted disrespect".[29] As an instituted form of sociality, reliant on humour, mischief and play, joking allows for critique, hostility and friendliness to be expressed between younger members of a community and elders without fear of repercussion. In the case of Yahgulanaas and Bill Reid, there appears to have been a structural symmetry to their joking relationship; it worked both ways. In Yahgulanaas' archive, there is an offset print depicting a Haida elder in ceremonial dress with a caption in hand-cut letters that reads: "Go to Hell Honky". This customized print dated 1989 was crafted by Bill Reid and gifted to Yahgulanaas during his tenure as a Haida chief councillor in Old Massett.

The irony of calling Yahgulanaas "honky"—a derogatory North American term for a Caucasian person—would certainly not have been lost on Bill Reid, who was known for his subversive antics. He was purposefully raised to believe he was 'White' as a child to protect him from the racism and colonial oppression that marked and scarred First Nation peoples in Canada. Through the Indian Act, which was passed in 1876 and is still enacted today with amendments, the Indigenous peoples of Canada had their lands appropriated. They were placed on reserves (reservations in the United States), and their children were forcibly removed and sent to residential schools—abusive institutions predicated on the oft-cited tenet "to kill the Indian in the child".[30] More pertinently, in relation to artistic production, the Indian Act prohibited ceremonial activities, including the renowned potlatch, which was central to the Indigenous social structure and cultural economy. With its spectacular displays of dancing, food, regalia and masks, the potlatch centred on the munificent exhibition and presentation of gifts. It was only in his later youth that Reid discovered he was part Haida. His father, William, was an American of Scottish German ancestry, and his mother, Sophie (née Gladstone), was Haida. Like Yahgulanaas, Reid publicly acknowledged his hybrid ancestry. At the unveiling of Reid's monumental yellow-cedar sculpture *The Raven and the First Men,* 1980, presided over by Prince Charles, Reid spoke of his intercultural

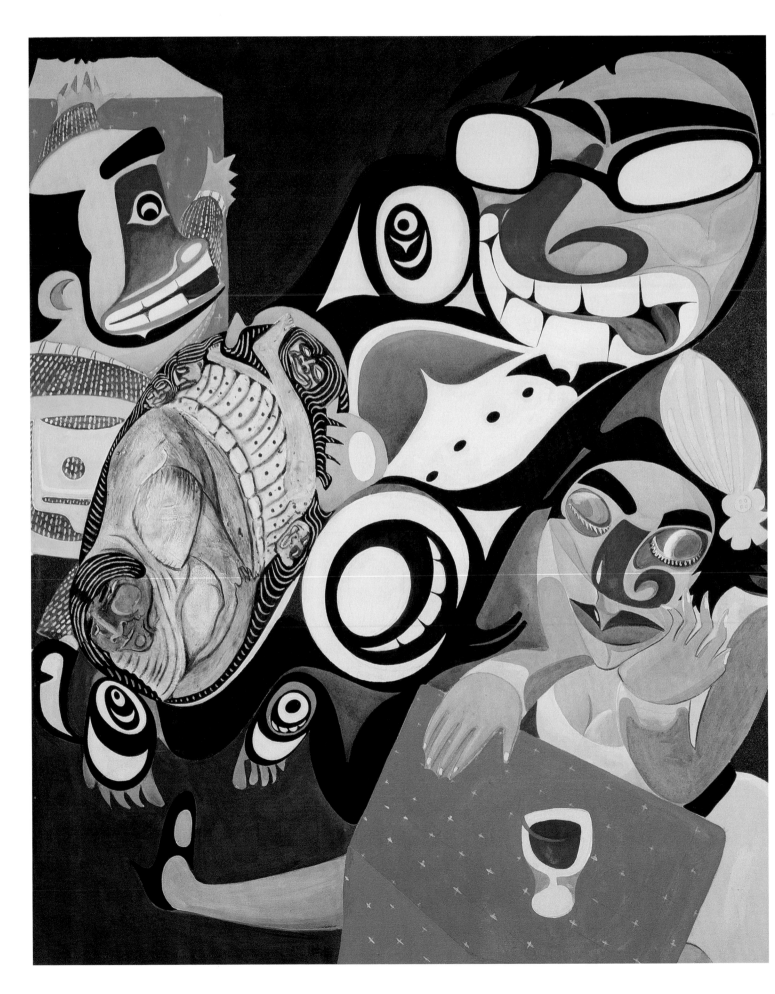

MISCHIEF MAKING

positionality. While he reserved his highest praise for the "great artists of the Haida past", especially Charles Edenshaw, who was his constant source of inspiration, Reid added, "It's far from being all brown and white, as this sculpture shows. It obviously owes much to the European part of my mixed heritage".[31]

Similarly, Yahgulanaas' art has been inspired by Haida masterworks of the past, both material objects and oral histories, which are modulated into new aesthetic forms. The acrylic painting *The Head Waiter*, 2006, for example, was inspired by a late-nineteenth-century argillite and silver carved box in the Glenbow Museum's collection. Attributed to John Robson (Giatlins), Charles Edenshaw's stepfather, the box is carved in high relief. On its lid, the handle takes the form of a reclining woman on a raised rectangular slab, whose solid mass is redolent of Henry Moore's monumental *Reclining Figure*, 1929, which was, the artist revealed, inspired by pre-Columbian Mexican sculptures, especially Chacmools. In the case of the argillite carving, the figure is surrounded and framed by a series of carved human heads in high relief, and eyes and wings in bas-relief cover the remaining surface of the lid. On the front of the box, there is a bear's head in high relief. In its mouth, a woman berry-picker is held in an upside down position, her wrists clasped in the bear's paws.[32]

Robson, who was a hereditary chief of a Raven lineage, is known to have taught his stepson Edenshaw carving techniques and worked with him on a number of totem pole projects. In the case of argillite carvings, these small- to medium-sized sculptures are made by individual artists and fashioned from argillite *(hlgas7agaa)*, also known as black slate, that is found only on Slatechuck Mountain (Kaagan) on Graham Island, Haida Gwaii. From the early nineteenth century, these smooth, dark and shiny objects, with their distinctive Indigenous Northwest Coast crests and iconographies, were largely created as souvenir wares for Europeans. Their decorative forms—trinket boxes, plates, model totem poles, pipes and figurative sculptures—some with silver and gold trim, reference the intersection or intercultural mixing of Indigenous and Western styles and tastes. *The Head Waiter*, 2006, arguably captures this ongoing fusion of different aesthetics and media as it morphs in the imagination of the artist. Yahgulanaas describes the narrative imagery: "on the top left we have the onlooker. The middle is the 'Head Waiter' just trying his best to keep everything together to serve the perfect dish. But we think our lady friend is poised to trip it all up".[33] The bold blocks of saturated colour, the stylization and fluidity of the figures and forms, which encompass Haida formlines and iconographies as evinced in the waiter's feet, also suggest a Fauvist sensibility. The scene and images bring to mind Matisse's compositions with their distinctive flat planes of intense colour, painterly lines and flatness of perspective. Insightfully, Matisse told an American interviewer that he drew inspiration from Asian pictorial sources. He said that he "relied on Oriental art to help him express abstract ideas through the simplification of form and colour".[34] So the complex confluence of artistic traditions and inspirations, radiating from different times, cultures and geographies, is echoed and metamorphosed in novel forms.

HYBRID IMAGERY

In *Charles Edenshaw* the artist and writer Robert Linsley sketches an artistic genealogy as he describes the ingenious use of space, design and formline that characterizes the artworks of Edenshaw, Reid

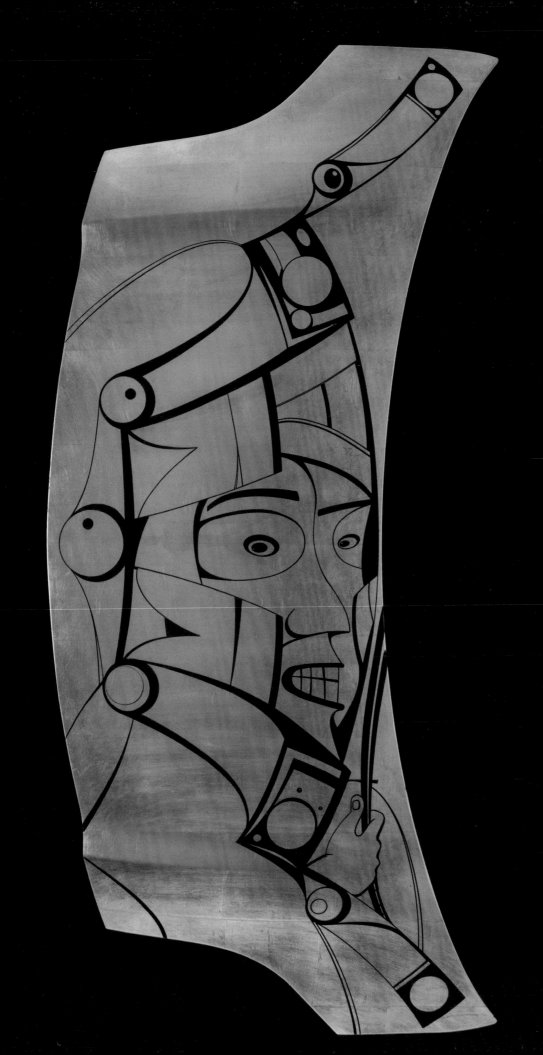

and Yahgulanaas, respectively. He directly compares the expressive imagery Yahgulanaas uses in his *Coppers from the Hood* series with the masterly compositions, fluid formlines, whimsical designs and playful characters Edenshaw painted on decorative wares. He writes:

> Totem poles and bentwood boxes lend themselves very naturally to symmetrical compositions, and the traditional formline patterns offer a natural way to fill the surfaces without remainder. Edenshaw allowed discrete figures to emerge from the pattern, necessarily creating asymmetries ... One contemporary artist who has learned from this is Michael Nicoll Yahgulanaas, whose works mix space-filling formlines, designs that are spread asymmetrically and hybrid figures who move freely inside and outside of curving boundaries. Yahgulanaas' so-called Haida manga are among the most important recent descendents of Edenshaw's narrative platters.[35]

Linsley continues, "the question that faces Haida art today is the hybridisation of traditional forms and Western visual languages, and this is an allegory of the ongoing political relationship between two societies".[36] For Linsley, Yahgulanaas and Bill Reid succeeded in inventing new ways of departing from the principles and categories of Haida art, moving beyond the symmetrical and stylized figurative forms and the distinctive red, black and teal-blue palette, to introduce a kind of 'realism' that speaks to a Western modernist sensibility.

Although Linsley makes some incisive observations, it is somewhat reductive to fix hybridity in relation to a series of age-old binaries: traditional/modern, local/cosmopolitan, Indigenous/settler, with the implication that hybridization in this case is the conjoining or fusion of two of these binary categories: Haida/Western.[37] This obscures the point. Hybridization—the creation of a third independent entity—offers a way of moving beyond these Western dualisms as a cosmopolitan effect and an unfolding process as opposed to creating a solid, fixed point. To invoke the words of the anthropologist Néstor García Canclini, "hybridisation is not the destination ... It is the recognition that cultures cannot develop in an autonomous way, isolated from what is happening on the global stage".[38]

While the discourse of hybridity, which emerged in the 1990s and was inextricably aligned with subaltern studies and postcolonial theory, offered a way of renegotiating, recasting and complicating the identities of and relations between the dominant 'colonial' subject and the colonized 'Other', it has evolved through time and critique. As Canclini, one of its main proponents, acknowledged in conversation in 2009, there is a shift in the discourse: "Within the social sciences in the last ten to fifteen years ... certain key concepts have been altered. Today, we speak of processes of identification more than of identity, of interculturality more than of hybridisation".[39] In explaining the significance of these conceptual changes, he notes, "Processes of identification instead are more dynamic and require us to take as a reference point that with which we identify ourselves, not to think of identity as something that we possess, as if it were a self-contained substance that belongs to us as a group".[40] He continues, "I still insist on the importance of examining the processes of hybridisation, but interculturality allows us to understand that cultures act among themselves without predefining what is going to happen or what is happening. We have to analyse the many forms of interculturality

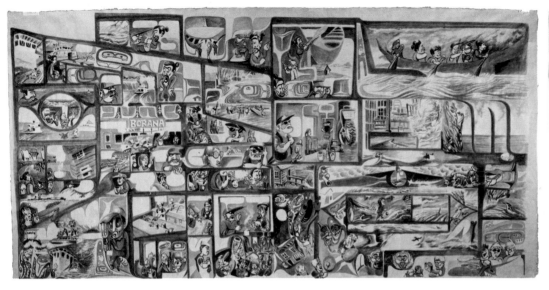

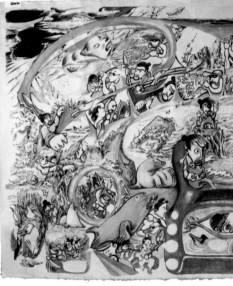

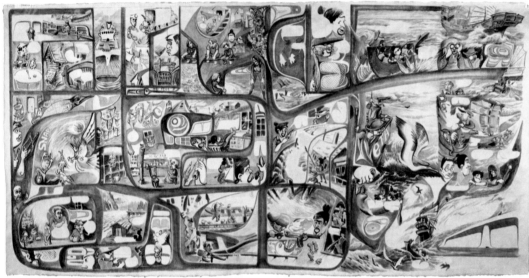

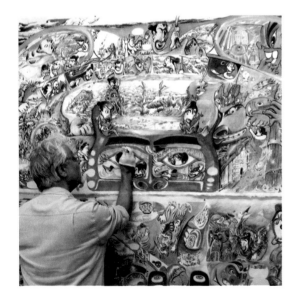

above *Carpe Fin*, 2018

below Michael Nicoll Yahgulanaas completing *Carpe Fin*, 2018

that imply acceptance, rejection, dominations, hegemonies, a multiplicity of forms of interaction".[41] Clearly, interculturality or to use Yahgulanaas' preferred term hybridity, works in this open-ended way. It resists the desire to prescribe, compartmentalize and fix cultural differences and identities. For Yahgulanaas, hybridization is a complex, fluid and multi-directional force, "a central process of modernity and postmodernity" that is articulated in his person and practice.[42] With this in mind, it is important to acknowledge that Yahgulanaas studied visual art outside of the Indigenous-settler complex. In 1999, he received training in Chinese brush stroke technique from the master brush-painter Cai Ben Kwon. The lightness and fluidity of Yahgulanaas' brush strokes, his calligraphic flourishes and the implements and mediums he uses embody the play of different traditions, experiences and influences. For example, his monumental watercolour, *Carpe Fin,* 2018, two metres high and six metres wide, was executed on kozo washi sourced in Japan, like *Orcinus Orca SKAAnaa.* Commissioned by the Seattle Art Museum, it is based on a Haida oral narrative and is the prequel to *Red,* and like the former it has been transformed into a book, *Carpe Fin: A Haida Manga* (2019). In his introduction, Yahgulanaas notes that he began the draft of *Carpe Fin* in 2001 while working as a watchman on Haida Gwaii. Funded by Parks Canada, the Haida Gwaii

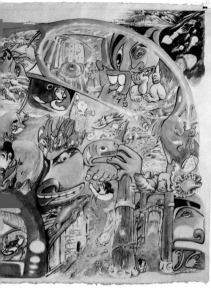
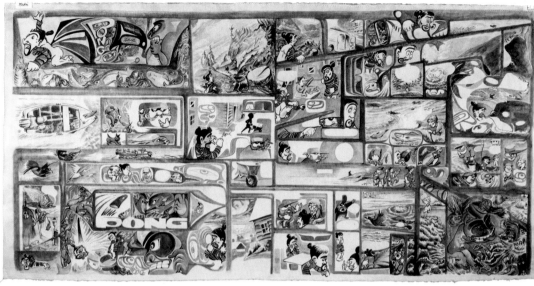
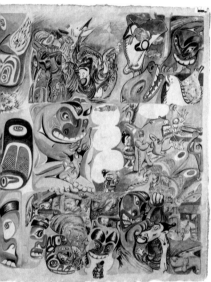
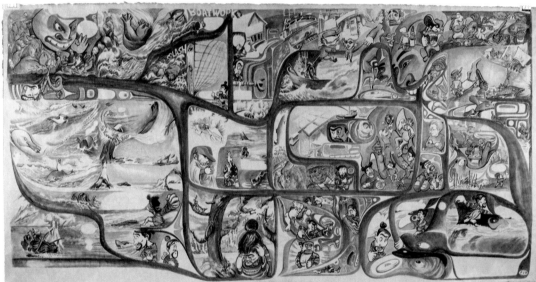

Watchmen Program was established in the 1980s to safeguard cultural
sites and introduce visitors to Haida heritage. Its name draws on past
practices when Haida watchmen were positioned at strategic village
outlooks to raise the alarm when raiders approached. Their important
role as protectors of Haida peoples and culture is often depicted on
historical and contemporary totem poles: three watchmen wearing
tall spruce root hats—a sign of status—crown the top. It was being a
watchman, looking at an inhospitable and isolated bluff, Lord's Rock,
thirty kilometres from the shore of Haida Gwaii, where "one chooses
to go ahead or turn back", that prompted Yahgulanaas to pick up his
brush and sketch out *Carpe Fin*.[43] It was also at this time that he met
his future wife, Launette Rieb, who is pictured in *Carpe Fin*. They met
on the beach at SG̱ang Gwaay, a UNESCO World Heritage Site, and
returned there as Haida watchmen when Launette was pregnant with
their daughter Mirella. In addition to collaborating as a ceramicist on
the *Tell Tiles* series, Launette works as a family physician, an addiction
medicine specialist and a clinical associate professor at the University
of British Columbia. She is a fount of spiritual, intellectual and artistic
inspiration that infuses Yahgulanaas' oeuvre.

One artistic tradition, which has been a source of inspiration
for Yahgulanaas and Western artists before him, is *ukiyo-e* Japanese

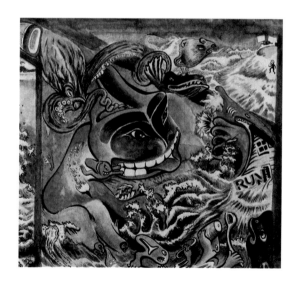

above *Carpe Fin*, 2018

below *Carpe Fin*, 2018 (detail)

woodblock printing. As a boy in grade six, Yahgulanaas was enamoured with a ukiyo-e image, especially the attention to detail of the hands, which he recalls had "graceful fingers with little finger nails. I told myself that I would never hide the hands when I paint them. Now, every time when I paint fingers, I remember that woodblock print".[44] Over five decades later, Yahgulanaas is still exploring the Japanese 'floating world' tradition in his art practice, as evinced in his Haida–ukiyo-e print *Finding Space*, 2015, which was commissioned for the exhibition Homage to Ukiyo-e, an element of the Tokyo Design Week staged in Milan, London and Tokyo. The global flow of technologies and images, which finds expression in contemporary art practices like Yahgulanaas', challenges the idea that art can be categorized and confined by national discourses, histories and boundaries.[45] The cosmopolitan mobility of artists and their artwork in the present means that it is no longer sufficient, if it ever was, to solely address art in relation to ethnic or cultural identifications or, according to Linsley's allegorical model, in relation to two socio-political systems: Indigenous and Western-settler. Art has the potential to transcend boundaries and foster intercultural conversations. Judith Ostrowitz, a New York based writer and visual artist, effuses, Haida manga is "a multifaceted negotiation that dances back and forth among genres and traditions. Yahgulanaas' ideas do not become subsumed by Japanese or Euro-North American culture on the basis of some vague formal affinity. Like his nineteenth-century [Haida] predecessors, he assembles a varied toolbox of devices and concepts to achieve his own ends. However, these ends are very much related to broad, worldwide dialogue".[46]

THE ELASTICITY OF HAIDA MANGA

The politics on Haida Gwaii, surrounding Indigenous natural and cultural heritage, dramatically changed over the course of the twentieth century. With the arrival of the new millennium Yahgulanaas made a decision to move out of the political sphere and devote himself to art on a full-time basis. Amusingly, he quipped, "better to move into the politics of art than into the art of politics".[47] Yet as we will discover these elements remain inextricably fused in his art. His debut was a graphic novel, *A Tale of Two Shamans*, 2001, based on the reformulation of an old Haida parable long separated into three dialects. I would argue that this work marks the advent of Haida manga proper. Curvilinear panels and borders in linear groups are replaced with bold asymmetrical calligraphic formlines. These lines emerge from representational figures or expand into abstract frames, structuring the page and lending a cadence and pace to the imagery, manga-style. Through the negative space of the Haida-inflected framelines, narratives and vistas, vignettes and characters surface and recede, without the presence of gutters to impede the immediacy of their play. This distinctive visual aesthetic is traced through Yahgulanaas' successive publications, including *The Last Voyage of the Black Ship*, 2002, *A Lousy Tale*, 2004, *Red: A Haida Manga,* 2009, *War of the Blink*, 2017, and *Carpe Fin: A Haida Manga*, 2019. It has also transmuted into other media forms, from watercolours like *Erika Prestige and Valdez*, 2006, which refers in title to the three oil tankers that sank, to ceramic surfaces, such as the *Tell Tiles* series, which Yahgulanaas has created in collaboration with his wife the ceramicist Launette Rieb, MD.

With each medium, Yahgulanaas' masterly calligraphic strokes and Haida framelines assume a different presence and intensity. In the *Blueprint* series, for instance, which was created when he was professor of contemporary art at the University of Victoria in 2011, the dominant framelines dissolve into deep space, and internal structures remain suspended in the fore and middle ground.[48]

Experimenting with different media and techniques gathered from various sources has ensured that Haida manga has not stood still and become a fixed recurrent monochrome form. It assumes different textures and guises as it materializes on mulberry bark, rice paper, tissue, wood, metal, clay and other mediums. In the process, it creatively draws on an expanding palette of colours and a growing box of tricks, including powdered pigments from Africa; miniature coloured pencils from the Netherlands; antique calligraphy brushes from Asia; lustre and metallic glazes and gold, platinum and copper leaves.

MANGAKAS—FREE-FLOATING ARTISTS

A Tale of Two Shamans carries another interesting connection to the history and etymology of manga. Looking inside the book, a surprised reader may encounter one of the original, one-off *Shamanic Doodles*. In a playful gesture, Yahgulanaas set aside ninety copies of *A Tale of Two Shamans*, and inside each one, using a limited number of drawing implements—calligraphic brush pens and felt-tip markers—he created a *Shamanic Doodle*, which can be removed and framed. Catalogued and numbered, the *Shamanic Doodles*' quirky fluid lines take the form of multifarious characters, ranging from fish and stylized shaman figures to more abstracted anthropomorphic forms. The practice of doodling, whether an unconscious drive or an intentional act, is another element of play. As Huizinga notes, "we play with lines and planes, curves and masses, and from this abstracted doodling emerge fantastic arabesques, strange animal or human forms".[49] The *Shamanic Doodles* bring to mind the famed *Hokusai Manga*—fifteen volumes containing thousands of woodprint sketches by the eminent Japanese ukiyo-e 'The Great Wave' artist Katsushika Hokusai (ca. 1760–1849). Reproduced in three colours (black, grey and beige-pink), Hokusai's manga depict a diverse range of ethnographic subjects, peoples and landscapes characterized by lively brush strokes that still impart a refreshing immediacy. Compiled as a teaching tool, this prolific body of work is usually credited as the origin of the term manga, which historically was a more generalized term in Japan that referred to cartoons and sketches as stand-alone elements as well as serial compositions, in contrast to manga's association today on a global scale with graphic narrative or comic forms.[50]

In an interview, responding to a question about cultural appropriation, Yahgulanaas revealed that it was a group of Japanese university students he was with in the 1990s who encouraged him to see his work as Haida manga.[51] He recalls, they "began to refer to me as 'mangaka'", the Japanese word for a manga artist. "They explained that mangaka is an artist who creates free-form pictures without limitations. 'Drawings without limitations' resonated with me and it was at this time that I started blending Haida techniques with Japanese manga and liberating the narrative and the line".[52]

Initially, Yahgulanaas' graphic novels received a much broader recognition in Asia, especially Japan and Korea, before proliferating in the North American market. A remarkable case in point is *The Flight*

top *Tale of Two Shamans 69*, 2001

bottom *Carl Went Searching*, 2015, *Tell Tiles* series

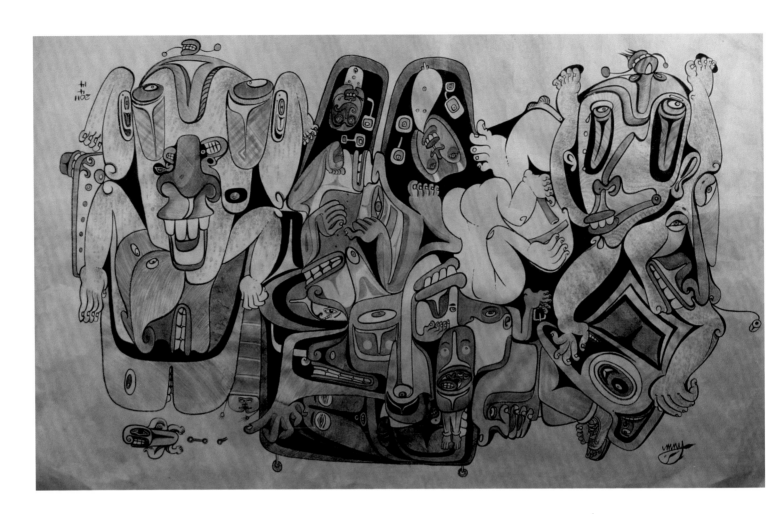

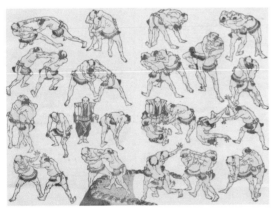

top *Untitled, 2011, Papered Over* series

bottom Katsushika Hokusai, *Wrestlers*, ca. 1815

of the Hummingbird: A Parable for the Environment, 2008. The first version of this book was a collaborative effort, entitled *Hachidori no Hitoshizuku*, 2005 (One Drop of Water from a Hummingbird). It was written in Japanese by the cultural anthropologist and environmentalist Keibō Ōiwa under his pen name Shinichi Tsuji and illustrated by Yahgulanaas. Published by the second-largest publishing house in Japan, Yusuke Tanaka notes, "This little book captured the hearts of the Japanese youth, making it into a smash hit, and selling over 30,000 copies".[53] The English edition, which followed in 2008, was written and illustrated by Yahgulanaas, with a foreword by Wangari Maathai and an afterword "Universal Responsibility" by His Holiness the Dalai Lama, both Nobel Peace Prize recipients. Rather than full flowing framelines and borders giving structure to the pages, the exquisite, simplified and stylized black, white and red images are surrounded by an expanse of negative space, complemented by the potency of a minimalistic text. This constitutes a startlingly different expression of Haida manga compared to the colourful and baroque imagery of Yahgulanaas' other award-winning publication *Red: A Haida Manga* and its fabulous pictorial source: a five-metre-long composite mural executed in watercolour and ink. In the perceptive words of one critic, in *Red*, "Yahgulanaas makes use of the buoyant and exaggerated caricatures seen in cartoons and comics, and uses the elegant lines of Northwest Coast design to both border the action and direct the flow. The result is narrative paintings that burst with motion, exuberance, humour and arresting characters, while tying together the graphic traditions of two disparate Pacific Rim island-dwelling cultures".[54]

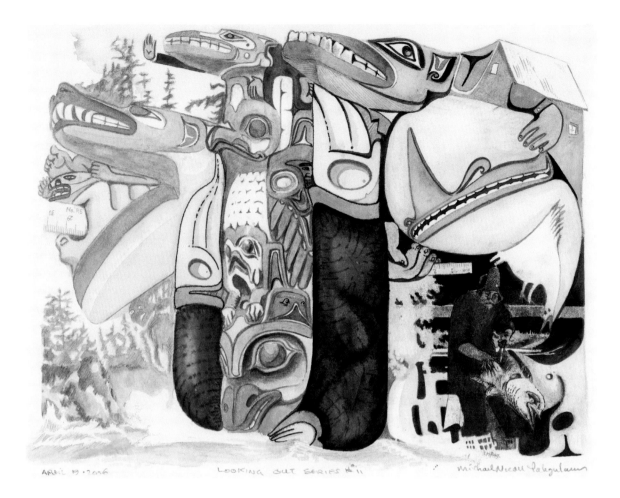

Looking Out 11, 2006

Red in its different iterations offers a fascinating insight into Haida manga's potential to open a space for collaboration, creative engagement, empowerment and play. It also brings us indirectly back to *Abundance Fenced.* In her influential book, *One Place after Another: Site Specific Art and Locational Identity*, 2002, the art historian Miwon Kwon argues that collaborative art practice "takes critiques of 'heavy metal' public art as its point of departure" and redefines the site as a social space rather than "a geographical location or architectural setting".[55] For Kwon, this shift from a concrete-physical to a social-relational context is the hallmark of "new genre public art".[56] This widespread "social turn" in contemporary art is focused on collective art-making processes, where the artist relinquishes some degree of authority and autonomy over the artwork to facilitate dialogue, intercultural conversations and critical engagement among diverse communities. Rooted in Dadaistic desires and Pop Art's later concerns to repurpose images to offer new insights into contemporary cultural practices and make art more accessible to a wider public, collaboration has emerged as a varied and hybridized aesthetic and praxis of empowerment.[57] It enables participants to engage with art and explore a broad range of issues, including individual and collective identity, belonging and responsibility. In different contexts— from museums and galleries, through lecture theatres and studios, to public libraries and domestic spaces—Yahgulanaas has invited participants from diverse communities, including students and artists, readers and animators, visitors and viewers, to remediate *Red*, through their own heuristic engagement. In this way, *Red* has been transformed from a book into a mural; from mural into a music video and from a

series of frameline templates into a collective artwork and more besides. So Haida manga continues to modulate into different hybridized forms. It remains a fertile and generative matrix of lines and colour, stories and characters, movement and the imagination that opens up a delta of possibilities, as *Looking Out II,* 2006, with the self-portrait of the artist in the lower right, intimates.

1 Emme, Michael, "Michael Nicoll Yahgulanaas: Art at the Edges", *Canadian Art Teacher*, vol 12, no 1, 2013, nn.

2 Griffin, Kevin, "Michael Nicoll Yahgulanaas: Haida Manga Public Art", *Vancouver Sun*, 2 December 2011, accessed 17 August 2021, https://vancouversun.com/news/staff-blogs/47377.

3 Michael Nicoll Yahgulanaas archives.

4 Michael Nicoll Yahgulanaas archives.

5 Park, Liz, *Michael Nicoll Yahgulanaas: Abundance Fenced*, Vancouver: City of Vancouver Public Art Program Information, 2011.

6 Babs Hageman Yahjaanaas, personal communication, 19 November 2010. Yahgulanaas was born to a Haida mother, Babs (née Adams), and a Scottish Canadian father, Tom Nicoll. The family moved back to Haida Gwaii when Yahgulanaas was a year old. His parents divorced when he was three and he stayed with his mother, who remarried a Haida man, Bruce Hageman.

7 Michael Nicoll Yahgulanaas, personal communication, 22 October 2014.

8 Prophetically, this graphic narrative tells of the insurmountable devastation to marine, human and animal life caused by oil tankers, which is still an everyday reality in Alaska following the 1989 Exxon Valdez disaster.

9 See Park, Liz, "Introduction", *Old Growth: Michael Nicoll Yahgulanaas*, Vancouver: Read Leaf and Grunt Gallery, 2011, p 7.

10 Over the years Yahgulanaas has worked on three different totem pole projects with Robert Davidson (1978) and 7idansuu James Hart (1999 and 2000).

11 In his award-winning book, *Red Skin, White Masks: Rejecting the Colonial Politics of Recognition,* Glen Coulthard, who is a scholar, activist and member of the Dene Yellowknives First Nation, powerfully argues that in the Canadian context to fracture the dominant colonial and capitalist power relations that structure the present, we need to move away from "recognition politics" toward a more radically transformative model of "Indigenous resurgence" that foregrounds Indigenous traditional knowledge, practices and relationships to land, including the ecosystems of human and non-human kin. In many ways, the Haida Nation has been pushing forward this model as described. Coulthard, Glen, *Red Skin, White Masks: Rejecting the Colonial Politics of Recognition,* Minneapolis: University of Minnesota Press, 2014.

12 Augaitis, Daina, "The Impulse to Create: Daina Augaitis in Conversations with Robert Davidson, Michael Nicoll Yahgulanaas, and Don Yeomans", *Raven Travelling: Two Centuries of Haida Art*, Peter McNair, Daina Augaitis, Marianna Jones and Nika Collison eds, Vancouver: Vancouver Art Gallery; Vancouver/Toronto: Douglas and McIntyre; Seattle: Washington University Press, 2006, p 157; with additional information supplied by Michael Nicoll Yahgulanaas, personal communication, 22 October 2014.

13 The two survey exhibitions were: Signed without Signature: Works by Charles and Isabella Edenshaw, November 2010–September 2011, UBC Museum of Anthropology, curated by Bill McLennan, and Charles Edenshaw, October 2013–February 2014, Vancouver Art Gallery, curated by Robin K Wright and Daina Augaitis. For exhibition timeline and images, see Wright, Robin K, and Mandy Ginson, "Chronology", *Charles Edenshaw*, Robin K Wright and Daina Augaitis eds, London/Vancouver: Black Dog Publishing/Vancouver Art Gallery, 2013, p 229.

14 Michael Nicoll Yahgulanaas, personal communication, 4 July 2021.

15 See "The Respect to Bill Reid Pole, Artist Profile: Michael Nicoll", accessed 20 October 2014, http://www.virtualmuseum.ca/sgc-cms/expositions-exhibitions/bill_reid/english/background/michaelnicoll.html.

16 Levell, Nicola, "Site-Specificity and Dislocation: Michael Nicoll Yahgulanaas and His Meddling", *Journal of Material Culture*, vol 18, no 2, 2013, p 99.

17 Williams-Davidson, Gid7ahl-Gudsllaay Lalaxaaygans-Terri-Lynn, *Where the Power Is: Indigenous Perspectives on Northwest Coast Art,* Vancouver: UBC Museum of Anthropology/Figure 1 Publishing, 2021, p 296.

18 Yahgulanaas was a forestry engineer until 1981 when he resigned his position and returned to his village to join his community in their fight for Indigenous rights and campaign against environmental destruction.

19 Guujaaw Nangiitlagada Gidansda and Michael Nicoll Yahgulanaas, personal communication, 5 June 2015. Two million cubic metres is the equivalent of 2 million telegraph poles. As Yahgulanaas explains, the forests on Haida Gwaii have been dated to 10,000–14,000 years according to pollen core sampling undertaken by Dr Rolf Matthewes, a professor of paleoecology at Simon Fraser University, and Haida narratives and crests that identify the first tree.

20 This form of campaigning was not an isolated phenomenon. Indigenous peoples and activists in the late 1970s were uniting across the globe to assert their rights to land, stewardship and self-governance. Organizations such as Survival International (established 1969) and Greenpeace, which was founded in Vancouver (ca. 1969), were part of the global campaign for Indigenous rights and environmental issues.

21 See *Pushing the Line: Art without Reservation*, DVD, directed by Lisa Jackson, Toronto: Mitzi Productions, 2009.

22 Collison, Jisgang Nika, and Council of the Haida Nation, *Athlii Gwaii: Upholding Haida Law at Lyell Island,* Vancouver: Locarno Press, 2018, p 157.

23 Sostar McLellan, Kristine, "Mythic Proportions: A Haida Artist Weaves Cultural Traditions into Something New", *SAD MAG: Stories, Art, and Design*, nos 16/17, 2014, p 38.

24 Park, "Introduction", p 13.

25 Park, Liz, "Oblique Strategies: A Conversation with Simon Davies, Michael Nicoll Yahgulanaas and Liz Park", *Old Growth*, pp 37-38.

26 See Vastokas, Joan, "Bill Reid and the Native Renaissance", *Artscanada*, nos 198/199, 1975, pp 12–21, and Hopkins, Thomas, "The Happy Rebirth of an Intricate Art", *Maclean's*, no 93, 1980, pp 56–58. For critiques of the idea of a renaissance in Native Northwest Coast art centring on Bill Reid, see Jonaitis, Aldona, "Reconsidering the Northwest Coast Renaissance", *Bill Reid and Beyond: Expanding on Modern Native Art*, Charlotte Townsend-Gault and Karen Duffek eds, Seattle/Vancouver: University of Washington Press/Douglas and McIntyre, 2004, pp 155–174.

27 Through his mother's line, Reid was a member of the Raven/Wolf Clan of T'anuu the Kaadaas gaah Kiiguwaay. For a detailed iconographic description of *The Respect to Bill Reid Pole* and a hyper-mediated history of the project, see the Virtual Museum of Canada's Virtual Exhibit, "Respect to Bill Reid Pole", accessed 14 October 2014, http://www.virtualmuseum.ca/sgc-cms/expositions-exhibitions/bill_reid/english/background/michaelnicoll.html.

28 Michael Nicoll Yahgulanaas, personal communication, 14 November 2014.

29 Radcliffe-Brown, AR, "On Joking Relationships", *Africa: Journal of the International African Institute*, vol 13, no 3, 1940, pp 195–196.

30 Carr, Geoffrey, "Bearing Witness: A Brief History of the Indian Residential School in Canada", *Witnesses: Art and Canada's Indian Residential Schools*, Scott Watson, Keith Wallace and Jana Tyner eds, Vancouver: UBC Morris and Helen Belkin Art Gallery, 2013, p 11.

31 Reid, Bill, Transcript of Bill Reid's speech, Unveiling of *The Raven and the First Men*, 1 April 1980, UBC Museum of Anthropology Archives.

32 Joanne Schmidt, collections technician, Indigenous Studies, Glenbow Museum, personal communication, 23 April 2015.

33 *Head Waiter*, 2006, description, Michael Nicoll Yahgulanaas archives.

34 Spurling, Hilary, *Matisse the Master: A Life of Henri Matisse, the Conquest of Colour*, New York: Random House, 2005, p 47.

35 Linsley, Robert, "Edenshaw's Legacy in Contemporary Art", *Charles Edenshaw*, Robin K Wright and Daina Augaitis eds, London/Vancouver: Black Dog Publishing/Vancouver Art Gallery, 2013, p 215.

36 Linsley, "Edenshaw's Legacy in Contemporary Art", p 215.

37 See Levell, Nicola, "Beyond Tradition, More Than Contemporary: Four Northwest Coast Artists and Citizens Plus", *Urban Thunderbirds, Ravens in a Material World*, Victoria: Art Gallery of Greater Victoria, 2013, pp 38–49.

38 Montezemolo, Fiamma, "Tijuana: Hybridity and Beyond. A Conversation with Néstor García Canclini", *Third Text*, vol 23, no 6, 2009, p 740.

39 Montezemolo, "Tijuana", p 741.

40 Montezemolo, "Tijuana", p 741.

41 Montezemolo, "Tijuana", p 741.

42 Montezemolo, "Tijuana", p 740.

43 Quoted in Yahgulanaas, Michael Nicoll, *Carpe Fin: A Haida Manga*, Madeira Park, BC: Douglas and McIntyre, 2019, nn.

44 Tanaka, Yusuke, "A Haida Artist's Tale Told in Manga Form: Something Wonderful Happened Historically Between Haida and Japan", *Nikkei Voice*, no 11, 2011, p 11.

45 Yoshimoto, Midori, "Beyond 'Japanese/Women Artists'", *Third Text*, vol 28, no 1, 2014, pp 67–81.

46 Ostrowitz, Judith, "Michael Nicoll Yahgulanaas: It Looks Like Manga", *Objects of Exchange: Social and Material Transformation on the Late-Nineteenth Century Northwest Coast*, Aaron Glass ed, New York: BGC Focus Gallery, 2011, p 87.

47 Michael Nicoll Yahgulanaas, personal communication, 20 November 2006.

48 Yahgulanaas was appointed as Audain Professor of Contemporary Arts of the Pacific North West at the University of Victoria for one term in 2011.

49 Huizinga, Johan, *Homo Ludens. A Study of the Play-Element in Culture*, London, Boston and Henley: Routledge, Kegan and Paul, (1949) 1980, p 168.

50 Peau, Lee, "Haida Tales in a New Context", *Wingspan*, October 2007, p 36.

51 Sostar McLellan, "Mythic Proportions", p 39. It is not surprising that Yahgulanaas was asked about appropriation at this time. In the 1990s, heated debates concerning cultural appropriation were circulating in academic media and the public sphere in Canada and beyond (see Todd, Loretta, "Notes on Appropriation", *Parallelogramme*, vol 16, no 1, 1990, pp 24–33; Thomas, Nicholas, *Entangled Objects: Exchange, Material Culture, and Colonialism in the Pacific*, Cambridge, MA: Harvard University Press, 1991; Thomas, Nicholas, *Possessions: Indigenous Art, Colonial Culture*, New York: Thames and Hudson, 1999; Young, James O, *Cultural Appropriation and the Arts*, Malden, MA: Blackwell Publishing, 2008). As Ziff and Rao argue, although cultural appropriation is fundamentally a multidirectional phenomenon, it is primarily problematized as the dominant culture taking from a subordinate group without consultation and permission, and thus it raises questions of power and exploitation. More recently, in discussing global art practices, Schneider has expanded on the idea of multidirectionality to argue that appropriation should be reimagined as a constructive site of cultural dialogue, understanding and exchange. It is in this global context that Yahgulanaas' Haida manga practice is situated. Ziff, Bruce H, and Pratima V Rao, *Borrowed Power: Essays on Cultural Appropriation*, New Brunswick, NJ: Rutgers University Press, 1997, p 5; Schneider, Arnd, "On 'Appropriation': A Critical Reappraisal of the Concept and Its Application in Global Art Practices", *Social Anthropology*, vol 11, no 2, 2003, pp 215–229.

52 Michael Nicoll Yahgulanaas, Interview, McMichael Art Collection, Kleinburg, Ontario, February 2015.

53 Tanaka, Yusuke, "A Haida Artist's Tale Told in Manga Form: Something Wonderful Happened Historically Between Haida and Japan", p 11.

54 "Michael Nicoll Yahgulanaas: Solo Exhibition, Stonington Gallery, Seattle", accessed 17 August 2021, https://stoningtongallery.com/exhibit/solo-exhibit-2/.

55 Bishop, Claire, "The Social Turn: Collaboration and Its Discontents", *Artforum*, vol 44, no 6, 2006, pp 178–183; and Kwon, Miwon, *One Place after Another: Site-Specific Art and Locational Identity*, Cambridge, MA: MIT Press, 2002, p 6.

56 Kwon, *One Place after Another*, p 6.

57 Kester, Grant, *The One and the Many: Contemporary Collaborative Art in a Global Context*, Durham: Duke University Press, 2011.

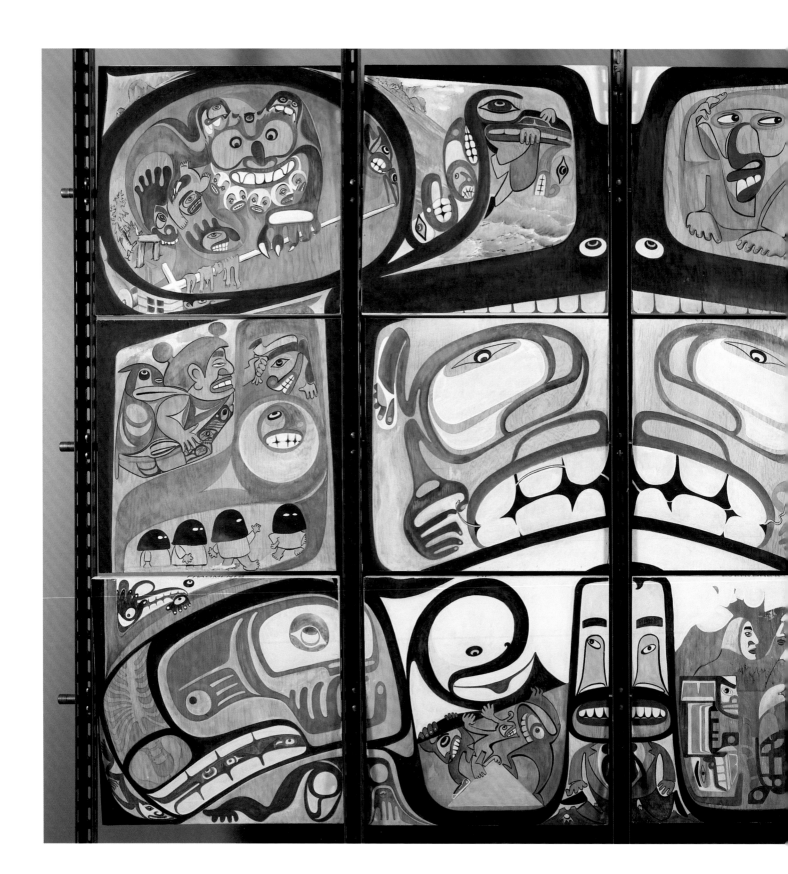

Bone Box, 2007

HAIDA GOES POP!

—

PLAYING WITH FRAMELINES

The comic form encourages me to extract meaning and form where I find it, in the Indigenous and the settler cultures, and to flip them upside down, reverse them, recombine them, to allow new meaning to emerge in renewed form.
Michael Nicoll Yahgulanaas[1]

When Lichtenstein appropriated the American comic form for his art practice, he exaggerated and amplified its visual imagery and effects, formulating boldly coloured cartoon images, with thick black lines and his hallmark Ben-Day dots: "I am nominally copying, but I am restating the copied thing in other terms. In doing that, the original acquires a totally different texture. It isn't thick or thin brushstrokes, it's dots, flat colours and unyielding lines".[2] In this way, Lichtenstein as well as other visual artists associated with the Pop Art movement harnessed traditional art forms and techniques and applied them to images from popular culture. Using strategies of appropriation, frequently laced with irony, they created hybridized works that not only critiqued the established canon of fine art and its haughty dismissal of mass culture as a subject matter; they simultaneously broadened the public's critical perception of culture at large. In their jarring creations the viewer is confronted by the society of the spectacle, with its accent on media technologies, consumer culture and the cult of the commodity. With its embedded critique of contemporary culture, Pop Art in general had the potential to become "a graphic weapon of social change", whether or not that was the artists' intent.[3]

From a different vantage point, Michael Nicoll Yahgulanaas has harnessed and transfigured the visual imagery and stylized expressions of classic Haida art. Through drawing and painting, colour and line, he has created a "totally different texture", a hybridized expression that challenges the canon and stereotypes of Indigenous Northwest Coast art. The comic genre in particular has enabled him to break free from the enclaves of indigeneity and reach out to a broader audience in Canada and beyond. Moreover, in naming his practice Haida manga, Yahgulanaas deliberately set out to circumvent the North American comic-aesthetic, abstracted and writ large in Lichtenstein's work, and declare an elective affinity with manga and more generally the visual culture of the North Pacific. In relation to Yahgulanaas' oeuvre, manga is understood as an expansive term. In line with its etymology and historical meaning in Asia, it encompasses the serialized comic format as well as the singular expression, be it a cartoon, a sketch, a drawing, a painting or some other form. By prefixing manga with Haida, Yahgulanaas is patently asserting his hereditary right to engage and play with Haida's tangible and intangible cultural heritage forms.

Although Yahgulanaas strategically identifies himself as Haida, he stresses, "I don't have an interest in defending *my* ethnicity as dominant or prevailing relative to any other ethnicity. This isn't about purity of culture, but rather about relationships between the various parts of humanity and those things we describe as the 'other'".[4] In rejecting notions of cultural 'purity' and difference—ideas that have fuelled the Western discourse of authenticity that haunts Indigenous artists and their works—Yahgulanaas' art effects a form of resistance.[5] It seeks to fracture dominant Western systems of knowledge and representation to create an alternative space where a plurality of worldviews can coexist. It openly resists the pressure to conform to the expectations of what constitutes Haida art and by

Roy Lichtenstein, *Whaam!*, 1963

extension what is manga. By championing hybridity, Yahgulanaas seeks to dismantle the discourses and traps of Nativism that define categories such as 'ethnic art', which are propagated by different constituencies, including the art world and the nation-state. He writes, "It is imperative that Haida manga incorporate contemporary social issues, that it speak to other people's needs rather than merely to 'mine.' Many ... are still stuck in the old game, the wooden Indian, the abandoned village, the romantic image of the vanishing people. There is a political market for that myth".[6]

The mythic image of the "wooden Indian", as Yahgulanaas intimates, is perpetuated by the fetishization of traditional forms such as totem poles, bentwood boxes and masks. While these categories of objects speak to the survival and ongoing transmission of Indigenous or more pertinently Haida cultural traditions, they generally avoid direct confrontation with the broader social concerns of being in the present. There is a profound irony, as Yahgulanaas has frequently noted, in the fact that modern-day Canada uses First Nation art as "cultural currency".[7] Large sculptures like totem poles are commissioned and displayed by the Canadian government and its embassies: scattered across the globe, in Europe, the Americas, Oceania and Asia, these monumental forms or gifts are seen to consolidate diplomatic relations and celebrate Canada's respectful and collaborative relations with its Indigenous peoples.[8] While they act as celebratory markers at home and abroad, pressing issues of spatial justice such as Indigenous land rights as well as wider environmental concerns are not being adequately addressed. That neo-traditional cultural expressions like totem poles have a limited capacity to grapple with contemporary social issues may partly explain why Yahgulanaas decided not to pursue traditional Haida art practices such as woodcarving. By pioneering Haida manga, he has created a broader platform and an alternative voice for unsettling the meaning, deconstructing categories and challenging fictions.

EXPLODING MYTHS

A small ink drawing, *Deconstruction of the Box*, 2003, offers a comic introduction to Yahgulanaas' commitment to mimic and undermine Western systems of knowledge that have contributed to the romantic stereotype of the "wooden Indian". In this drawing Yahgulanaas parodies the methodology of formal analysis developed by the American art historian Bill Holm for understanding Indigenous

Deconstruction of the Box, 2003

Northwest Coast historical art forms. In his studies, Holm anatomizes Haida artefacts, including bentwood chests, deconstructing their iconography, working from the formline down to abstracted skeletal innards to explain form and meaning. In his cartooned version, Yahgulanaas playfully goads us to "deconstruct the box, extract a meaning, any kind of meaning, as long as it's relevant. BANG".[9]

To appreciate more fully the way in which Haida manga wantonly subverts, stretches and twists traditional formline structures, colours and iconographies as it mutates into different media, it is worthwhile touching on a number of historical sources. The formal study of Indigenous Northwest Coast art is generally traced back to the anthropologist Franz Boas (1858–1942), who introduced a preliminary vocabulary of style in his groundbreaking book *Primitive Art*, 1927. In a renewed effort to understand, codify and elevate this genre of art, in the 1950s, Bill Reid and Bill Holm embarked on a mission "to reconstruct the formal rules of the Haida tradition by studying, copying, and learning from the work of earlier artists" found in museum collections and illustrated in books.[10] At the same time, Holm extended his study to incorporate other Northwest Coast "tribal variations" and devised a particularized terminology, rooted in art historical terms, for describing recurrent iconographic motifs, crests, symbols and forms or what he termed "the principles of … [the] system" of two-dimensional design.[11] He explained and illustrated these principles in his 1965 publication *Northwest Coast Indian Art: An Analysis of Form*, which arguably has had the most far-reaching effect of formalizing and fixing the 'language' of the Indigenous Northwest Coast art style. Still in use today—with its 50th anniversary edition released in November 2014—Holm's book provides a detailed formal analysis of bentwood boxes, totem poles, painted screens, rattles, canoes, masks, wooden bowls, carved spoons, textiles, silver bracelets, and argillite carvings among other objects. From analyzing the decorated surfaces of these objects, Holm concludes:

> It is apparent that there was, on the Northwest Coast, a highly developed system for the organisation of form and space in two-dimensional design as an adjunct to the well-known symbolism … Chief among these principles was the concept of a continuous primary formline pattern delineating the main shapes and elaborated with secondary complexes and isolated tertiary elements. Also important to it was a formalised colour usage that prescribed the placement of the three principal colours: black, red, and blue-green.[12]

Holm introduced terms such as ovoid, U-form and split U to describe the formal elements or "design units" that fill the internal negative spaces created by the formline.[13] Whereas the "formline outlines the basic anatomical structure of all creatures represented, no matter how abstracted their forms may be",[14] their internal structures are composed of secondary and tertiary elements such as ovoid forms, which are identified as an omnipresent feature used "as eyes, joints, and various space fillers".[15] It is this language of formlines, ovoids and U-forms that continues to be reproduced by artists and others to describe the stylized elements and attributes of the Indigenous art of the Pacific Northwest.

Although Holm's contribution to this field of study as a scholar and an artist cannot be underestimated, with its reliance on a limited corpus of historical artefacts and formalist principles of analysis, it

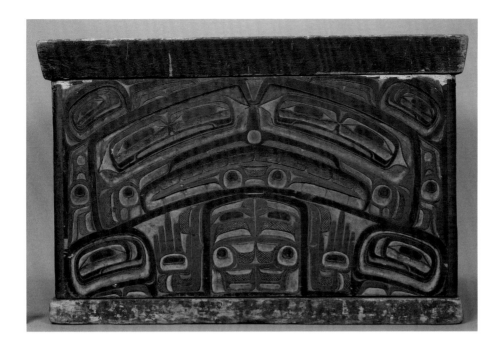

nevertheless created a somewhat rigid set of criteria or canon that continues to burden the production and evaluation of Indigenous Northwest Coast art.[16] He even began with the grounded assertion, "Northwest Coast Indian art is essentially a wooden art", based on a materialist view of cultural heritage, largely preserved in museums.[17] In some quarters, his work has been viewed as a form of appropriation: it signals the assimilation of Indigenous Northwest Coast art design into a Western art historical discourse. More recently, a younger generation of Haida artists has emerged to challenge the modernist and universalist language of formal analysis. These young artists are in effect restituting the formline, artistically pushing it in different directions and intellectually reasserting its connection to Haida worldviews. Gwaai Edenshaw, for example, who credits Yahgulanaas with nurturing in him "an interest in more experimental styles in Haida art", is currently working to develop a different vocabulary for understanding Haida artforms.[18] He is seeking to reconnect language and art to find a more holistic avenue to explore and extend his own artistic practice. As part of this process, Gwaai and others have been "speaking to elders and pouring over the notes of early anthropologists", particularly those of Franz Boas, James Swan and John Swanton and dictionaries including John Enrico's *Haida Dictionary*, 2005, as well as drawing on their own knowledge to identify concise and meaningful Haida terms for conceptualizing and describing art forms and designs. Although this is still very much work-in-progress, Gwaai offers a fascinating and eloquent insight into the process and possibilities of reconnecting Haida language and art:

Formline is the universally accepted term to describe the art that governs our life, and yet it is a term that comes from without. 'Formline' is a difficult word to replace. For one, its existence, for me, has been life long. It is ingrained in me and it does, as does the rest of Holm's developed language, embody and explain a great deal about our art. Holm has provided the artists of the coast with an excellent tool in terms of a language that we have been using to advance our ideas and the art we live in and through. In trying

top Albert Edward Edenshaw, Haida bentwood chest, nineteenth century

bottom Bill Holm, detail of the design from a painted box, from *Northwest Coast Indian Art: An Analysis of Form*, 1965

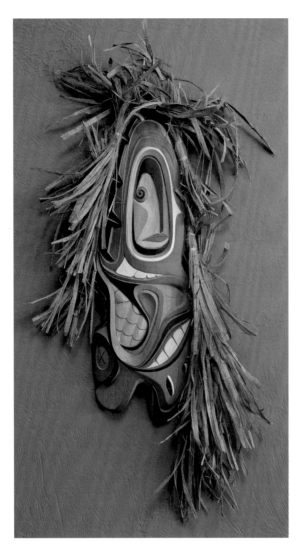

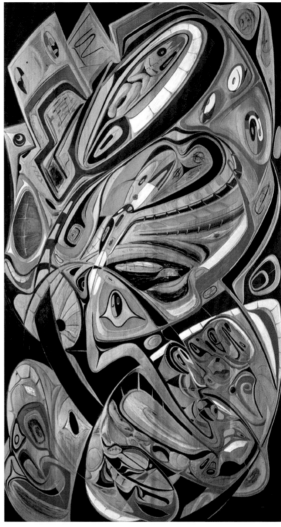

left Donald Varnell, *The Shape of Things to Come*, 2009

right Donald Varnell, *Logic Board*, 2007

to formulate a Haida solution or alternative, we saw 'formline' as the golden standard that we would want our Haida words to live up to. For us, it is a real challenge to come up with another word to describe the art as a whole. The word that we have arrived at is *Sga Gisdll Kuts*. *Sga* is a Haida shape classifier that is used to describe a flexible tapered line. It is used to describe for example an octopus arm, a stream, an eyebrow as well as the passage of time, a voice, a song, and importantly it extends to define the concepts of myth, story, and feeling. For example, the English translation of *Sga gisdll* is storyline. Ovoid is a word that I am quite happy with. In my mind it refers specifically to the Haida design component that Holm assigned it to. In actuality, it means oval-like or 'ovalish' as I like to say. And so we prefer to use the word *Xans K'ul*, which means socket form. The other term that I think is important is what Holm referred to as 'salmon-trout head', which is a universally accepted descriptor ... My preferred term is *Aaw Kaats'ee* or mother head. This refers to the fact that the *Aaw Kaats'ee* is the basic scaffolding upon which all Haida heads are built. I think that it is an excellent descriptor that has the power to convey to artists and laypeople alike the fundamental principles of our particular art form that is to say *Aaw Kaats'ee* contains the core elements and is the generating source of all our designs.[19]

Donald Varnell Gawa Git'ans (Galaa) of the Eagle clan of Gawa Git'ans Gitanee—another Haida artist whom Yahgulanaas admires—plays with wood, paint and form to offer a contemporary twist on the old, as shown in works like *Logic Board*, 2007, and *The Shape of Things to Come,* 2009. A member of the Eagle clan of Gawa Git'ans Gitanee, Varnell explains that his experiential grounding in classic Haida art forms, learned from master carvers including Nathan Jackson, Reg and Robert Davidson and Nathan Hill and illuminated by the teachings of his grandmother Delores Churchill Gawa Git'ans, has provided him with the technical skills, knowledge and confidence to push beyond the constraints of tradition imposed from within and without. In his words, "My training in Northwest Coast carving techniques has amplified my sensitivity toward power structures, both external and internal. From this training and experience grew a desire to transform the conservative tradition from within".[20]

THE MEANING OF WATER

Rather than using the Haida language or carving in wood, Yahgulanaas has honed in on the comic idiom, as medium and message, to exploit and undermine the prescriptive 'principles' of formline analysis. Watercolour, acrylic and ink on canvas or paper have become alternative media for deconstructing and critiquing historical typecasts and forms. In reflecting on his own practice, Yahgulanaas has likened "the study of Haida design" to "the study of water".[21] Growing up on an archipelago surrounded and traversed by waterways, it is perhaps not surprising that water figures prominently in Yahgulanaas' oeuvre and his conceptualization of his practice. His studies and paintings are ripe with imagery of water in motion; seas and underwater realms are dancing with boats, fishing trawlers and canoes and teeming with supernatural and eccentric marine life forms. In observing the movement of water, Yahgulanaas describes the tension that is tangible as it moves into different spaces:[22]

> I watched the water between the rocks at the most southern end of Haida Gwaii; it was a bright sunny day over the Pacific. The light contained in the narrow passageway between two high cliffs was so bright I could barely look through this doorway ... Hidden below in the shadows were sea lions braying, roaring, guarding these two stone gates. I looked straight down into the deep water that arched through the passage, swelling in the middle like a muscle, tense with anxiety to get through to the other side. It was so compressed ... I see that same tension in Haida design where space is either obviously filled or seemingly empty, compression seeking expansion.[23]

It is these tensive qualities of water that Yahgulanaas sees or rather feels in the flowing formlines he creates. Moreover, he explicitly rejects the idea of the formline as the primary and continuous compositional force. Rather he describes the bold calligraphic lines that define his Haida manga compositions as "framelines", echoing comic strip terminology. In his case, the frameline is conceptualized as a wave that swells, breaks, rolls and ripples across the surface of the paper or other material. In moving and unfurling, it creates a series of non-linear, asymmetrical spaces, bodies or "chambers" in which visual effects, images and narrative vignettes— rather than Holm's abstract "secondary complexes and isolated tertiary elements"—can unfold. But the flowing frameline does not necessarily dominate and contain the image content. It provides another

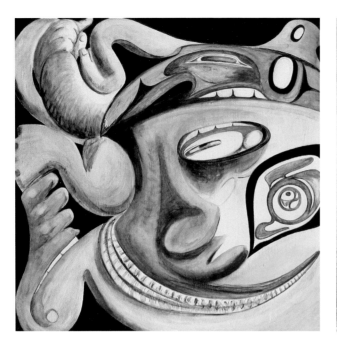

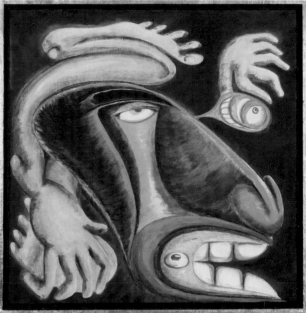

left *Speak*, 2009

right *Strands*, 2009

liquid space where images can emerge, intervene and offer another perspective on the whole.

In the series of acrylics on wood, *Reflecting on (R)ed*, 2009, *Strands*, 2009, and *Speak*, 2009, there are multiple references to water, marine life and the ocean deep. In *Speak*, for instance, in the entangled and layered images of twisted limbs, eyes, speech bubbles and mouths, a "salmon trout's head"—one of the primary forms dissected and illustrated by Holm—appears, like a surrealist cap. In contrast, *Strands*, which is another "study of flesh form", is in the words of the artist: "positioned in a submarine world. Like a Nautilus swimming in the depths ... In the crushing weight of darkness it exists as a ... being familiar yet strange. Here we are only a strand of color and sentience".[24] *Reflecting on (R)ed* offers a more explicit vista of the movement of water and the interrelations between humans, supernatural beings and the sea. Yahgulanaas describes the polysemantic imagery:

> Red is the principal character. His body lies below. His head, against a yellowed atmosphere, looks east towards a maple leaf, hidden in the post-and-beam framework of a classic Haida building. The black frameline is an arch of horizon, separating water above and water below. The vast blue hill rises in the reddened sky and in the black sea below, a colourful sail. One-in-the-Sea and his aide de camp (with the fin rising out of his head) are crouching on the right-hand side. Red's hand that rises out of the waves forms a ship with a figure in the shrouds. The figure is a reference to argillite sailor carvings ... The curve of an inner elbow becomes a strange creature in flight. Flecks of foam break off the waters and pattern up like ship sails.[25]

The analogy between frameline and water is given most literal expression in Yahgulanaas' sequence of ink drawings *The Wave*, 2014. One page from *The Wave* offers us an unprecedented insight into Yahgulanaas' thinking about his Haida manga practice and its playful proclivities. He has confessed that this is one of his most self-reflexive works, in which he explores through comic imagery how he creates works. There are two

caricatured self-portraits of the artist on the page: one looking up and the other looking down. A frame- or formline thought bubble at the top of the page introduces an unfinished line of thought: "The ink of an idea fills the empty chamber and is focused and directed by ...". In another chamber, which is spatially disconnected from the first thought bubble, the line of thought is completed: "... this", which refers to the ink brush held by a hand from below, which one assumes belongs to the artist, pictured in the bottom right-hand corner, a face without a body, peering upward. The largest chamber contains a realistic impression of Yahgulanaas' studio.

A MEMORY OF DROWNING

We can observe the force and movement of water, line and colour clearly at work in the quadriptych *Remember*, 2008. Executed in acrylic on canvas, *Remember* was commissioned by *Geist*, a Canadian magazine of ideas and culture, for an issue on hybridity and memory. Each of the four panels incorporates two letters of the title: re-me-mb-er. Their fluid, calligraphic and abstracted forms echo the frameline structures associated with Indigenous Northwest Coast art, but their interior spaces do not contain abstract design elements. Rather they are the pockets in and around which action unfolds. We see comic characters tumbling through space, ghostly landscapes and struggling figures, compressed and contorted between the lines. Above and below these open pockets, there is movement: water breaks and swells, the raven flies, surreal humanoid forms clamber and cumulus clouds float by.

 Complementing the vitality of line and form are the bright planes of colour, which strikingly depart from the restricted palette defined by Holm but parallel the primary colours of Lichtenstein's Pop Art. As the curator and art historian Ian Thom notes, "The colours—vivid yellows, reds and blues against a white background—are bold and expressive, with a vibrancy and life which suggests the transparency of watercolour and an acute sensitivity to the power of light".[26] The flatness of the colour blocks, such as the yellow sky and the stylized formation of the clouds and the crests of the waves may remind us of Japanese woodblock prints that we know inspired the artist as a child. This is a meaningful observation. The subject of the work as a whole is memory, how memory intersects in our individual everyday lives and collective understandings of the past and what we see and create in the present. In the case of *Remember*, as Thom explains, the work is an idiosyncratic exploration of the work of memory undertaken by the artist: "The four panels might be described as a stream-of-consciousness riff on Yahgulanaas' personal history and the Haida mythic world".[27]

 In his detailed interpretation of *Remember*, Yahgulanaas' words capture the way in which the memory of things past and present is conjured by an associative, non-linear way of thinking that draws on sensory experiences, visual images and subconscious elements.[28] The first panel, he recalls, was inspired by the memory of his grandmother Selina Peratrovich Adams Gitans, who was "a mighty strong woman" who "wore high heels in the woods. She was so strong that special paddles had to be made for her; the ordinary paddles would break under the force of her powerful stroke".[29] The second panel was stimulated by a childhood memory of daydreaming while watching dust motes descend through shafts of sunlight. Four decades on, he can still vividly recall his vision of the stern-faced woman and "the last ascending bubbles of a descending man".[30] This is a personal

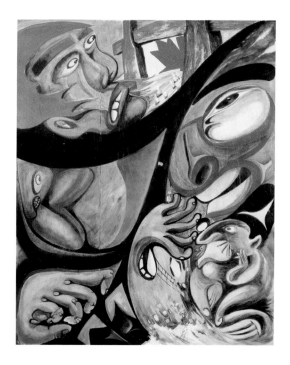

top *Reflecting on (R)ed*, 2009

bottom *The Wave*, 2014

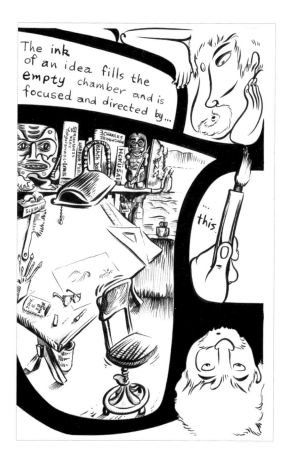

 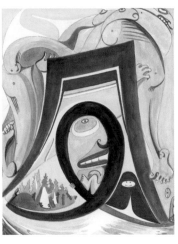

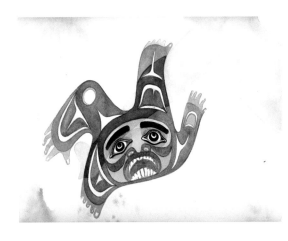

top *Remember*, 2008

above *Overhead*, 2006

opposite top *Orange (Lightning Bolt)*, 2010

opposite middle *West Nile*, 2010

opposite bottom *Ancestress*, 2010

reference to the plight of the Haida. Yahgulanaas elucidates, "with the person falling into the water ... I started integrating bits of community history, the relationship between colonial society and Indigenous peoples, and the horrific elements of that relationship".[31] In the third panel, we witness the descending man thrashing around in the water. His contorted form struggles in the waves of Yahgulanaas' imagination: "I suppose that as he was drifting about, he wondered if his gods no longer loved him. But they hadn't left him entirely. One of them was chewing on his ankle and the other one flew low and slowly away from his wrinkling skin".[32] Elsewhere, Yahgulanaas describes how this third panel draws on a collective memory of traumatic events, rather than his first-hand personal experiences: "I think of people who have endured famine or concentration camps or residential schools or any horrifying moment when we think we've been abandoned by our gods, where there is no hope, there is nothing, no refuge. The end. In some respects, that moment occurs in drowning".[33] In the final panel hope returns: the central character is reborn "between his mother's thighs".[34]

From reading these excerpts, it is clear that *Remember* is an intimately personal and allegorical work. It speaks to the importance of memory in the recovery and constitution of the self and by extension Haida culture. It metaphorically depicts the struggles and sense of loss as well as the resilience and survival of individuals and their subjective and collective memories. Tellingly, Yahgulanaas says of the work, "I want to find a way to see memory not as a distance but as a post-it note ... a reminder to recover those distant elements".[35] As a work of art, it invites us to dwell awhile on the intricacies and meaning of memory, as we try to decipher and make sense of the symbolism and imagery: the entangled letters and comic characters, the bold lines and distorted forms, the twisted limbs and ghostly landscapes. It opens itself up as a comic medium, a symbolic landscape, and we are encouraged to connect or fill in the narrative gaps with our own thoughts, memories and understandings.

THE VISUAL PLANE

While Yahgulanaas clearly draws inspiration and ideas from his Haida cultural heritage, the content of his compositions is not restricted to the Indigenous local but incorporates other familiars, influences and places. These elements that pulse through his art practice connect to

his life-world and experiences from childhood to the present day. He is an avid traveller and since 1995 has spent periods of time in Europe, Asia, Africa and the Americas with a focus in Central Asia and the South Pacific. While serving as a board member for various organizations he has looked to promote awareness of the importance of bio- and cultural diversity and the rights of Indigenous peoples over their waters and lands and heritage. These experiences and connections with other peoples, cultures and places are indexed in his art. They are not only represented in the subject of his compositions like the *Altiplano* series but also in the tools and media he uses. For example, when in Asia he buys handmade paper, folding books and brush pens. From North Africa, he acquired some intensely coloured pigments, which after sending them to a laboratory for toxicity testing, he used to create works like *Ancestress,* 2010, and *Orange (Lightning Bolt)*, 2010. But Yahgulanaas is not a purist when it comes to experimenting with these media. He has combined, for instance, his African pigments with Haida pigments taken from a cave on SG̱ang Gwaay (Skungwaii). Intermixing imagery and media from other places enables him to push his practice in a different direction beyond the traditional subjects, techniques and forms of Haida art. The watercolour *Overhead*, 2006, for example, captures Yahgulanaas' response to news of the war in Iraq: isolated in a hot desert landscape, the central figure stares upward, presumably at the war planes overhead, with a look of utter horror.

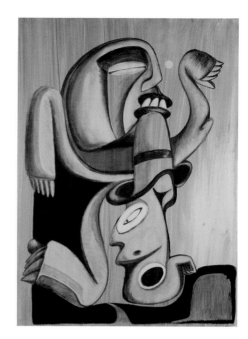

Although intercultural mixing and experimentation inform Yahgulanaas' visual practice, he nevertheless links these elements back to his understanding of Haida culture:

> I like to adhere to one of the basic Haida tenets or traditions if you must, the tradition of innovation. All material culture, and I suppose intellectual culture is constantly adapting to changes of circumstance. Culture is alive, responsive, engaged and changing. Because I reject the idea of a singular cultural dominance or exclusivity, my work creates places for people to discover an emotional connection with other people, even when they feel those people are strange, distant and even alien.[36]

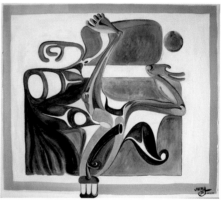

In reflecting on the different sources of inspiration that coalesce in Haida manga, Yahgulanaas frequently speaks of his "emotional connection" with Japan, which is steeped in romantic and traumatic memories:

> In historical times Japan was a refuge for Haida. In my own family we have stories of people working on ships, fur sealing ships, and actually abandoning ship and paddling off to Hokkaidō to become integrated into Japanese society ...[37]
>
> Haida men in Japan were treated like full people, like human beings. They could walk the streets freely and no surprise they loved Japan. Meanwhile, here, there were things like Indian toilets, restrictions of theatre seating, certain cafes that we could and could not eat in. We were not allowed to vote, not allowed to own land, not allowed to visit relatives, hire lawyers or be citizens. Yet we were told we were Canadians, while anything we valued was assaulted ... When I grew up and heard about this Japan I became interested in this place of refuge.[38]

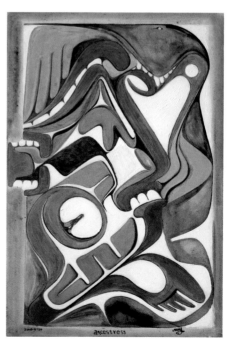

These memories of the past reveal the way in which Japan captured Yahgulanaas' imagination as a child. They also shed light on a

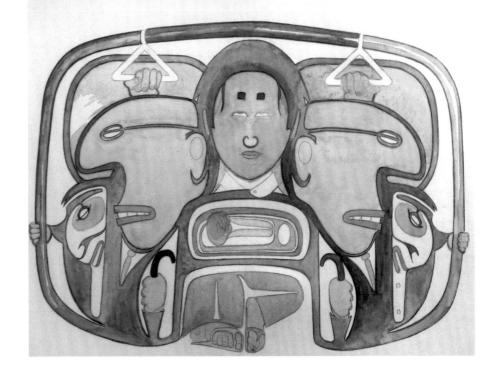

dark past. His recollections, in first person, describe the system of apartheid, disenfranchisement and oppression that continues to affect and traumatize Indigenous peoples in Canada and elsewhere. It is also important to recognize that Japan has a recent history of colonialism, with oppressive rules and regimes of violence inflicted on the Indigenous Ainu peoples of Hokkaidō as well as on the inhabitants of its former overseas colonies such as Korea and Taiwan.[39] Yahgulanaas' first-hand experience of the colonial structures and systems operationalized in Canada to contain and control Indigenous peoples may help us to understand more fully why he purposefully sought to subvert the Euro–North American comic aesthetic: it represented another space of colonization in which Haida cultural expressions would be subsumed, assimilated and acculturated. In contrast, the visual culture of the Pacific Rim offered an alternative, non-aligned arena for mischief making and artistic play.

FLOATING WORLDS

Yahgulanaas' elective affinity with Japan and its visual culture is embodied in his commission *Finding Space,* 2014, a Haida–Ukiyo-e. This coloured woodblock print speaks to the intercultural merging of different cultures, technologies and places. The image depicts the interior scene of a Japanese Metro train. It has a notable symmetry, echoing the aesthetics of a butterfly, which is one of the crest symbols of Haida culture, representing "the messenger of the departed souls".[40] The young girl pictured in the centre of the scene is, according to Yahgulanaas, shown in semi-traditional attire, relaxed and at ease with herself. In contrast, the older suited businessmen who flank her, creating the symmetry of form and depth to the visual field, look grey and ill-at-ease or uncomfortable. *Finding Space* can be understood as a visual metaphor that speaks to the intersections and frictions between tradition and modernity and spiritualism and capitalism that are expressed in the material culture and social practices of everyday life. The artwork was commissioned for an international exhibition Homage to Ukiyo-e that in concept and

content focuses on these concerns, the interplay between traditional and contemporary practices. With the curatorial theme of the "Avant-Garde", the exhibition not only represents the idea of paying homage to ukiyo-e (literally "pictures of the floating world") as a historical practice but also seeks to bolster its continuance in the present.[41]

The backstory of *Finding Space,* a Haida-Ukiyo-e, gives an insight into Yahgulanaas' artistic process and in particular into his intellectual exploration and understanding of the development of ukiyo-e as a historical form and practice. Before he set about creating his own work, he spent time looking at the literature and seeking to understand the social role this art form played in Japan, in the past and the present. Flourishing in the Edo or Tokugawa Period (1603–1868), ukiyo-e woodblock printing came into being with the advent of new reproduction technologies. Produced en masse, ukiyo-e signalled the democratization of art: its movement out of the private domains of learned and wealthy citizens into the broader public sphere. Its multi-coloured imagery was oriented to contemporary matters and popular culture, forms of entertainment and everyday social activities that appealed to the Japanese public at large. From the outset, ukiyo-e artists were required to innovate and think about how to pare down the production process, in particular the number of wood blocks needed to complete a print. This 'reductive' and widely circulated art form not only captivated the Japanese public but went on to enthrall and influence artists and audiences in other parts of the world, including an eleven-year-old boy, Yahgulanaas, living on Haida Gwaii in the 1960s.

It is well documented that ukiyo-e prints inspired the French Impressionists as well as other nineteenth-century Western artists. They were drawn to what has been termed the "Japonisme" aesthetic of the prints: their imaginative compositions, which are marked by a lack of perspective, depth and shadow; fine lines and textured forms and flat areas of strong colour. It has been argued that it was ukiyo-e that lured "their art towards the threshold of Modernism".[42] More recently, the social import and aesthetics of ukiyo-e have been linked to contemporary visual culture. Scholars, cultural critics and artists have argued that the idea of flatness, as a distinctive attribute of Japanese visual culture, can be traced from woodblock printing through manga to anime.[43] Its most recent and extreme iteration is found in the contemporary Japanese art movement Superflat. Originated by the visual artist and curator Takashi Murakami, Superflat refers to the flattened aesthetic of different forms of Japanese art: traditional, modern and contemporary. More poignantly, Superflat is articulated as a biting critique of the superficiality or "shallow emptiness of Japanese consumer culture".[44] In his manifesto Murakami explicitly locates Superflat in relation to the visual culture of the Edo period and particularly ukiyo-e prints. We see this connection exploited and peppered with irony, in the work of Superflat artists such as Chiho Aoshima, Yoshitomo Nara and Aya Takano. Yahgulanaas intellectually appreciates the work of these artists, and he also admires Masami Teraoka's ukiyo-e–inspired satirical watercolours and woodblock prints that critique the global food economy and especially the 'invasion' of North American fast-food culture in Japan.

We can discern the 'constraints' or characteristics of design associated with ukiyo-e and Superflat—the stylization, fine lines, flatness and colour—in the *Finding Space* print as well as in a significant number of Yahgulanaas' other works including the series, *Flesh Tones,* 2008–2014, and *Water,* 2002. In *Water,* which was inspired by a gold bracelet carved by Charles Edenshaw, there is a distinct flatness to

Adachi Institute of Woodcut Prints, Tokyo, making Yahgulanaas' Haida–Ukiyo-e print *Finding Space,* 2014

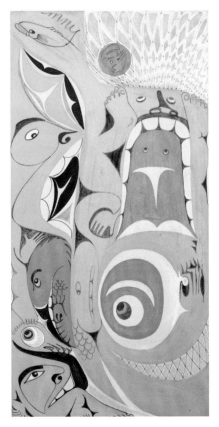

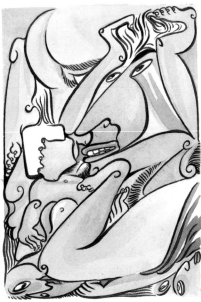

the fields of colour, as noted in *Remember*.[45] But the Haida-inflected internal design elements, the embedded life forms and the cellular watery turquoise diamond-pattern, in *Water*, add a sense of depth and vitality as well as a texture, reminiscent of the textile patterns found on kimonos in ukiyo-e prints.

Although *Finding Space* began life as a one-off, unique watercolour like *Water*, its transformation into an ukiyo-e print proper and serial-production involved collaboration with Japanese woodcarvers and printers from the Adachi Institute of Woodcut Prints in Tokyo. An interesting comparison can be drawn with Lichtenstein, who is known to have explored East Asian art in and through his practice, drawing on, for example, Hokusai's great wave for his *Drowning Girl*, 1963. The American artist also collaborated with two master craftsmen, a woodcut carver and printer from Japan, to produce his series *Seven Woodcut Apple*, 1983.[46] Like Yahgulanaas' *Finding Space* and Teraoka's invading Japan series, Lichtenstein's prints were made using traditional ukiyo-e techniques and media. They were hand-carved from blocks of cherrywood and printed on *washi* handmade Japanese paper. Whereas Yahgulanaas' original and prints exploit the subtle and delicate palette of the natural dyes and rely on blocks of colour for effect, in his apples series, Lichtenstein used his trademark primary colours and broke the colour field apart by amplifying the brush strokes, creating striated and stylized outlines and in-fills, almost abstract forms.[47] Even though the Adachi Institute is dedicated to using traditional techniques and materials, it strives to ensure that ukiyo-e remains meaningful in the present. While it continues to reproduce old masterpieces by artists like Hokusai or Utagawa Kunisada (1786–1865), it also seeks to work with contemporary artists like Yahgulanaas to broaden ukiyo-e's repertoire and relevancy in the increasingly "flattened" and globalized world of the twenty-first century.[48] From this perspective, ukiyo-e and by extension *Haida-Ukiyo-e* remain true to their founding principles, as democratizing art forms that speak to everyday practices and contemporary culture.

DECONSTRUCT THE BOX

The idea of democratizing art or more specifically deconstructing "the box"—the cultural artefact or institution—and filling its empty

top left *Water*, 2002

top right Utagawa Kunisada, *Hitori musume ni muko hachinin* (Eight Bridegrooms for One Daughter), ca. 1847–1851

bottom *Flesh Tones*, 2014

chambers with alternative, comic and unexpected things is illustrated par excellence by Yahgulanaas' kinetic installation *Bone Box,* 2007, which is located at the UBC Museum of Anthropology, Vancouver. In this particular work, Yahgulanaas invites us to actively participate in the act of deconstruction, in dislocating forms and images to create different ways of seeing and experiencing space and place, artefacts and history, museums and meaning.

Commissioned for the exhibition Meddling in the Museum: Michael Nicoll Yahgulanaas curated by Karen Duffek, *Bone Box* is a large-scale site-specific artwork. In its resting position, it is said to resemble "the front of the carved chests [the Haida bentwood boxes] displayed on surrounding platforms—the elaborate containers used by chiefs to store their treasures".[49] But it is not a box. It is a louvered facade of twelve panels or plywood trays, which functions as a screen or dividing wall, demarcating the border of the museum's Great Hall, which is devoted to Indigenous Northwest Coast art.

The title of the artwork, like those of Yahgulanaas' other works, has multiple playful and punning references. In this case, *Bone Box* references both the material origins and metaphorical operations of the installation. The plywood trays were originally used for storing archaeological specimens (not human remains) in the Laboratory of Archaeology. During the museum's extensive refurbishment, the storage trays were dismantled and thrown away. When Yahgulanaas was exploring behind the scenes—mining or meddling in the museum for ideas and materials for his three site-specific interventions—he came across these discarded remains in a skip. He 'salvaged' the trays and repurposed them to create *Bone Box,* a low-technology interactive artwork, which is painted on one side with a site-inspired Haida manga. At a number of levels, Yahgulanaas' meddling resonates with the site-specific works of the installation artist Fred Wilson, such as his classic *Mining the Museum,* 1992, Baltimore, or his more recent institutional critique *Site Unseen: Dwellings of the Demons,* 2004, Gothenburg.[50] More specifically, Wilson's practice is marked by the 'fieldwork' he undertakes in the host museum. He 'mines' its stored collections, digging out forgotten objects that speak of repressed histories, especially those of African American peoples. Through visual and textual exhibition strategies of inversion and juxtaposition, heavily laced with irony, Wilson displays these artefacts and allows previously silenced voices to emerge, while simultaneously offering a damning critique of museum politics and practices.

There is certainly an ironic twist to Yahgulanaas' rescuing of archaeology's 'material culture', its storage trays. From the late nineteenth to the mid-twentieth century, the entangled disciplines of anthropology and archaeology were driven by a salvage mentality. Their research, fieldwork and collecting activities were grounded in what has been termed "salvage anthropology", which James Clifford eloquently describes as "the desire to rescue something 'authentic' out of destructive historical changes".[51] Believing that Indigenous cultures, their objects and cultural practices would disappear because of cultural contact, colonization and assimilation, anthropologists, archaeologists, museums and other agencies desperately sought to 'rescue' what they identified as the remnants of 'dying' cultures. The Haida were certainly not immune to these acquisitive, racially inflected and destructive colonial discourses and practices. One category of objects patently marked for rescue and preservation was the totem pole. At the UBC

top Masami Teraoka, *McDonald's Hamburgers Invading Japan/Tattooed Woman and Geisha III,* 2018

bottom Masami Teraoka, *31 Flavors Invading Japan/Today's Special,* 1980–1982

Michael Nicoll Yahgulanaas
playing with *Bone Box*

Museum of Anthropology, the monumental aged and weathered Haida poles on display in the Great Hall were primarily acquired during the legendary 'salvaging' expeditions of the late 1940s and 1950s, in which Bill Reid played a prominent role.[52] Coordinated by Canadian anthropologists, these salvaging enterprises were explicitly directed at obtaining "the last remaining massive carvings", totem poles and architectural structures from individuals, families and communities.[53] It is these remnants that *Bone Box* invites us to reframe and to reflect on the past in the present, the politics of acquisition, cultural heritage and land that scar Indigenous-settler sites and relations.

Installed in the framed space between the corridor axis and the Great Hall, the twelve panels are connected to a series of three copper cranks. When the visitor turns a crank clockwise by 90 degrees, the louvered panels rotate, creating a series of horizontal openings or windows. These openings enable the viewer to look through the Haida manga artwork, across the surface of the acrylic graphics, to the age-worn and weathered Haida carvings on display in the museum's ceremonial Great Hall. The line of sight extends through the Great Hall's iconic glass curtain to the Haida-inflected backdrop that includes an ethno-botanical landscape and reflecting pool and a Haida House complex with totem poles, and out to the Pacific Ocean and the horizon beyond. In terms of middleground, the viewing frames capture the displays of Haida carved and painted wooden forms, including cedar bentwood boxes, the mythological *Wasgo* (7waasru), 1962, by Bill Reid and the monumental, dissected and whole bodies of the salvaged totem poles. In the foreground, when the *Bone Box* panels lie flat on a horizontal plane, a message is revealed (one word is stencilled on the edge of each tray):

A STACK OF PLYWOOD
TRAYS BUILT TO CONTAIN
FRAGMENTS OF EVERYONE'S CULTURE

Viewing culture or cultural heritage through this three-dimensional lens, with this twelve-word philosophical caption occupying the foreground, invites the viewer to become an active participant, rather than a passive viewer, and to reconfigure space and meaning. In the exhibition text, Yahgulanaas expands, "this is a very public venue ... When you flip the work you affect how other people see it. It's like taking ownership of the issue of representing other people. You must be engaged; you are engaged. It's not 'them,' it's 'us'".[54] Again this is Yahgulanaas at play, encouraging us to engage and think about our implication in the material world. We are not separated by ethnicity into concrete categories of objects but share a common history. This is a complex intercultural narrative marked by the politics of 'discovery', exploration, exploitation, acquisition and exchange. It is this entangled intercultural history that is referenced in an idiosyncratic fashion on the plywood skin of *Bone Box*.

Loosely echoing the late-sixteenth- and seventeenth-century Japanese *namban* screens that depict the arrival of Portuguese explorers, *Bone Box* offers an alternative visual take on a history of cultural encounters. Whereas the centuries-old black lacquered and gold-leafed folding screens, which reveal the Japanese fascination with the curious features and material culture of the namban (the Southern Barbarians),[55] absorb the exotic into a familiar knowable form, Yahgulanaas' Haida manga screen works in reverse. In many ways, *Bone Box* turns the familiar into the exotic. But it is also wont

to turn the exotic into the familiar too. This concept of augmenting perception and understanding through a constant interplay or oscillation between the poles of the familiar and the strange is often viewed as a hallmark of anthropology. Anthropology as a self-reflexive discipline was predicated on what has been described as a "reciprocal reversal of perspective: by seeing the exotic in the light of what is familiar, and by seeing the familiar as, *per contra*, exotic or strange".[56]

A REVERSAL OF PERSPECTIVE

Like the sculptural works of the Constructivists, the kinetic qualities of *Bone Box* offer a different perspective on space, the solidity of material forms and movement. It is insightful to know that Yahgulanaas is inspired by the Constructivist works of Vladimir Tatlin, especially if we recall *Abundance Fenced* and its use of metal and mesh, and he is similarly intrigued by the monumental sculptures of Barbara Hepworth, with their pierced and tautly strung ovoid forms. Whereas the movement of *Bone Box* in a Constructivist fashion reconfigures the architectural space, offering alternative views of the surrounds, objects and matter, its Haida manga imagery encourages a different way of seeing the locale—the landscape, human intervention and memories of the past and present. Notably there is no text to interpret the painted imagery. Indeed there is no clear narrative path or linear sequence to the image-rich panels or chambers. We are encouraged to construct our own narratives or understandings, relying on context and visual cues. Of course, uniting and interweaving the expressive elements are the bold curvilinear framelines, echoing those found on the bentwood boxes and artefacts viewed through its open frame. On *Bone Box* we see the frameline rolling across the plywood surface to create and envelop mythic and personified landscapes, filled with strange or absurd scenes. These are replete with caricatured, surreal and stylized human and animal forms, sacred and profane entities, including warriors and ravens, a bear and ghosts, raven hawks and a suited man being pulled through time and space. The small humanoid figures with black-domed heads, depicted exiting and entering the water, are said to be representations of the first men. Suffusing the pictorial frame are images of ghosts, x-ray abstractions of skulls and the bones of the dead. There are, for example, the symmetrical compositions of what Yahgulanaas describes as "human bones vs the corporate structure and hierarchy" depicted on the corner panels at the bottom of the screen. Then there is the frontal view of the face, which extends across the central panels, shown flossing its teeth or "Keeping the Bone Clean".[57]

In the lower third of *Bone Box*, the personified landscapes of the two central panels anchor the artwork to the locality. The panel on the right depicts the North Shore mountains that dominate the Vancouver skyline and can be seen from the museum. In particular, the two immense peaks, the Two Sisters, are shown in stately repose with snow-white hair, presiding over the geometric high-rise buildings that define downtown Vancouver. The name Two Sisters refers to an Indigenous oral history about the creation and naming of local topographical features. The story tells of the long-standing conflict between the Coast Salish and Haida peoples, which was resolved when two Salish sisters intervened and persuaded the two warring factions to make peace. In recognition of their roles, they were immortalized, transformed into two mountains: the Two Sisters. In

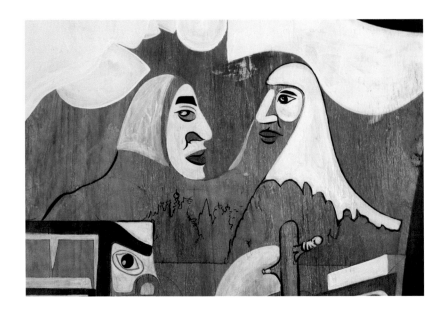

above Two Sisters, *Bone Box*, 2007 (detail)

opposite top *Sea Cliff*, 2007

opposite middle *Cliff*, 2007

opposite bottom *Poke*, 2007

the late nineteenth century, these mountains were renamed the Lions after Landseer's lions in Trafalgar Square. This colonial reinscription has since been stabilized through the naming of other prominent local features after the Lions, for example, Lions Bay, Lions Gate Bridge, and the BC Lions Football Club.

The success of this colonial strategy of renaming is apparent in early-twentieth-century literature. In *Legends of Vancouver*, 1913, E Pauline Johnson (Tekahionwake), a Canadian writer of Mohawk and British ancestry, registers the potency of 'official' mapping practices to suppress Indigenous histories. In transcribing the Squamish version of the Two Sisters, which had been told to her by Chief Joe Capilano, Johnson opines, "You can see them as you look towards the north and the west ... Twin mountains they are, lifting their peaks above the fairest city in all Canada, and known throughout the British Empire as 'The Lions of Vancouver.'"[58] However, she continues, "The Indian tribes do not know these peaks as 'The Lions' but as the Two Sisters".[59] This assertion retains a certain degree of validity. The name and the narrative of the Two Sisters maintain their currency among certain Indigenous groups on the Northwest Coast, including the Coast Salish and Haida.[60] It is noteworthy that in a number of his publications, Yahgulanaas describes himself as an artist living "on an island in the Salish Sea, in the shadow of the Two Sisters".[61] In reflecting on his location and relation to the narrative of the Two Sisters, he muses, "This story anchors me to this new landscape ... Not in as robust a sense of connection and duty as in Haida Gwaii, but being here is not casual. It's an awareness of obligation to the place and the people".[62]

This sense of obligation to acknowledge the land and the local First Nations is captured in Cliff. Pictured on *Bone Box*, in the upper third, second panel on the right, scratching his tree-topped head, Cliff is said to personify the peninsula on which the museum is sited. Before being transformed into a university campus and long before the construction of the museum, this area was used as a lookout point for thousands of years by the ancestors of the hən̓q̓əmin̓əm̓-speaking Musqueam peoples. In the context of *Bone Box,* Cliff is said to represent "the ever-shifting interplay between the [settler] institution and the Musqueam people who lay claim to the territory".[63] He is caught in the frame, looking over his shoulder as other nations arrive by ship.

Cliff appears in different guises in a number of sketches, studies and watercolours that Yahgulanaas created while working on *Bone Box*, including *Cliff and Iona*, 2007, *Poke*, 2007, *Cliff*, 2007, and *Sea Cliff*, 2007. These 'character studies' seem to mark a transition in Yahgulanaas' art practice, as Haida manga further develops its distinctive expression and moves away from its dependence on an accompanying textual narrative. In effect, Haida manga representational forms break free from the 'tyranny' of the text to become purely visual open signifiers. Their meanings and narrative lines are not prescribed. Rather viewers are encouraged to formulate their own interpretations through looking at the different forms' symbols and expressions and drawing on the context and their subjective experiences and memories. In describing the watercolour *Cliff*, Yahgulanaas touches on this moment of transition:

> Somewhat of a caricature, *Cliff* is my early effort to bridge the more classic use of the Haida visual idiom with populist-based contemporary graphic literature. In this image Cliff, the personification of the landscape, nestles up against another personified, more passive, red and grey landscape form. Notice how Cliff's hand slowly creeps onto the beach, as he gradually extends and makes his landing.[64]

REMAPPING THE LAND

Yahgulanaas' reference to the Two Sisters and his use of formerly contested nomenclature such as the Salish Sea clearly constitute a move to reclaim and remap the land, reinscribing local topographical features and urban aspects with Indigenous expressions, stories and iconographies. Yahgulanaas' remapping of landscape forms through his Haida manga practice is evident in his *Vancouver at Large* series, which includes works such as *English Bay*, 2006, *West Vancouver*, 2007, *Hiroshima in Kitsilano*, 2007, and *Residential*, 2011. In *West Vancouver*, for instance, we are given another view of the Two Sisters rising above the residential dwellings of the North Shore that nestle among immense cedars. These structures cling to the shoreline and adjoining waterway, which is spanned by the Lions Gate Bridge. The watery frameline subtly changes colour as it moves to define and encompass different topographical features and forms. In contrast, *Hiroshima in Kitsilano* is a more cartographic reimaging of part of the city— a city that is often controversially envisaged as a young glass-towered metropolis with a shallow history. This acrylic rendition offers a bird's-eye view of Kitsilano, a Vancouver neighbourhood, from 3,700 feet above the south entrance of the Burrard Bridge. The title of the painting takes it name from the small centrally located Seaforth Peace Park where an eternal flame burns in a water-filled bronze cauldron to commemorate the 1945 atomic bombing of Hiroshima.[65] Before being dedicated as a park, this land was part of the Kitsilano Indian Reserve. The Indigenous ghosts of the past are suggestively presenced in the yellow and black geometric spaces and curvilinear framelines. In colour and design, these shapes and forms containing stylized images and echoes of a Raven, a tail feather, peering eyes and teeth bring to mind the geometric cells of the coveted *naaxiin* robes that are abstracted in the ghost bags designed and woven by Lisa Hageman Yahjaanaas (Kuuyas 7waahlal Gidaak or Precious Potlatch Woman), Michael Nicoll Yahgulanaas' youngest sister.

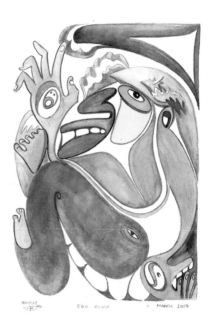

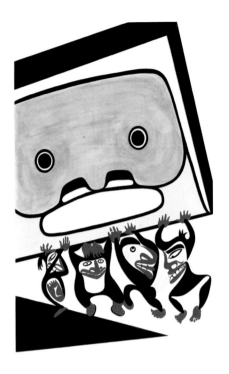

Waa Haa, 2005

The distinctive naaxiin form is rendered in a number of Yahgulanaas' artworks, from watercolours through acrylics to copper shields. A case in point is the watercolour *Waa Haa*, 2005. Included in the exhibition and catalogue, *Carrying on 'Irregardless': Humour in Contemporary Northwest Coast Art*, 2013, *Waa Haa* explicitly communicates the idea of humour and play that lies at the core of the curatorial vision.[66] Peter Morin, one of the co-curators and a Tahltan visual and performance artist, writes that joking practices, humour and play stand "within indigenous knowledge systems, not as a reactionary response to outside influences but as a well-established tradition of making sense".[67] While humour is recognized as a strategy exploited by Indigenous peoples as a mode of survival during dark periods of colonial oppression, as Morin intimates, it is not a product of colonialism. Rather it is an Indigenous way of being in the world that predates Western contact. It is equally, I propose, part of the universal human predisposition to play.

Humour upsets and inverts the normalized rules and social expectations that govern our behaviours and actions. For the social anthropologist Victor Turner, these moments when unwritten rules are broken—social categories and hierarchies inverted, traditions challenged and future outcomes left uncertain—represent examples of what he terms "anti-structure".[68] Anti-structural events and actions can inculcate a sense of collective unity that cuts across social divides, including those of ethnicity, indigeneity and gender, for example. We see this trans-cultural border crossing at play in *Waa Haa*, which is an exemplary, if somewhat literal, manifestation of rude humour and play. At a superficial level, it brings to mind Chiho Aoshima's Superflat artwork *The Divine Gas*, 2006. In his inimitable storytelling style, Yahgulanaas describes the iconography and meaning of the comic narrative:

> *Waa Haa*: A [Haida] Massett saying expressing mild disgruntlement towards another person's action. The large head is inspired by *naaxiin* (Chilkat) image. It is a "ghost" figure and is hoisted up on the arms of four Massett lads walking along an edge. Obviously this large, weighty and significant burden is shifting precariously to the right and appears to be in danger of collapsing. The ghost face is depicted rather faithfully to the *naaxiin* style and seems to convey an appropriate emotional response to its impending disgrace. The cause of the struggling porters is that one lad has passed the sacred gas, and his fart has caused a fellow porter to push his share off balance threatening the entire performance. Oh! That such precious icons should fall to the daily needs of our bodily errors![69]

A similar composition appears on *Bone Box*, on the tray that is juxtaposed to the left of the Two Sisters panel. In this case, we see three characters holding up a ghost and trying to climb the golden mountain. In Yahgulanaas' words, the image conveys the "idea of what is important, that which we value—the past, that which is dead".[70] This is a fitting visual metaphor for museums in which the past is privileged, mapped out and preserved. The image of the golden mountain is another encoded reference to the mapping of the region in the nineteenth century. In their maps of North America, the Chinese named and labelled British Columbia Gumshan or Gold Mountain. The name, which is still in use, is derived from the discovery of gold in the Fraser Valley, British Columbia, in the 1850s,

which precipitated a mass influx of Chinese migrants, prospectors whose presence has shaped the "multicultural mosaic" of present-day Canada. For Yahgulanaas these juxtapositions open up the "discourse on differences between Asian and Western concepts of exploration and conquest".[71] This alternative history of exploration prompted the historical geographer Howard Stewart to suggest that it is time to consider renaming British Columbia: "If British Honduras and British Guiana and British Somaliland have all managed to find new names in this postcolonial era, it kind of begs the question about why we still have ours".[72] One alternative Stewart proposes is Gold Mountain for British Columbia to reflect its non-British immigrant groups. Again, this is a nineteenth-century inscription. Although it eschews the Western colonial power to name, it continues to suppress the First Nations' history of belonging and title to land. More recently, Indigenous activists and artists like Lawrence Paul Yuxweluptun and Michelle Nahanee have activated the debate to rename BC.

FLAGS AND CRESTS

These entwined intercultural histories, marked on maps, sit side-by-side on *Bone Box* and invite us to reflect on the construction of place. Not surprisingly, there are embedded references to the history of colonial and capitalistic intervention and environmental destruction that have shaped the province and fuelled Yahgulanaas' visual practice. In the lower third of the screen, compressed between the representations of the Two Sisters and Gold Mountain and spanning two panels, is the image of 'Richard Cranium'. Deeply split down the middle, Richard Cranium (AKA Dick Head) is a caricature that appears in different locations on *Bone Box*. He is identifiable by his 'corporate' appearance in business dress, jacket and tie. On the left-column middle panel, for example, "a warrior-like figure reaches through the traditional Haida formline and pulls Cranium back into this world".[73] In his central location at the base of *Bone Box*, Cranium's abbreviated jocular name takes on an added signification. The frameline that envelops him is said to represent the penis of the tooth-flossing ancestral being. With a domed head and greedy grimace, Richard Cranium, the "salary man", is pictured standing amidst a red logged landscape. The reference to logging and more generally international investment and resource extraction is more explicitly illustrated on the upper right-hand panel. The scene is dominated by the hulk of a container ship with smoking stacks that is flying the flags of different geo-polities including British Columbia, Canada and Japan. The waterway on which it travels is strewn with floating logs—referencing the immense log booms that are a distinctive part of British Columbia's river landscape. Reaching over the starboard side of the ship with enlarged grasping hands is a caricature of an avaricious industrial magnate. Yahgulanaas describes this image as a "carryover from twenty-five years of activism".[74]

Yet Yahgulanaas' activism is not restricted to this one panel: it is subtly encoded and suffused throughout *Bone Box* and a great many of his painted works. He aims to liberate Haida culture from its anchorage to an imaginary past and relocate it in the messy and mutating intercultural present. There is a continuing commitment to challenge our acculturated understandings of the human condition, to disturb our personal and collective memories of the past and to unsettle our understanding of landscapes, artefacts and visual culture. By deconstructing and rethinking historical forms, from

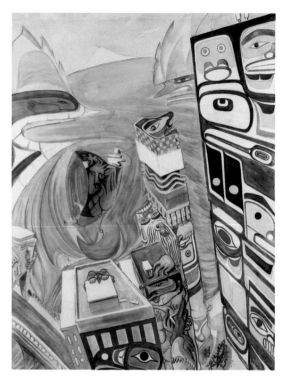

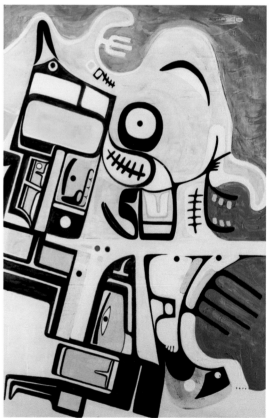

top *English Bay*, 2006

bottom *Hiroshima in Kitsilano*, 2007

Haida boxes to ukiyo-e prints, Yahgulanaas provokes viewers to reflect on the relations between different aesthetics and systems of value and contemplate alternative ways of seeing, representing and knowing the world. He invites viewers to pause and look at the visual imagery from different angles—to see familiar and unfamiliar forms—and generate their own interpretations, meanings, narratives and connections. The artwork is therefore imagined as a formative experience. This brings to mind the deliberations of the philosopher Ernst Cassirer, who insists that art "is neither merely representative nor merely expressive (idiosyncratic/subjective) but symbolic in a new and deeper sense".[75] He opines, "Like all other symbolic forms art is not the mere reproduction of a readymade given reality. It is one of the ways leading to an objective view of things and human life. It is not an imitation, but a discovery of reality ... a continuous process of concretion".[76] This continuous process of finding or making meaning in art, and by extension life, clearly involves the viewers as much as the makers. Perception, memory and imagination are the active ingredients in this process of discovering or seeing other 'realities' or life-stories through visual media, lines, colour and imagery.

1 Yahgulanaas, Michael Nicoll, "RE ME MB ER: The Hybrid Art of Michael Nicoll Yahgulanaas", *GEIST Magazine*, no 70, 2008, p 54.

2 Dunne, Nathan, *Lichtenstein*, London: Tate Publishing, 2012.

3 Nigel Henderson quoted in Stonard, John-Paul, "The 'Bunk' Collages of Eduardo Paolozzi", *Burlington Magazine*, 2008, p 242.

4 Sostar McLellan, Kristine, "Mythic Proportions: A Haida Artist Weaves Cultural Traditions into Something New", *SAD MAG: Stories, Art, and Design*, nos 16/17, 2014, p 38.

5 Townsend-Gault, Charlotte, "Impurity and Danger", *Current Anthropology*, vol 34, no 1, 1993, pp 93–100.

6 Yahgulanaas, "RE ME MB ER: The Hybrid Art of Michael Nicoll Yahgulanaas", p 54.

7 Duffek, Karen, *Meddling in the Museum: Michael Nicoll Yahgulanaas*, Vancouver: UBC Museum of Anthropology, 2007, nn; Levell, Nicola, "Site-Specificity and Dislocation: Michael Nicoll Yahgulanaas and his Meddling", *Journal of Material Culture*, vol 18, no 2, 2013, p 102.

8 Totem poles have been gifted to many nations including Greece, Austria, Mexico, the United States, Australia and Japan. For a detailed historiography of totem poles, see Jonaitis, Aldona, and Aaron Glass, *The Totem Pole: An Intercultural History*, Seattle/Vancouver: University of Washington Press/Douglas and McIntyre, 2010.

9 Yahgulanaas, "RE ME MB ER: The Hybrid Art of Michael Nicoll Yahgulanaas", p 54.

10 Bunn-Marcuse, Kathryn, "Form First, Function Follows: The Use of Formal Analysis in Northwest Coast Art History", *Native Art of the Northwest Coast. A History of Changing Ideas*, Charlotte Townsend-Gault, Jennifer Kramer and Ki-ke-in eds, Vancouver and Toronto: UBC Press, 2013, p 435.

11 Holm, Bill, *Northwest Coast Indian Art: An Analysis of Form*, Seattle: University of Washington Press, 1965, p 20.

12 Holm, *Northwest Coast Indian Art*, p 92.

13 Holm, *Northwest Coast Indian Art*, p 92.

14 MacNair, Peter, "From the Hands of Master Carpenter", *Raven Travelling: Two Centuries of Haida Art*, p 88.

15 Holm, *Northwest Coast Indian Art*, p 37.

16 It was the desire to fracture the increasing lacklustre reproduction of images and rigidity of formline compositions, especially prominent in serigraphs that inspired the Image Recovery Project. See McLennan, Bill, and Karen Duffek, *The Transforming Image: Painted Arts of Northwest Coast First Nations*, Vancouver/Seattle: UBC Press/University of Washington Press, 2000.

17 Holm, *Northwest Coast Indian Art*, p 14.

18 Edenshaw, Gwaai, "Biography", accessed 17 August 2021, https://gwaai.com/bio/.

19 Gwaai Edenshaw, personal communication, 31 May 2015.

20 Donald Varnell, Artist Statement and personal communication, 22 May 2015.

21 Tanaka, Yusuke, "A Haida Artist's Tale Told in Manga Form: Something Wonderful Happened Historically Between Haida and Japan", *Nikkei Voice*, no 11, 2011, p 11.

22 Notably Yahgulanaas' description resonates with the adjectives Holm used to describe the characteristics of the primary formline.

23 Augaitis, Daina, "The Impulse to Create: Daina Augaitis in Conversations with Robert Davidson, Michael Nicoll Yahgulanaas, and Don Yeomans", *Raven Travelling: Two Centuries of Haida Art*, Peter McNair, Daina Augaitis, Marianna Jones, and Nika Collison eds, Vancouver: Vancouver Art Gallery; Vancouver/Toronto: Douglas and McIntyre; Seattle: Washington University Press, 2006, p 156.

24 Strands, 2009, description, Michael Nicoll Yahgulanaas archives.

25 *Reflecting on (R)ed*, 2009, description, Michael Nicoll Yahgulanaas archives.

26 Thom, Ian, Challenging Traditions: Contemporary First Nations Art of the Northwest Coast, Vancouver/Toronto; Kleinburg, ON, and Seattle: Douglas and McIntyre; McMichael Canadian Art Collection and University of Washington Press, 2009, p 174.

27 Peau, Lee, "Haida Tales in a New Context", *Wingspan*, October 2007, p 36.

28 Yahgulanaas' extended commentary on Remember first appeared in *Geist Magazine*, 2008, and was reworded in Thom's book, Challenging Traditions.

29 Yahgulanaas, "RE ME MB ER: The Hybrid Art of Michael Nicoll Yahgulanaas", p 50.

30 Quoted in Thom, *Challenging Traditions*, p 174.

31 Yahgulanaas, "RE ME MB ER: The Hybrid Art of Michael Nicoll Yahgulanaas", p 56.

32 Yahgulanaas, "RE ME MB ER: The Hybrid Art of Michael Nicoll Yahgulanaas", p 52.

33 Yahgulanaas, "RE ME MB ER: The Hybrid Art of Michael Nicoll Yahgulanaas", p 56.

34 Yahgulanaas, "RE ME MB ER: The Hybrid Art of Michael Nicoll Yahgulanaas", p 53.

35 Yahgulanaas, "RE ME MB ER: The Hybrid Art of Michael Nicoll Yahgulanaas", p 49.

36 Sostar McLellan, "Mythic Proportions", p 38.

37 Peau, "Haida Tales in a New Context", p 36.

38 Sostar McLellan, "Mythic Proportions", p 38.

39 In 2019, Japan passed a parliamentary bill that officially recognizes the Ainu as the Indigenous peoples of Hokkaidō.

40 Skidegate Repatriation and Cultural Committee, "Butterfly Design", accessed 26 March 2015, http://www.repatriation.ca.

41 Tokyo Designers Week, "Homage to Ukiyoe", accessed 27 March 2015, http://tokyodesignweek.jp/docs/HOMAGE%20TO%20UKIYOE%20-%20Milano%20Salone%202015.pdf.

42 Neuer, Roni , Herbert Libertson and Susugu Yoshida, *Ukiyo-e: 250 Years of Japanese Art*, New York: Mayflower Books, 1981, p 48.

43 Avella, Natalie, *Graphic Japan: From Woodblock and Zen to Manga and Kawaii*, Mies/Hove: RotoVision, 2014.

44 Drohojowska-Philp, Hunter, "Superflat", accessed 17 August 2021, http://www.artnet.com/magazine/features/drohojowska-philp/drohojowska-philp1-18-01.asp ; also see Steinberg, Marc, "Otaku Consumption, Superflat Art and the Return to Edo", *Japan Forum,* vol 16, no 3, 2004, pp 449–471.

45 This work was designed as a result of Yahgulanaas handling a gold bracelet by Charles Edenshaw, which Yahgulanaas explained was "likely one of the last pieces still owned and passed down along female lineage from Charles's daughter". Personal communication, 11 March 2015.

46 Hendrickson, Janis, *Lichtenstein*, Köln: Taschen, 2000, p 34.

47 Bandlow, Karen, "East Asia in the Art of Roy Lichtenstein", *Interculturalism: Exploring Critical Issues*, Diane Powell and Fiona Sze eds, Oxford: Inter-Disciplinary Press, 2004, pp 40–41.

48 For the Homage to *Ukiyo-e* project, the woodblock carvers, Morichika Niinomi and Chikura Kishi, and the printers, Noboru Nakata and Yoshio Kyousou, were from the Adachi Institute of Woodcut Prints in Tokyo (est 1928).

49 Duffek, *Meddling in the Museum*, nn.

50 Levell, "Site-Specificity and Dislocation", p 103; also see Farmer, John Alan, and Antonia Gardner eds, *Fred Wilson: Objects and Installations, 1979–2000*, Baltimore: Center for Art and Visual Culture, 2001.

51 Clifford, James, "The Others: Beyond the Salvage Paradigm", *The Third Text Reader: Art, Culture, and Theory*, New York: Continuum, 2002, p 160.

52 The major totem pole 'salvaging' expeditions of 1947 and 1958, which took place in British Columbia, were coordinated and supervised by the anthropologists Marius Barbeau and Harry Hawthorn, respectively.

53 Hawthorn, Audrey, "A History of the Museum of Anthropology, University of British Columbia", *Papers in Honour of Harry Hawthorn*, VC Serl and JHC Taylor eds, Calgary: University of Calgary, 1975, p 95; also see Hawthorn, Audrey, *A Labour of Love: The Making of the Museum of Anthropology, UBC: The First Three Decades, 1947–1976*, Vancouver: UBC Museum of Anthropology,1993; Halpin, Majorie, *Totem Poles: An Illustrated Guide*, Vancouver: UBC Press, 1981.

54 Duffek, *Meddling in the Museum*, nn.

55 This term is used to denote European, in particular Portuguese and Spanish adventurers.

56 Strathern, Andrew, *Landmarks: Reflections on Anthropology*, Kent: Kent State University Press, 1993, p 22. Although the appropriateness of this structural opposition as a trope for contemporary anthropology has been debated in recent years. See, for example, MacClancy, Jeremy ed, *Exotic No More: Anthropology on the Front Lines*, Chicago and London: University of Chicago Press, 2002.

57 *Bone Box*, 2007, Transcription of UBC Museum of Anthropology digital video footage, Michael Nicoll Yahgulanaas archives.

58 Johnson, E Pauline, *Legends of Vancouver*, Vancouver: GS Forsyth, 1913, p 1.

59 Johnson, *Legends of Vancouver*, p 2.

60 Cruikshank, Julie, *Life Lived as a Story: Life Stories of Three Native Yukon Elders*, Lincoln: University of Nebraska Press, 1992.

61 See, for example, Yahgulanaas, Michael Nicoll, *Red: A Haida Manga*, Vancouver: Douglas and McIntyre, 2009.

62 Duffek, *Meddling in the Museum*, nn.

63 Ramsay, Heather, "Artist Portrait: Michael Nicoll Yahgulanaas", *Galleries West*, no 17, 2007, p 34.

64 Levell, Nicola, "Coppers from the Hood: Haida Manga Interventions and Performative Acts", *Museum Anthropology*, vol 36, no 2, 2013, p 123.

65 This public sculpture was designed by Sam Carter and unveiled in 1986.

66 The exhibition was co-curated by Morin and Martine Reid and took place at the Bill Reid Gallery, Vancouver, September 2012–March 2013.

67 Morin, Peter, "Another One Bites the Dust", *Carrying on 'Irregardless': Humour in Contemporary Northwest Coast Art*, Martine Reid ed, Vancouver: Bill Reid Gallery of Northwest Coast Art, 2012, pp 9–10.

68 In introducing the concept of anti-structure, Turner explains that the term had been adopted by Brian Sutton-Smith and specifically applied to "a series of experimental studies" he had been conducting on children's (and some adult) games. Turner, Victor, *From Ritual to Theatre: The Human Seriousness of Play*, New York: PAJ Publications, 1982, p 28.

69 Yahgulanaas, Michael Nicoll, "Waa Haa", *Carrying on 'Irregardless'*, p 96.

70 *Bone Box*, 2007, Transcription.

71 *Bone Box*, 2007, Transcription.

72 Stewart, Howard, "Finding a New Name for B.C.", The 180, CBC Radio, accessed 27 March 2015.

73 Ramsay, "Artist Portrait", p 34.

74 *Bone Box*, 2007, Transcription.

75 Cassirer, Ernst, *An Essay on Man: An Introduction to a Philosophy of Human Culture*, New Haven: Yale University Press, 1944, p 146.

76 Cassirer, *An Essay on Man*, p 143.

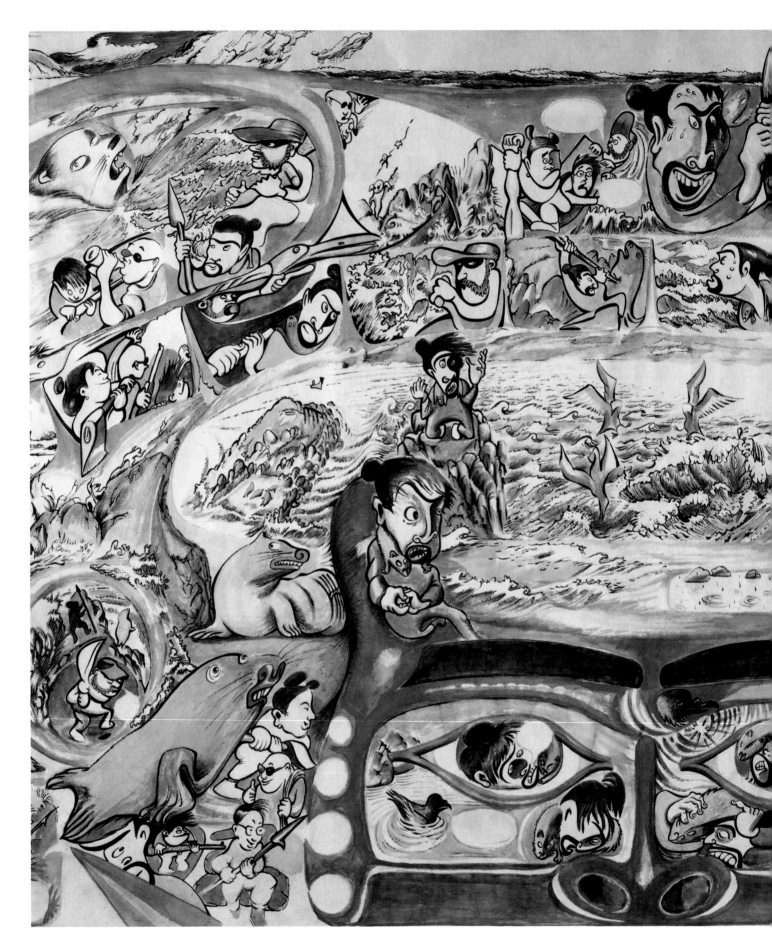

Carpe Fin, 2018 (detail)

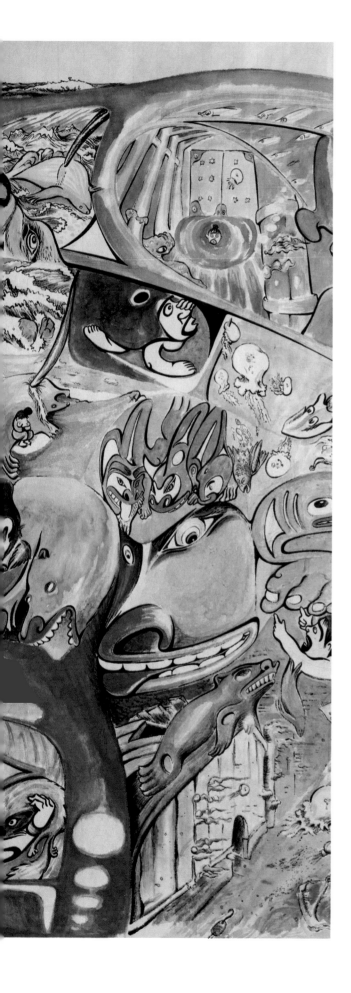

COOL MEDIA

—

THE ART OF
TELLING TALES

I chose manga because of ... the literal translation of the word ... imagery without restrictions. I liked the notion of the wide expanse that was available. I used manga because I was speaking primarily to a North American audience, saying this is not a comic book. This is not a North American or Euro-based narrative. This is a narrative that comes from somewhere else. *Michael Nicoll Yahgulanaas*[1]

"Somewhere else" is Haida Gwaii. Many of the stories Michael Nicoll Yahgulanaas spins are anchored to this archipelago and frequently moored to oral histories. Among the Haida, each lineage has its own repertoire of legends that has been transmitted across generations. These narratives are a valued source of historical and present-day knowledge that encapsulates their worldviews and tells of creation, the formation of the landscape, customs of inheritance and genealogies, interdependent ecologies and lifeways, the meaning of art and more. Jisgang Nika Collison elucidates:

> We are an oral culture. Before European contact, our records of events, knowledge and technology were carefully preserved in our oral histories, and accompanied by visual representation in the form of two-dimensional formline, carving, weaving and dance. Even today, almost all Haida objects—from everyday utensils to monumental poles—are painted, carved or woven with our clan crests and histories to show our rights and privileges. In order to properly 'read' these figures, one needs to know the histories they represent.[2]

As with other forms of heritage, oral histories by their performative nature are subject to change, as UNESCO explains: "Intangible cultural heritage ... is constantly recreated by communities and groups in response to their environment, their interaction with nature and their history, and provides them with a sense of identity and continuity, thus promoting respect for cultural diversity and human creativity".[3] It is the respect for cultural pluralism and the freedom of artistic licence that coalesce in Yahgulanaas' visual practice and its playful intermingling of unfamiliar narratives, media, meanings and forms.

BORDERS: ON THE EDGE OF SOMEWHERE ELSE

When Yahgulanaas decided to extend his art practice—beyond his political cartooning of the 1970s–1990s—to reconfigure Haida oral narratives and contemporary struggles in comic form, he rejected the Euro–North American format. On the one hand, Yahgulanaas eschewed the Western comic format because it represented another hegemonic, if not neo-colonial, way of harnessing and 'disciplining' Haida thought-worlds, histories and cultural expressions. Overlaying this viewpoint, there was a more specific aesthetic consideration. Yahgulanaas wanted to break free from the constraints of the linear and sequential frames typically associated with Euro-American comics. In traditional terms, these comics follow a particular narrative path. Their storylines unfold in strips or tiers consisting of a series of panels, frames or boxes. These graphic elements are frequently defined by geometric borders or outlines and separated by gutters. Voices and thoughts are contained within

balloons and bubbles. Or a third-person or narrator's voice can appear as a textual commentary or caption. Yahgulanaas wanted to develop an alternative comic idiom that could accommodate the explosion of action and the multiplicity of play between physical and metaphysical beings and realms that are characteristic of Haida oral histories. In sum, he set out to try and capture the complexity of an alternative or more experiential worldview. In his words: "After two decades of political service I turned to art, wanting to build graphic novels that would tell stories different than the ones we were served up on the book and magazine shelves. I didn't want to be part of those traditions but longed for something that felt more truthful. I had to innovate".[4]

In his effort to be more true to a Haida worldview, through an ongoing process of experimentation, Yahgulanaas discovered that the stylized compositional formlines, long associated with classical Haida art, provided a more complex and fluid framework in which to illustrate his fabulous tales.

In the preface to *A Tale of Two Shamans*, his first Haida manga, which was published in 2001 and again in 2018, Yahgulanaas gives an insight into the creative process of telling or retelling tales, of breathing new life and relevance into old stories. He touches on the idea of stories as property, while inviting us, the readers, to become involved and see connections between different times and peoples:

> 'Notes on *A Tale of Two Shamans—Ga SGáagaa Sdáng/Ga SGaaga Sding*'. The work that you are about to read is old, much older than any of us still living. It is probably older than anything one could even call Canadian. It precedes us all. Obviously I am not the primary creator of such a narrative, but as a Haida citizen, it is an ancestral experience. The strength of owning a thing is often expressed as a right to share it ...

> This story is a blend of accounts recorded in the early 1900s in three of the once numerous dialects of the Haida language. This is one of the first publications to include the differing orthography of all three dialects in one edition. In my telling I have blended elements from three separated versions and retold the story, seeking a coherent, unified whole ... Be cautioned that these images are interpretations informed by my own cultural composition and life experiences. This is a contemporary rendering of a worldview first expressed in different times and probably for different reasons. I am not stepping up to join that dais filled with authorities claiming to represent those distant times. I am a Haida whose life experiences are probably very similar to that of your own. In many respects that greater distance between the first tellers of *Ga SGáagaa Sdáng/Ga SGaaga Sding* and ourselves, makes us both readers ...

> I have restrained myself from writing an extensive opinion, instead limiting my retelling to a brief text and illustrations. This should suffice to give the engaged reader a hint of the amazing concepts which ripple through this shamanic tale and remain a substantial element of that dynamic living society of Indigenous Peoples called Haida.[5]

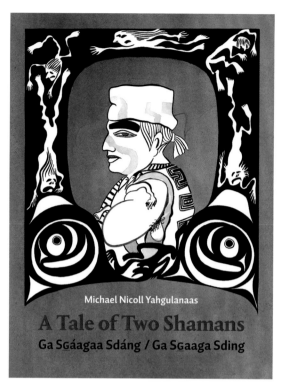

Michael Nicoll Yahgulanaas

A Tale of Two Shamans
Ga SGáagaa Sdáng / Ga SGaaga Sding

top *A Tale of Two Shamans*, 2018 (front cover)

bottom *A Tale of Two Shamans*, 1999

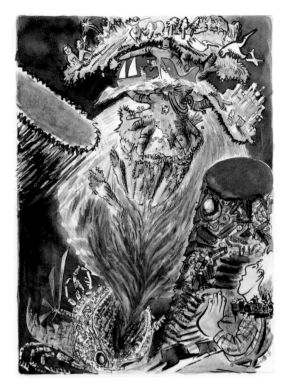

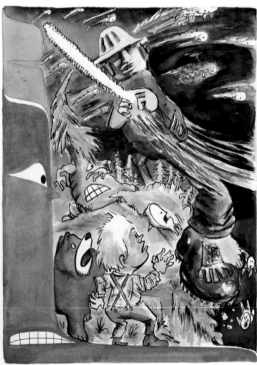

The Last Voyage of the Black Ship, 2002

The vitality of Haida culture, particularly the energy and commitment to language revitalization, is referenced in the 2018 edition. In addition to dedicating the book "to all the students of this generation who have committed themselves to language revitalization", Yahgulanaas explains that while the English-language version remains unaltered and true to its 2001 telling, the parallel narratives told in the three regional dialects of Haida—X̲aad Kil (Old Massett), X̲aayda Kil (Skidegate), X̲aad Kil (Kaigani, Alaskan)—have been updated. More specifically, his collaborators, including language scholars, fluent speakers and students, have imbued the texts with, Yahgulanaas notes, "a welcomed and long-awaited precision in phonology, morphology and syntax as understood in the three regions".[6]

By extending these Haida-rooted narratives to a broader audience in visual form, Yahgulanaas hopes that readers and viewers alike will engage and reflect on their own individual agency—the ramifications of their actions or inactions—and the impressions and typecasts they have of others. He encourages us to identify, to form a cognitive or emotional connection with his Haida manga characters and the issues they face in a way that enables us to see the basis of our common humanity and by extension our individual and shared responsibility in the present. With his customary idealism, which is always tempered with a political accent, Yahgulanaas hopes that his graphic novels and artworks can foster a form of "conciliation".[7] Through their universal significations, they can help bridge the gap of cultural misunderstanding or the tendency we have to distance and disassociate ourselves from cultures and peoples whom we think of as 'other'.

KALEIDOSCOPIC REALMS: SEEING FROM DIFFERENT ANGLES

While informed by critical undercurrents, Yahgulanaas' graphic narrative artworks generally explore the human condition through an expressive imagery of surreal happenings, dynamic action and comic characters, as exemplified in his second Haida manga, *The Last Voyage of the Black Ship*, 2002. Departing from the black-and-white graphics of his earlier work, *The Last Voyage of the Black Ship* is replete with vivid and intense colours. The formlines or rather framelines startlingly depart from the palette of black, red and teal-blue, long associated with Haida classic art forms. They sweep across the page and fill the gutters with a chromatic, iridescent and florescent vitality. Their saturated hues include bright forest green, primary yellow, neon-red, midnight blue, liquid ochre and tangerine-orange.

Every page of *The Last Voyage of the Black Ship* is composed of curvilinear panels, which are delineated in part by the vibrant free-flowing yet non-continuous framelines. Their irregular 'voids' are filled with colour-saturated realist and sci-fi imagery—landscapes, characters and machines—offering different angles, perspectives and depths of perception. The manifold scenes erupt with action, motion-lines and movement. In the publication, these polychromatic spreads are further punctuated with text. In some cases, text appears in white rectangular blocks, superimposed on the pictorial plane. In other areas, it occupies the amorphous white shapes as well as conventional speech and thought bubbles that were marked for text and left unpainted. These texts and shapes often fill the voids created by the framelines.

The kaleidoscopic quality of the visual field is amplified by the colourful characteristics of the three main protagonists: the young Haida woman, who introduces herself as the "pink gyrrl" (in reference to the

colour of her hair); the small blue talking bear, with its distinctive Haida iconography; and the supernatural being. The latter, who is an "ancient ... born out of the roots of the forest", is depicted in humanoid form tinged green. That the human protagonist is a young Haida woman with pink hair can be understood as part of Yahgulanaas' mission to explode stereotypes of Indigenous peoples and to offer a fresh perspectives in this case on the power of marginalized groups to make a change.

By introducing a female action hero Yahgulanaas' graphic practice can be positioned in relation to the third-wave feminist movement detected in other popular cultural forms, including comics, that depict women and girls as independent, 'cool' and resourceful combatants. This foregrounding of "grrrl power" unsettles the archetypes of the auxiliary, vulnerable female character that have dominated the action-adventure genre of comic books, graphic novels, video games and films.[8] The recognition of the power and strength of women also speaks to the traditional social organization of Haida society. Like many other Indigenous Northwest Coast communities, Haida clans are organized according to matrilineal patterns of descent. Women occupy a prominent and important position within this system of inheritance and cultural transmission. Growing up, Yahgulanaas was surrounded and continues to be inspired by a cohort of strong female relatives, including his mother, Babs Hageman Yahjaanaas, his sisters, Tracy Auchter Yahjaanaas, Shelley Hageman Yahjaanaas and Lisa Hageman Yahjaanaas, and his great-aunt Delores Churchill Gawa Git'ans and her daughter April Churchill Gawa Git'ans, among others. Outside of the Haida consanguineous context, Yahgulanaas is married to a remarkable, creative and accomplished woman, Launette Rieb, MD. That they were expecting their child, a girl, Mirella, when *The Last Voyage of the Black Ship* went to print—as revealed on the back cover of the book—may also explain why the human protagonist is a young girl.

The narrative of *The Last Voyage of the Black Ship* centres on the three protagonists' successful attempt to halt the mass destruction of Haida Gwaii's unique red cedar ecosystem. The forest is in imminent danger of disappearing because of the clear-cut logging practices, executed by monstrous machines, managed by large corporations and masterminded by an alien being. The human population is resigned, trapped and dependent within this capitalistic system, which is based on an insatiable desire for energy. But the girl, the bear and the ancient being, "with the magical powers of a flying canoe carved out of old-growth tree", manage to "redirect the alien to his home planet and break the spell of lumber dependency".[9]

Although the story of *The Last Voyage of the Black Ship* is laden with supernatural and sci-fi events and imagery, it is very much anchored in reality. The black ship of the title is based on a self-loading log-hauling barge, which worked in and around Haida Gwaii and was ironically called the *Haida Brave*. With the capacity to transport twelve thousand logs per load—the equivalent of four hundred logging trucks—this titanic machine was deeply involved in the despoliation, rape and pillage of the archipelago. There is a cartoon in Yahgulanaas' archive, reproduced in *Old Growth,* 2011, which documents the incredible David and Goliath encounter between the *Haida Brave* and a small vessel out at sea. Captioned "The Haida Brave meets the Brave Haida", the illustration refers to the momentous confrontation between the *Haida Brave* and a small cedar canoe paddled by eight young environmentalists, which took place mid-channel in the Masset Inlet (in Haida Auu), off the coast of Haida Gwaii on 1 August 1996. The canoe, flying the Haida

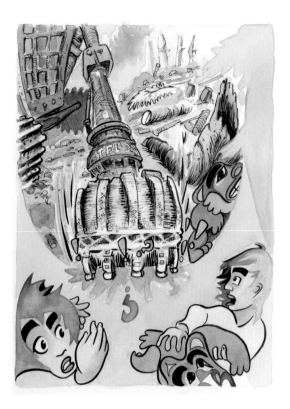

The Last Voyage of the Black Ship, 2002

The Last Voyage of the Black Ship, 2002

flag, blocked the passage of the immense barge for hours, until the black ship laden with logs altered its course and 'fled' from the smaller vessel.[10] Inspired by this episode, in *The Last Voyage of the Black Ship* the infamous black ship with its hull full of cut logs is towed away into the galaxy by the mythical canoe, and the heroic trio fly back to earth and the ancient forests of Haida Gwaii on the oars.

From a populist perspective, the return flight of the three heroes brings to mind Osamu Tezuka's Astro Boy or Mighty Atom (Tetsuwan Atomu) as he was called in Japanese.[11] Mighty Atom is regarded as the catalyst that fuelled the post-war craze for serialized manga in Japan. In his graphic practice, Tezuka (1928–1989), the so-called god of modern manga *(manga no kamisama)*, created a new hybridized art form or idiom. He not only drew on Japanese pictorial traditions but appropriated, mimicked and integrated characters and techniques from North American visual culture like films to offer an insight into contemporary concerns, particularly the ambivalent relations between humans and technology and the politics of progress and peace.[12] We can detect this creative hybridization in Yahgulanaas' work. He draws on elements of Haida, Euro–North American and Japanese visual culture and integrates other influences to create something new. This has prompted Judith Ostrowitz to suggest, "Perhaps paradoxically, it is through this unusual combination of existing devices that Yahgulanaas takes his work into completely unexplored territory, creating something that has never existed before in any of these traditions".[13]

SPECTACULAR ECOLOGIES: DYSTOPIAS AND WASTELANDS

There is a strong futuristic strain woven into *The Last Voyage of the Black Ship*. We can see the horror of a dystopian and ruined civilization captured in the images of mutant alien cyborgs, dazed and discombobulated human beings and toxic industrial wastelands —visual themes of degeneration also manifest in Yahgulanaas' earlier comics.[14] These futuristic characters and environs, which come into conflict with the symbolic forces of Indigenous culture, betray Yahgulanaas' long-standing fascination with science fiction in comics, literature and film. Revealingly, Yahgulanaas identifies Moebius—a pseudonym used by the avant-garde French cartoonist, artist and writer Jean Giraud (1938–2012)—as an inspirational source. Characterized as "an insolent jester, subtle, incisive, ironic and often outrageous", Moebius is recognized as one of the leading fantasy graphic artists who revolutionized the Western comic format, specifically challenging the archetypal Marvel-hero mould.[15] His influence extended into the Japanese world of manga too. In the science fiction fantasy comics he originated as part of the avant-garde collective Les Humanoides Associés (The Associated Humanoids), under the title "Heavy Metal" in the mid-1970s, Moebius established his reputation for creating a "new comic" idiom of dystopian otherworldly realms that "pose metaphysical questions and comment wryly on the state of human culture".[16] In his acclaimed full-colour series *Arzach*, Moebius experimented without text and pushed the graphic layout into a more open and variegated pattern; for example, "a short action sequence may be interposed with a single panel covering two pages".[17] In this way, we journey with Arzach, who flies on the back of a pterodactyl-like creature over bizarre, surreal landscapes "of gigantic bones, reptilian animals and carnivorous vegetation".[18] In *Masters of*

Comic Book Art, PR Garriock contends that Moebius' graphic drawing "relates to a private world of pure fantasy where the people, objects and general landscape are mutations of objective reality".[19]

There is no "world of pure fantasy", if such a state could ever exist, in Yahgulanaas' graphic novels. They are unashamedly rooted in a contemporary Haida-inflected worldview, one that is mixed and muddled with the subjective proclivities, idiosyncratic personality, whimsical imagination, life experiences and political acumen of the artist. While grounded in Indigenous concerns and especially the Haida locale, the environmental and anti-capitalistic messages embedded in *The Last Voyage of the Black Ship* are clearly directed at a wider body politic. This point is made clear in the preface to the volume, which informs the reader:

> British Columbia, Canada is the last region in the world with large stands of old-growth red cedar. More than 95 percent of the world's remaining old-growth red cedar is here in the North Pacific. Red cedar fetches a higher price than any other wood being logged in the province. This high price is the driving force behind the clear-cutting of the last remaining intact valleys and remote forests. This tragedy extends far beyond the biological implications for North America's remaining temperate rainforest. Red cedar along with wild salmon provide the foundation for the Indigenous Peoples' rich culture on the North Pacific coast. As the red cedar and salmon go, so does the culture. And that just won't do.[20]

There is the implicit recognition that the destruction of these ancient rainforests has serious ramifications for humankind across the globe. With deforestation comes a dramatic and dangerous increase in global greenhouse gas emissions, the reduction in bio-diversity and the erosion of cultural lifeways.

These are pressing concerns, which we can become immune to as we are swept up and sucked into the consumerist drives of late-capitalist society, as *The Last Voyage of the Black Ship* illustrates. We are susceptible to being transfixed by the spectacle of progress, in which commodity culture and lifestyles are mediated through images and technologies of mass production. In his seminal text, *The Society of the Spectacle*, 1967, Guy Debord offers a damning Marxist critique of our slavish addiction to the world of commodities and our alienation from the 'real' social world, from the people and relations that surround us. He incites artists and others to revolt, to subvert and overthrow the powerful hold of consumerist desires by exposing their delusionary foundations. We witness this kind of social awakening in *The Last Voyage of the Black Ship,* when a worker comments, "I see the black ship now for what it is. A dark desire. A hunger never satisfied. A dangerous illusion. I never went back to the forest with a chainsaw in my hand".[21] This reflection emotively resonates with Yahgulanaas' personal decision to abandon his position as a forestry engineer in 1981 and focus his attention on Haida environmental and political issues.

The Last Voyage of the Black Ship, 2002

WIDE OPEN SPACES

The environmental concerns that lie at the heart of *The Last Voyage of the Black Ship* are compellingly expressed in Yahgulanaas' publication, *The Flight of the Hummingbird: A Parable for the Environment,* 2008.

The Flight of the Hummingbird, 2008

This captivating narrative has been reproduced in multiple languages and in different media forms, including a children's edition (*Little Hummingbird*, 2010), two animations and most recently an opera (2020). The latter was co-commissioned by the Pacific Opera Victoria and Vancouver Opera, with school and family audiences in mind, as a call to action in the face of climate change. The music was composed by Maxime Goulet, Glynis Leyshon worked as the dramaturge and Yahgulanaas collaborated with Barry Gilson on the libretto and costume design. Unfortunately, due to the COVID-19 pandemic, its May 2020 live debut had to be postponed, but it has been launched as an online video production until live touring can begin.[22]

The Flight of the Hummingbird began life as a collaboration between Yahgulanaas and Keibō Ōiwa, a Japanese cultural anthropologist, writer and environmentalist. Based on an Indigenous oral narrative, attributed to the Quechua people of South America and echoed in Haida epics, the tale's hero is the hummingbird Dukdukdiya (the word for hummingbird in Haida). This diminutive creature flies back and forth, from the lake to the burning forest, carrying one drop of water at a time in an effort to extinguish the ferocious blaze. The other forest animals that have fled the fire are perplexed. Finally, the big bear asks, "Little Dukdukdiya, what are you doing?" The story concludes with the small hummingbird looking down on the other animals and replying, "I'm doing what I can". This effectively constitutes a call for us, as engaged readers and global citizens, to do what we can to preserve and sustain the environment. This entreaty to act is iterated in the foreword and afterword penned by Wangari Maathai and His Holiness the Dalai Lama, respectively, and Yahgulanaas' closing statement "A Single Bead of Water".

While the underlying social and environmental messages of *The Last Voyage of the Black Ship* and *The Flight of the Hummingbird* are notably similar if not identical, their Haida manga imagery is startlingly different. *The Flight of the Hummingbird* separates text and image, in line with the conventional illustrated book format. But the images are not fixed within the confines of the page. They move across the central line. They occupy corners. They are depicted from different angles: from the side, above and below, allowing the reader to see from different perspectives. The zoomorphic characters—the hummingbird, bear, rabbit, frog, beaver, elephant, wolf and raven— with their distinctive Haida formlines and elements, interact with each other through eye contact, movement and gesture. Despite the impression of frantic movement, there is a serenity that radiates from the compositions.

The artwork is limited to a palette of red, black and white. The animal and the forest forms appear stylized and silhouetted. There is a pregnant or suggestive expanse of negative space—black, red or white, depending on the colour of the background paper—surrounding these imaginative forms. The stylized simplicity and calligraphic elegance of the imagery and the complementary minimalism of the text unite to produce a potent and poetic parable. The distinctive Haida manga aesthetic of *The Flight of the Hummingbird* resonates with the qualities attributed to Japanese art forms and aesthetics. While the origins of manga have been attributed to Hokusai:

> Manga-style is said to have a much greater historical depth, descending in spirit from ancient caricatures, illuminated scrolls, and even brocade prints. We do know that historically,

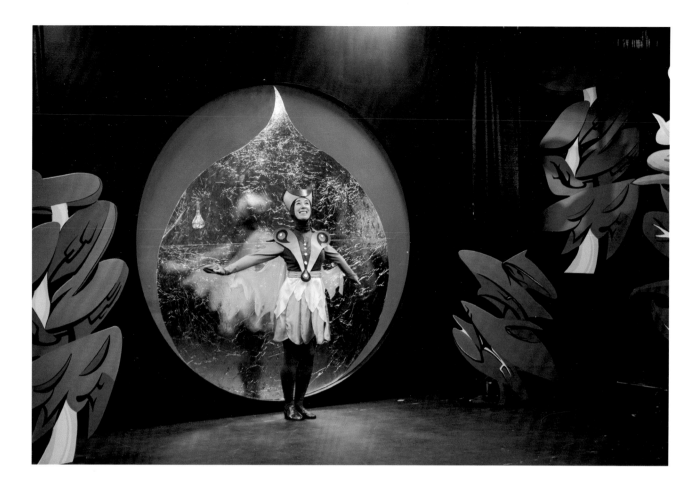

Chinese and later Japanese scrolls encouraged the production of images as a series of vignettes and often from a variety of angles, sometimes as bird's-eye-views, each frame permitting the viewer to experience a different perspective.[23]

Certainly this notion that manga has its roots in the Asian tradition of 'picture scrolls' dating to the Middle Ages is propagated by the noted manga artist, anime director and co-founder of Studio Ghibli Hayao Miyazaki.[24] This artistic approach to creating a series of isolated and multi-perspectival scenes on a singular backdrop, each one surrounded by an expanse of negative space, is considered to be part of an Asian aesthetic, which has influenced Western modern art traditions.

In *Japanese Aesthetics and Anime: The Influence of Tradition*, 2013, Dani Cavallaro touches on the way in which Japanese aesthetics have had a profound influence on art created outside of Japan. She contends that artists, "painters and architects keen to disengage their visions from the constraints of rigorous representationalism have found Japanese art most appealing, feeling particularly drawn to its use of neat silhouettes, essential shapes, delicate lines, bold colours and airy spaces, as well as to its daring approach to both structure and perspective".[25] In a more essentializing move, Donald Keene argues that aesthetics in Japanese art forms are based on four guiding principles: suggestion, simplicity, irregularity and perishability.[26] These principles pervade Yahgulanaas' version of the hummingbird narrative. Suggestion and simplicity are, for example, exemplified in the images of vortex rings, which are produced when a drop of water hits a body of water.

Scenes from *The Flight of the Hummingbird* opera dress rehearsal, 2020

BAROQUE: THE HORROR OF THE VOID

In contrast to the stylized simplicity and 'airy spaces' of *The Flight of the Hummingbird*, in the majority of Yahgulanaas' graphic narratives the pages are pulsating with imagery. In *Gone Fishing*, 2003, for example, every page is cleverly composed of frameline structures, luminous voids and grey aquatic realms, which are impacted and crowded with characters and action.[27] In effect, no space is left unfilled. The aesthetic proclivity for covering every surface with rich expressive imagery is a noted characteristic of the baroque. Yet, in Yahgulanaas' case, this is not a historical baroque, a European baroque, but rather what has been termed a neobaroque, a resurgent baroque, a New World baroque. César Augusto Salgado explains, "The term baroque was first used to designate a stylistic period of extravagant artificiality and ornamentation in post-Renaissance European art and literature and to characterize the doctrinal and iconographic strategies of the Counter-Reformation"; however, more recently it has been used to describe the exuberance and hybridity of New World creativity.[28] More specifically, in the mid-twentieth century, the Cuban novelist and essayist Alejo Carpentier argued that the term baroque should be expanded beyond its historical frame of reference and applied to the Indigenous arts and cultures of the Americas. He contended that the baroque needs to be understood as a "human constant that absolutely cannot be limited to an architectural, aesthetic, and pictorial movement originating in the seventeenth century".[29] For him, the baroque is a human spirit, a sensibility that traverses all ages:

> The baroque ... is characterised by a horror of the vacuum, the naked surface, the harmony of linear geometry, a style where the central axis, which is not always manifest or apparent ... is surrounded by what one might call 'proliferating nuclei', that is, decorative elements that completely fill the space ... motifs that contain their own expansive energy, that launch or project forms centrifugally. It is art in motion, a pulsating art that moves outward and away from the center, that somehow breaks through its own borders.[30]

Carpentier's writings on the baroque can be positioned as part of an emergent postcolonial critique. They are arguments against dominant modernist Western art discourses and movements like Cubism, Abstraction and Surrealism. To some extent, Carpentier set out to create a counter-art history, which celebrated art and artists and more generally popular culture from somewhere else; in his case this elsewhere was Latin America. In his view, *The Jungle*, 1943, by the Cuban artist Wilfredo Lam, who was of African, Chinese, Indian and European ancestry, exemplified his argument. This exuberant canvas is writhing with Afro-Cuban cultural symbols and suffused with the European painterly conventions of Cubism and Surrealism. It prompted Carpentier to declare, "It had to be an American painter—the Cuban, Wilfredo Lam—who taught us the magic of tropical vegetation, the unbridled creativity of our natural forms with all their metamorphoses and symbioses on monumental canvases in an expressive mode that is unique in contemporary art".[31] He continued, Latin America is "the chosen territory of

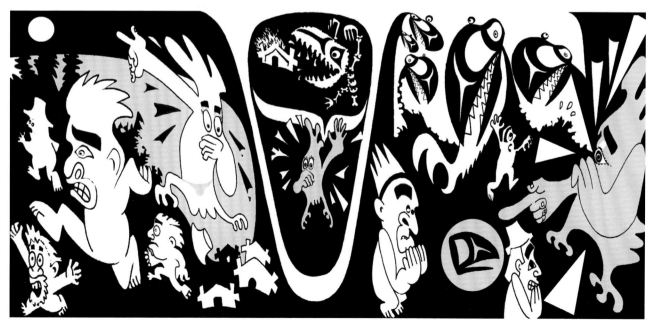

above *Gutter Layout*, 2000

opposite *In the Gutter*, 2011

the baroque ... because all symbiosis, all *mestizaje*, engenders the baroque. The American baroque develops with the *criollo* culture ... the awareness of being Other, of being new, of being symbiotic, of being a *criollo*".[32] In this context, *criollo* is synonymous with the term creole and refers to the racial and cultural mixing that produces new cultures. This understanding resonates with Yahgulanaas' thinking and championing of hybridity as a creative and symbiotic dynamic that gives rise to new cultural forms—in his case Haida manga. The comparison does not however stop there: it extends to the aesthetic realm of the baroque.

The baroque aesthetic, which fills and covers surfaces, lines and crevices with a body of "proliferating nuclei", is embodied in Yahgulanaas' art. In a number of his works, he actively reflects on his aesthetic strategy to confound "the horror of the vacuum" or comments on the significance of empty space. For example, in the one-page ink cartoon *In the Gutter*, 2011, with its distinctive Haida-inflected framelines, Yahgulanaas playfully critiques Western comics' privileging of "empty space". He pokes fun at their conventional use of borders and gutters to structure and separate time and space and to 'discipline' the content into sequential panels or frames. Again a parallel can be drawn between Carpentier's conviction that the pure mimicry of Western art styles like Mondrian's abstractions is inappropriate for Latin American cultural expressions and Yahgulanaas' conviction that Euro–North American comic formats are unfitting for Haida-inspired narrative forms.[33] To cite Salgado: "To cross from the European baroque into the ... neobaroque is to move from a hegemonic, diffusionist, and acculturating conception of the term to an emancipating, autochthonous, and transculturating one", hence Yahgulanaas' enthusiasm for this notion.[34]

Interestingly, Carpentier had his epiphany on seeing the monumental works of the Mexican muralists and having stimulating conversations with Diego Rivera, Clemente Orozco and others in the 1920s. He recalled, "in Mexico I encountered a kind of painting profoundly rooted in the reality around it, in contingency, in lived experience, which was giving form to a series of new American realities in completely unexpected and unforeseen ways".[35] He was particularly struck by the originality of Rivera's murals: their extraordinary encompassment of history and politics; their intertwining of mythologized and everyday figures and faces, landscapes and places, which cover the walls of public buildings. In situ, these expansive artworks represent a rewriting of history: the optimistic creation of a new art for the new nation that celebrated its *mestizo* (hybrid) foundations. The refusal to imitate Western art forms and to suppress an Indigenous presence is clearly enunciated in *In the Gutter*. At the bottom of the page, Yahgulanaas draws a poignant analogy between the dominant structures of Euro-American comics and Western colonial practices, noting: "gutters are like terra nulius [sic] so beloved by colonizers because empty land means my land".

AGAINST *TERRA NULLIUS*

The colonial incentive to represent Canada as an empty space, an untamed and uninhabited wilderness, was transmuted into the urge to produce a national art for Canada in the first decade of the

left *Temperate Rain Forest*, 1998

opposite *Culturally Modified Trees*, 1998

CULTURALLY MODIFIED TREES

is another way to refer to HAIDA FOREST UTILIZATION. THE FEW REMAINING SITES ARE EVIDENCE OF HAIDA TECHNOLOGY AS WELL AS REVEALING THE EXTENT OF THE IMPACTS OF THE GREAT PLAGUES.

MOST SITES WEREN'T ABANDONED!

MASSETT BOAT BUILDERS GEOFF WHITE & ALF. DAVIDSON STATED THAT TREES WERE NOT TEST HOLED. THE SUITABILITY OF A TREE WAS FULLY KNOWN BEFORE ANY CUTS WERE MADE.

WHAT IS OFTEN CALLED A TEST HOLE IS ACTUALLY THE FIRST CUT,

= SOME CMT MAPPING ICONS =
- Triangular bark strip
- Rectangular/Bark Board
- "Test" hole/ First cut
- Canoe "blank"

GENERALLY CMTS ARE FOUND IN CLUSTERS CALLED FOREST UTILIZATION, OR CMTS SITES.

THESE SITES ARE PROTECTED UNDER HAIDA AND CANADIAN LAWS AND PROCEDURES.

TOP

MISSING CHUNKS

MEDIAL

BUTT

TRIANGULAR BARK STRIPPED.

CHUNKS, STUMPS & PIECES ARE CMTS THAT CONTAIN USEFUL DATA.

© Yaku 97

BARK BOARD CMT

CREEKS WERE KEPT CLEARED OF FALLEN LOGS SO THAT CMT LOGS COULD MORE EASILY BE REMOVED TO THE SALT WATER.

© 1998 Yaku

REDUCED LIGHT AND CONSTANT HUMIDITY OF OLD GROWTH CREATE IDEAL GROWING CONDITIONS.
WHY? → ANSWER NEXT ISSUE OF SPRUCEROOTS.

ALSO NEXT ISSUE: THE JEALOUS CANOE WAS A CMT ALMOST 70' LONG, YET IT SUDDENLY VANISHED!

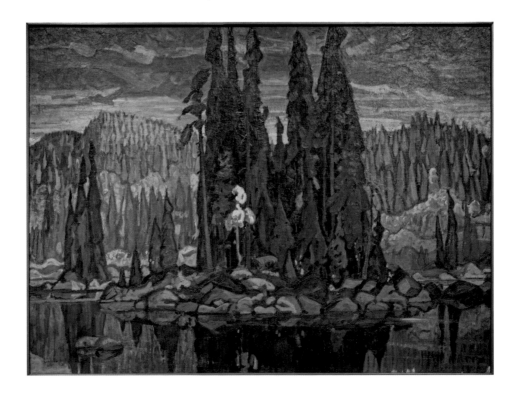

Arthur Lismer, *Isles of Spruce*, 1922

bottom *After Lismer*, 1996

twentieth century. In particular the Group of Seven and other artists, supported by the National Gallery of Canada and private patrons, were determined to forge a particularized Canadian aesthetic. They "set about making and remaking the prevailing conventions of landscape painting … They wished to develop an independent aesthetic—homegrown, northern, and free of foreign influence … For them Canadianess was defined by way of northerness and wilderness. The nation, in their view, should shed its Eurocentrism and embrace its northern identity. Wilderness was a source of power".[36] Central to the fiction of wilderness, as embodied in the art of the nation, is the erasure of Indigenous peoples, their culture and history from the landscape. As Métis artist Edward Poitras incisively observes, "Memories of conquest and resistance are vanquished from a representational field, their absence papered over by mythologies of pristine wilderness or technological progress"—the inverse of the artistic strategies promulgated by the Mexican muralists during the same period.[37] In the 1990s, when heated debates—grounded in postcolonial theory and subaltern discourses of cultural appropriation and symbolic violence—were taking place in Canada and elsewhere, Yahgulanaas took aim at one member of the Group of Seven, Arthur Lismer. In a black-and-white etching, *After Lismer,* 1996, he produced for an illustrated talk at the Vancouver Art Gallery, Yahgulanaas reworked Lismer's pristine forested landscape, refiguring it as a decimated clear-cut logged environment. With a customary ironic nod, the preposition in the title "after" not only refers to the original source, Lismer's oil painting *Isles of Spruce,* 1922, but also refers to the passing of time and the gross disfigurement of the landscape by industrial-scale clear-cut logging practices.

Yahgulanaas' commitment to revise and expand 'Canadian' history, to reclaim and assert an Indigenous presence and counter the myth of terra nullius, consistently underpins the content and aesthetics

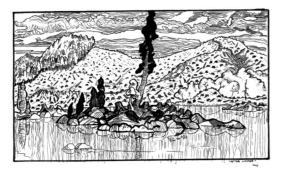

of his graphic artworks. He makes this point explicit in the brief introduction he penned for his fifteen-page black-and-white graphic story, *A Lousy Tale*, 2004. In his preamble—expanding on *In the Gutter*—Yahgulanaas explains how and why he fills the page, the negative or empty spaces between and within the framelines, with content, storylines, characters and action. He begins with a playful yet poignant and politically charged analogy concerning the colonial renaming of Haida Gwaii (Islands of the Haida People). In the late eighteenth century, the archipelago was mapped by the British explorer and maritime fur trader Captain George Dixon and named the Queen Charlotte Islands. This colonial toponym remained in place to haunt and taunt the Indigenous peoples until the archipelago was officially 'renamed' in 2010 as part of the Haida Gwaii Reconciliation Act:

> Once upon a time there was an Englishman who said he had named a Pacific island after a British Queen. Some said that filled the emptiness of the Haida inhabitants with the fullness of George's wife Queen Charlotte. Haida manga challenges fundamental cartoon elements. Where a typical comic represents time and space as an empty white gutter, Haida manga, assisted by Raven reveals that time/space is an active, twisting and expanding vitality where no island needs renaming.[38]

As this excerpt indicates, Raven is the central character in *A Lousy Tale*. Raven also occupies a prominent position in Yahgulanaas' oeuvre. This wily critter is not only discernible in Yahgulanaas' black-and-white graphic narratives, such as *The Strong Silent Type*, 2002 (Japanese text only), *Gone Fishing*, 2003, and *A Lousy Tale* but also figures extensively in his text-free artworks—his shamanic doodles, drawings, watercolours and mixed media compositions. The prominence of Raven arguably reflects the importance of this morally ambiguous figure for Indigenous thought-worlds. Raven is recognized as an archetypal trickster who traverses the oral narratives belonging to many First Nation polities. For the Haida, in particular, Raven is a highly symbolic figure and clan crest. According to a Haida creation story, it was Raven who discovered the first human beings in a clamshell that was washed up on the shore of Haida Gwaii. This discovery marks the beginning of the epic oral narrative, *Raven Who Kept Walking*. Made up of innumerable episodes, this Indigenous epic has inspired a wide range of artworks by contemporary artists, ranging from sculptures, paintings, prints and drawings to the series of children's animations, *Raven Tales*.

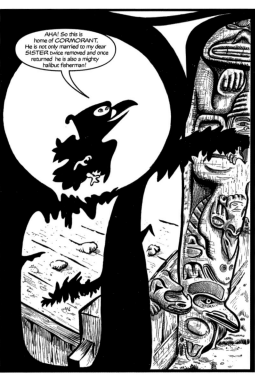

A Lousy Tale, 2004

In the Haida epic, Raven is invariably portrayed as the anti-hero whose deeds and actions constantly create problems and irritations as well as insights and solutions for human beings. Raven is the very essence of mischief and play. Tales about Raven's antics abound and are still transmitted among the Haida today during informal and intimate as well as ceremonial gatherings. Although specific to the Haida and their worldview, they expose characters, dispositions, traits and foibles— universal characteristics—that figure in our common humanity. While drawing on the past or profiling stories from elsewhere, they nevertheless offer meaningful insights into being in the contemporary world. For this reason, Yahgulanaas is fervently committed to disseminating these Haida-based narratives and experiences in and through his art practice and storytelling. And of course, he has the right to do so.

The Strong Silent Type, 2002

THE BLACK-FEATHERED MUSE

Inspired by episodes from *Raven Who Kept Walking*, *The Strong Silent Type*, *Gone Fishing* and *A Lousy Tale*, like their forerunner *A Tale of Two Shamans*, are restricted to a black-and-white gradated palette. This monochromatic restriction ensures that the Haida-inspired iconography, the compositional framelines, stylized comic imagery and silhouetted forms attain a bold, hard-edged feel. In these three composite graphic artworks, which were produced under the rubric Rockin' Raven, the feathered culture hero, Raven with their distinctive beak and mischievous countenance is pictured in action, occupying, transgressing and escaping the framelines. Despite the seemingly continuous calligraphic flow to these lines, they are prone to erupt, to fracture and fizzle with movement.

In *A Lousy Tale*, for example, this black mischief-maker dive-bombs, tumbles and soars through the negative space of the sky, with speedlines marking their passage through time and space. We witness this action from up close, above and afar. The bold black compositional lines not only frame the scenography of sky and landscape, they actively transmute into different forms. They become the profile of Cormorant, Raven's gullible companion, who had a louse on his head, which gave rise to the punning title of the work. They extend to create foliate silhouettes, echoing the leafy limbs of a tree—an aesthetic mirrored in the silhouetted forest in *The Flight of the Hummingbird*. In other scenes, the frameline dissipates to become elliptic fluid black shapes depicting the waves of the sea. The flat blacked-out surfaces are also ruptured as rounded speech bubbles or jagged scream bubbles explode onto the scene, bright white and filled with text. In some cases, the thick black line acts as a medium where disembodied eyes can be seen peering through, surveying the action.

Disembodied eyeballs are a recurrent motif in Yahgulanaas' art. Their pupils are surprisingly expressive: they follow the action and they stare back at us. Yahgulanaas acknowledges that he is especially fond of drawing eyeballs, and he almost always begins an artwork with an eye. This penchant for incorporating staring eyeballs on a flattened field of colour is also a hallmark of Takashi Murakami's art. Known as the originator of Superflat, Murakami takes the Japanese manga predilection for accentuating the eyes to another level. In *Super Nova*, 1999, *Jellyfish Eyes*, 2001, *Superflat Jellyfish Eyes 2*, 2003, or his installation *Wink*, 2001, the eye becomes the fetishized form. We see, for example, manifold spherical tri-lashed eyes, some wide open, others partially or fully closed, reproduced in his kitsch palette of candy colours on a flat-coloured background. Whereas Yahgulanaas' eyes, despite their cartoonish look and disembodied state, convey emotion, Murakami's are symptomatic of the art of mechanical reproduction, literally his own brand of neo-pop, with its critique of the superficiality of consumer culture.[39] This point is captured in *The Last Voyage of the Black Ship*, where the human being is transfixed by the toxic green illuminated screen inside the "Climate Hostil" that conveys the message "Consume. Be happy".

Whereas in *A Lousy Tale*, as well as *The Strong Silent Type* and *Haida Cosmic*, 2013, the dominant frameline is executed in black, in *Gone Fishing* the pattern is largely reversed. In this work, the free-flowing curvilinear framelines transform from black to white, creating isolated pockets of deep space where action unfolds. These monochromatic compositions, with their fluid grey-textured underwater scenes,

convey a maelstrom of activity propagated by Raven. This brings us back to Yahgulanaas' assertion that it is Raven who helps to ensure that the gutters are animated with twisting and swirling, dilating and contracting features and lines. There is an intriguing ambiguity surrounding this claim. Is Raven, who makes Haida manga such a twisting dynamic by disrupting the geography of white spaces, the comic feathered anti-hero of the tale? Or is Raven the alter ego of the artist and storyteller? Certainly, this latter suggestion is given a certain amount of credence when we realize that in the past Yahgulanaas has aligned his interventionist creative spirit with Raven and has been described by curator Karen Duffek as an "artist/trickster" who is known "to mix things up, to twist and challenge, to raise questions ... and to literally turn an established structure upside down".[40] With these thoughts in mind, it is perhaps best to assume that Raven is destined, as in Haida oral narratives, to remain an ambiguous entity, a multiplicity of male and female, animal and human, natural and supernatural attributes. This possibility of understanding Raven, from an Indigenous perspective, as a fluid shapeshifting of being, fractures Western modernist notions of identity and self, which are generally transfixed on binary oppositions such as man/woman, human/animal. By introducing Raven as a complex transgendered, inter-species entity, as graphically depicted in *Gone Fishing,* Yahgulanaas succeeds in introducing us to alternative ontologies, different ways of being in the world that come from 'somewhere else'.

A WORLD OF INCLUSIVE GESTURE

Listening to Yahgulanaas or reading his words—whether they are honed for publication or hastily scribed in an email—it is clear he is a skilled wordsmith and a superlative raconteur. He constantly plays with words and stories in his visual practice. With minimal text, he creates complex narratives, comic titles and pithy captions that exploit the comedic devices of pun and satire, mistaken identity, double entendre and taboo. One only has to browse through his archive of cartoons from the 1970s to 1990s to realize that wordplay is a long-standing element of his artistic expression. So what happens when he divests a narrative-based work of its textual component? Certainly, this was a creative strategy successfully harnessed by Moebius in *Arzach,* as well as a noted characteristic of manga. Despite his penchant for words, a number of Yahgulanaas' narrative-inspired artworks are without text, and a significant number of his drawings, paintings and mixed media forms are untitled. He does not want to prescribe meaning but rather leave a space for the viewer to interpret the imagery and generate narratives. Hence, there is a strong emphasis on visual literacy, on not just looking at the Haida manga composition but rather actively seeing and cognitively processing the lines, characters and features. This belief in the power of the comic form to make us think through multiple, if not always sequential, images was articulated by the renowned media theorist Marshall McLuhan, known for originating the phrase "the medium is the message".

McLuhan celebrated comics, qualifying them as "cool media", low-tech creations that require audience, viewer or reader participation: in contrast to "hot media" like films, which make the viewer a "passive consumer of actions, rather than a participant in reactions".[41] More telling still, in his chapter "The Print: How to Dig It", McLuhan compared

top Takashi Murakami and Michael Nicoll Yahgulanaas, 2018

bottom Sketch of Takashi Murakami, 2018

modern comic strips and comic books to old prints and woodcuts about which he wrote, "These forms provide a world of inclusive gesture and dramatic posture that necessarily is omitted in the written word". He continued, "It is relevant to consider that the old prints and woodcuts, like the modern comic strip and comic book, provide very little data about any particular moment in time, or aspect in space, of an object. The viewer, or reader, is compelled to participate in completing and interpreting the few hints provided by the bounding lines".[42] These cool media qualities of dramatic effect and expressive gesture that require the viewer to actively decipher the visual narrative, to 'read' between the lines and fill the gaps, are writ large in Yahgulanaas' *The War of the Blink,* 2006. Although this large-scale composite watercolour charts a Haida oral narrative, the work is completely devoid of text. It challenges us to develop a purely visual literacy.

In brief, *The War of the Blink* is based on an oral history that is known to and involves the Haida and the Heiltsuk peoples of Wáglísla (Bella Bella). In Yahgulanaas' graphic rendition, the imagery tells the story of the planned attack on a village by a horde of canoe-faring warriors. They manage to capture a village fisherman, who is guarding the coastline. But they are taken by surprise by the villagers, and a hostile confrontation ensues between the two opposing clan leaders. Ultimately, a battle is averted when a strange forest fly appears between the two warriors and causes one to blink, hence the title of the work.

Viewing *The War of the Blink* in its entirety, the composite panels are drawn together in unity by the bold and fluid framelines. Executed in black, red and midnight blue, these curvilinear compositional lines echo the stylized frontal view of the Bear, frequently depicted on Haida art forms. We can detect the ears and eyes, the central torso, limbs and the four paws. In Haida oral narratives and art forms, the Bear is an important crest. Whereas in classic Haida art forms these compositional lines typically contain more abstracted and stylized design elements, in Yahgulanaas' artworks this skeletal framework is filled with realistic imagery and vivid vignettes. The framelines provide a series of non-linear spaces wherein visual effects, images and narratives unfold. Yet the frameline is not privileged as a continuous, unbroken and separate primary force. Rather Yahgulanaas' graphic action is played out in, through and across the framelines, which produces an aesthetic that is startlingly different from the geometric and linear borders, frames and gutters of the Euro–North American comic format.

This distinctive baroque aesthetic, with its indigenized accent, not only challenges the geometries of Euro–North American comic forms but also intentionally rebukes the Western discourse of formal analysis, which clinically anatomizes Haida art, privileging the so-called formline and positioning the internal structures as secondary abstract elements or voids.

In *The War of the Blink* the framelines transmogrify into multifarious forms: the crests of waves, the tail of a whale, the prow of a canoe, the tip of a spear and an elder's hat. They fragment into spume or are fractured by the stamp of a foot allowing supernatural beings to break free. They create horizons, landscapes and vistas where forests and totem poles are grounded, characters converse and ravens rest. In their fluid and watery bodies, sea creatures dwell and emerge to survey the scene. They form tight intimate spaces, where characters squeeze, pull and push their humanoid bodies. Elsewhere Haida supernatural beings are seen to dance the line. In effect, the viewer's eye is compelled to travel across, in and through the line.

Through their non-linearity, fluid and mutating qualities, Yahgulanaas' distinctive frameline compositions offer a different way

of seeing, 'reading' or experiencing art. They encourage a form of what the art critic David Sylvester has called "afocalism". More specifically, Sylvester argues that the later drawings and painting of Paul Klee engender a form of afocalism: they require the viewer to search and scan the visual field looking for relations and meanings among the multiple parts:

> These are pictures without a focal point. They cannot be seen by a static eye, for to look at the whole surface simultaneously, arranged about its center—or any other point which at first seems a possible focal point—is to encounter an attractive chaos. The eye must not rest, it must allow itself to be forced away from the center to find a point at which it can enter the composition— there are usually many such points, most of them near the edge— so journey through the picture, taking a way with a line.[43]

As viewers we are drawn into the picture through the frameline portals exploding with action. We become immersed in and part of the adventure. This sensorial idea of participative engagement, experiencing through looking or rather seeing, is another dimension of afocalism. According to Sylvester: "with a Klee the relationship between the picture and yourself is reciprocal; you touch a loose rock with your foot, it falls from under you and you are left dangling in space. You are part of it as you are part of the sea as you go swimming ... In Klee world motion is primary. It is a world of space-time".[44]

From this viewpoint, space is conjoined with time to create a sense of energy and movement. This idea is certainly not alien to Yahgulanaas. In *In The Gutter* he expressly makes the connection between space and time as he fills his framelines with a stream of philosophical and comic musings that engage us, leading us through the gutter-filled landscape, beyond the realm of emptiness. It is this enticement to travel through baroque realms, full of motion and extravagant imagery, that is concentrated in *The War of the Blink*.

Although the narrative informs the imagery, Yahgulanaas does not privilege either of these components but rather envisages each artwork as a dynamic process. There is no prescriptive interpretation. Meaning is something that is constantly recreated as viewers engage and imbue the artwork with their own experiences and understandings. When asked in an interview, "What is more important, the story or the design?" Yahgulanaas replied, "I don't want to pull the thing apart. By pulling it into pieces it's probably going to fall down. It's the dance between the various aspects of the work. It is the story and it is the aesthetics. It is the techniques, it is the audience, all those things together. It's a recipe".[45]

Initially, this unique Haida manga recipe proved far more popular in Japan and Korea than in Canada or more generally North America. Part of the reason for its lagged reception on home soil may be the feelings of ambiguity and discomfort that surround art with an Indigenous accent that departs from the traditional canon cultivated by the local and international art-market and museums. This anchorage is layered on top of the ambiguous relations—clouded by Indigenous hurt and postcolonial guilt—that exist between the Canadian multicultural state and First Nation, Inuit and Métis peoples and their cultural heritage. As Yahgulanaas noted on one occasion, "It is Haida that has a great gift, and strangely, Canada doesn't know how to receive it. I am one of many going through a fence, building a gate, creating a narrow passageway so that we can experience the other side without fear or hyperbole".[46]

top Yahgulanaas Live Painting,
Manga-Wars at the World Expo,
Japan, 2005

opposite *The War of the Blink*, 2006

Leaving aside the politics of reception, Haida manga's enthusiastic embrace in Asia can also be understood in terms of aesthetics. This point has not escaped Yahgulanaas. In reflecting on the reasons why his art became popular in Japan and Korea, he opines, "Maybe the complexity of the image. Given their experience with manga and *manhwa* (in Korean) as a form of literature, there's an opening to seeing risks taken. They enjoy seeing the way the lines move, the compression and expansion—an aesthetic unto itself—but then they step back and, aha it's a bird or it's a person or it's a narrative".[47] This is a valid and interesting assertion. It has been argued that manga as an aesthetic or visual language is less reliant on text than Euro-American comics. It places more of a "communicative focus on visuals", with seasoned manga readers scanning the page and imagery to determine a point of entry.[48] As the art historian Aarnoud Rommens explains:

> The amount of wordless passages in any volume of manga may be striking to the Western eye. To 'read' manga is to read images—the rhythm is determined by the sequence of images ... Manga speed-reading is made possible through the elimination of textual information ... In most cases, this means that the image alone (in isolation and the sequence) conveys narrative information, its narrative potential being used to the full.[49]

In this case, the principal technique of storytelling used in manga is "analytical montage".[50] As with film production techniques, montage involves the creative selection and fusion of visual elements to form and tell a story. In manga, Rommens argues, the montage or "the sequencing of plates is very resourceful in comparison with a rather constrained Euro-American montage and page layout. In manga, there is no textual interference".[51] Instead the story is expressed through the visual language, through the use of stylistic conventions such as motion, focus and speedlines to depict action and direction and other visual devices to indicate emotions and offer different perspectives on the same event or scene.[52] For example, "a scene that would 'normally' (at least, from a western point of view) be captured in a single pane—with the necessary (or if you like redundant) descriptive information—is now cut up over different frames. The isolated frames, with alternating 'camera-angles', are put together in a visual continuum".[53] In Rommens' opinion, fighting scenes exemplify this technique of montage. With their "rapid succession of images" seen from different angles, they are able to convey a real sense of action in time and space:

> Manga artists are real masters in creating such sweeping visual arrangements. Story tension and atmosphere are effected through the variation of the number of plates per page—while applying cinematographical techniques such as fade-out, fade-in and superimposition—ultimately resulting in flexible page layouts. The 'mise-en-page' shows endless variation and is baroque compared to prototypical Euro-American page layouts.[54]

The War of the Blink is undoubtedly a baroque composition of depth and rhythm that communicates the heady atmosphere and emotions of conflict. Isolating the central panel, for example, we are

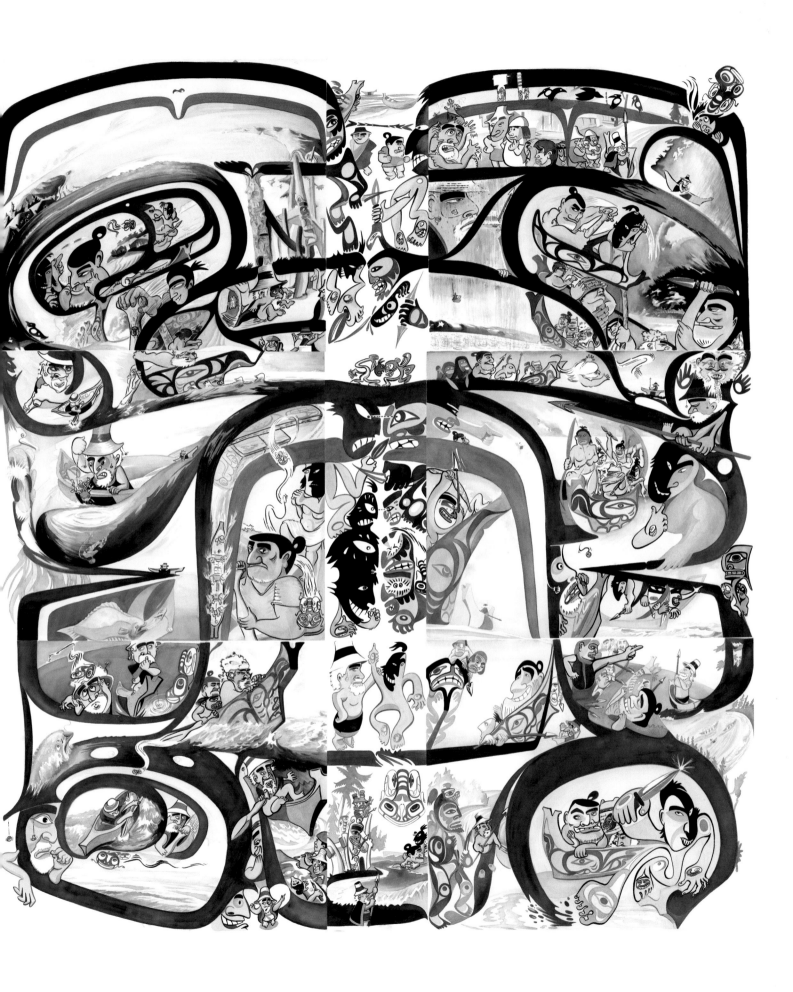

confronted with the intensity and hostility of the encounter between the two warring factions. Whereas a more prototypical manga may have offered a series of different angles onto this epic moment of confrontation spread or 'scattered' over a number of frames, Yahgulanaas instead intensifies and piles up the action. Tension is concentrated and held in this fulcrum of the visual narrative. Whereas the surrounding panels are marked by realistic mise en scène—vistas of landscapes and dwellings; watery seascapes traversed by canoes; horizons, skylines and silhouettes of forests populated by characters— the confrontation between the two warriors is isolated on a white background and compressed into the narrower central panel. Attention is focused on the intense moment of engagement when the opponents fix each other with an unblinking stare. The emotional intensity of this aggressive confrontation is graphically conveyed in the countenances and expressions of the characters. In their face-off, their weapons are drawn and their eyes are locked in combat, distinctive manga-style focus lines indicate the resolute direction of their stare. In this isolated panel, moving or 'reading' from top to bottom, the fixed stare of the warring parties, which intensifies as the characters are amplified in scale, is eventually broken when the strange Haida-esque forestfly intervenes.

Eschewing the convention of linear and sequential reading, *The War of the Blink* follows an idiosyncratic narrative path. The visual chain leads from top to bottom, rather than from left to right. While it starts on the left, in accordance with Western comic traditions, as opposed to Japanese manga's 'reading' leading from right to left, it moves down rather than across the page. The storyline travels down the two broader outer columns, before reaching its climactic conclusion in the narrower central column. It is like a disordered triptych, a baroque montage that challenges us to make sense of its narrative imagery.

Although there is a linear-pattern to *The War of the Blink* as well as Yahgulanaas' other graphic narrative works such as *Red* and *Carpe Fin*, 2018, like manga these action-filled montages encourage a different form of visual literacy. While the panels and frames can be read from top to bottom, left to right, they consist of multiple convoluting and free-form panels that create a composite whole.

RED AS COOL MEDIA

McLuhan's assertion that "comic book[s] ... as cool media involve the user, as maker and participant, a great deal" is illustrated par excellence by Yahgulanaas' full-colour graphic novel, *Red: A Haida Manga*. Based on a Haida oral narrative known to Yahgulanaas' family, *Red* tells the story of a young girl Jaada and her brother Red, who live together on the west coast of Haida Gwaii. One night their village is attacked by pirates and Jaada is captured. When Red grows up and becomes a chief, he directs his energies and mobilizes the resources of his community to finding his long-lost sister. With the invention of a mechanical whale and a flying canoe propelled by copper kites, Red neglects his chiefly responsibilities as he pushes forward with his individualistic crusade. The tale turns tragic when Red finds Jaada, murders her husband and then accepts the only viable course of action to prevent full-scale war between the two communities—suicide. The story concludes as Jaada and her small son, who has bright red hair like his deceased uncle, are accepted back into the community.

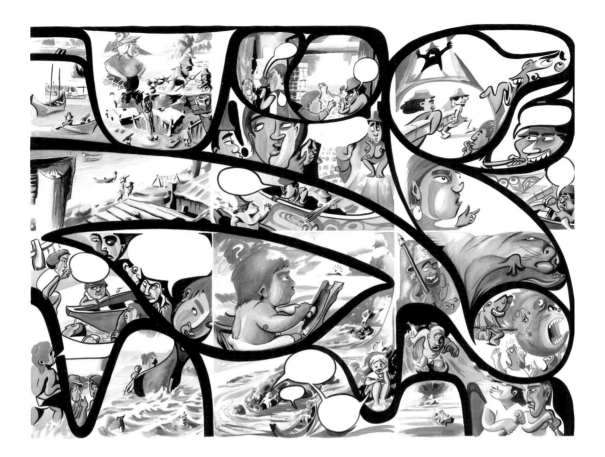

As scholars have demonstrated, this complex Haida manga can be interpreted from multiple perspectives that encompass Indigenous Northwest Coast worldviews or epistemologies and manga iconographies as well as cross-cultural themes such as sacrifice, honour and obligation.[55] Like its graphic forerunners, *Red* plays with Haida framelines and iconography and complicates any straightforward reading of the narrative imagery. As Perry Nodelman explains, "*Red*'s 'twisting' makes it a particularly intense example of proliferating energy—and thus an extreme version of comics' characteristic structure".[56] By playing with time and space and distorting the linear sequential format, Yahgulanaas encourages different strategies of reading, different ways of seeing and understanding the action: "often switching between scenes involving different characters from page to page, sometimes doing so on the same page or two-page spread, and frequently offering different panels in different sizes that depict the same action from multiple points of view".[57] This is analytical montage in action, and Nodelman offers a clear example:

> In a sequence in which the hero Red thwarts a raider's attempt to capture him, for instance, only close inspection reveals that repeated figures of the raider's weapon connect the various separate images of him and eventually account for how he dies. Close-ups of Red's feet and hands are so extreme in these images that his entire position remains unclear until he falls; meanwhile, Yahgulanaas devotes increasing attention to the raider's hair clasp, which gradually grows from a few blurred impressionistic lines into what appears to be another fully realised character involved in the scene, thus making the actual physical relationship between the two real characters harder to decode.[58]

top *Red*, 2008 (detail)

bottom Corey Bulpitt NaiKun Qigawaay, *Reclaimed Spaces*, 2020

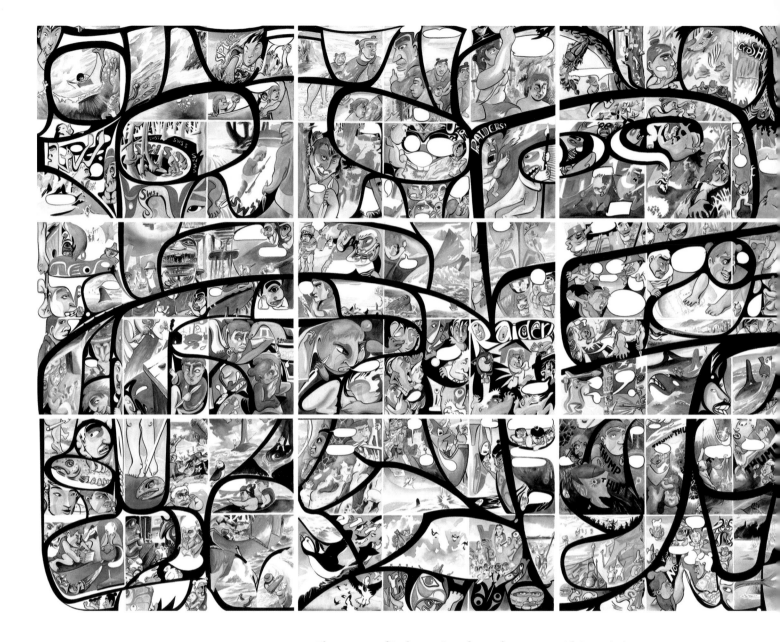

The concept of *Red* as a unique form of montage, with its variations of rhythmic lines, its play of perspective and focus and its proliferation of action that pulsate throughout, is further manifest at the end of the book. On a double-page spread, the 108 individual pages that make up the manga are arranged in sequence. Together they form a truly baroque composition—a miniature version of the five-metre-long watercolour mural that is the original source of the artwork. What for the first-time reader were the abstracted framelines of each page are now connected. They join to create the stylized image of a Haida supernatural being or crest, executed with a bold calligraphic flourish. This figurative form unifies the different components of the work. For readers, the display of the whole can be a surprising revelation, as Peter Stanton recalled: "I really love the way that the last pages of the book reveal how each page of the story can be fitted into a single formline design; as I was reading, I had no idea that would be possible".[59] In telling terms, Stanton described the composite image as "mysterious and exciting, like a Northwest Coast crest mixed with urban graffiti".[60] This analogy brings to mind the writhing and energetic graffiti art of the award-winning Haida artist Corey Bulpitt NaiKun Qigawaay—who is also a descendant of Charles Edenshaw—such as his diptych *Reclaimed Spaces,* 2020. When Yahgulanaas was asked if he and Corey were

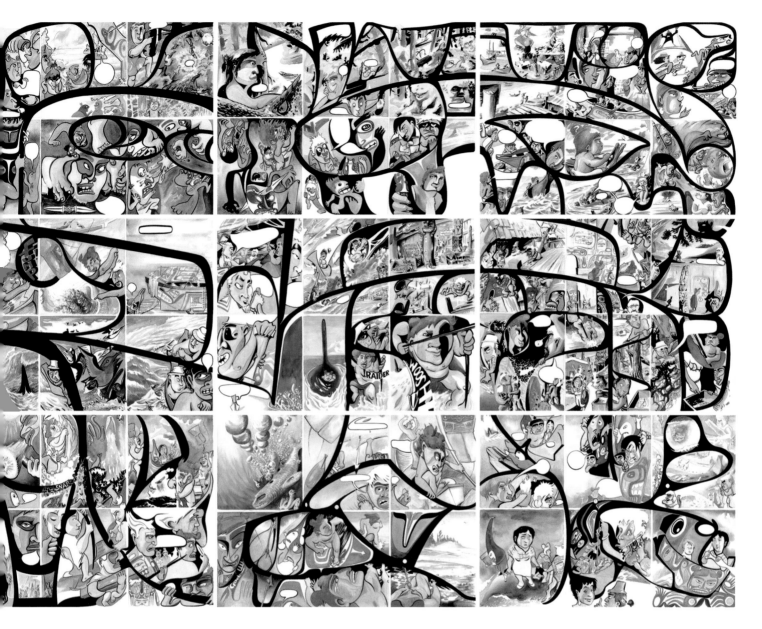

Red, 2008

cousins, he tellingly replied, "I haven't figured out what the English term cousin really means but Corey is my younger clan-brother's son (my mother's younger sister's oldest son). This would make me his Tsinnii. Notwithstanding this, Corey does call me Uncle as we attempt to concile kinship relations across this choppy sea".[61]

That the lines of *Red* connect to form a whole presents us with another way of seeing and thinking about the art and the story. By extension, it may make us reflect on the different ways we perceived or misperceive the world around us. To some extent, this holistic display at the end of the book allegorically affirms the moral aspect of *Red*. In Yahgulanaas' words *Red* is "not so much about revenge. Yes the story has revenge as a theme but at its core it is an examination of what happens when we get it all wrong. What happens if all our facts are actually fiction? What happens if we don't think there is such a thing as climate change, or that we don't need science in politics ... ? I think that we need to be a little less sure about what we know, and to be more certain about what we don't know".[62]

When McLuhan asserts that comics as cool media engage the user, as maker and participant, he is alluding to the way in which readers are actively involved in decoding and reconstructing the story in their own way. Unquestionably there are many different ways of reading these

distinctive graphic media. Readers can follow a linear path and piece together the narrative frames, or they may adopt a more afocal strategy, scanning the page as a discrete visual object, from which they extrapolate story and meaning. Equally, they can shift between these different visual and textual reading strategies, looking for cues—body language, motion-lines, text, dialogue or sound—to make sense of the narrative. This interplay between signs is currently referred to in a growing body of literature as multi-modal literacy or multimodality, wherein our cognitive powers of perception are working across different genres of representation.[63] There is also a haptic dimension to reading comics and graphic novels as we turn the pages or flip back to enhance our understanding. As Yahgulanaas notes, "The reader is free to direct pace and even narrative direction. If they want to go backward, they can. No one is preaching or demanding that they have to do something in a particular way. The reader experiences control and authority".[64]

POSTPRODUCTION PLAYS

The possibility of amplifying our senses of touch and perception and augmenting our participation in the making of comic forms is taken one step further by Yahgulanaas. With the release of *Red* in paperback form in 2014, he provocatively invited readers to destroy the book:

> Red is more than a collection of bound pages, something more than a story to be read page by page. Red is also a complex of images, a composite one that will defy your ability to experience story as a simple progression of events.
>
> I welcome you to destroy this book. I welcome you to rip the pages out of their bindings. Using two copies of Red, and following the layout provided at the back of the book, you can reconstruct this work of art.[65]

This provocation takes McLuhan's notion of comics having a "participational and do-it-yourself character" to another level.[66] By inviting us to participate in a heuristic manner, Yahgulanaas seeks to broaden access to his visual practice. Through the process of making, we are encouraged to experience the artwork in a different way, to feel the paper, to reconnect the frameline, to develop a more intimate connection with aspects of the imagery and narrative flow and to see the composition from a different angle and scale, as it transforms from a hand-held interactive volume to a large-scale two-dimensional composite print.

With the destruction of *Red* and the piecing together of its parts, we are able to view the monumentality and complexity of the original artwork. Although *Red* has been exhibited in museums and art galleries across North America and in 2020 it was donated to the UBC Museum of Anthropology by the collector and philanthropist Michael O'Brian, it nevertheless remains in restricted circulation. By empowering the viewer to replicate the original, Yahgulanaas is effectively taking André Malraux's concept of the "museum without walls" in a different direction with a twist. For Malraux, the possibility of reproducing 'great art' in books, by means of photography, represented a way of democratizing art by overcoming the physical constraints of institutions. Illustrated art books were a way of figuratively breaking down the walls of museums and galleries and enabling the broader public to access, see and learn about world art. These ideals of public engagement and access

to culture are central to Yahgulanaas' artistic philosophy. In his case, the deliberate destruction of the art book gives access to copies of the original masterwork. Moreover, in encouraging a form of iconoclasm directed at the book, Yahgulanaas is also consciously challenging us to think about the value we place on material things. In his words, "I wonder: Why are books sacred? Are people sacred? Can we really still afford to agree that ideology is more sacred than people?"[67] Clearly, the act of cutting out the pages of the book can create a liminal space of contemplation where we become more mindful of our actions and aware of our principles, values and emotions. As Michael Emme notes, "Following the artist's invitation involves reading with knife-in-hand and a ritual of unbinding that can be unsettling. Committing to the process offers an incredible reward by revealing an entirely different view of the story and illustration".[68]

Yahgulanaas' commitment to making his art accessible to diverse publics in different forms and places is testified to in the activities he undertakes beyond the studio walls. He is a seasoned public speaker and storyteller, who has participated in artist-in-residence programs, documentaries, workshops and public events in museums, galleries, universities, libraries and other cultural venues. He also encourages, and on occasion commissions, other artists, particularly young emerging Indigenous artists, to engage with his work in a collaborative fashion. In this way, *Red* has been digitally remixed. In contemporary culture and cultural theory, remixing is understood as a creative process of hybridization. It samples or appropriates from existing art 'objects'—whether they are material or digital, visual or audio-media—editing, deconstructing and remixing to create a new artwork.[69]

In the case of *Red*, the remix was a collaborative venture. The music was composed and performed in *Red Remix*, 2009, by the award-winning young cellist Cris Derksen. Her haunting soundtrack is a manifestation of her classical training interwoven with her Indigenous Cree ancestry and new school electronic music. The Haida illustrator and animator Chris Auchter Yahgulanaas, acclaimed for his work with Electronic Arts and the National Film Board, brought *Red* to life. He dipped into the imagery and created an engaging short anime that shows Red searching for his long-lost sister Jaada. *Red Remix* was not the first time Yahgulanaas' art has been animated. The year before, following the release of *The Flight of the Hummingbird*, 2008, Yahgulanaas and Auchter collaborated on a 'Haida anime' version of the parable.[70] Whereas the collaboration for *Red Remix* was confined to studio spaces and fellow artists, Yahgulanaas has also actively sought to democratize and extend his collaborative practice to a broader public. Working with institutions such as the American Museum of Natural History in New York and the McMichael Canadian Art Collection in Kleinberg, Ontario, for example, he has developed innovative public programs and workshops inspired by *Red*.

For the McMichael—an art gallery that not only accommodates one of the largest collections of works by the Group of Seven but its surrounding gardens are the burial grounds for six of the founding members of the Group, including Arthur Lismer—Yahgulanaas has created a series of blank frameline templates. These 'blanks' are rich in allegory: they are empty landscapes, like those of the Group of Seven's canvases, waiting for individual and collective histories and memories to be inserted. This is Yahgulanaas' stated objective. He invites visitors to engage with *Red*, to start a conversation,

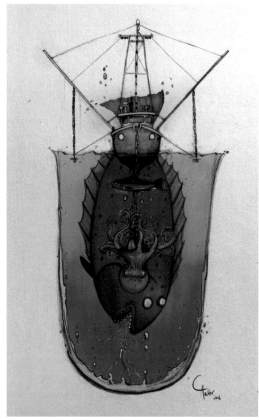

top Chris Auchter Yahgulanaas, *The Mountain of SGaana* poster, 2018

bottom Chris Auchter Yahgulanaas, *What Lies Below*, 2019

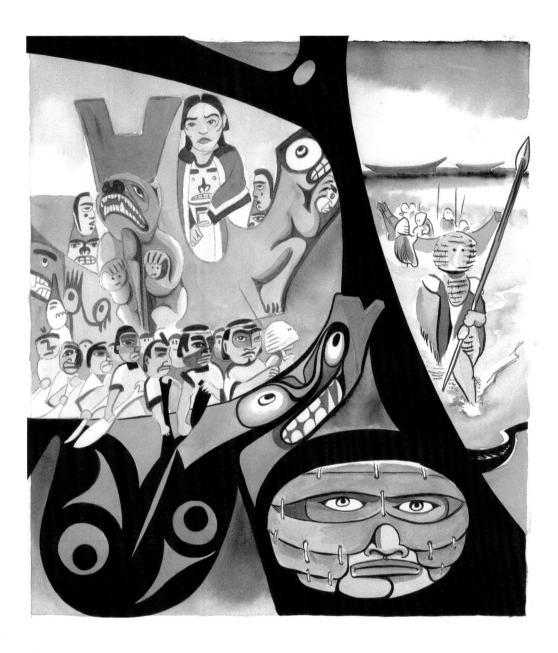

Red, 2008 (detail)

to create personal graphic or text narratives using provided individual templates that are jigsawed together with others to create a singular large mural. The theme for that interactivity is the core story idea behind *Red* which is 'what do we do when all we believe to be true turns out to be false?' I hope to encourage individuals to see that such situations are not at all unique and these shared and frequently unsettling experiences can become the basis for increasing collective identity.[71]

This belief in the power of art to open a space for participation and dialogue is characteristic of the shift in contemporary art practices toward collaboration.[72] Rather than focusing attention on viewing the finished product of an artist, emphasis is placed on the social dimension of making art. In effect, the artist is repositioned as a creative facilitator or catalyst, and the artwork that emerges is a collective enterprise, based on a plurality of shared insights, experiences and conversations. The French curator Nicolas Bourriaud originated the term "relational aesthetics" to describe this movement that opens up the category

of art as a social space, to activate the audience and erode the idea of viewing as an asocial, subjective or private act. In his theorization of relational aesthetics, while acknowledging the diversity of art practices encompassed by this term, Bourriaud draws on his own curatorial practice and discusses installation art of the 1990s produced by artists such as Liam Gillick, Dominique Gonzalez-Foerster and others. In other essays, Bourriaud connects relational aesthetics to what he terms a "postproduction" modality wherein contemporary artists draw on existing works to create an opportunity for different publics or users to participate and direct content. To illuminate the way in which postproduction art blurs the boundaries between consumption and production practices, he cites the influential French artist Dominique Gonzalez-Foerster: "Even if it is illusory and Utopian ... what matters is introducing a sort of equality, assuming the same capacities, the possibility of an equal relationship, between me—at the origins of an arrangement, a system—and others, allowing them to organise their own story in response to what they have just seen, with their own references".[73] These postproduction ideals of empowerment, as shown, are central to Yahgulanaas' deconstruction and reworking of *Red* as a collection of blank frameline templates that awaits audience narrative input. As Bourriaud surmises:

> This culture of use implies a profound transformation of the status of the work of art: going beyond its traditional role as a receptacle of the artist's vision, it now functions as an active agent, a musical score, an unfolding scenario, a framework that possesses autonomy and materiality to varying degrees, its form able to oscillate from a simple idea to sculpture or canvas. In generating behaviors and potential reuses, art challenges passive culture, composed of merchandise and consumers ... meaning is born of collaboration and negotiation between the artist and the one who comes to view the work.[74]

Viewers are not positioned as onlookers but rather as active participants, users and makers, as McLuhan confirmed, who extract and construct their own meanings and narratives. By engaging with others, our individual perspectives, cultural references and systems of value can be shared, expanded and revised. In this way we move beyond the traditional into the open-ended pluralistic and interconnected realm of the present. Yahgulanaas' retelling of tales in his visual practice explicitly encompasses the idea of ownership, sharing and above all the poetic licence to creatively embellish.

These possibilities and especially the idea of generating new storylines to reimagine the past, present and future are being ignited again in Yahgulanaas' 2021 commission for the Humboldt Forum, the grand museum complex in Berlin that holds one of the oldest and most important collections of Indigenous Pacific Northwest treasures, for which Yahgulanaas is creating a monumental Haida manga similar in scale to *Red* and *Carpe Fin*. This eight-metre-square action-packed narrative, titled *JAJ* after the main protagonist, has been sketched out and will eventually be executed in watercolour and ink on kozo washi and reproduced as a book. The storyline draws on historical and archival sources and weaves them together with Yahgulanaas' lineage narratives and the artist's imagination to provide a critical perspective on Germany's collecting and the colonial scouring of the globe. In particular, it profiles the Norwegian adventurer Johan Adrian Jacobsen and his

Michael Nicoll Yahgulanaas in his studio working on scaled sketches of JAJ, 2021

1881 expedition to the Pacific Northwest to collect for the Ethnological Museum of Berlin. In the Haida manga retelling we join Jacobsen and a host of other historical actors, including Yahgulanaas' great-great-grandfather George and Haida treasures too as their paths cross and they travel in various directions. Through combining his life experiences and cultural knowledge with his artistic practice and fertile imagination, he is able to imbue old stories with a contemporary relevance. By playing with the narrative, pushing the frameline, dissolving the gutter and developing expressive characters and multiperspectival scenes, Yahgulanaas succeeds in creating a new potent, idiosyncratic and hybridized comic idiom.

1 Peau, Lee, "Haida Tales in a New Context", *Wingspan*, October 2007, p 36.
2 Collison, Nika, "Story of the Haida People", *That Which Makes Us Haida—the Haida Language*, Haida Gwaii: Haida Gwaii Museum Press, 2011, p 17.
3 UNESCO Definition of Intangible Cultural Heritage, , accessed 19 August 2021, http://uis.unesco.org/en/glossary-term/intangible-cultural-heritage.
4 Sostar McLellan, Kristine, "Mythic Proportions: A Haida Artist Weaves Cultural Traditions into Something New", *SAD MAG: Stories, Art, and Design*, nos 16/17, 2014, p 38.
5 Yahgulanaas, Michael Nicoll, *A Tale of Two Shamans-Ga SGáagaa Sdáng / Ga SGaaga Sding*, Vancouver: Locarno Press, 2018, pp 4–6; Yahgulanaas, Michael Nicoll, *A Tale of Two Shamans*, Haida Gwaii: Theytus Books and Haida Gwaii Museum, 2001, nn.
6 Yahgulanaas, *A Tale of Two Shamans*, p 5.
7 Jewkes, Matthew, "Haida Art Hopes to Inspire Engagement", *Ubyssey*, vol 89, no 19, 2007, p 2. The Métis academic, curator and artist David Garneau strongly suggests that we reframe the dialogue between Indigenous and non-Indigenous peoples in Canada as a process of conciliation rather than reconciliation. He argues that the idea of reconciliation, in the Canadian context, is deeply flawed because reconciliation means repairing relationships that were once amicable and harmonious. In contrast, conciliation is an alternative dispute-resolution process that brings parties together to work through problems and differences and find mutually acceptable solutions. So, Garneau asks, "How are we to change the sites of Reconciliation into sites of Conciliation?". Garneau, David, "Imaginary Spaces of Conciliation and Reconciliation: Art, Curation, and Healing", *Arts of Engagement: Taking Aesthetic Action in and beyond the Truth and Reconciliation Commission of Canada*, Keith Martin, Dylan Robinson and David Garneau eds, Waterloo: Wilfrid Laurier University Press, 2016, p 29.
8 Hopkins, Susan, *Girl Heroes: The New Force in Popular Culture*, Annandale: Pluto Press, 2002.
9 Park, Liz, "Introduction", *Old Growth: Michael Nicoll Yahgulanaas*, Vancouver: Read Leaf and Grunt Gallery, 2011, p 11.
10 Yahgulanaas was out at sea in a small rubber boat and witnessed this momentous event. He recorded his observations in photographs and words, which were published as an article in *SpruceRoots* Magazine, "How Many Canoes Are on That Black Ship?".
11 Schodt, Frederik, *The Astro Boy Essays:* Osamu Tezuka, Mighty Atom, Manga/Anime Revolution, Berkeley: Stone Bridge Press, 2007.
12 Phillips, Susanne, "Characters, Themes, and Narrative Patterns in the Manga of Osamu Tezuka", *Japanese Visual Culture: Explorations in the World of Manga and Anime*, Mark W MacWilliams ed, New York: ME Sharpe, 2008, pp 68–90.
13 Ostrowitz, Judith, "Michael Nicoll Yahgulanaas: It Looks Like Manga", *Objects of Exchange: Social and Material Transformation on the Late-Nineteenth Century Northwest Coast*, Aaron Glass ed, New York: BGC Focus Gallery, 2011, p 82.
14 See, for example, the second volume from the *Tales of Raven* series, "Mutants of the Pit", 1987, reproduced in Park, *Old Growth: Michael Nicoll Yahgulanaas*, pp 47–63.
15 Garriock, PR, *Masters of Comic Book Art*, New York: Images Graphiques, 1978, p 67.
16 Garriock, *Masters of Comic Book Art*, p 66.
17 Garriock, *Masters of Comic Book Art*, p 67.
18 Garriock, *Masters of Comic Book Art*, p 75.
19 Garriock, *Masters of Comic Book Art*, p 67.
20 Yahgulanaas, Michael Nicoll, *The Last Voyage of the Black Ship*, Vancouver: Western Canada Wilderness Committee & Tales of Raven, 2002.
21 Yahgulanaas, *The Last Voyage of the Black Ship*, p 13.
22 "The Flight of the Hummingbird: Goulet | Yahgulanaas | Gilson", accessed 27 June 2021, https://pacificopera.ca/event/the-flight-of-the-hummingbird/.
23 Ostrowitz, "Michael Nicoll Yahgulanaas: It Looks Like Manga", p 80.
24 Manga! BBC documentary, 1994.
25 Cavallaro, Dani, *Japanese Aesthetics and Anime: The Influence of Tradition*, Jefferson: McFarland, 2013, pp 51–52.
26 Keene, Donald, "Japanese Aesthetics", *Japanese Aesthetics and Culture: A Reader*, Nancy G Hume ed, New York: State University of New York Press, 1995, pp 27–42.
27 These storyboards were originally produced for the Tokyo Designers Week, 2003.
28 Salgado, César Augusto, "Hybridity in New World Baroque Theory", *Journal of American Folklore*, vol 112, no 445, 1999, p 316.
29 Carpentier, Alejo, "The Baroque and the Marvellous Real", *The Marvellous Real: Art from Mexico, 1926–2011*, Nicola Levell ed, Vancouver and Monterrey: Figure 1 Publishing, MOA at the University of British Columbia and FEMSA Collection, 2013, p 20.

30 Carpentier, "The Baroque and the Marvellous Real", p 21.

31 Carpentier, Alejo, "Marvelous Real in America", *Magical Realism: Theory, History, Community*, Lois Parkinson Zamora and Wendy Faris eds, Durham and London: Duke University Press, 1995, p 85.

32 Carpentier "The Baroque and the Marvellous Real", p 25.

33 Levell, Nicola, "Introduction: A Baroque Aesthetic", *The Marvellous Real: Art from Mexico, 1926–2011*, p 13.

34 Salgado, "Hybridity in New World Baroque Theory", p 316.

35 Levell, "Introduction: A Baroque Aesthetic", p 13.

36 O'Brian, John, and Peter White, "Introduction", *Beyond Wilderness: The Group of Seven, Canadian Identity, and Contemporary Art*, John O'Brian and Peter White eds, Montreal: McGill-Queen's University Press, 2007, pp 3–4; also see Watson, Scott, "Race, Wilderness, Territory, and the Origins of Modern Canadian Landscape Painting", *Beyond Wilderness: The Group of Seven*, pp 277–282.

37 Poitras, Edward, "Offensive/Defensive", *Beyond Wilderness: The Group of Seven*, p 339.

38 Yahgulanaas, Michael Nicoll, "A Lousy Tale", *Lake: A Journal of the Arts and Environment*, no 7, 2012, p 15.

39 Cornyetz, Nina, "Murakami Takashi and the Hell of Others: Sexual (In)Difference, the Eye and the Gaze", Criticism, vol 54, no 2, 2012, p 187.

40 Duffek, Karen, *Meddling in the Museum: Michael Nicoll Yahgulanaas*, Vancouver: UBC Museum of Anthropology, 2007, nn.

41 McLuhan, Marshall, *Understanding Media: The Extensions of Man*, Cambridge, MA: MIT Press, 1994, p 320.

42 McLuhan, *Understanding Media*, p 160.

43 Highmore, Ben, "Image-Breaking, God-Making': Paolozzi's Brutalism", *October*, no 136, 2011, p 97; Causey, Andrew, and Peter Lanyon, *Modernism and the Land*, London: Reaktion Books, 2006, p 100.

44 Causey and Lanyon, *Modernism and the Land*, p 101.

45 Peau, "Haida Tales in a New Context", p 36.

46 Augaitis, Daina, "The Impulse to Create: Daina Augaitis in Conversations with Robert Davidson, Michael Nicoll Yahgulanaas, and Don Yeomans", *Raven Travelling: Two Centuries of Haida Art*, Peter McNair, Daina Augaitis, Marianna Jones, and Nika Collison eds, Vancouver: Vancouver Art Gallery; Vancouver/Toronto: Douglas and McIntyre; Seattle: Washington University Press, 2006, p 160.

47 Peau, "Haida Tales in a New Context", p 36.

48 Cohn, Neil, "Japanese Visual Language: The Structure of Manga", *Manga: An Anthology of Global and Cultural Perspectives*, Toni Johnson-Woods ed, London: Continuum Books, 2010, p 199.

49 Rommens, Aarnoud, "Manga Story-Telling/Showing," *Image & Narrative: Online Magazine of the Visual Narrative*, accessed 19 August 2021, http://www.imageandnarrative.be/inarchive/narratology/aarnoudrommens.htm.

50 Rommens, "Manga Story-Telling/Showing".

51 Rommens, "Manga Story-Telling/Showing".

52 Although manga artists developed a unique technique of using motion lines to suggest the speed and trajectory of a moving object, which was depicted as static in the picture, according to Scott McCloud, this was one of the first characteristics that Euro-American comic artists appropriated in the 1980s and 1990s when manga was becoming increasingly popular. See Cohn, "Japanese Visual Language", p 193.

53 Rommens, "Manga Story-Telling/Showing".

54 Rommens, "Manga Story-Telling/Showing".

55 See, for example, Brown Spiers, Miriam, "Creating a Haida Manga: The Formline of Social Responsibility", *Studies in American Indian Literatures*, vol 26, no 3, 2014, pp 41–61; Emme, Michael, "Michael Nicoll Yahgulanaas: Art at the Edges", *Canadian Art Teacher*, vol 12, no 1, 2013; Nodelman, Perry, "Michael Yahgulanaas's Red and the Structures of Sequential Art", *Seriality and Texts for Young People: The Compulsion to Repeat*, Mavis Reimer, Nyala Ali, Deanna England and Melanie Dennis Unrau eds, Basingstoke and New York: Palgrave Macmillan, 2014, pp 188–205; Harrison, Richard, "Seeing and Nothingness: Michael Nicoll Yahgulanaas, Haida Manga, and a Critique of the Gutter", *Canadian Review of Comparative Literature*, vol 43, no 1, 2016, pp 51–74.

56 Nodelman, Perry, "Picture Book Guy Looks at Comic: Structural Differences in Two Kinds of Visual Narrative", *Children's Literature Association Quarterly*, vol 37, no 4, 2012, p 440.

57 Nodelman, "Picture Book Guy Looks at Comic", p 440.

58 Nodelman, "Picture Book Guy Looks at Comic", p 440.

59 The reader in question is Peter Stanton, an Alaskan teacher and historian. Accessed 7 July 2015, http://peterstanton.blogspot.ca/2013/06/red-haida-manga-and-possibilities-of.html.

60 http://peterstanton.blogspot.ca/2013/06/red-haida-manga-and-possibilities-of.html.

61 Michael Nicoll Yahgulanaas, personal communication, 3 July 2021.

62 Sostar McLellan, "Mythic Proportions", p 39.

63 See Emme, "Michael Nicoll Yahgulanaas: Art at the Edges".

64 Sostar McLellan, "Mythic Proportions", p 39.

65 "Red—A Haida Manga by Michael Nicoll Yahgulanaas—Make the Mural!", accessed 19 August 2021, https://www.youtube.com/watch?v=kIFdczERISs.

66 McLuhan, *Understanding Media*, p 165.

67 Sostar McLellan, "Mythic Proportions", p 39.

68 Emme, Michael, "Michael Nicoll Yahgulanaas: Art at the Edges".

69 Knobel, Michele, and Colin Lankshear, "Remix: The Art and Craft of Endless Hybridisation", *Journal of Adolescent and Adult Literacy*, vol 52, no 1, 2008, pp 22–33.

70 In 2010, Yahgulanaas and Auchter collaborated with Tim Linklater to produce a short Haida anime, *Raven's Call*. Commissioned by Canadian Heritage for its Virtual Museum of Canada, the animation, with its deliberately unfinished storyline, was based on a narrative written by Bill Reid.

71 McMichael Canadian Art Collection Interview, Notes and Correspondence, Michael Nicoll Yahgulanaas archives.

72 See Bishop, Claire, *Artificial Hells: Participatory Art and the Politics of Spectatorship*, London: Verso, 2012.

73 Bourriaud, Nicolas, *Postproduction Culture as Screenplay: How Art Reprograms the World*, New York: Lukas and Sternberg, 2002, p 19.

74 Bourriaud, *Postproduction Culture as Screenplay*, p 20.

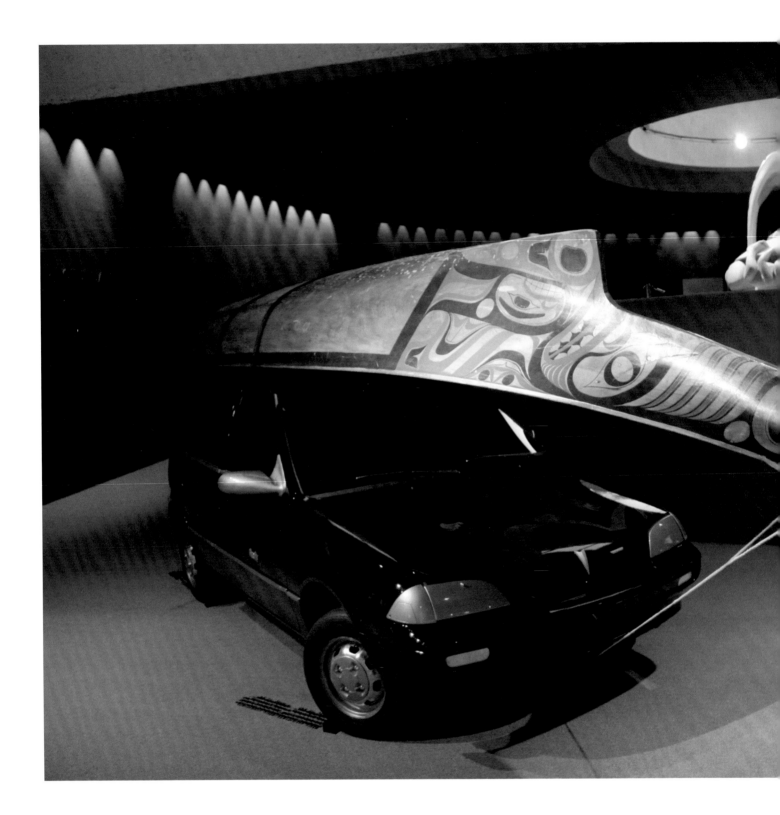

Pedal to the Meddle, 2007

CULTURALLY MODIFIED

—

PRECIOUS METALS, CARS AND CRESTS

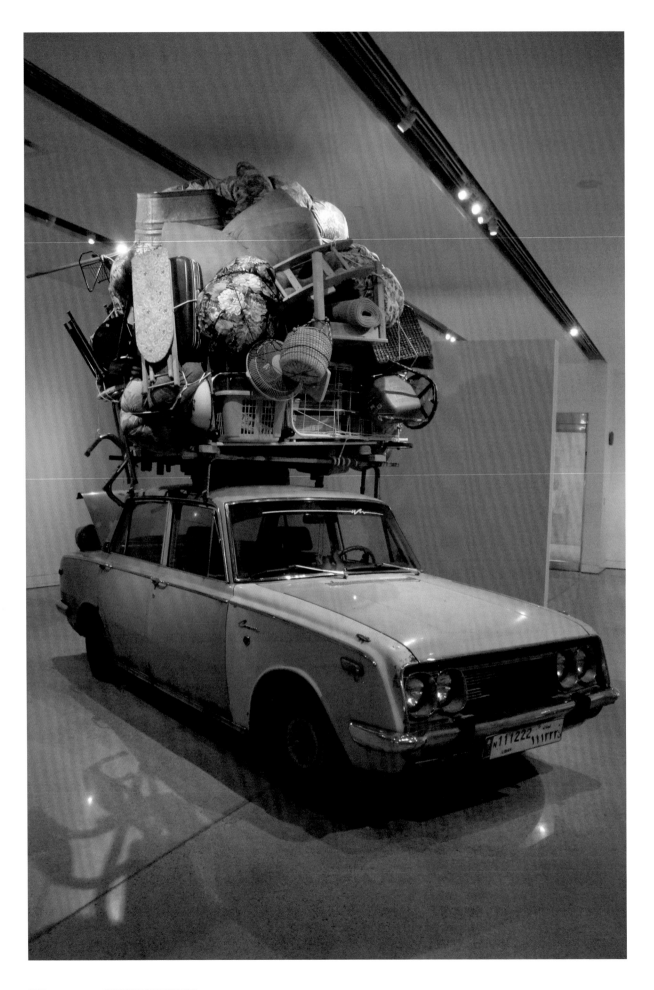

■n Haida-manga, objects ... that appear to us one way can be flipped around and rearranged to find new relationships among the parts, and a new dimension for the whole. In a field of wrecked automobiles, I found evidence of an artistic tradition in what used to be the hood of a car. An acid bath, plenty of flipping around, some refinishing, and a memory of the traditional copper shields of the Haida, resulted in a contemporary shield of greatly mixed heritage.
Michael Nicoll Yahgulanaas[1]

Cars are bodies of cultural knowledge. They are global signifiers, icons of modernity, masterpieces of technology, symbols of status, freedom and mobility as well as objects of menace, destruction and pollution. While they enable us to escape in real and imaginary or symbolic ways, they nevertheless blight the landscape and harbour the potential to be killing machines. It is the complex and ambivalent nature of the car, as a charged form of mass culture, that has captured the imagination of modern and contemporary artists. Cars have been depicted and distorted in a diverse range of media forms, from the surreal canvases of Dalí and the frenetic abstracts of the Italian futurists like Giacomo Balla to graphic crashes of Andy Warhol and the gritty photoconceptualism of John Baldessari and others besides.[2] In these artworks, the car is reduced to or rendered as an image or a metaphorical lens through which the mechanical world in motion, fossilized, impacted or frozen, is perceived.

For other artists, the physical properties and materiality of the car trigger associative memories and critical thought-processes that are articulated in their creative practice. In such cases, there is a return of the real: the metal bodies of cars are engaged, repurposed, embellished, modified or dissected to offer multiple different perspectives on the human condition and the technologies of material culture. In installation works like Ayman Baalbaki's *Destination X,* 2010–2013, or Kimsooja's *Bottari Truck,* 2008, battered old vehicles are piled high with material possessions. These works speak of the anxieties of exile, nomadism and migration forced by conditions of war and social unrest. In contrast, rather than foregrounding the car as an asset of mobility on a terrain riven by politics and distress, artists such as Dirk Skreber and Ron Arad have intentionally crashed and crushed the bodies of cars, brand new and old vehicles, to explore the aesthetics of catastrophe, memory and technology. In *Inopportune: Stage One,* 2004, Cai Guo-Qiang offers a different take on catastrophe and the exploded form: the bodies of nine cars are tumbling yet suspended in space, shot through with intense neon-light shafts. For the artist, these freeze-frames are not representations but the "dream image" of a car bomb: terrorism is materialized through the imagination.[3] Using a different strategy of deconstruction, for *Cosmic Thing*, 2002, Damián Ortega systematically took apart a vintage Volkswagen Beetle—a symbol of modernity and mobility in Mexico— and reconstituted and suspended each part in gallery space. Thus his "exploded view" metaphorically and literally opened up the cultural body of the car to enable us to rethink the familiar, perhaps to make us reflect on the national legacies and trajectories of different commodities and material forms.[4] In contrast, Marcus Bowcott's *Trans Am Totem*, 2015, a site-specific intervention in Vancouver's urban landscape, is a ten-metre-tall hybrid totem. It consists of a stack of five salvaged, wrecked but partially restored automobiles surmounted on an old

Marcus Bowcott, *Trans Am
Totem*, 2015

growth cedar trunk with a large stylized bear paw, which was carved by the Squamish artist Xwalacktun (Rick Harry).[5] At the top of the sculpture is "a Pontiac Trans Am, an icon of speed, power and status", which like the other cars and their relation to the immense body of the ancient tree speak to the dominant excesses of consumer culture, environmental issues and the history of the city that was built on unceded Indigenous lands and resource extractive industries, especially logging.[6]

In Michael Nicoll Yahgulanaas' practice, cars have become potent artefacts or cultural belongings for exploring the contested terrains of heritage and dispossession, the forced movement of objects across time and space and the significance of materiality and memory. Yet Yahgulanaas' exploration of the intercultural values and meanings of cars and Indigenous cultural heritage is riddled with comic Haida manga effects. A case in point is *Pedal to the Meddle*, 2007, and its dialogic companion *Stolen But Recovered*, 2007. These two mixed media forms, along with *Two Sisters*, 2007, were the first artworks Yahgulanaas created using the body parts of cars. They were conceptualized as site-specific interventions, commissioned for the Meddling in the Museum: Michael Nicoll Yahgulanaas exhibition at the UBC Museum of Anthropology, Vancouver. Through their playful and satirical juxtaposition of visual and material systems, the old and the new, these three copper-accented installations embodied and performed a special kind of mixing, an artistic politicking that confronted the history of land and other legacies of colonialism that are traced in the museum and its history of collecting, classification and display. Whether a whole body or a reassembled part of a car, Yahgulanaas' coppered creations were purposefully charged to spark narratives and conversations about the Indigenous-settler encounter, the idea of ownership and belonging, objects of value and reclaiming the past.

CULTURAL RECLAMATION

Pedal to the Meddle consists of a Pontiac Firefly, a small hatchback car that has been transfigured into a black sculptural form with copper accents. When Yahgulanaas first spotted the used Firefly, it had bright-blue bodywork, a classic economy car colour of the 1990s, and it was parked on the side of a road with a 'for sale' sign. He bought it, regarding it as a fantastic *objet trouvé* and 'canvas' for extending his Haida manga meddling. With its body gutted, the car was dipped in acid, spray-painted black and covered in sparkling argillite dust. The copious quantity of dust effectively transformed the car into a large-scale argillite sculpture. Like the historical argillite carvings Haida artists fashioned combining Indigenous imagery and Western decorative wares, *Pedal to the Meddle* is a hybridized or culturally modified commodity, based on an appropriated form, transfigured by Indigenous matter and iconography. Yahgulanaas obtained the argillite dust from the Haida carver Ronnie Russ. It was the residue of carving for more than three decades for the art market, which Russ had preserved in his workshop.

Contrasting with the shiny black surfaces of the body, certain elements of the Firefly—the trim, the indicator and headlights, the hubcaps, the windshield wipers, the Firefly nameplate and the Pontiac Native American Indian arrowhead logo—are covered in copper leaf.

On the hood, there is a large-scale Haida manga image of Cliff executed in copper paint. Cliff is the personification of the local landscape, specifically the escarpment at the tip of Vancouver's West Point Grey recognized as the traditional, ancestral and unceded territory of the Musqueam First Nation. Cliff is an Indigenous character or shape-shifter, depicted on *Bone Box* as well as a series of Yahgulanaas' watercolour studies. On the car, he is portrayed in action, running across the hood, with his distinctive tree-topped head and Haida-inflected framelines. A smaller humanoid figure appears to be free falling, maybe dropped by Cliff as he extends his right arm or facial features to form a horizon.

When *Pedal to the Meddle* was first displayed, an upturned seven-metre-long dugout canoe was strapped onto the roof of the car. The canoe, part of the museum's permanent collection, is decorated with the distinctive red and black Haida stylized forms: the front, for example, depicts a dogfish.[7] It was designed and carved in 1984 by Bill Reid with the assistance of the Haida carver Guujaaw Nangiitlagada Gidansda and the Kwakwa̱ka'wakw carvers Simon and 'Walas G̱wa'ya̱m–Beau Dick. The mounting involved fastening the canoe, overturned and lengthways, to the car with straps, which passed through the open windows. This mounting system precluded the possibility of visitors opening the car doors and sitting inside, which was one of the ideas that Yahgulanaas was interested in pursuing. He wanted *Pedal to the Meddle* to stimulate interaction, to be a multi-sensory intervention rather than just a visual-optical experience. He recalls wanting a sound-system in or under the car that would play "Californian beats", to disrupt the contemplative aura of the museum space and encourage visitors to linger and socialize near the vehicle.[8] This desire reflects Yahgulanaas' anti-Kantian notion of his artworks as interactive hybrid objects that can foster intercultural dialogue, which resonates with Bourriaud's theorization of relational aesthetics in contemporary art practice. Relational art installations seek to activate the public and erode the idea of a subjective engagement, by encouraging interaction and sociability. While Yahgulanaas' conceptualization of *Pedal to the Meddle* as a form of relational art was unrealized in the Museum of Anthropology—there was no audio component, and visitors were not invited to literally enter into the artwork—these relational possibilities of the work were reimagined and experienced after it was dislocated from its site of origin and located elsewhere.

For its debut, the large-scale composite installation was positioned on the perimeter of the Bill Reid Rotunda—a curvilinear gallery space devoted to the artworks of Bill Reid. The centrepiece of the rotunda is the monumental yellow-cedar carving, *The Raven and the First Men*, 1980. Described as "something of a national emblem", this iconic work was reproduced and circulated, in miniaturized form, along with three other works by Bill Reid, on the Canadian twenty-dollar bill issued in 2004.[9] This fact provokes Yahgulanaas to satirically comment, "The Haidabuck wasn't issued by the Haida Nation … yet it clearly signals that someone sees Indigenous culture as Canadian currency".[10] In part this provided the grist for his interventionist retort. The Pontiac was specifically sited on the edge of the rotunda, with rubberized skid marks tattooed on the museum's grey carpet to give the impression that the car was careening out of the museum. As Yahgulanaas explained, "it looks like we're trying to take the canoe back".[11] Whereas Baalbaki's and Kimsooja's cars are weighed down with

domestic items and clothing that capture the emotional and material ties of personal memory, the Haida canoe strapped on top of the Pontiac Firefly represented the figurative reclaiming of a collective history.[12]

Yahgulanaas' decision to use the body of a Pontiac can similarly be understood as an act of reclamation: a gesture to remember an Indigenous icon, whose name and cultural imagery were appropriated by General Motors. Pontiac (Obwandiyag) was an eighteenth-century leader of the Odawa or Ottawa peoples, who famously opposed the British occupation of the Great Lakes region of eastern Canada. He rose to prominence because of his role in Pontiac's War, 1763–1766, which is named after him and began when he laid siege to Fort Detroit.[13] When General Motors introduced the Pontiac brand in 1926, it used a Native American Indian headdress as its logo, which it replaced in 1957 with a Native American Indian arrowhead design. The company openly exploited the connection between its brand and the warrior chief in its advertising campaigns, co-opting Pontiac as an emblem of American independence and strength. As Francis argues:

> The point is not that General Motors presented a false image of Pontiac. That may or may not be. The point is that the company appropriated an actual historical character and turned him into a commercial icon of the industrial age. A figure who once led an unprecedented resistance against White civilization is now a symbol of that civilization. An important part of Native history is at once trivialised and domesticated. Pontiac is not an isolated example. He represents, in fact, a final stage in the creation of the Imaginary Indian.[14]

Pedal to the Meddle figuratively reclaims or repatriates the icon and simultaneously rejects the neo-Romantic image of the imaginary Indian. The character Cliff is not a noble warrior adorned in traditional regalia but a comic-looking figure, an Indigenous crest emblazoned on the body of an icon that symbolizes, for some, status, freedom, modernity and progress.

Similar strategies of appropriation, repurposing or culturally modifying cars can be seen at work in annie ross' *Forest One*, 2012, and *el Vochol*, 2010, by Huichol (Wixárika) artists from the Bautista and Ortiz families. For *Forest One*, ross, who is a maker and professor in the Department of Indigenous studies at Simon Fraser University, transformed a battered 1956 Nash Metropolitan car with a cracked windshield and missing headlights she found abandoned in a barn in Oregon, into an eccentric woven work of art. In part a response to the deforestation and spoilation of British Columbia's natural heritage, ross, who learnt weaving from her Mayan mother, set about salvaging cedar bark from clear-cut urban forests and other discarded materials such as plastic strapping tape from shipping pallets, skeins of old wool, commemorative china plates, artificial roses and sawn-off bits of wood known as "biscuits" to envelop her vintage car.[15] The body is covered with twined and plaited cedar bark, and embroidered and appliquéd "creatures of nature and of indigenous belief—a snowy owl, a butterfly, a sturgeon, a frog, a Sasquatch, a double-headed serpent—are worked in repurposed wool into the car's exterior covering".[16] In the funky interior, the seats, the steering wheel and trim are covered and upholstered with charity-shop finds including a faux-fur coat and a brightly coloured patchwork quilt. The act of repurposing the car with

salvaged media invites us to reconsider our relationship with nature, our exploitation of the environment, our dependency on extractive industries including fossil fuels and our wastage of resources and manufactured things.

In contrast, *el Vochol*, a vintage Volkswagen Beetle, colloquially known in Mexico as *vocho*, was transformed by a collective of eight Huichol artists from western central Mexico into a beaded artwork. Exploiting their Indigenous practice of creating decorative beadwork forms, such as bowls, animal heads and figures for the tourist market, the Huichol artists embellished the vocho with over 2 million tiny coloured glass beads embedded in resin. The beadwork designs, which include abstract patterns and stylized representations of deer, snake and eagles; deities of the sun, fire, peyote and corn; the eye of god, clouds and rain and a shaman in a canoe, were formulated by Francisco Bautista and based on Huichol beliefs and spiritual practices. Having been exhibited in different venues around the world, from Mexico to Europe and the United States, *el Vochol* seeks to raise awareness of Indigenous lifeways and arts as a means to safeguard culture and secure survival in the twenty-first century. Through its global travels, moving from site to site, Vochol: Huichol Art on Wheels merges Indigenous art and popular culture to celebrate creativity rather than critique our patterns of consumption.

DISLOCATION FROM SITE

Like these other automotive installations, *Pedal to the Meddle* did not remain in situ: it has been creatively reconstituted and exhibited elsewhere. During these different rearticulations, its composition, aesthetics and meanings have been revisioned and modified, which unsettles the founding ideal of site-specific art with its emphasis on location and immobility. When site-specificity emerged as a defined practice in the 1960s, its proponents like Richard Serra stressed the indissoluble significance of site and vehemently defended the immobility or locational 'permanence' of the artworks they created.[17] However, in the last few decades, the notion of permanent displays and the non-circulation of artworks has become more untenable. The contemporary art world is increasingly mobile and hyper-mediated, and an emphasis is placed on changing exhibitions and circulating works. Miwon Kwon introduced the term "unhinging" to describe the way in which site-oriented artworks are being mobilized: they are subject to a form of recommoditization, a process of diversion, circulation and relocation. For Kwon, unhinging is "provoked not so much by aesthetic imperatives as by pressures of the museum culture and the art market".[18] Furthermore, she adds, "generally, the in situ configuration ... is temporary, ostensibly unsuitable for re-presentation anywhere else without altering its meaning, partly because the commission is defined by a unique set of geographical and temporal circumstances and partly because the project is dependent on unpredictable and unprogrammable on-site relations".[19] That site-specific interventions are seemingly unsuitable for relocation is especially applicable to those works whose meanings and forms are heavily dependent on their juxtaposition with or integration of the objects and displays of the host institution. Yahgulanaas' *Pedal to the Meddle*, with its composite dependence

on the Bill Reid canoe and its siting on the edge of the Bill Reid Rotunda, is an exemplary case in point.

When Meddling in the Museum closed, *Pedal to the Meddle* and *Stolen But Recovered* were purchased by the Glenbow Museum in Calgary, Alberta.[20] Before being sent to Alberta, however, *Pedal to the Meddle* was crated and transported to Ottawa-Gatineau to be part of the Scene, a multi-sited biennial festival, which focuses on the arts and cultures of different regions of Canada.[21] In 2009, the Scene focused exclusively on British Columbia: it featured the works of six hundred artists from the province, whose products and practices were exhibited in multiple places, including museums, galleries, theatres, music venues and restaurants.

During the planning stages, *Pedal to the Meddle* was selected as one of the iconic large-scale installations to be displayed in the foyer of the National Arts Centre, the key venue and the starting point of SWARM, the dramatic, ambulatory opening-night party. In preparation for this event, Yahgulanaas set about finding a canoe to enhance his artwork and through a series of avenues came across the *Cereal Box Canoe,* 2000. Part of the Ottawa Art Gallery collection, this multi-coloured canoe was created by Greg Hill, a multidisciplinary Kanyen'Kenhà:Ka Mohawk artist and senior curator at the National Gallery of Canada. It is made of recycled cereal boxes, with the distinctive brand-name packaging visibly forming its exterior skin. The visual media and the form are intended to draw attention to the ways in which capitalism, commercialization and consumerism have impacted Indigenous ways of living. Hill had used the *Cereal Box Canoe* in his 2000 intervention at the Champlain monument in Ottawa and in his 2005 performance, *Portaging Rideau, Paddling the Ottawa to Kanata.*[22] In both cases, the canoe contributed to his ongoing creative campaign, The Kanata Project—Kanata being the Iroquoian word for town or village, from which Canada is derived—which critically reimagines the nation-state, acknowledging the proprietary rights of First Peoples and critiquing the (neo-)colonial practices that devalue Indigenous histories and cultural heritages.[23] For Yahgulanaas the *Cereal Box Canoe* was a perfect fit for his mischief making because it came with "its own history": a history of creatively contesting the colonial past and playfully engaging with the politics of the present.[24]

Hill and Yahgulanaas collaborated together and worked out a way to conjoin their artworks. In this rearticulation, the *Cereal Box Canoe* was mounted laterally on the roof of *Pedal to the Meddle*, like a downturned pair of buffalo horns, which allowed the doors of the car to open, so people could sit inside. The shiny black bodywork mirrored and distorted the cereal box packaging—the Jumbo Shreddies, Honey Nut Cheerios and the like—adding more reflective layers of history and meaning.

In preparation for the Scene's opening event, which included a series of performances in the foyer, Yahgulanaas filled the trunk with drinks and party snacks. During the Anishinaabe artist Rebecca Belmore's powerful performance *Victorious*—created as a response to Prime Minister Stephen Harper's apology to former students of Indian residential schools in Canada —Yahgulanaas recalled sitting in *Pedal to the Meddle* with a number of other First Nation artists, socializing, consuming the refreshments and viewing the act. Working from an image of Queen Victoria, Belmore ceremonially dressed her 'monarch' Daina Warren in a spectacular paper and honey costume. As

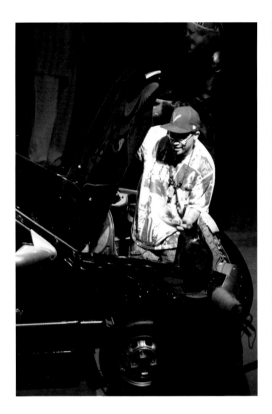

Pedal to the Meddle, 2007, with Haida artist Corey Bulpitt NaiKun Qigawaay (left) and *Cereal Box Canoe*, 2000, by Greg Hill (right), National Arts Centre, Ottawa, 2009

the First Nation Queen was nearing completion, there was a choral and crowd crescendo of the royal anthem, "God Save the Queen". Yahgulanaas reminisced, "we all stood up singing, belting it out".[25] In effect, Yahgulanaas' utopian ideal of *Pedal to the Meddle* as a piece of relational art, which to use Bourriaud's words, refers to art that takes "as its theoretical horizon the realm of human interactions and its social context, rather than the assertion of an independent and *private* symbolic space", was seemingly attained during SWARM.[26]

THE FIX

The interior of *Pedal to the Meddle* was also used as a relational space for socializing and consuming refreshments at the opening of the exhibition Michael Nicoll Yahgulanaas: Exploring Haida Manga at the Glenbow Museum. But this boundary-pushing use of the museum object, by the public not the artist, which apparently left debris inside the artwork and scars on the installation floor, led to another form of dislocation. With institutional concern for the preservation of its recent acquisition, after the opening event, stanchion barriers were installed in the gallery thereby preventing the public from physically engaging with *Pedal to the Meddle*. This barrier to engagement was problematic because as it countered the desire of the artist. The curator Quyen Hoang explains, "Michael wanted this to be an interactive piece that you could move around, get inside, listen to some music. He was even open to artists responding to it. He didn't want a static sculpture just to be contemplated. He wants people to engage with it and with contemporary issues".[27]

While *Pedal to the Meddle* was effectively rendered a non-relational artwork in the Glenbow Museum, its potential to articulate contemporary issues, to offer political critique, to provoke social

commentary and to animate conversation was still threaded through the exhibition. But in this context, Yahgulanaas' intervention took the form of a more generalized critique—touching on Indigenous issues, land and environmental politics, provincial and state policies, as well as global ecologies—rather than being specifically directed at the host museum, an institution with a reputation for promoting a corporate management model, philosophy and structure.[28]

The icon of the exhibition, which emblazoned the publicity poster, was *Pedal to the Meddle*. Whereas Yahgulanaas' other artworks were mounted as discrete objects, the car was rearticulated as part of a composite installation that drew on the museum's permanent collection to impart a critical message regarding the local-global eco-politics of land, with a light accent on the province of Alberta. The curatorial process surrounding the rearticulation and siting of *Pedal to the Meddle* unfolded as a collaboration between the artist and the curator. But it also brought to light conflicts of interest within the institution surrounding issues of ownership and intellectual property rights. Hoang's role, it seems, was complicated because she was mediating at multiple levels, not only between the artist and the institution but also between these subject positions and her curatorial self. As a curator, she says, "I am very interested in having an open, transparent process and working collaboratively and giving voice to artists and communities", but the institution had a different set of priorities and values that had to be accommodated.[29]

The realization of *Pedal to the Meddle* at the Glenbow Museum, as elsewhere, reveals a story of creative ideas and pragmatic compromises. Hoang elucidates further:

> The car was probably the most ambitious part of the project because we went through many phases: What are we going to do with it? ... We didn't want the canoe ... We are on Plains Indian Territory, so we thought about the possibility of tipi poles on top ... [But] very early in the process Michael made it clear that he wanted to respond to the tar sands, which made me think that we could use the Edward Burtynsky collection ... The content of his works really resonated with Michael and his concerns with the ideas of progress and how that alters our landscape ... I suggested that we could project Burtynsky's images and Michael suggested having a stretch of highway with an oil slick. He wanted the car to be skidding [balanced on two wheels] against the wall. We explored that possibility but it was too expensive ... But we did create the oil-slicked highway. The road surface is painted canvas, it looks like asphalt, and Burtynsky's photographs create vistas along the route.[30]

Economics also precluded projecting the photographic images and creating movement. In the end, the *Pedal to the Meddle* installation included four framed images from the altered landscapes series by Edward Burtynsky. Through poetics and pathos these images capture the raping of the earth's resources and the extensive degradation of the landscape, facilitated by corporate greed and dirty politics, which resonate with the exploitation of the Albertan tar sands. However, framed and mounted at regular intervals on the gallery walls, these images were isolated, detached and distanced from the car. The phenomenological awareness of the disconnect between the photographs and *Pedal to the Meddle*, as well as an overall sense of separation and stasis were catalyzed by the systems of display and the architectonics

of space. With its fitted carpet, low lighting and ceiling tiles, the gallery exudes a dated, conference centre aesthetic. That *Pedal to the Meddle* was displayed in a quarantined state, separated by the line of stanchions, which made it difficult to view the domestic-scaled framed photographs up-close, arguably precluded the possibility of an immersive experience. Hence, the installation failed, in my opinion, to convey a coherent and powerful critique. In his recollection Yahgulanaas captures the way in which the different unhingings of *Pedal to the Meddle* created interesting new combinations and social spaces but also had the potential to result in a misalignment or an unsatisfactory fix:

> In Calgary, the way it ended up was parked. It was definitely parked even though there was visual reference to it skidding on the oil. In Vancouver, it was flying, in many ways, because it had Bill [Reid]'s canoe on it and the Raven meddling in it ... In Ottawa, I think it was also flying, with the *Cereal Box Canoe* and the people in it during the SWARM events ... but when I saw it at Glenbow, I really felt—as much as we had the macadam, the oil spill, and ... the Burtynsky photographs—for me, it still felt parked. It was STILL ... As I told them in an email, as well as verbally: *Pedal to the Meddle* is a vehicle and it's supposed to be used by other people. They're *not* to show it in the same way, time after time, it's supposed to change ... You can't just pin it down to one place and time.[31]

COPPERS FROM THE HOOD

Yahgulanaas' repurposing of automobile parts as a means to playfully explore the politics of cultural heritage—the creation of value and the encoding of meaning—is arguably most pronounced in his *Coppers from the Hood* series. The two Coppers or 'shields' *Stolen But Recovered* and *Two Sisters*, made for the Meddling in the Museum exhibition, are the prototypes of this series. Each shield consists of two car hoods that are welded together to create a large metal diptych. These resonant metal forms were dipped in an acid bath, before being covered in copper leaf and decorated with Yahgulanaas' distinctive Haida manga design. The outline form, surface lustre and imagery conjure, as Yahgulanaas observes, "a memory of the traditional copper shields of the Haida".[32]

Historically, Coppers were among the most valuable objects—symbols of prestige and wealth with mythological associations—for certain coastal peoples, such as the Haida, Tlingit and Kwakwa̲ka'wakw. Despite differences in size and iconography, Indigenous Northwest Coast Coppers share a common basic form and materiality: each one is "a flat, shield-shaped object made of copper, its distinctive shape comprised of two parts—a flaring, trapezoidal upper portion and a rectangular lower section—which are united by the horizontal cross bar of a raised T form".[33] The upper section is generally decorated. For example, Haida Coppers *(t'aaGuu)* are typically embellished with stylized representations of crest animals: Raven, Eagle, Bear and Killer Whale. Belonging to chiefs and high-ranking families, they were prominent among the categories of objects displayed and enacted at potlatches. With the colonial prohibition of such ceremonies, Coppers were also among the treasures confiscated and consigned to museums.

top Yahgulanaas and *Two Sisters* Copper, outside the UBC Museum of Anthropology, Vancouver, 2007

bottom Haida chief NEnkaidsuglas, David McKay of the Ya'ku gitina'-I, standing with a Copper, in front of his house in the village of Xaaya (Haina), ca. 1888

At potlatches, Coppers were not only presented as valuable gifts, they could also be 'broken' or cut into smaller pieces and "distributed by the host to honour respected guests or to pay for deeds not equaling the full value of the copper".[34] In other cases, the public 'breaking' of a Copper was considered to be an act of confrontation and insult that was intended to "challenge, obligate or shame" an adversary. Jisgang Nika Collison explains, "The confronted person, if they wish to save face, must meet or exceed the presented challenge by righting a wrong, repaying a debt, or by demonstrating greater status and wealth than their opponent".[35] Value not only resides in the material object but the act of giving it away. Guujaaw Nangiitlagada Gidansda illuminates this intricate Indigenous system of value in which Coppers circulate:

> More than a mystical geometric form
> and challenging piece of metallurgy
> the Copper's function is central
> to a complex economic system
> whereby, in the measure of wealth
> a song or a name can be
> more valuable than material possessions
> influence is gained through respect
> earned through life deeds
> where prestige is the reward
> gained through distribution
> rather than the accumulation of wealth
> the value of the Copper measured
> in accordance with that given
> This is the weight of the Copper.[36]

As Coppers circulate, whether intact or in pieces, they too accrue additional value and meaning: "The value of a copper depends on the history it acquires. A gifted copper or piece of copper holds value; a piece of copper presented in a challenge becomes a debt; the sum total of a *t'aaGuu* that's been put back together—its pieces reacquired through purchase, gift or payment of debt—can far exceed its original worth".[37] In 2013, Walas G̲wa'ya̲m Beau Dick, a hereditary chief and acclaimed artist of the Musg̲amakw Dzawada̲'enux̲w peoples, who worked on the 1984 Bill Reid canoe project with Guujaaw Nangiitlagada Gidansda, 'resurrected' what he described as this "long-dormant ritual shaming practice" of breaking the Copper as a means to challenge the Government of Canada.[38] In July 2014, with an entourage of supporters and activists, Beau Dick made the journey of five thousand kilometres across Canada, from Vancouver to the seat of government, Parliament Hill, in Ottawa with a large Haida Copper, which had been made by Guujaaw Nangiitlagada Gidansda on Haida Gwaii, to perform the shaming ceremony.

In front of Parliament, in a symbolically arranged sacred space, displaying regalia, chests, blankets and masks, Guujaaw Nangiitlagada Gidansda and his son Gwaai Edenshaw unwrapped and paraded the Copper. It was then ceremonially broken on the artwork *WE ARE SORRY*, 2013, by Cathy Busby, a large vinyl text panel composed of excerpts from the 2008 apology issued by Prime Minister Stephen Harper on behalf of Canadians to survivors of the Indian residential schools system. However, the ceremony of shaming was not directed at Canadians as the official statement made clear:

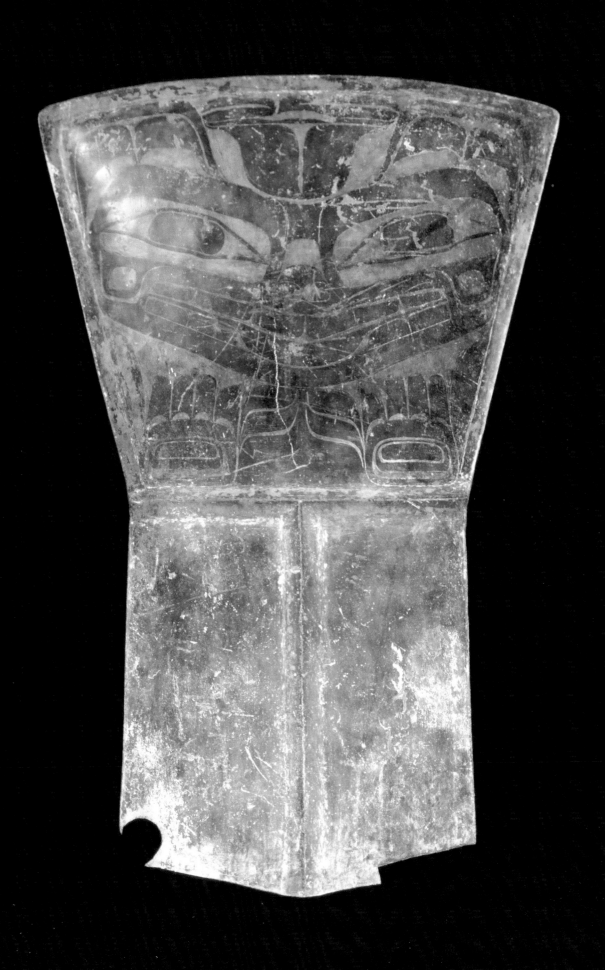

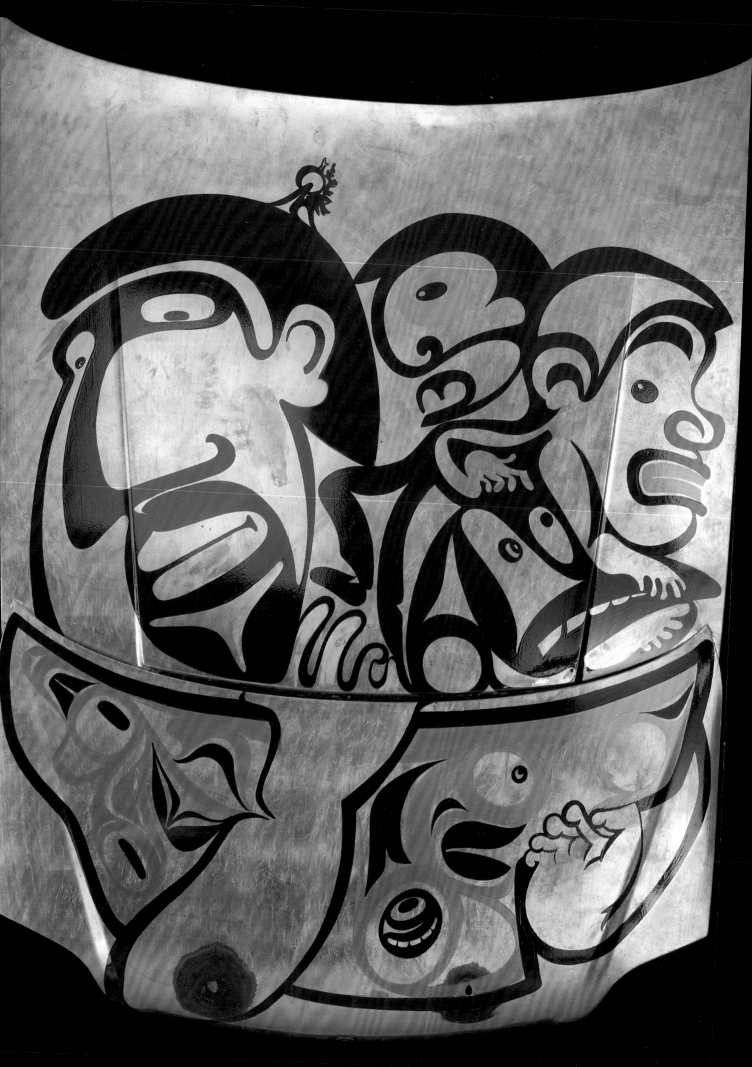

The copper symbolises our wealth ... we break this copper, we break it at the doorstep of the government of Canada with a great sense of celebration. We break this copper not as a slight to Canada or an insult to Canadians who have shown us nothing but support and encouragement. In breaking this copper we confront the tyranny of the government of Canada who has forsaken human rights and turned its back on nature in the interests of the almighty dollar.[39]

The act was not only a challenge to the government to repair its broken relations with First Nations but also an invitation for Canadian and global citizens to engage in environmental debates and issues like the Albertan oil sands and pipeline projects, which are threatening our shared lands and interdependent ecologies.

The idea of mobilizing Coppers to critique hegemonic systems, reclaim heritage practices and forms and open a space for intercultural dialogue on contemporary issues and popular culture underpins Yahgulanaas' Hoods project. In his prototype, *Stolen But Recovered*, 2007, which works in dialogue with *Pedal to the Meddle*, Yahgulanaas conjoined a Pontiac and a Plymouth hood. As is his customary practice, the title, materiality and iconography of this Copper contain multiple references, both playful and punning diversions. The title *Stolen But Recovered* replicates the exact wording on the police or coppers' label that was stuck to the underside of the Plymouth hood, which Yahgulanaas discovered when looking for inspiration in a "field of wrecked automobiles", in a scrapyard in Delta, British Columbia. The graphic imagery continues this idea of 'theft' and reclamation and explicitly connects with *Pedal to the Meddle*. It depicts four comic characters, an animated gaggle of caricatures including the mischievous Raven, 'stealing' away in a Haida canoe.

The decision to transform car hoods into contemporary Coppers was not only inspired by the semblance of aesthetic forms—the outline shapes and metallic bodies—but also by the symbolic processes of creating value. In describing the historical significance and value of Coppers for the Haida, Yahgulanaas touches on these points of comparison: "When made ... a copper shield began a journey, accumulating a lineage of value and esteem, often marked by events that, while resulting in destruction or 'damage' to the physical form, would enhance the shield's potency as a symbol of the transformation of material wealth into a more sophisticated form of value".[40] Similarly, the *Coppers from the Hood* series indexes this process of transformation: the salvaging of damaged objects of status—cars being a quintessential symbol of individual standing and family prestige—and their rearticulation and recommoditization as a more complex form of wealth. The car part becomes art and thus attains a more sophisticated and metaphysical form of value with added history.

Two Sisters embodies a different form of historical reclamation. The title refers to the Indigenous name for the two mountain peaks that define the Vancouver skyline, depicted on *Bone Box* and other painted forms. The name *Two Sisters* is rooted in First Nation oral narratives that tell of the history and sacred geography of place. In this case, two sisters, the daughters of a local Salishan chief, were transformed by the Sky Brothers or Transformers into mountain peaks in recognition of their roles in bringing peace through marriage and reconciliation between the warring Squamish and Haida Nations. In the colonial period, these dominant topographical features were renamed the Lions, which suppressed Indigenous histories and alternative ways of understanding the landscape. Yahgulanaas' Copper *Two Sisters* challenges the colonial mapping and assumed entitlement to land as it reasserts this Indigenous

narrative in the public sphere. This point was made explicit in the original siting of the two Coppers.

Two Sisters and *Stolen But Recovered* were exhibited at the main entrance to the UBC Museum of Anthropology. Each Copper was mounted on one of the concrete posts that form a series of modernist, geometric post-and-lintel structures and lead to the double-fronted glass doors. In situ, these Coppers literally faced and challenged the nation-state's inscription commemorating the inauguration of the museum. More specifically, on two of the parallel concrete supports, French and English inscriptions detail the federal government's contribution toward the construction of the museum. This inscription reads "to honour the centenary of the Province's entry into the confederation in the conviction that it [the museum] will serve and bring pleasure to the people of the Nation". As Yahgulanaas contends, "inscribed on the bones of the museum", this effectively constitutes a "land-claim statement" that needs problematizing because as it overlooks the fact that the museum is sited on the unceded ancestral lands of the Coast Salish.[41] It was within this polemical context that the two prototypical *Coppers from the Hood* were originated as a form of institutional critique. They were conceptualized to stimulate a conversation around the politics of ownership and especially the issue of land rights, which are subtly implicated in the provincial and the federal governments' assumed proprietary right to build the museum on unceded Musqueam land and gift it to the people of Canada.

The contentious subject of land rights resonates through the word 'hood' used in the title of the series *Coppers from the Hood*. Yahgulanaas expounds on this pun: "Hoods refer to neighbourhood, community, tribe, nation state, land, and territory, and includes the various and conflicting identities and claims that construct the current political, legal, and moral landscape we call Canada".[42] For him, the Haida manga Coppers represent an "obvious commentary on a long line of constitutionally inconsistent activities by Canadian governments regarding land and governance".[43]

THE MUSEUM AND THE WOODWORM

From 2007 onward, Yahgulanaas has continued to expand and explore the fertile territory of cars and coppers, as aesthetic media and highly symbolic forms. He even suggests that the car, with its meticulous engineering, smooth contours and association with mobility and wealth, can be regarded as "the modern canoe".[44] In addition to hoods, he has requisitioned fuel cap doors for his series entitled *Flappes* and Volvo sunroof panels for his *Volvoxii* series. The name of the latter series not only references the car brand Volvo, the base medium for his paintings, but also *volvoxii*, a species of freshwater algae that lives in colonies. This species acts as a metaphor for the content of the imagery, as Yahgulanaas reveals:

> *Volvoxii* reflects on the importance of an ability to quickly adapt, to change one's mind, to respond and to evolve in demanding circumstances. Individual volvox form large colonies of tens of thousands of individuals. *Volvoxii* considers individualism in service of community. Volvox dance, they spin and waltz. *Volvoxii* dance with classic North Pacific design principles ... The work is a series, a contemplation on how individual pieces maintain personal identity and still serve the group.[45]

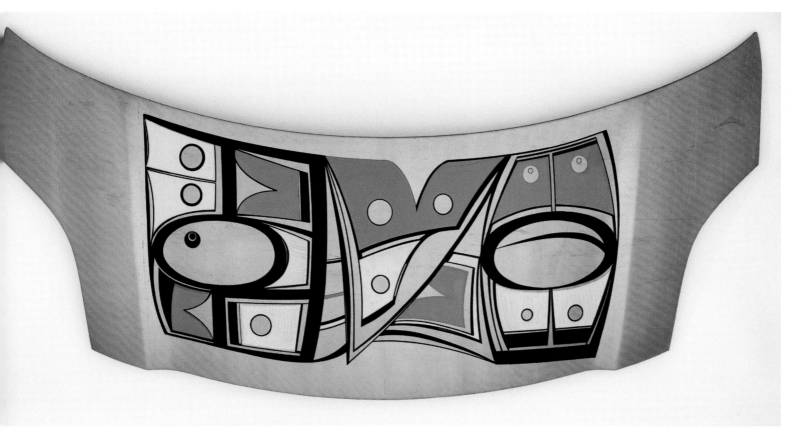

Untitled, 2014, *Coppers from the Hood* series (back and front)

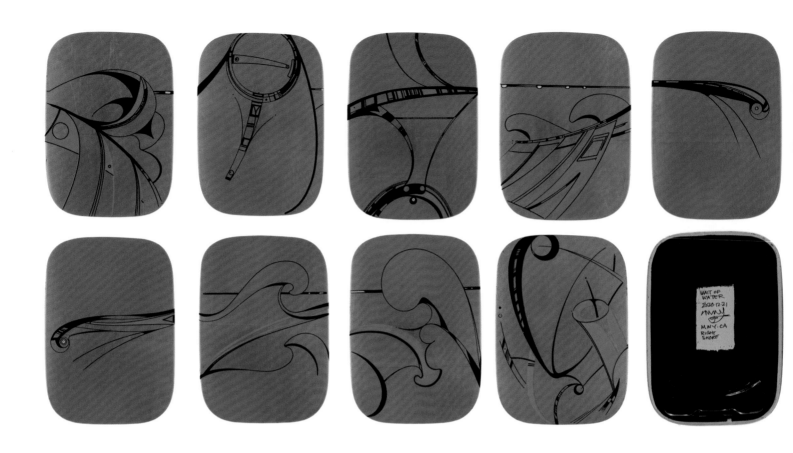

Wait of Water, 2020, *Flappes* series

Looking at the imagery from different angles, we can see the energy of life forms as they entwine and cannibalize each other, with abstracted bodies, peeping eyes and twisting limbs or flagella.

For the *Volvoxii* series, Yahgulanaas acquired fifteen, all of the remaining 1992 model Volvo sunroof panels, from car dealers across North America. His choice of the 1992 model was based on the aesthetic appeal and size of the panel: it is a highly geometric flat-surfaced quadrangle, in contrast to the moulded, curvilinear, convex and undulated surfaces of hoods. He notes, "These steel roofs have a very simple yet sophisticated shape … The proportions as well as the detailed edges appear to be simple but are really the results of the most sophisticated aerodynamic engineering".[46] Moreover, the date of manufacture, 1992, is a poignant reminder of the harbinger of colonialism. It was a year in which Indigenous peoples in the New World rose to protest and challenge the celebrations that were being held to mark the five-hundred-year anniversary of Christopher Columbus' historic voyage of 1492.[47] The general rallying cry was that Columbus did not 'discover' the New World because Indigenous people were already there. He was not a discoverer but an invader.

Whereas the Detroit artist Tyree Guyton relies on battered and abandoned car parts for his *Faces in the Hood* series, which speaks to the disenfranchised and decayed urban environment where he sources and places his art as part of his ongoing Heidelberg Project, Yahgulanaas now prefers to work with unused body parts. To a certain extent this preference is based on practical matters: it takes time to clean, to strip away the dirt, oil and residue and prepare a hood or some other component for coating in copper leaf. Plus the

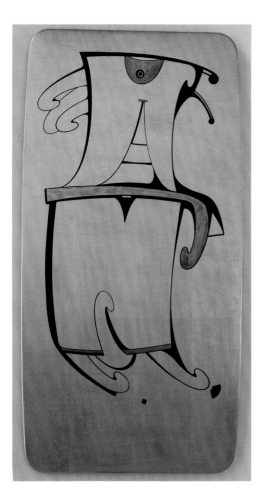 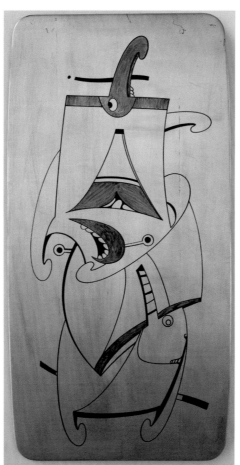 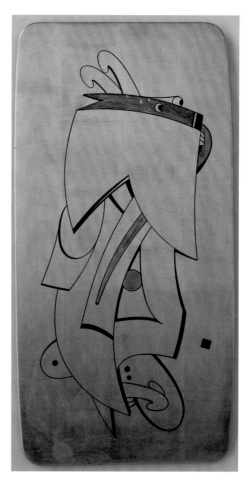

Untitled, 2012, *Volvoxii* series

unblemished surface of 'new' body parts allows the copper leaf to attain a smoother, reflective texture. The surface sheen enables ghosts or silhouettes and shadows of the viewer and the Haida manga imagery to converge. This interest in the skin of things providing a metaphysical point of access into the sculptural form is exemplified in the monumental artworks of Anish Kapoor, whom Yahgulanaas greatly admires. From the intensely coloured powdery pigments exploited in his series *1000 Names*, 1979–1995, to the shiny polished stainless steel skins of works like *Turning the World Inside Out*, 1995, or *Sky Mirror*, 2001–2013, Kapoor plays with ideas of perception and the poetics of being in the world. According to Kapoor the highly polished metallic skins are "in fact not different from the pigment" surfaces because they too are intended "to make something else possible".[48] In Teverson's words, "they use their reflective qualities to draw in the world around them and to blur the boundaries between the seen and the unseen".[49] In conversation with Kapoor, Homi Bhabha makes more explicit the relationships and interplay between the visible and the invisible, between individual and collective histories as they surface and recede in Kapoor's sculptures. He notes, "through the erasure of a particular kind of individualist history of the self ... a ... much more collective" public recognition of the past in the present can emerge, which he stresses is "no less a part of the inter-subjective space. A space where the erasure of a memory or the suppression of a subject's history becomes the element of recognition that provides the links for a community, or the narrative of its history".[50] We can detect this erasure and collective identification at work in Yahgulanaas'

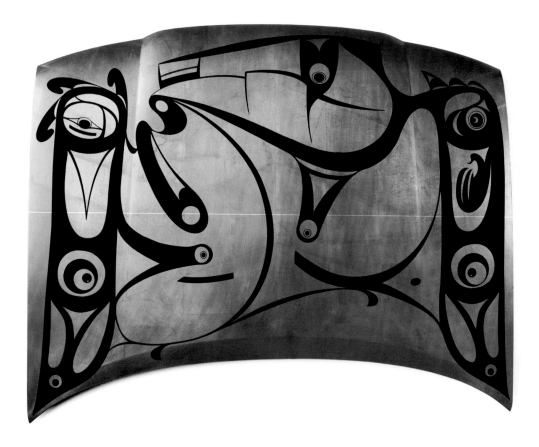

Copper From the Hood, 2011

modified car bodies. They embody and reflect intercultural histories rather than the autobiography of the artist: they invite us to reflect on the narratives of metal belongings and other matter and their symbolic meanings and biographical trajectories.

Although Yahgulanaas has not created any more site-specific coppers, the shield he made for the British Museum *Copper From the Hood,* 2011, certainly plays with the idea of history and destination. Commissioned by the museum's Department of Africa, Oceania and the Americas, whose collection of about 350,000 objects contains contemporary, historical and archaeological Haida material, including totem poles, masks, bentwood boxes, coppers and carved feast bowls, Yahgulanaas' copper is intended to challenge public expectations. As Jonathan King, the former keeper of anthropology at the British Museum, elucidates, "What is exceptional about Michael Nicoll Yahgulanaas' art is the imaginative leap—how Michael's design sense and sure skill in drawing and conceptual realisation—enables him to re-situate the Haida. Using crests and formline designs he transcends the traditional to create new works which express contemporary Haida identities"[51] in a world where cars and other consumer goods have replaced "traditional coppers as symbols of wealth in Haida Gwaii".[52] King explains further: "While Haida artists continue to make modern works in wood, acquiring a contemporary work in wood might send a message to ... [the audience] that nothing has changed and everything has survived intact in Haida Gwaii", which was not the kind of message the museum wanted to promote.[53]

The British Museum's *Copper from the Hood* is made from the bonnet of a Toyota Tercel. The striking black calligraphic imagery depicts among other forms a small bird and a woodworm. It has been suggested that this refers to the Haida oral history concerning a young girl who

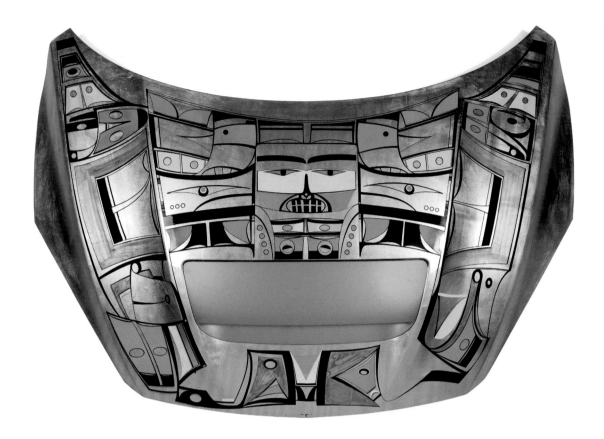

Naaxiin, 2013

secretly kept a woodworm as a pet. She constantly fed her hidden woodworm to such a degree it became insatiable. It began devouring everything in sight. When the Haida people discovered the gluttonous creature, they were forced to kill it to prevent it from eating all their supplies.[54] There is a playful prank at work: in sending his Copper to the British Museum, Yahgulanaas knew that the woodworm would be placed among thousands of wooden objects, 'hidden' treasures to be consumed. The imagery can therefore be understood as an ongoing critique of museums as keepers and containers of cultural heritage.

METAL REGALIA

The concept of using car bodies as base media to open a space for reflection on different systems and objects of value similarly informs the large-scale Copper, *Naaxiin*, 2013. Departing from the more fluid asymmetrical frameline characters depicted on other Coppers, the painting on *Naaxiin* fills the available surface space with a geometric cellular pattern. The cells are filled with abstract shapes, as well as humanoid features, such as the omnipresent eye, and accented with colour. There are blocks of bright blue, primary yellow and liquid red. The name, the shape of the hood and the colours and content of the bold imagery refer to naaxiin (also known as Chilkat), which is described as "the most revered of textile arts on the Northwest Coast", whose cellular and "more squared" formline pattern is said to echo the design found on early bentwood boxes, rather than the more curvilinear compositions on later forms.[55] The distinctive colours of the naaxiin weavings were created using handspun mountain goats' wool and natural dyes: black from hemlock bark, yellow from wolf

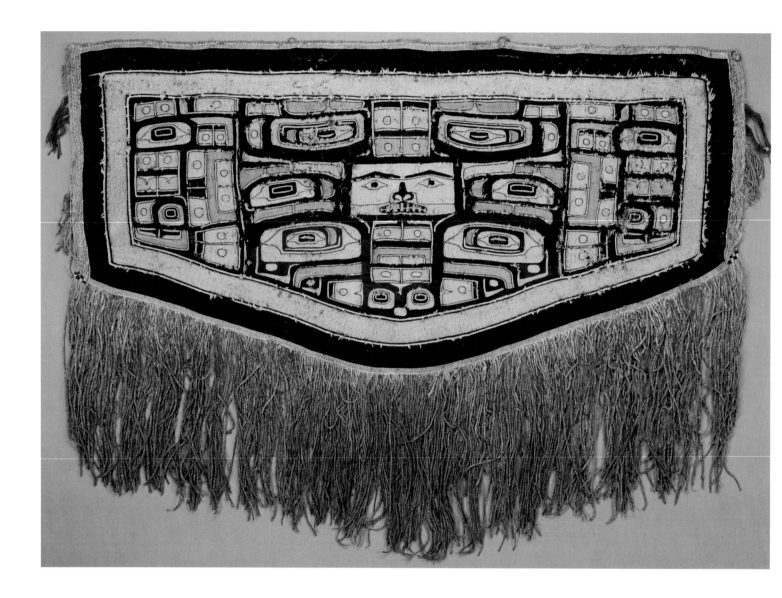

above Naaxiin robe, Haida, before 1931

opposite Naaxiin tunic, Haida, ca. 1800–1850

moss and slate green from wolf moss combined with blue from copper or trade blankets. The designs of the earliest naaxiin garments were, it is thought, provided by shamans, whose spirit helpers enabled them to materialize their visions in paintings that were then passed on to accomplished weavers. The acclaimed Haida weaver and naaxiin creator Evelyn Vanderhoop (Kujuuhl) eloquently explains:

> Strict adherence to the conventional patterns originated by the supernatural could ensure their favour. The ancient patterns abstracted the living beings into the two-dimensional format of the woven matrix, splaying wing, fin, face and joints bilaterally across the woven plane. The abstract presentation of conventionalised symbols of the Eagle's talon and beak, the fin and fluke of the Whale, the teeth and tail of the Beaver, as well as the supernatural juxtaposition of hand and fin, fluke and wing, often puzzle people not privy to the oral histories of the Northwest Coast clans and nations. Indeed, early ethnologists such as George Emmons, Franz Boas and John Swanton often disagreed about which animal or spirit being was depicted in the bilateral designs centred within the broad black and yellow bands of the Naaxiin robe.[56]

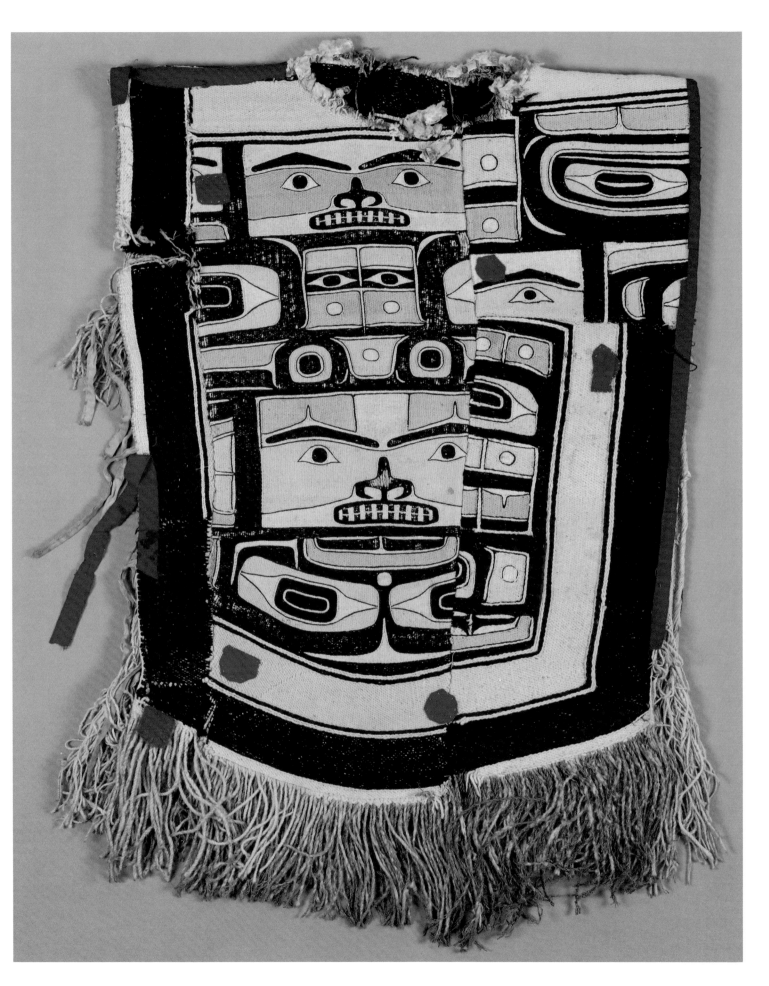

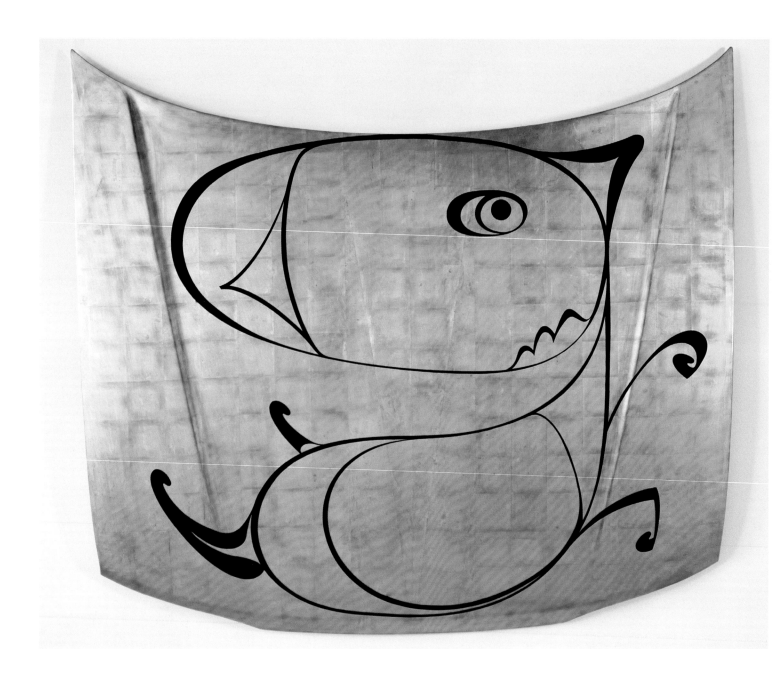

Untitled, 2010

Despite the socio-economic and cultural upheavals caused by colonialism, acculturation and exchange, this distinctive five-sided textile garment, woven from wool and often edged with sea otter fur and extended with an elegant fringe, continues to be a highly desired form of wealth:

> The esteemed Naaxiin chief's robe draped the shoulders of leaders ... showing their allegiance to ancestors and the supernatural. In early hierarchical Haida society, the robe, with its bold formline iconography, declared clan prerogatives, power and wealth. Today, in the 21st century, 230 years since first recorded European contact with the Northwest Coast, it remains the garment most coveted by First Nation chiefs, leaders and dancers. [57]

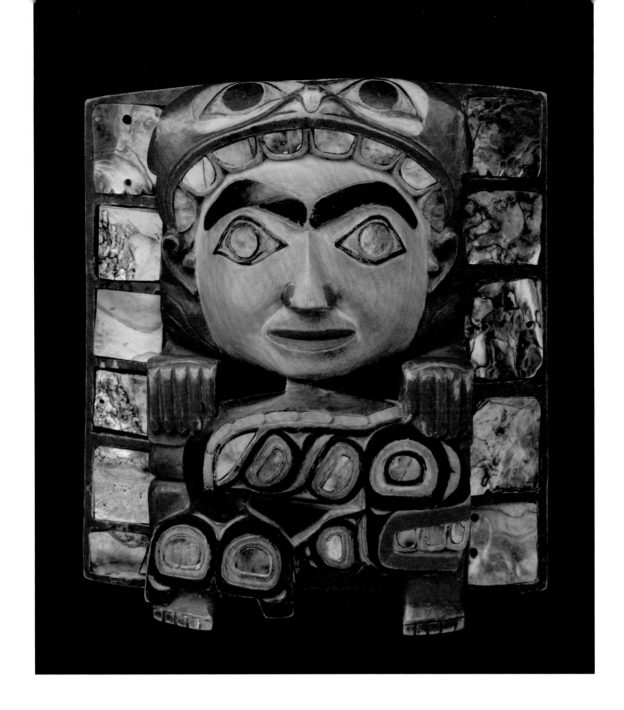

Albert Edward Edenshaw, *Headdress Frontlet (Sakiñ.id)*, ca. 1870

It is not only striking in appearance: it is a "technology of enchantment" that truly captivates the beholder because when worn, due to its weight and structural properties, it moves in the most spellbinding way.[58] The naaxiin dances alongside its wearer. The wealth and prestige associated with naaxiin are attested to in their historical role in the potlatch. Chiefs could increase their social status and prestige by giving away their naaxiin: "If there was no chief attending of high enough rank to receive it, the blanket might be cut into strips and distributed to a number of persons of prestige. These strips would be made into other ceremonial garments, such as shirts, aprons, leggings, headdresses, or bags".[59] The naaxiin tunic illustrated on page 121 was sewn together from pieces cut from different robes, as Evelyn Vanderhoop notes: "This tunic demonstrates the owner's high rank, as he received enough cut naaxiin pieces to create a single garment. If the tunic was created by assembling pieces received by both the wearer and his clan members, this could indicate not only his high standing, but that of his clan as well".[60]

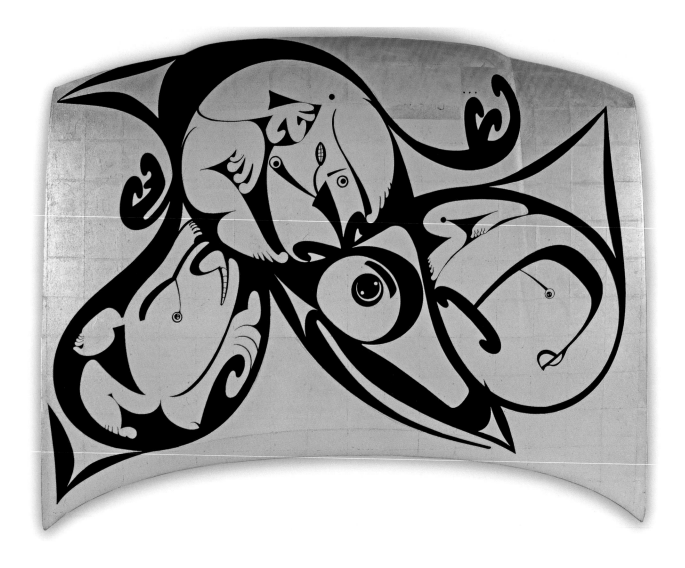

Yelthadaas, 2010

OTHER PRECIOUS FORMS

Through playing with cross-cultural symbols of status and worth—cars, Coppers and naaxiin—Yahgulanaas invites us to reflect on the different systems of value that privilege certain substances and objects, transforming them into precious and covetous things. In extending his exploration of meaning and media, he has moved beyond copper to platinum and gold. These precious metals, like gemstones, occupy the upper echelons of our hierarchies of value. It is these very substances that Damien Hirst exploited in his wish to create the "most expensive art object ever made": *For the Love of God*, 2007, a platinum cast of a human skull encrusted with over eight thousand flawless diamonds.[61] Said to be part inspired by the *vanitas* of the Dutch Golden Age and an Aztec turquoise-inlaid skull at the British Museum, *For the Love of God* twists these past practices and enables us to witness the gross materialism of contemporary consumer culture that radically fetishizes and consecrates certain branded commodities, institutions, artists and art.

For different cultures, precious substances have historically been imbued with symbolic, mythological, aesthetic and sensory properties that are not reducible to outward material form and economic worth. The Aztecs (or Mexica), for example, highly prized obsidian, jade and

turquoise, as Hirst's British Museum muse reveals. These materials were suffused with excess meaning. Turquoise, like other minerals, possessed its own unique qualities and relationship to deities and the intertwined natural and supernatural worlds. Its iridescent surface was said to smoke, embodying the energies of deities like the feathered serpent Quetzalcóatl, who is associated with underground waters that transform into clouds that make the rain and enable crops to grow.[62] This transferability between different registers of knowing and perceiving the world, between the material and the metaphysical and the landscape and the spiritual, is similarly articulated in Haida worldviews. The frontlet (*Sakíi.id*) is an example of a material thing that incorporates many precious substances and symbols. Worn on the forehead of persons of high rank to symbolize their power and wealth, frontlets are frequently inset with shiny copper plates and the shimmering abalone shell and further adorned with sea lion whiskers and ermine pelts. Yahgulanaas is especially captivated by the materiality and expressive form of the frontlet attributed to his ancestor Albert Edward Edenshaw. It encapsulates the story of a family clan member who wore the protective skin of a sea monster when fishing in deep waters. In this painted maple wood carving, decorated with abalone shells, we see the eyes and the beak of the glistening-toothed monster crowning the fisherman's head, and in his hands he holds his catch: a black whale. This image forms the central frameline of *Carpe Fin*.

The intermingling of narrative and imagery enhanced by iridescent and precious matter is captured in Yahgulanaas' platinum shield or heraldry device, *Yelthadaas*, 2010. The imagery depicts a swooping Raven, with a mischievous glinting eye. The wings and the body act as chambers that contain surreal shapes and characters. Twisted and contorted humanoid animal and plant-like forms and legs that walk without bodies attached, conjure up the whimsical essence of a Miró, such as *Figures at Night Guided by the Phosphorescent Tracks of Snails*, 1940, from his *Constellation* series. *Yelthadaas* references the Haida creation story of Raven bringing light to the world. In the beginning Raven's feathers were silky-white but when they stole the light from an old man, who kept it hidden in a box in his house, to escape Raven was forced to fly up the smokehole, and their plumage was forever transformed by the soot and smoke. Although Raven brought light, casting the sun and the moon and the stars into the sky, the trickster was destined to be a pitch-black entity. The silvery-white lustre of the platinum leaf on the steel base of *Yelthadaas* not only alludes to Raven's plumage before it was transformed but also to the luminous surface of celestial bodies like the moon that Raven hung in the sky.

It is not surprising to learn that along with naaxiin textile art, the other equally prestigious form of Haida weaving is *Yeil koowu* or Raven's Tail weaving. Yahgulanaas' sister Lisa Hageman Yahjaanaas is an award-winning practitioner. Growing up and living on Haida Gwaii, her artistic philosophy is inextricably intertwined with her Haida ways of being and knowing that resonate with those of her older brother. In describing the symbolism of her exquisite robe *Raining Gold,* which is shot through with golden thread, she reveals,

top *Craft*, 2012

bottom Lisa Hageman Yahjaanaas
Raining Gold, 2017 (front and detail)

The topmost pattern is called Waters of Gwaii Haanas. I designed it originally as a headdress that belongs to the position of the Superintendent of Gwaii Haanas. It represents the rain that falls

Rivers, 2012

on Gwaii Haanas and becomes the rivulets, rivers and streams flowing into the waters of Haida Gwaii. The sides borders are a continuation of this pattern to represent the oceans of the world that connect us all. Alongside this black-and-white patterning runs a cream-and-cream pattern meant to represent the slanting of falling rain as seen outside our windows regularly and as depicted in Japanese woodblock printing.

Within the main design field, there are two patterns being woven. The first pattern band is that of Longhouses. Ancestral Raven's Tail did not noticeably depict pictorial patterning. The Longhouse design came out of my thoughts of community ... The second pattern band is that of Lightning, a very ancient pattern. This is representative of the incredible power that Haidas have when we work together as one community. The Longhouses are woven in cream on a black background to represent our connection with the Supernatural. This also plays with the artistic notion of positive/negative space. There are five rows of Longhouses on the Chief's robe. This touches upon the Five Realms or Five Sky Villages and the Five Rows of Longhouses that were in the Supernatural Storytowns.

This is my woven homage with gratitude to the Haida system and the earth of which we are all stewards.[63]

CRAFT AS COSMIC AXIS

In Yahgulanaas' oeuvre, there is one artwork that continues his exploration of surfaces and substances, value, meaning and form, which is starkly devoid of imagery: *Craft*, 2012. In the words of the artist:

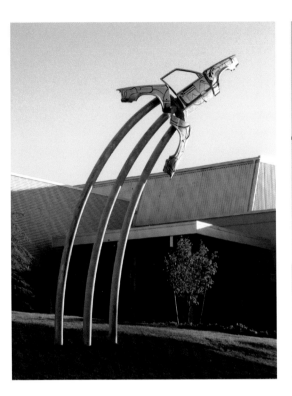
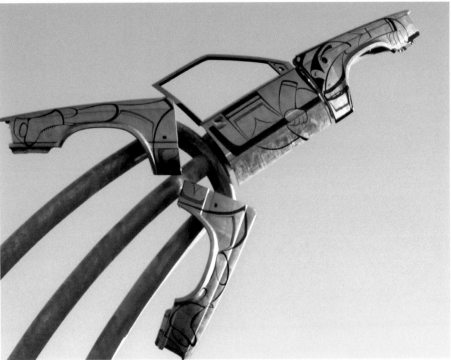

Take Off, 2010

Craft is a 50-foot-long rowboat with a 5-foot beam. It was originally built by Gwiis, Wilfred Bennett, a Tsiit Gitanee, boat builder from Old Massett. He started this boat as an old man shortly before his death, based on his recollections of the skiffs in Massett in which he used to play. This vessel is an historical throwback: when these boats were originally built in the 1900s they were designed to be used as hand-powered salmon boats. Within a short time, machine-powered boats appeared on the horizon all along the west coast ... This double-ended rowboat marks a transition from the intimate relationship between the fisher and the fish. The machine interface leads us ultimately to today with our tremendous industrial impact on the ocean ecosystem ... The inside of the hull is finished with copper leaf ... in direct opposition to the way that copper was attached to the hulls of the historic sailing ships. Historically, copper protected the vessel from the burrowing Teredo clam. This reversal raises the question of what the hull is now being protected from. As with much of my recent work, I am using precious metals, here copper on the hull and platinum on the oars to examine ideas of wealth and value.[64]

Whereas Gwiis' rowboat was intended to sit horizontally on the sea, and indeed Yahgulanaas used it to transport Launette, his pregnant wife, around the shorelines of Haida Gwaii, in the gallery setting, he insists that *Craft* be suspended on high and mounted vertically from its platinum-pointed prow. From this perspective, we can appreciate the craftsmanship and technical virtuosity of form. The curved body has ten geometrically positioned silvery-white oars, exposed like the skeletal ribs of a fish. The metallic skin of the hull and oars accentuate, through reflection and movement of shadow and light, the smooth, curvilinear depths, volumes and contours. There is also another intention that

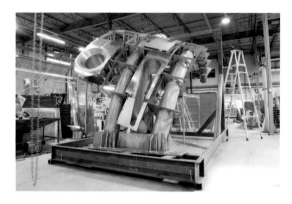

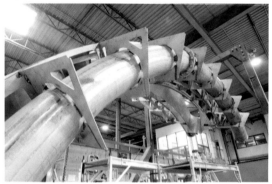

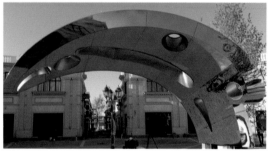

above The fabrication of *Sei*, 2015, and the sculpture in situ

opposite *Sei*, 2015

underpins its perpendicular hanging, as Yahgulanaas reveals: "*Craft* is suspended on the vertical axis, which is the cosmological map according to Haida understanding. The central axis, the axis mundi, the access route to all these levels is represented by the vessel itself".[65] In his fourteen-page graphic narrative, *Haida Cosmic*, 2013, Yahgulanaas further illuminates this cosmology and sacred geography. He begins:

> Somewhere below us all
> Sacred one standing and yet moving
> rests on a copper box.
> A single pillar placed on his chest
> rises up to hold all our worlds
> together as one.[66]

Yahgulanaas concludes his visual mapping of his Haida worldview by returning to the lodestar of this cosmic enterprise, the allegorical canoe:

> There are worlds above and below us
> and all are held together by a single central shaft
> resting on the chest of a supernatural one
> ... still among us all.[67]

A different kind of geography, connected to the physical waterways of British Columbia rather than a sacred cosmology, is captured in Yahgulanaas' monumental site-specific artwork *Rivers*, 2012. Located in Riverside Park in the city of Kamloops, *Rivers* symbolically represents the confluence of the North and South Thompson Rivers that defines the locality. Over ten metres tall and made of anodized aluminum and galvanized steel, this immense sculpture consists of two solid strong arms that soar into the sky, and on their crests are the stylized faces of two androgynous swimmers. Their visages consist of four side profiles that mirror each other but do not touch, creating two open triangular heads. The faces are composed of flat plates of aluminum, anodized and covered in copper leaf, with their features and hair rendered in black oil paint. The abstracted bodies, in front-crawl motion, echo the framelines, ovoids and ellipses of Yahgulanaas' graphic practice and suggest the flow and bubbles of riverine water. Their skeletal steel bodies are accented with anodized aluminum cutouts, and their borders are rendered in dark champagne and cobalt blue. Each arm of *Rivers* is accented with one of these colours, which reference the distinctive character of the two respective rivers "before they meet to become one and flow west to eventually join the Fraser River".[68] Yahgulanaas explains, "The figures are like swimmers and they'll reach their arms out together and almost touch them towards the apex. So, two human figures, two swimmers, two rivers, two solitudes, I guess".[69]

In conceptualizing the sculpture, the artist purposefully tried to dilute the Haida imprint partly out of respect for the Indigenous peoples of the locale. *Rivers* is situated in an area that was historically an important meeting point for the ancestors of the Secwepemic First Nation. The art critic Kevin Griffin expands, "Kamloops derives its name from the Secwepemic word T'kemlups which means where the rivers meet. Knowing that he's creating a work for a site on traditional Secwepemic territory, Yahgulanaas said he's consciously adapted traditional Haida ovoids and framelines in his sculpture to make them more universal".[70] The ongoing struggle for Indigenous title to land continues to haunt the content, commission and placement of public art in British Columbia.

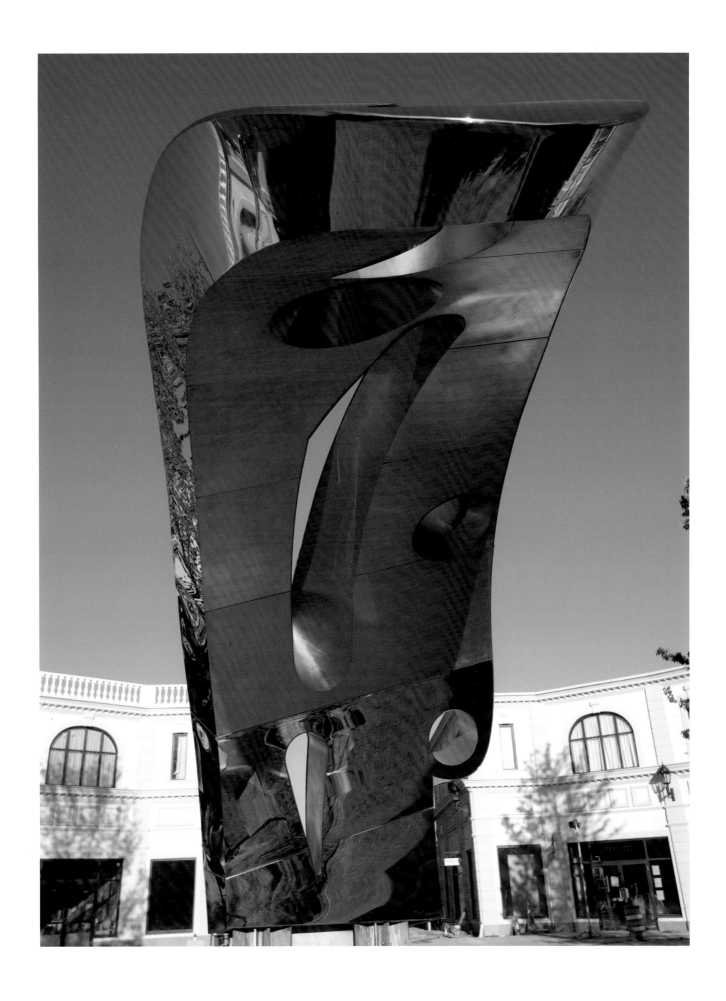

THE METAPHOR OF FLIGHT

Take Off, 2010, is another public art installation by Yahgulanaas that speaks to human mobility, cultural symbols and site. Located outside the entrance to the Thunderbird Winter Sports Centre in Vancouver, *Take Off* was commissioned by the Vancouver Olympic and Paralympic Winter Games committee. Like *Rivers, Take Off* soars into the sky; in this case, it takes the form of three tall steel tubular arcs, surmounted by an arrangement of repurposed automotive parts. These copper-leafed elements—three car fenders and a door—are positioned to be suggestive of a bird in flight. Yahgulanaas explains, "The Volvo front fenders have a very elegant little sweep and notch at the end which really attracted my sensibility".[71] Flipped and rearranged, "the piece captures the movement of a mallard duck as it flies off the water in its typical fast ascension into the sky".[72] Linking the sculpture to site, the framelines and imagery in black and cerulean blue, accented with gold leaf, incorporate a representation of a hockey goalkeeper, an archetypal hero of Canadian popular culture.

Whereas Yahgulanaas' heavy metal sculptures like *Rivers* and *Sei*, 2015, are created through the artist's concept drawings, annotated blueprints and scaled maquettes, which are translated by project managers working in industrial metal processing and fabrication plants, *Take Off* followed a slightly unusual trajectory. It emerged from a collaborative project in which Yahgulanaas mentored a group of seven artists from the Native Youth Association.[73] Yahgulanaas wanted to encourage these young artists to think outside the box of traditional materials and techniques. This provided a metaphor for working through the sculptural form: in his words, "the bird embodies the metaphoric flight of the creative impulse. The automotive world, with its elegant designs and materials, jump starts inspiration; combinations of traditional symbols with modern materials express new ideas".[74] The artwork "speaks to the intersection between our earthbound reliance on cars and our desires for freedom associated with flight, even flights of fantasy".[75]

The desire to create movement and extend our sense of perception and imagination beyond the concrete materiality of metal bodies, artworks and commodities and their anchorage to the physical plane is exemplified by Yahgulanaas' monumental sculpture *Sei*, 2015, which is sited in the outdoor plaza of a boutique shopping centre on Sea Island near Vancouver International Airport. *Sei*'s body captures and mirrors the state of the sky, the flight paths of airplanes overhead, the pale brick facades of surrounding buildings, the movement of foliage, trees and passersby, as well as the faces and features of those who stop to explore its protean contours. Eight and a half tons of stainless steel, copper, granite and marble, twelve metres in length and four metres high, *Sei* is Yahgulanaas' largest heavy metal artwork to date. Its elegant streamlined body, pierced through with ovoids and other three-dimensional frameline shapes, arches into the sky like the shiny grey diving body of its namesake, the sei whale. The skin of Yahgulanaas' *Sei*, which covers a complex skeleton of steel tubes and plates, is made of highly polished stainless steel, with an underbelly of burnished copper leaf. The overall form and tonal sheen of the artwork, as the artist explains, is reminiscent of the carved, highly polished, wide silver cuff bracelets associated with Haida artists of the present and the past. The warm copper concave in *Sei*'s case gestures to the reflection or "flesh tones" of the wearer's skin. Yahgulanaas elucidates further: "While the overall physical structure is very reminiscent of North Pacific

Indigenous Arts ... the manner in which the sculptural mass is pierced is very much a conversation with the voids in Barbara Hepworth's work, particularly her 1969 *Two Form with White (Greek)*. The curving metal form directly arises easily out of carved silver bracelets of lineage artist Charles Edenshaw but is also at play with Henry Moore's nearby *Knife Edge Two Piece*, 1965".[76] The latter, a monumental abstract and bifurcated soft-curved bronze cast, which was inspired by the shape of a fragment of bone, is sited in Vancouver's Queen Elizabeth Park. The highly polished stainless steel outer skin of *Sei*, which constantly changes, expanding, absorbing and magically transforming or distorting its surrounds and the viewers' perceptions, brings to mind Kapoor's *Cloud Gate*, 2006, or Jun Ren's *Freezing Water #7*, 2009, and *Freezing Water #10*, 2009. As Yahgulanaas perceptively comments, although grounded in Haida philosophical conceptions of currency and value, embodied in silver and copper effects, *Sei* is a hybrid sculpture that fuses materials and cultural influences to offer a fluid and open-ended third space for contemplating the present: "While it speaks to issues of indigeneity, it is a piece that I think we need to see more as a contemporary piece of artwork without reference to its ethnicity, and in that, I think it begins to go into that place in between".[77]

Whether working with the entire body of a car or salvaged parts, the carcass of a rowboat or fabricated metal skeletons, Yahgulanaas culturally modifies forms, covering them in precious substances shot through with his idiosyncratic Haida-inflected iconography. These new geographies of matter, surface and lines provoke us to reflect on the meaning and shape of things. We draw on cultural connections, our inherited systems of value, as we follow the outline, contour, fanciful imagery and play of shadow and light. From these mobile topographies we are able to formulate our own metaphoric flights, our own journeys into the realm of the imagination, and perhaps experience the interplay between visible and invisible worlds, where individual histories recede and collective memories surface to become a reflective patina of shared realities. In these mirrored moments, we can observe a Haida past intersecting with the twenty-first-century landscape of commodities and possessions, culture heroes and cars, cosmic things and technologies that enchant.

1 Yahgulanaas, Michael Nicoll, "RE ME MB ER: The Hybrid Art of Michael Nicoll Yahgulanaas", *GEIST Magazine,* no 70, 2008, p 55.

2 For a critical exploration of the car as a subject and mode of conceptual art practices, see Terranova, Charissa, A*utomotive Prosthetic: Technological Mediation and the Car in Conceptual Art,* Austin: University of Texas Press, 2014.

3 Harrison, Robert Poguae, "Of Terror and Tigers: Reflections on Cai Guo-Qiang's Inopportune", *Cai Guo-Qiang: Inopportune,* North Adams: Massachusetts Museum of Contemporary Art, 2005, pp 28–36.

4 Latour, Bruno, "Can We Get Our Materialism Back, Please?", *Focus-Isis,* vol 98, no 1, 2007, p 139. For a detailed critique of Ortega's installation in the light of philosophical materialism, see Tresch, John, "Technological World-Pictures: Cosmic Things and Cosmograms", *Focus-Isis,* vol 98, no 1, 2007, pp 84–99.

5 Marcus Bowcott, personal communication, 4 June 2015; also see "Trans Am Totem", accessed 19 August 2021, https://marcusbowcott.com/wordpress/2019/05/07/trans-am-totem/.

6 Richardson, Don, "High Five!", *The Source,* vol 15, no 17, 2015, p 12. This site-specific intervention is part of the Vancouver Sculpture Biennale, 2015–2017.

7 Canoe, Object no Nb1.737, MOA CAT, accessed 16 March 2015, http://collection-online.moa.ubc.ca/collection-online/.

8 Levell, Nicola, "Site-Specificity and Dislocation: Michael Nicoll Yahgulanaas and his Meddling", Journal of Material Culture, vol 18, no 2, 2013, p 106.

9 Townsend-Gault, Charlotte, and Karen Duffek, "Introduction: Image and Imagination", *Bill Reid and Beyond: Expanding on Modern Native Art,* Charlotte Townsend-Gault and Karen Duffek eds, Vancouver/Seattle: Douglas and McIntyre/University of Washington Press, 2004, p 7. The twenty-dollar note that depicts two of Bill Reid's monumental sculptures is being phased out as of 2012. See Levell, "Site-Specificity and Dislocation", p 101.

10 Duffek, Karen, *Meddling in the Museum: Michael Nicoll Yahgulanaas,* Vancouver: UBC Museum of Anthropology, 2007, nn.

11 Ramsay, Heather, "Michael Nicoll Yahgulanaas: Meddling in the Museum", *Galleries West,* 31 August 2007, accessed 20 August 2021, https://www.gallerieswest.ca/magazine/stories/michael-nicoll-yahgulanaas%2C-%22meddling-in-the-museum%2C%22-july-10-to-december-31%2C-2007%2Cmuseum-of-anthropology-at-the-university-of-british-columbia%2C-vancouver/.

12 The notion of "figurative repatriation" as a strategy used by contemporary artists to reclaim their Indigenous cultural heritage and renegotiate their identities in the present, while subverting Western ideas of ownership, is introduced by Jennifer Kramer in her article "Figurative Repatriation: First Nations' Artist-Warriors Recover, Reclaim and Return Cultural Property through Self-Definition", *Journal of Material Culture*, vol 9, no 2, 2004, pp 161–182.

13 This history is graphically retold by the Kwakwaka'wakw artist Gord Hill in his *The 500 Years of Resistance Comic Book*, Vancouver: Arsenal Pulp Press, 2010, pp 44–45.

14 Francis, Daniel, *The Imaginary Indian: The Image of the Indian in Canadian Culture*, Vancouver: Arsenal Pulp Press, 1992, pp 171–172; Phillips, Selene G, "'Indians on Our Warpath': World War II Images of Native Americans in *Life Magazine*, 1937–1949", *American Indians and the Mass Media*, Meta G Carstarphen and John P Sanchez eds, Norman: University of Oklahoma Press, 2012, pp 42–43.

15 Laurence, Robin, "Artist Annie Ross Builds Vehicle for Ideas", *Georgia Straight*, 21 March 2012, accessed 16 March 2015, http://www.straight.com/arts/artist-annie-ross-builds-vehicle-ideas.

16 Laurence, "Artist Annie Ross Builds Vehicle for Ideas".

17 Kaye, Nick, *Site-Specific Art: Performance, Place and Documentation*. London: Routledge, 2000.

18 Kwon, Miwon, *One Place after Another: Site-Specific Art and Locational Identity,* Cambridge, MA: MIT Press, 2002, p 33.

19 Kwon, One Place after Another, p 46.

20 The Glenbow Museum purchased *Pedal to the Meddle* and *Stolen But Recovered* as part of its revitalized commitment to acquiring contemporary art and in furtherance of its Indigenous studies program. The other Copper, *Two Sisters*, was dispatched to a commercial gallery, and *Bone Box* was acquired by the UBC Museum of Anthropology, Vancouver.

21 The BC Scene took place from 21 April to 3 May 2009.

22 Phillips, Ruth, "Settler Monuments, Indigenous Memory: Dis-membering and Re-membering Canadian Art History", *Monuments and Memory: Made and Unmade*, Robert S Nelson and Margaret Olin eds, Chicago: University of Chicago Press, 2003, p 286; Levell, "Site-Specificity and Dislocation", p 108.

23 Walsh, Andrea, and Daniel McIver Lopes, "Objects of Appropriation", *The Ethics of Cultural Appropriation*, James O Young and Conrad C Brunk eds, Oxford: Wiley-Blackwell, 2009, p 223.

24 Levell, "Site-Specificity and Dislocation", p 108.

25 Levell, "Site-Specificity and Dislocation", p 109.

26 Bourriaud, Nicolas, *Relational Aesthetics*, Simon Pleasance and Fronza Woods trans, Paris: Les presses du réel, 2002, p 14, original emphases.

27 Levell, "Site-Specificity and Dislocation", p 110.

28 Janes, Robert, *Museums and the Paradox of Change: A Case Study in Urgent Adaptation*. Calgary: University of Calgary Press, 1997.

29 Levell, "Site-Specificity and Dislocation", p 111.

30 Levell, "Site-Specificity and Dislocation", p 111.

31 Levell, "Site-Specificity and Dislocation", p 112.

32 Yahgulanaas, "RE ME MB ER: The Hybrid Art of Michael Nicoll Yahgulanaas", p 55.

33 Jopling, Carole, "Coppers of the Northwest Coast Indians: Their Origin, Development and Possible Antecedents", Transactions of the American Philosophical Society, 1989, p 1.

34 Collison, Nika, "SihlGa.dllsgid. Inheritance", *Gina Suuda Tl'l Xasii. Came to Tell Something. Art and Artist in Haida Society*, Nika Collison ed, Skidegate: Haida Gwaii Museum Press, 2014, p 15.

35 Collison, "SihlGa.dllsgid. Inheritance", p 15.

36 Guujaaw Nangiitlagada Gidansda quoted in Collison, "SihlGa.dllsgid. Inheritance", p 15. Guujaaw explained that his original syntax needs to be adhered to because without it the emphasis and full meaning of his statement are lost. Guujaaw Nangiitlagada Gidansda, personal communication, 5 June 2015.

37 Collison, "SihlGa.dllsgid. Inheritance", p 15.

38 An earlier ceremony of shaming instigated by Beau Dick took place in February 2013. He walked from his home on the northern tip of Vancouver Island to the British Columbia legislature where he conducted the copper cutting ceremony. For detailed accounts of the two copper-breaking ceremonies, Awalaskenis I (February 2013) and Awalaskenis II (July 2014), see *Lalakenis/All Directions: A Journey of Truth and Unity*, Scott Watson and Lorna Brown eds, Vancouver: Morris and Helen Belkin Art Gallery, 2016.

39 "Copper Breaking Ceremony Speech, 27 July 2014".

40 Exhibition text, "Michael Nicoll Yahgulanaas: Exploring Haida Manga", January 2010, Glenbow Museum, Calgary, Alberta.

41 Levell, Nicola, "Coppers from the Hood: Haida Manga Interventions and Performative Acts", *Museum Anthropology,* vol 36, no 2, 2013, p 118.

42 Exhibition text, "Michael Nicoll Yahgulanaas: Exploring Haida Manga", January 2010.

43 Exhibition text, "Michael Nicoll Yahgulanaas: Exploring Haida Manga", January 2010.

44 Scherb, Sarra, "Haida Manga: Michael Nicoll Yahgulanaas", Seattle, Stonington Gallery, 2015, accessed 5 April 2015, http://issuu.com/stoningtongallery/docs/mnyahgulanaas_2015_catalog.

45 Cameron, Ann, "Paintings on Recycled Volvo Sunroof Panels", *The Beat: Aboriginal Art on Canada's Pacific Coast*, 8 December 2012.

46 "Volvoxii Note", Michael Nicoll Yahgulanaas archives.

47 Simon, Roger, "Forms of Insurgency in the Production of Popular Memories: The Columbus Quincentenary and the Pedagogy of Counter-Commemoration", *Cultural Studies*, vol 7, no 11, 1993, pp 73–88.

48 Teverson, Andrew, "'The Uncanny Structure of Cultural Difference' in the Sculpture of Anish Kapoor", *Gothic Studies*, vol 5, no 2, 2003, p 85.

49 Teverson, "The Uncanny Structure of Cultural Difference", pp 85–86.

50 Quoted in Teverson, "The Uncanny Structure of Cultural Difference", p 86; also see "Homi Bhabha and Anish Kapoor: A Conversation", 1 June 1993, accessed 20 March 2015, http://anishkapoor.com/976/

Homi-Bhaba-and-Anish-Kapoor%3A-A-Conversation.html.

51 "Visual Artist Michael Nicoll Yahgulanaas' Work Enters Permanent Collection of the British Museum", accessed 20 March 2015, http://artdaily.com/news/62835/Visual-artist-Michael-Nicoll-Yahgulanaas—work -enters-permanent-collection-of-the-British-Museum#.VQy472bZrjA.

52 "Copper from the Hood", accessed 20 March 2015, http://museum.wa.gov.au/extraordinary-stories/ highlights/copper-hood/.

53 Griffin, Kevin, "Work Acquired by British Museum Embodies Haida Identity in Several Layers of Symbolism", Vancouver Sun, 23 April 2011.

54 Griffin, "Work Acquired by British Museum".

55 Collison, Nika, "Gii.insduu. Garments", Gina Suuda Tl'l Xasii, p 27.

56 Vanderhoop, Evelyn Kujuuhl, "From One Realm to Another: The Naaxiin Robe", Gina Suuda Tl'l Xasii, p 9.

57 Vanderhoop, "From One Realm to Another: The Naaxiin Robe", p 7.

58 Gell, Alfred, "The Technology of Enchantment and the Enchantment of Technology", Anthropology, Art and Aesthetics, Jeremy Coote and Anthony Shelton eds, Oxford: Oxford University Press, 1992, pp 40–63.

59 Chilkat Tunic, Object no A7080, MOA CAT, accessed 15 March 2015, http://collection-online.moa.ubc. ca/collection-online/.

60 Collison, "SihlGa.dllsgid. Inheritance", p 11.

61 Silverman, Debora, "Marketing Thanatos: Damien Hirst's Heart of Darkness", American Image, vol 68, no 3, 2011, p 392. In other works such as The Golden Calf, 2008, a bovine specimen preserved in a formaldehyde tank, with its hooves and horns replicated by eighteen-karat solid gold wraps, Hirst has similarly exploited our culturally constructed systems of value.

62 Saunders, Nicholas, "The Cosmic Earth: Materiality and Mineralogy in the Americas", Soils, Stones and Symbols: Cultural Perceptions of the Mineral World, Nicole Boivin and Mary Ann Owoc eds, New York: Routledge, 2012, pp 123–142; Bahr, Donald, "Temptation and Glory in One Pima and Two Aztec Mythologies", Journal of the Southwest, vol 46, no 4, 2004, pp 705–761; Shelton, Anthony Alan, "Realm of the Fire Serpent", British Museum Bulletin, no 58, 1988, pp 21–25.

63 Lisa Hageman Yahjaanaas, personal communication, 16 July 2021.

64 Craft, 2012, accessed 10 April 2015, http://mny.ca/en/craft.html.

65 Craft, 2012.

66 Yahgulanaas, Michael Nicoll, "Haida Cosmic", Native Art of the Northwest Coast: A History of Changing Ideas, Charlotte Townsend-Gault, Jennifer Kramer and Ki-ke-in eds, Vancouver and Toronto: UBC Press, 2013, p 32.

67 Yahgulanaas, "Haida Cosmic", pp 44–45.

68 Griffin, Kevin, "Meeting of the Rivers: Michael Nicoll Yahgulanaas' Sculpture in Kamloops", Vancouver Sun, 15 January 2014, accessed 17 August 2021, https://mny.ca/en/article/45/meeting-of-the-rivers -michael-nicoll-yahgulanaas-sculpture-in-kamloops.

69 "City's Newest Piece of Art Displayed: Public Art Sculpture Represents the Merging of Two Rivers", CFJC News, 6 February 2014.

70 Griffin, "Meeting of the Rivers".

71 Griffin, Kevin, "UBC Gets 2010 First Nations Art", Vancouver Sun, 10 September 2009, accessed 17 August 2021, https://vancouversun.com/news/staff-blogs/ubc-gets-2010-first-nations-public-art.

72 Take Off, 2010, accessed 7 April 2015, http://mny.ca/en/take-off.html.

73 The artists who worked with Michael are Maria Aksic, JR Davis, Isaac Duncan, Nicole Hoof, Linnea McArthur, Jascine Peterson and John Ram. See Vancouver Organizing Committee for the 2010 Olympic and Paralympic Games (VANOC), O Siyam, Vancouver: VANOC, 2010, p 104.

74 VANOC, O Siyam, p 105.

75 VANOC, O Siyam, p 104.

76 Michael Nicoll Yahgulanaas, personal communication, 20 May 2015.

77 Siebert, Amanda, "Exclusive Sneak Peek at Michael Nicoll Yahgulanaas' Latest Work at McarthurGlen Designer Outlet: SEI Explores the Magic of Hybridity through Fusing Materials and Cultural Influences", Georgia Straight, 12 June 2015, accessed 20 August 2021, https://www.straight.com/arts/470511/ exclusive-sneak-peek-michael-nicoll-yahgulanaas-latest-work-mcarthurglen-designer-outlet.

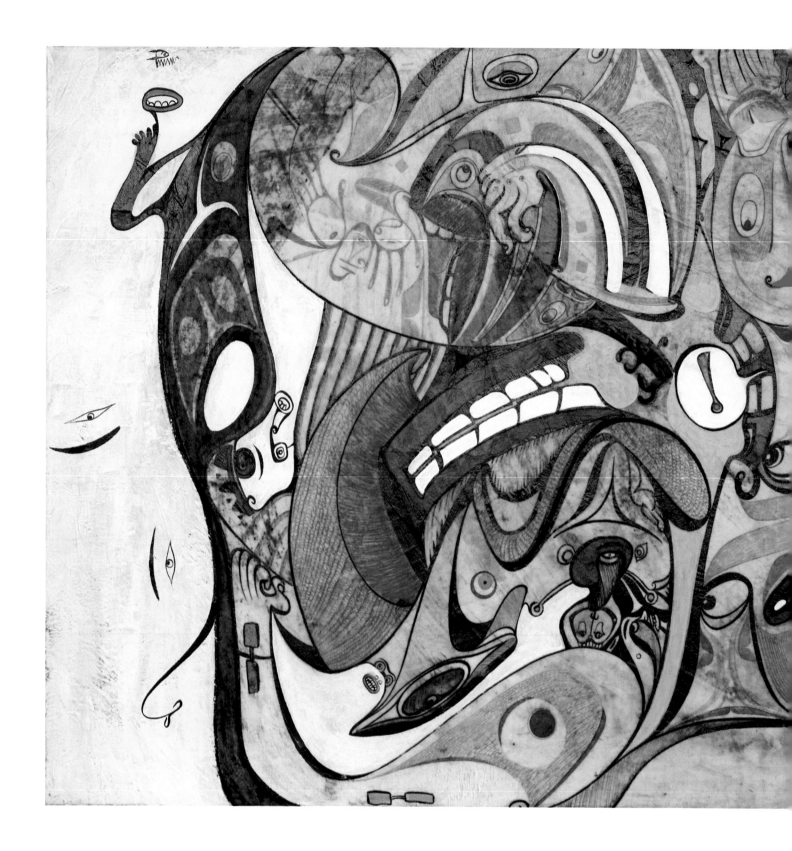

Papered Over, 2011

VISUAL JAZZ

THE ADAPTABILITY OF FORMS

I don't feel constrained by tradition rather I feel my learned techniques in North Pacific Indigenous art acted as a positive catalyst for the unexpected hybrid visual practice I explore today.
Michael Nicoll Yahgulanaas[1]

"Visual jazz" is the term David Byrne, the musician and founder of Talking Heads, uses to describe *vodou* altars. He compares their eclectic mixture of gaudy and bizarre objects—"sequined whiskey bottles, satin pomanders, clay pots dressed in lace, plaster statues of St Anthony and the laughing Buddha, holy cards, political kitsch, Dresden clocks, bottles of Moët & Chandon, rosaries, crucifixes, Masonic insignia, eye-shadowed kewpie dolls, atomisers of Anaïs-Anaïs, wooden phalluses, goat skulls, Christmas tree ornaments and Arawak celts"—to "frozen waterfalls" and "dances for the eyes".[2] The idea of visual art as a form of music, a polyrhythmic and open-ended composition that is "constantly reworked and reactivated" by players and listeners or viewers, is not new.[3] Kandinsky, it is generally agreed, was the first artist to formally write about the relationship between music and visual art.[4] In his 1912 book *Concerning the Spiritual in Art,* Kandinsky wrote of the synergies between these different art forms and the potential of visual art to draw on the methods of music to "cause vibrations in the soul".[5] He used a figurative language, laden with terms like harmony and discord, melodic and symphonic composition, rhythm and counterpoint, the movement of pictorial form and notes of colour and sound. His ideas are grounded in synaesthesia wherein the senses intermingle across different perceptive registers, and in such cases colour can be experienced as sound.[6] We see the dominance of the music metaphor in the titles of his works such as his *Improvisation, Impressions* and *Composition* series. In reviewing Kandinsky's improvisations of landscapes and abstract forms in 1913, the eminent art critic Roger Fry declared, "As one contemplates ... one finds that after a time the improvisations become more definite, more logical and closely knit in structure, more surprisingly beautiful in their colour oppositions, more exact in their equilibrium. They are pure visual music".[7]

Through a deep rather than a superficial assimilation of music into visual art, Kandinsky hoped to construct and abstract "a new spirit in painting" or "dance-art of the future" alive with movement, emotion and energy that would resonate in the mind, body and soul of the perceiver.[8] He opined:

> When features or limbs for artistic reasons are changed or distorted ... these ... alterations in form provide one of the storehouses of artistic possibilities. The adaptability of forms, their organic but inward variations, their motion in the picture, their inclination to material or abstract, their mutual relations, either individually or as parts of a whole; further, the concord or discord of the various elements of a picture, the handling of groups, the combinations of veiled and openly expressed appeals, the use of rhythmical or unrhythmical, of geometrical or non-geometrical forms, their contiguity or separation—all these things are the material for counterpoint in painting.[9]

These endless possibilities of form, "wildly proliferating between patterns and organisms", combined with the psychic and sensory effects of colour, cohere and convey the complexity and chaos of the

world around and within us.[10] These improvised, interactive and polyrhythmic compositions that speak to Byrne's idea of visual jazz are exemplified in Michael Nicoll Yahgulanaas' *Papered Over* series and the techniques he uses to make forms dance.

SEEING FORMS DANCE

In *Papered Over*, 2011, which was made when he was writer in residence at Mount Royal University, Calgary, Yahgulanaas created a luminous field that pulsates with rhythm, splashes of colour and biomorphic forms. A writhing mass of dancing lines extends beyond the page, exploding with chattering mouths, bubbles of sound, peeking eyes, tickling fingers and animated shapes. To make this graffiti-like melange, Yahgulanaas drew on techniques of collage. He initially outlined and coloured aspects of the composition on fine one-ply Asian paper. He then attached the cut-out image to a thicker and stiffer paper and added layers of wash, watercolour and ink with brush and pen, layering the texture and imagery further still with polymers, graphite and crayon details. The outline shape, lurid colours and rebellious imagery are reminiscent of Elizabeth Murray's large-scale explosive canvas sculptures such as *Bop*, 2002–2003, *Do the Dance*, 2005, and *Lo*, 2006, *Oooh*, 2006, and *Bongo*, 2006, from the *Sweetzer Suite*.

It is not surprising to learn that Murray, like Yahgulanaas, was fascinated by comic books as a child. She believed they influenced her art as an animated and playful form along with the work of Picasso, Cezanne and other artists on display at the Art Institute of Chicago.[11] We can detect the comic influence in Murray's work as Stephen Westfall notes of her shaped canvas compositions: "when they weren't morphing into schematic cartoon heads they jostled and nestled like body organs and sometimes they did both. The scapes of her pictures were metaphoric invocations of interior realms of feeling and the embodied imagination".[12] Alive with colour, lightning bolts and writhing body parts, Murray's painted world has been described as "all fire and music, jazzy rhythms spun from the everyday world", which led the writer Francine Prose to exclaim, "Murray's paintings all seemed to come with a sound track".[13] Indeed Murray confessed in an interview with Robert Storr:

> I work with music. In fact I *need* to work with music, because it gets the flow going ... I listen to just about everything, but I don't like radio because I don't want talk, I want music, I want flow. I listen to Ray Charles and Betty Carter, classical; I love opera, but some opera you can't paint to. Wagner is tough. I prefer Verdi, and all kinds of instrumental music. Some rock 'n' roll is okay; Otis Redding and Aretha Franklin are great, ... I like jazz a lot, and some jazz is perfect. Especially Thelonius Monk.[14]

Looking at Yahgulanaas' other works in the *Papered Over* series such as *Dancing Dragon*, 2012, *Faux Palindrome*, 2012, and *Untitled*, 2012, we can sense an anarchic world in rhythmic motion, turned inside out and upside down. There are flesh tones, parts of human bodies, sinewy limbs and zoomorphic forms contorted and forced through and out of deep black pockets, interwoven with Haida frameline, ovoid and split U forms. In *Dancing Dragon*, for example, we can decipher the material culture of the everyday that marked Murray's compositions.

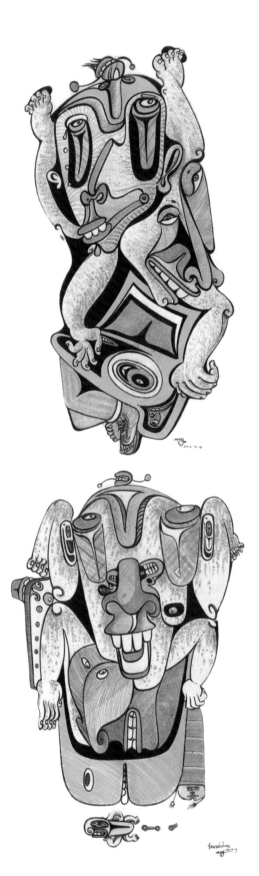

top *Dancing Dragon*, 2012, *Papered Over* series

bottom *Faux Palindrome*, 2012, *Papered Over* series

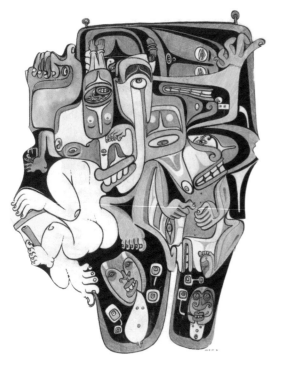

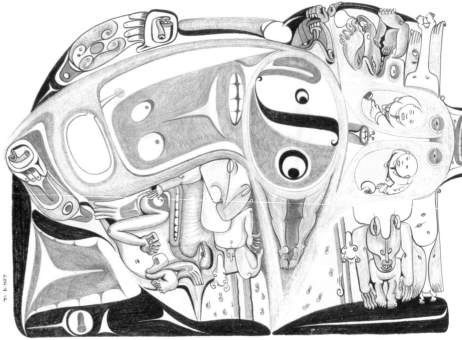

left *Untitled*, 2012, *Papered Over* series

right *Untitled*, 2011, *Rotational* series

bottom *di-sect-ed*, 2010, *Rotational* series

Whereas tables, coffee cups, hats and slippers were common objects that captured Murray's imagination, for Yahgulanaas blue jeans and a broken toe-revealing running shoe are caught in the maelstrom. On closer inspection, we see the fine lines of coloured hatching that add a depth and a counterpoint rhythm or tonality to the whole. Likewise the intricate coils of purple and blue body hair rupture the solidity of the dragon-inspired form. There is a distinct and purposeful afocalism to the visual field. There is a weeping eye; a bearded chin; a jumble of faces, features and limbs; a pair of bare feet pointing upward; arms reaching downward and hands grasping on to what looks like the green head of a Haida stylized animal, perhaps an upside-down bear, who has a diminutive and discontented character trapped in its ear. Ultimately, there are no prescriptive interpretations of the *Papered Over* series. Each composition is an embodiment of visual jazz consisting of a surreal assemblage of absurd and humorous forms.

THREE HUNDRED AND SIXTY DEGREES

The possibility of seeing things from different angles, upside down and inside out, is taken a step further in Yahgulanaas' *Rotational* series, which he began making in 2010. The title of the series not only references the technique he uses when creating the imagery but it also invites viewers to tilt or rotate their heads to see from different angles or, if possible, physically re-orientate the painting on the wall. In the case of the artworks in this series such as *Untitled*, 2011, *di-sect-ed*, 2010, *Up Down Play Reverse*, 2010, and *Bigger*, 2011, there is no right way up. When Yahgulanaas creates these works, he begins painting with a certain horizon and orientation for a period and then he intentionally rotates the paper by 90 degrees, and he continues this jazz-like composition with its swing note groove until he arrives full-circle back at the beginning.

As part of this polyrhythmic four-part process, Yahgulanaas positions the text—his name, the title of the work and the date—

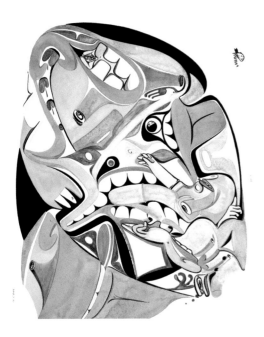

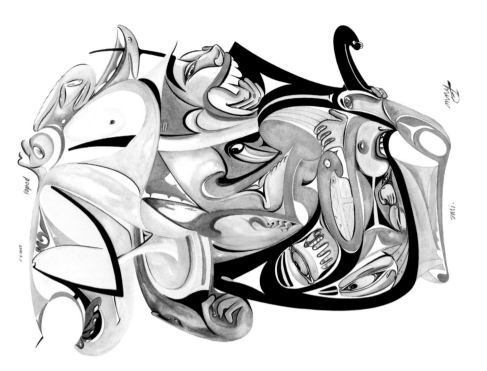

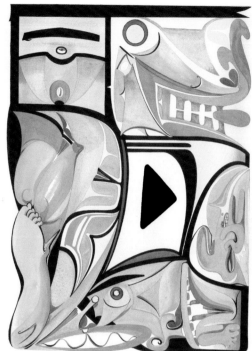

according to the different orientations of the paper. Consequently, these textual elements can appear either horizontally or vertically, upside down, inverted or the right way up. In this way, Yahgulanaas invites viewers to find their own ways of seeking and seeing meaning in the imagery. A note in the artist's archive gives an insight into the improvisational way his rotationals take form: "In *di-sect-ed* the paper began with a pencil sketch of the head of Hagu (halibut). As its great body splayed across the sheet I saw a large cavernous stomach, a gut that replaced the massiveness of this magnificent sea creature. Then came the yellow gloved and rubber booted fish worker grasping always at parts and missing the whole"[15]. As with Yahgulanaas' other artworks, the influence of fishing and marine life is manifest in the jazzy ensembles of his rotational works like *Anti-Podes*, 2010, and *Aatgyaa Fishing Net*, 2010.

In 2016, in a solo exhibition called The Seriousness of Play: Michael Nicoll Yahgulanaas at the Bill Reid Gallery, Vancouver, for the first time the artist was able to display a rotational work, *A Sailing Light*, 2015, to enable audience participation and play. The canvas was installed on a rotational metal armature with a mirror mounted on the wall behind. Visitors were encouraged to rotate the canvas to view it from different angles as the art critic Kevin Griffin explains:

> *A Sailing Light* ... depicts a ship with billowing sails covered in fantastic, biomorphic forms that include an oval shape that can be seen as two different faces depending on your point of view. The mixed media collage is built on texts such as the UN Declaration of the Rights of Indigenous People ... and a report on the state of Indian reserves and reservations in North America. Words and images play peekaboo with one another over the work's surface ... [A] *Sailing Light* recalls the arrival of foreign sailing ships on the Northwest Coast and the continuing efforts of indigenous and European cultures to resolve themselves into something new.[16]

left *Anti-Podes*, 2010

right *Up Down Play Reverse*, 2010, *Rotational* series

bottom *Untitled*, 2010, *Rotational* series

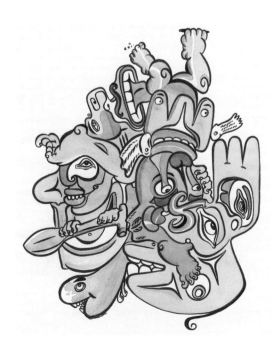

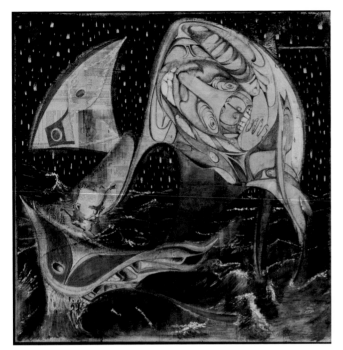

A Sailing Light, 2015 (recto and verso)

On the back (verso) of the work—as is the case with his more recent collages such as *Edge of Asia,* 2017, *Milkit,* 2020, *Hooked,* 2020, and *Gunit,* 2020—the entire surface is collaged with segments of maps. For *A Sailing Light* these were appropriated from Rand McNally atlases of North America, and they depict swathes of Native American land criss-crossed with a network of highways, connecting different states, cities, and sites, bodies of water and land, and in the lower left quadrant there is a street-view map of the political and ceremonial heart of Washington, DC. Visitors to the 2016 exhibition could examine this constructed map by looking in the mirror.

True to form, in the title of the work, Yahgulanaas is purposefully punning, poking and playing with multiple meanings, in this case the idea of 'a sail'—the billowing cloth of a marine vessel referenced by Griffin—and the verb 'assail' with its more ominous meaning of assault, a violent and concerted attack on, in this context, the Indigenous peoples of America.

INTERPENETRATIONS COLLAPSING INTO ONE

The relationship between Yahgulanaas' visual practice and music is made more concrete in works such as *John Cage on 5th de Mayo,* 2009, *Jon Hassell,* 2010, or *Orpheus in the Underworld,* 2015. These works were inspired and took form while Yahgulanaas was listening to music in his studio. Visitors to this artistic space may readily spy the bright red, wind-up plastic radio that sits on the shelf or hear sounds of music or the spoken word playing. Like Murray, Yahgulanaas admits his taste in music is diverse. As well as the 'Fourth World' sounds of Hassell and the experimental music of Cage, he listens to jazz and opera and is especially drawn to world music and more generally expansive, long-playing compositions. When asked to name some of the artists whose work he enjoys, off the top of his head, he mentions John Adams, the

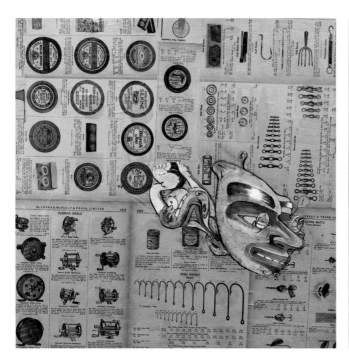

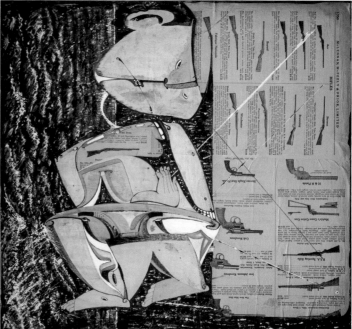

Allman Brothers, Ilhan Ersahin, Maxime Goulet, Keith Jarrett, Nusrat Fateh Ali Khan, Fela Kuti, Bill Laswell, Pat Metheny, and Frank Zappa.

The music Yahgulanaas listens to may not only influence the cadence and colour of his compositions, as Kandinsky theorized, but may also stimulate non-associative thought-processes and the imagination. Interestingly, in Yahgulanaas' archive, there is an interpretive note attached to *John Cage on 5th de Mayo*, which reveals the free-flowing work and psychic pulse of music, sound, colour and movement:

> Painting started on 5 of May while listening to John Cage. Colours are sunny and warm recalling the Battle of Puebla in 1862 between 4,000 Mexicans and 8,000 French soldiers, a continental army that had not lost a battle in 50 years. This work shows a multiple of beings all collapsed into one. They spill out in different directions. Simultaneously they reach out for what appears to be something, part abandoning the collective.[17]

This disclosure resonates with John Cage's conception of music as a pervasive aesthetic force that can intersect and create a meaningful dialogue with other visual art forms and thus alter our senses of perception and experience through interweaving unexpected elements including sound and silence, being and 'nothing', individual and collective strains and the happenstance interferences of the everyday. He writes, "I am interested in any art not as a closed-in thing by itself but as a going-out one to interpenetrate with all other things, even if they are arts too".[18]

Interestingly, *John Cage on 5th de Mayo* contains notable pockets of negative, unpainted white space between the battling coloured forms, whereas in other rotational works the negative space is harnessed and compressed. We can see the crevices emerge as the cannibalistic devouring mouths, shapes and forms spill and thrash across the page. In contrast, *Carbon Divers*, 2009, is held in tension by an elastic band of composite framelines that contains and constricts the imagery.

left *Hooked*, 2020

right *Gunit*, 2020

bottom *Orpheus in the Underworld*, 2015

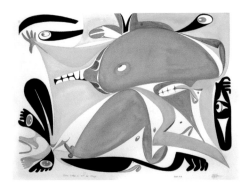

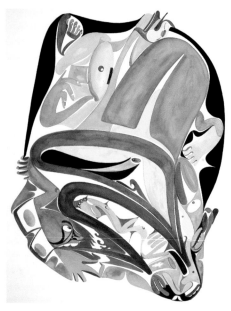

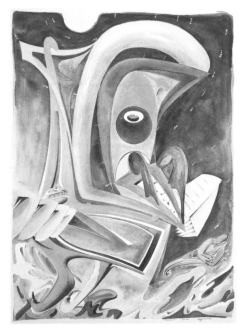

top *John Cage on 5th de Mayo*, 2009

middle *Carbon Divers*, 2009

bottom *Tripudio #3*, 2014

Yahgulanaas captures this sense of contraction: "Here is Haida manga taking the form and structure to an edge of color and meaning. An orange-hooded being seizes a smaller form in its mouth while observed by another water creature … centre top is a creature straining as in birth".[19] Again the fluidity of the twisting framelines and vibrancy and symbolism of the colours, bright yellow and orange, as well as "flesh tones", blacks and blues, convey an energy and rhythm. In the words of Delacroix, "Everyone knows that yellow, orange, and red suggest ideas of joy and plenty".[20] A comparable ebullience with a different palette of vital hues is concentrated in Yahgulanaas' *Tripudio* series. The title is based on the Latin word meaning exultation, jubilation, a feeling of extreme joy.

In *Tripudio #3*, 2014, movement and rhythm are conveyed through the star-shot sky and buoyant forms, including the flying avian character, with colourful cubist inflections and angles, which dominates the pictorial plane. On its geometric yellow wing-feathers, we spy the round air-pulled face of a free-loading passenger whizzing through the sky. Below, the surreal unfurling landscape references another kind of elevation and escapism.

DEEP BLUE PRINTS

In the *Blueprint* series, Yahgulanaas departs from the bright liquid tones of his watercolour compositions to offer light- and shadow-filled glimpses into mysterious underwater realms. *Cnidaria*, 2012, for example, takes its name from the phylum of marine invertebrates that encompasses sea anemones and jellyfish, including the distinctive Pacific sea nettles that inhabit the waters off Haida Gwaii. These enigmatic creatures are identifiable by their large copper-coloured bells and their long trailing white oral arms and maroon-coloured tentacles. It is possible to detect these characteristics abstracted and reimagined in Yahgulanaas' *Cnidaria*. In his theorization of the language of form and colour, Kandinsky expanded on the psychic and emotional meaning of the colour blue: "The power of profound meaning is found in blue, and first in its physical movements (1) of retreat from the spectator, (2) of turning in upon its own centre. The inclination of blue to depth is so strong that its inner appeal is stronger when its shade is deeper".[21] He analogized the different shades of blue to the sounds of musical instruments: "In music a light blue is like a flute, a darker blue a cello; a still darker a thunderous double bass; and the darkest blue of all—an organ".[22] These musical qualities of blue can be cognitively processed and experienced when looking at *Tripudio #3* in relation to, for example, the blueprint *Untitled*, 2013. That colour is an analogue necessitates understanding that it is not a 'scientific' matter or universal signifier reducible to a stable and singular meaning. Rather it is a cultural and aesthetic phenomenon that has the power to elicit different emotional experiences and responses in viewers, as Goethe noted in his *Theory of Colour*, 1840. Goethe suggested that colour could "have direct, unmediated effects on people" and in particular could "excite particular feelings" in the individual beyond its symbolic meaning.[23]

More recently, in his seductive literary and metaphysical musings, the anthropologist Michael Taussig has further propelled our understanding of colour as an inherently unstable cultural and historical form. He pushes colour beyond the concrete and physical,

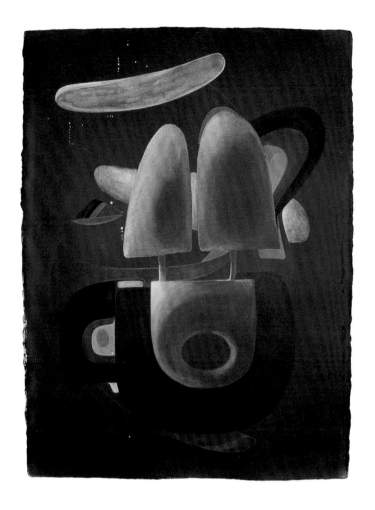

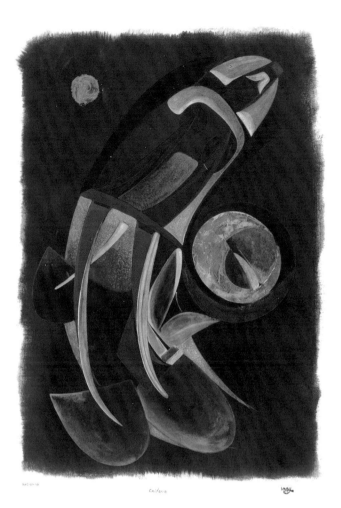

left *Untitled*, 2013, *Blueprint* series

right *Cnidaria*, 2012, *Blueprint* series

showing that it pervades dematerialized states that are magically interlaced with our experiences and perceptions of being in the world. In reference to paintings, Taussig observes:

> In other words, when we see a color we are actually seeing a play with light in, through, and on a body—refracting, reflecting, and absorbing light—something we are aware of but rarely [see] such as sunlight filtering through a forest ... or rainbows on oil slicks on a wet roadway. Given the play with light brought about by texture, it is no wonder that colour can seem to be what I call a polymorphous magical substance, twisting itself as if alive through the branches along with the dying sun.[24]

Donald Judd's *Untitled*, 1972, exemplifies this play of surface, colour and light. Consisting of a large box with an open top, its walls are made of shiny copper and its base is made of an aluminum sheet enamelled in cadmium red. The red of the base is reflected and refracted by the interior copper walls so as you approach the box, it appears to be filled with an intense red glow. Not surprisingly, Judd has been "recognised as one of the century's great colourists" whose work has inspired many artists including Anish Kapoor.[25]

Yahgulanaas' blueprints embody these ephemeral qualities that Taussig calls polymorphous magical properties and effects. Quoting the Romantic German painter Philipp Otto Runge—one of Goethe's

collaborators in the field of colour theory—Taussig aligns his theory of colour with Runge's reflections on the relationship between light and "transparent colour". The artist described this relationship as "an infinite delight; and the igniting of the colours, the blending of them one into the other, their rebirth and their vanishing, is like breath being drawn at great pauses from eternity to eternity, from the highest light down to the lonely and eternal silence that lies in the deepest of tones".[26] The dialectic of rebirth and vanishing that Runge attributes to transparent colours assumes a layered and literal expression in Yahgulanaas' *Blueprint* series.

The indigo-coloured background of the prints was initially the result of an experiment with paper, photographic chemicals and light exposure undertaken by one of Yahgulanaas' students at the University of Victoria. After the cyanotype had been sufficiently exposed to ultraviolet light to produce a deep organ-tonal blue, Yahgulanaas acquired these blanks and began experimenting or playing with media, form and colour. He explained, "I began to paint with light washes of pigment that settled down into the paper rather than simply lying on top".[27] Looking at the imagery, we can sense the absorption and igniting of colours in the deep blue silence and the layers of wash that add opacity and more texture to the translucent speckled surfaces.

Moreover, the intensity and depth of the blue are never a constant. The cyanotype process involved in creating the light-sensitive blueprinted surface ensures that it is constantly changing according to its environmental conditions. Exposed to light, the midnight blue fades, which lends a poetic ephemerality to Yahgulanaas' *Blueprint* series. However, cyanotypes are also known for their unusual regenerative qualities. When the faded print is stored in a dark environment, its intense blue tone can be restored. The idea of transformation, the aging and fading of colour and imagery through exposure to light, appeals to Yahgulanaas' sensibility. He favours artworks that are not stable but open to transformation, manipulation and play, whether that involves temporarily putting a print in a storage box or turning a picture upside down.

PAPER MEMORIES

The wildlife in and around Haida Gwaii and the use of second-hand paper matter, evinced in *Cnidaria*, are also manifest in Yahgulanaas' *Lé(d)ger* series. The title of the series is a play on the historical genre of Plains Indian ledger art blended with a reference to the French modernist painter Fernand Léger, which draws attention to the intersection between Indigenous art forms and the West. From the mid-nineteenth to the early twentieth centuries, Plains Indians living under repressive colonial conditions in the United States and Canada recorded their memories of pre-colonial lifeways and of post-contact encounters and battles between their people, their warriors and the soldiers and settlers from the West on ledger paper as well as other forms of everyday stationery.[28] These pictographic records executed in coloured pencils, watercolours, crayon and ink are noted for their striking colours and stylized and flattened aesthetic, with figures, animals and other subjects rendered on the plain white background. Ledger art correlates in style and content with the older practice of painting biographic scenes on the whitish hides of buffalo and other wild animals, using natural dyes and pigments. Often with the fine

Attributed to Howling Wolf,
Southern Cheyenne, Central Plains,
Cheyenne Medicine Lodge,
Ledger drawing, ca. 1875–1878

printed lines of the ledger geometrically traced through the imagery, these works of art speak volumes of the history and culture of the Plains Indians and their fate, resilience and creativity when confronted with Western technology, brutality and oppression.

When Yahgulanaas discovered a binder in an antique and bric-a-brac shop full of blank ledger sheets of the Silver Association of Canada, British Columbia Branch, ca. 1934, as well as a large cheque book emblazoned with the baroque calligraphic insignia of the Imperial Bank of Canada, he purchased these colonial-era finds. In his view, they are heavy with the weight of history. Their materiality, texture and scent bring to mind an imposed and alien system of value, predicated on currency and control, numerals and audit, symbols and status, profit and gain. He felt an overwhelming desire to work with these documents of the past, transforming them into contemporary visions while paying homage to the struggles of the Plains Indians during the reservation era, which are starkly depicted in their ledger art.

Whereas the Plains Indian ledgers focus on the past and the present, Yahgulanaas' *Lé(d)ger* series is in part concerned with future trajectories. He invites us to look up from our earthly anchorage into the cosmos, the deep space traversed by magical northern lights and shooting stars. We can see characters escaping a planet that has been overlaid and transfigured by human-systems of numbers. In *Untitled*, 2015, shown on the following page, the central character, with his Haida-inflected blue whale-fin headdress, tilted head and upturned eyes, reaches out and gazes into space. He is surrounded by minor characters who, according to Yahgulanaas, appear preoccupied, hesitant and distracted by other matters. For the artist, this imagery speaks to the way in which we as individuals act within social collectives. We are not all captivated and concerned with the same things, possibilities and places, but we nevertheless share deep-rooted commonalities. Despite

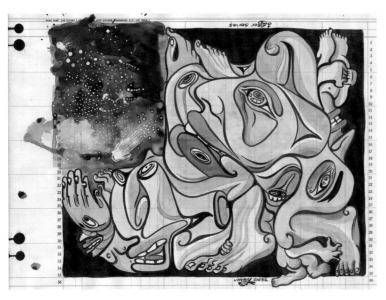 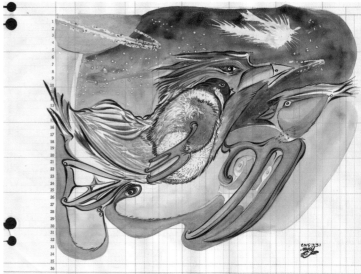

left *Untitled*, 2015, *Lé(d)ger* series

right *Untitled*, 2015, *Lé(d)ger* series

the lack of consensus and our individual orientations and struggles, we are visually entreated to look up at the stars and reflect on our relation and connection to existence beyond ourselves and out to the rest of the universe. This is what Yahgulanaas terms "thinking outward".[29]

Thinking outward operates on a relative scale: it does not always involve stretching our sight to planetary bodies. We can think outward to a more immediate environment of interdependent relations and ecologies. Yahgulanaas' *Lé(d)ger* image of the ancient murrelet (*SGin Xaana Sdiihltl'lxa* or "night bird" in Haida), the small black-headed seabird with its soft grey-feathered back, white vest and stubby yellow beak gliding through air and sea, was inspired by the story of its survival and fight against rats. Over half the world's population of ancient murrelets breed on Haida Gwaii, laying their eggs in burrows in the forests, among the roots of trees, in grassy mounds and under the bodies of logs. However, with the arrival of black and Norway rats that disembarked from ships beginning in the eighteenth century, ancient murrelets were almost extirpated as a species.[30] When Yahgulanaas was chief councillor for the community of Old Massett, Haida Gwaii, in 1995 they supported a highly successful rat eradication program on Langara Island, on the northwest tip of the archipelago, aimed at protecting the endangered ancient murrelet. Again in 2013, the Haida Nation in collaboration with a number of nature conservancies implemented an aerial eradication of rats on different Haida Gwaii islands. The history of the ancient murrelets' battle against the invasive species can be understood as a potent allegory of survival. When European explorers and colonizers arrived on Haida Gwaii, they brought gifts as well as smallpox and other infectious diseases. It is estimated that by the end of the nineteenth century over two-thirds of the archipelago's population had died of these foreign diseases and left behind deserted villages.[31] The ancient murrelet, with its stoic countenance and enlarged three-digit left claw, claims a central space on the Silver Association ledger paper, thus marking its passage through history.

Works in Yahgulanaas' *Lé(d)ger* series can be perceived as palimpsests. They are visual documents in which traces of the past, although overlaid with contemporary imagery, remain partially visible. Like history, the palimpsest assumes a coherent form, but on closer inspection we

realize that it is deceptively composed of fragments, partial erasures and layers and the imposition and elaboration of dominant characters and forms. The yellowed, ragged and hole-punched pages with their official Silver Association typeset header, their blue and red grid lines and vertical rows of numerals, provide a symbolically encoded history-soaked canvas. Yahgulanaas has remarked on the quality and feel of the paper. He enjoys its sensuous and robust materiality, noting that it can withstand and absorb a substantial amount of water laced with pigment, ink and colour, which makes him think that it has a high cotton or linen content. He responds with sensitivity to the aesthetic and sensory qualities of materials and substances as well as the haunting histories that often emanate from *objets trouvés* and second-hand things. As viewers, we may discover other relations and memories that seep through the aged, lined paper and its typed numbers, ink blotches and cosmic apparitions.

IN CHAOS STILL

The palimpsest layering of salvaged printed-paper forms is manifest in *Valiant*, 2011, in a different way. This mixed media canvas incorporates three panels cut out of the acclaimed comic book *Prince Valiant*. Originated in 1937 by Hal Foster (1892–1982), *Prince Valiant* charts the adventures "in the days of King Arthur" of a Nordic prince, who is a knight of the Round Table and heir to the throne of Thule. Foster is an important figure in the history of comics. His early work, specifically *Tarzan and the Apes*, 1929, marked the emergence of "non-humour [comic] strips devoted to adventure narratives" that sat beside the weekly "funnies".[32] His long-standing epic *Prince Valiant*, which was reproduced in newspapers and later comic books from 1937 to the present, was recognized almost from the outset as "a masterpiece of comic art".[33] With its realist-coloured landscapes, uninterrupted by speech bubbles and packed with action and adventure, we journey alongside the swashbuckling Prince Valiant, his singing sword and entourage to foreign lands and cultures, beyond Europe to the Middle East, Asia, Africa and the Americas.

The three frames in Yahgulanaas' *Valiant* depict the prince arriving on the shores of Canada and his anachronistic encounter with the hospitable "Indians", who are said to be in awe of his ship. It is, the narrator notes, "the biggest man-made thing the Indians have ever seen … and they [show] their excitement with wild … [dancing] and boasting". This romanticized and patronizing commentary and attendant imagery foregrounds the myth of the 'savage' Indian that is dialectically bound to the construction of the white male protagonist as a technologically superior, civilized and courageous culture hero. This racist macho imaginary was the dominant leitmotif of the action-adventure graphic narratives born in the golden age of comics.

Drawing on techniques of collage, the three rhetoric-laden panels from *Prince Valiant* are positioned in the lower left quadrant. These graphic components are integrated into a rich and textured field of geometric shapes, distressed and abstracted forms. We can perhaps detect the energy of the four elements erupting as a stormy aesthetic across the canvas plane. Unlike many of Yahgulanaas' other works, there is a dark tormented atmosphere that emerges from the application, blocking, hatching and scraping away of layers of paint. There is a formalist grid or brick-like structure to the composition. Interestingly, Yahgulanaas reveals that one of the narratives informing *Valiant* centres

Valiant, 2011

on the tension between a romanticized image of pre-contact Indigenous lifeways and urban decay. In *Valiant*, the artist notes, there are visual references to "urban dystopia, the rusted girders of buildings are exposed, paint peels, there are fires and a river below. It is chaotic".[34]

The use of collage and comic strips, the thick application of strips of paint, the intense colours and focus on the urban bring to mind Rauschenberg's combine paintings of the 1950s. In these collage-based works, Rauschenberg moved beyond the white paintings that cemented his fertile collaborations with the musician John Cage to focus on the multiplicity of media, structural forms and matter that create and surround, circulate and congest our everyday lives. Pushing beyond the aesthetic concerns that preoccupied Braque and Picasso, which were expressed in their pioneering use of collage, Rauschenberg began incorporating fragments of newsprint, ledger sheets, comics, political posters, fabrics and other matter he found in the neighbourhood of his Lower Manhattan studio. He regarded these elements as equal participants alongside paint in the making of art: "As the paintings changed, the printed material became as much of a subject as the paint (I began using newsprint in my work) causing changes

of focus; A third palette. There is no poor subject".[35] He famously explained in 1959, "Painting relates to both art and life. Neither can be made. (I try to act in the gap between the two.)"[36] It is not surprising to learn that Jaune Quick-to-See Smith lists Rauschenberg as one of her inspirations along with Picasso, Klee and more generally traditional Native American arts.

Through collaging and combining these salvaged items with layers of paint and colour rendered in a quasi-grid-like pattern, Rauschenberg's combines are said to resemble scrapbooks, albums or "archival repositories of society … [whose] materials confront the viewer with a certain figuration of memory, or of the past".[37] They achieve this by what Rauschenberg called in reference to his larger oeuvre, "dealing with multiplicity":

> These archival remnants, available in the present, are confronted as an objective discourse, a reality of thorough mediation in which the present is no less cut off from integral experience than the past … The openness of their multiplicitous material constellations seeks a turning … away from the increasingly reified and regulated social sphere and toward an immanent, indeterminate force of difference coursing through its interstices.[38]

Valiant similarly opens up an interstitial space that has the capacity to fracture our ways of seeing and thinking about the combinations, relationships and meanings of the parts, of the past and of the present milieux. As viewers, we are drawn to scan the different aspects of the canvas, from the windows onto Prince Valiant's encounters in the New World to the structured turmoil of colour, substance and composition. We are free to generate our own interpretations of the relations between these elemental forces and graphic forms. This is multiplicity in action or the "poetry of infinite possibilities".[39] Rauschenberg himself declared, "If you do not change your mind about something when you confront a picture you have not seen before, you are either a stubborn fool or the painting is not very good".[40]

John Cage offers further insight into Rauschenberg's paintings, including his combines and combine-drawings and their ability "to unfocus attention" and encourage us to formulate our own understandings, through a multiplicity of impressions and mediations.[41] In "On Robert Rauschenberg, Artist and His Work", 1961, for instance, Cage notes, "over-all where each small part is a sample of what you find elsewhere … there is at least the possibility of looking anywhere, not just where someone arranged you should. You are then free to deal with your freedom just as the artist dealt with his, not in the same way but, nevertheless, originally … All it means is that, looking closely, we see as it was everything is in chaos still".[42]

SEEING THROUGH RESIDENTIAL SCHOOLS

The idea of individual autonomy and the independence of the spirit, which are central to Cage's artistic convictions and indeed lie at the heart of moral and political philosophy, are further complicated and twisted in Yahgulanaas' canvas *Don't Bunch Up*, 2009. Created as a private commission, the title and imagery of the painting are a reference to the disciplinary regimes and dictates of the Indian residential school system in Canada that was initiated in the second

half of the nineteenth century under the auspices of the Indian Act. These educational institutions, which continued to operate until the last federally run school closed its doors in 1996, were specifically created to ensure, as their leading protagonist Duncan Campbell Scott declared in 1920, "there is not a single Indian in Canada that has not been absorbed into the body politic and there is no Indian question, and no Indian Department".[43] In an attempt to achieve these ends, attendance was made compulsory, and Indigenous children were 'legally' removed from their families and communities from the age of five years old and upward and sent to these often remotely located "total institutions" to be moulded into Canadian citizens.[44]

With the establishment of the Truth and Reconciliation Commission of Canada in 2008, the dark histories and traumatic memories associated with these schools and their treatment or rather mistreatment and neglect of the children placed in their care are increasingly coming to light in the broader public sphere. There are innumerable heart-wrenching testimonies of the physical, psychological and sexual abuses that took place under the mantle of the paternalistic state and the 'altruistic' church and of the devastating multigenerational effects of these mistreatments on First Nation individuals and communities. In 2021, the discovery of the remains of 215 children in unmarked graves at the site of the Kamloops Indian Residential School in British Columbia is a horrific indication of a history of genocide that is continuing to emerge. It is a history known and spoken about in Indigenous communities but one that was suppressed by colonial and settler agencies.

In the residential school system, children were prohibited and often severely punished if they spoke their Indigenous languages or talked to members of the opposite sex. They were assigned numbers and given Christian names. In some provinces, sterilization programs were introduced and medical experiments conducted with no consultation or consent. The educational policy was explicitly geared toward assimilation and the attendant obliteration of Indigenous culture and lifeways. There were policies established for splitting siblings and extended family groups and placing them in separate institutions. As Geoffrey Carr argues, "these policies for isolating students ... often turned family, friends, and community members into strangers, precisely the sort of effect the DIA [Department of Indian Affairs] sought".[45] This leads him to ask the emotive question, "So, what does it mean when the very foundation for individual and collective identity is purposefully destroyed? When a language dies, it could be argued, a world dies with it".[46]

The regime of segregating and isolating individuals is captured in *Don't Bunch Up*. Yahgulanaas explains further, "in the residential 'schools' students were told not to bunch up. In other words, 'be isolated', 'don't be supportive', 'don't socialise well', 'don't trust others'".[47] In fact, in some schools certain children were empowered to police and discipline the rest.[48] In *Don't Bunch Up* we can see Yahgulanaas experimenting with richly coloured acrylics and surreal imagery, marked with Haida frameline elements. In the background there is the buttoned-up house with its disturbing front door, opened wide to reveal the teeth inside. Spewing out of the door is the yellowy bile containing the written directive "don't bunch up".

This imagery recalls the potent memories and words of Dennis Saddleman, a survivor of the Kamloops Indian Residential School who has used his poetry as a means of healing. From his home on the

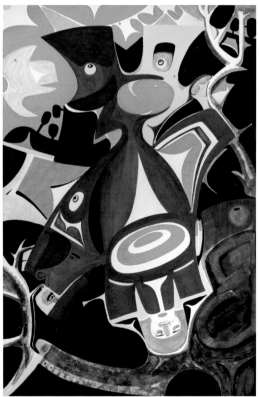

top *Don't Bunch Up*, 2009

bottom *Birds and Baby*, 2010

Coldwater reserve near Merritt, British Columbia, he was sent to the Kamloops residential school at the age of six, and he spent eleven years there suffering physical and sexual abuse. His poem *Monster* poignantly captures his first impressions of the intimidating structure. He vividly remembers being afraid of the huge, windowed edifice and the priests, nuns and oblate brothers, whom he refers to as the "black creatures", who came from the "mouth" of the monster to take him inside:

> I hate you residential school
> I hate you
> You're a monster
> A huge hungry monster
> Built with steel bones
> Built with cement flesh
> You're a monster
> Built to devour
> Innocent Native children
> ...
> Your ugly face grooved with red bricks
> Your monster eyes glare
> From grimy windows
> Monster eyes so evil
> Monster eyes watching
> Terrified children
> Cower with shame
> I hate you residential school, I hate you
> ...
> I hate you residential school, I hate you
> You're a monster with huge watery mouth
> Mouth of double doors
> Your wide mouth took me
> Your yellow stained teeth chewed
> The Indian out of me
> Your teeth crunched my language
> Grinded my rituals and my traditions
> ...[49]

In keeping with Yahgulanaas' proclivity for analytical montage, the view inside the house is made visible. In this case, it occupies the central foreground. Here we see the dormitory-style rows of small beings, wide-eyed and in uniform dress, and the enlarged and menacing disembodied hand moving through the dark compressed space, touching or perhaps fondling their extremities. There is a small uniformed body in the left corner whose face and body are partially concealed by the hand and head of another figure, with bright red lips, long tongue and two rows of bright white teeth. This can be viewed as another angle on the contorted and composite standing figure, depicted on the left, with strap, boot and hat. Half dressed in blue-black trousers and with a naked torso, in a menacing fashion his hand claws the air. His red fleshy lips part perhaps in a grin, revealing rows of white teeth like the figure within, as he looks to the centre. On the opposite side, floating near the dormitory scene, is a ghostly puffy pale-faced figure wearing what appears to be a religious habit. This can be interpreted as a visual metonym for the clergy, whose members were charged to oversee the welfare of the children in the Indian residential schools but were later recognized as serial abusers of the innocents

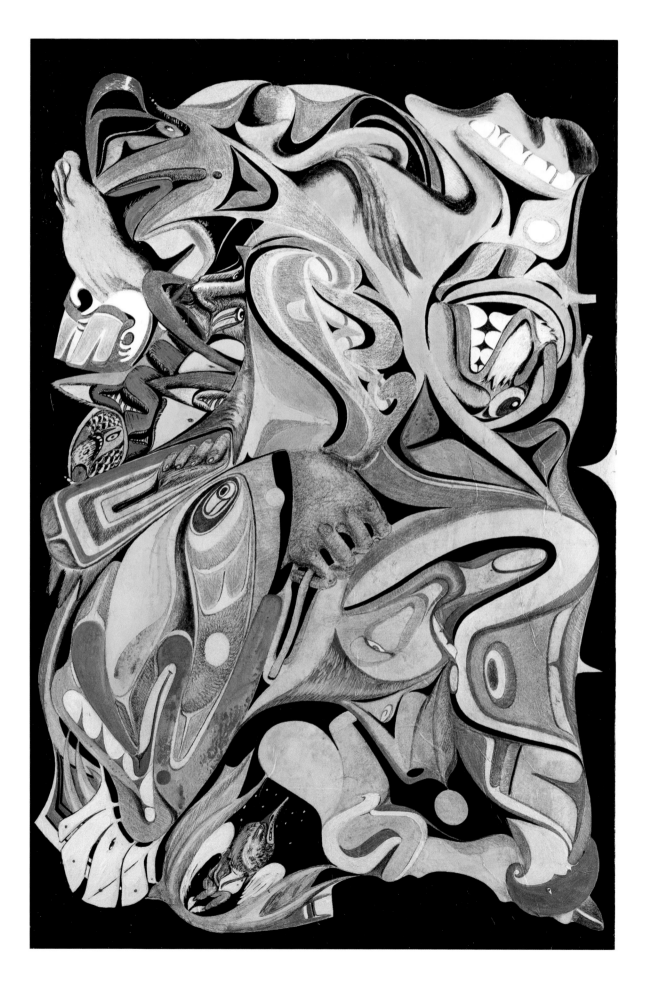

Krygyz, 2013

they were supposed to protect. Despite the whimsical imagery of the rainbow, big buttons, a blue sky with clouds and the somewhat comic or clown-like anthropomorphized house, the overall composition exudes a stormy feeling of foreboding, anxiety and fear.

Yahgulanaas' cousin 7idansuu James Hart has updated this narrative on his monumental *Reconciliation Pole*, 2017, which charts the time before, during and after the residential school system. In the centre of the pole is a representation of the Coqualeetza Industrial School that Hart's and Yahgulanaas' relatives attended. The upper section of the pole depicts the present time and the resurgence of Indigenous culture with a family group wearing regalia including a Sakíi.id (a frontlet embellished with abalone shell) and a naaxiin (Chilkat robe). On the top, there are four Coppers, a rowboat, a canoe and an eagle taking flight symbolizing the way forward. But "the most poignant symbols of all are the thousands of copper nails, precious beings that are clustered on *Reconciliation Pole:* each one commemorates a child who died while at residential school. On the underside of the residential school, copper nailheads are shaped into two haunting, stylized skeletons, symbolizing the children's bodies buried in the cemeteries of these negligent institutions".[50]

EXPERIMENTAL MATTERS

Over the past decade, Yahgulanaas has consistently pushed his practice, experimenting with different media, substances and forms. He has participated in courses and workshops in, for example, Chinese brush painting, woodblock carving, classic Haida design and carving, bronze casting and watercolour, as well as a number of artist residencies. During the COVID-19 pandemic, in 2021, he connected with the Malaspina Printmakers society in Vancouver and attended a one-on-one workshop with Heather Ashton and became hooked. In his words: "In that glorious two-day workshop I smeared pigment on the glass and Heather immediately printed them in the press. I was so taken with the quick linkage between Heather's instructions, spontaneous creativity and rapid production that I went back for more. I continue to explore print options".[51] The results are dramatic: a set of unique monotype prints bursting with textures and movement. Of all of the different creative environments Yahgulanaas has studied and worked in, arguably his two residencies at Emma Lake, Saskatchewan, in 2006 and 2014 have had a profound and lasting influence on his painterly practice, on the techniques and the media he uses.

The Emma Lake Artists' Workshops were initiated in 1955 in a remote location, in the northern boreal forest of Saskatchewan, and are affiliated to the University of Saskatchewan. In the beginning, established artists and scholars, many from outside Canada, including notable figures from New York, were invited to lead a summer workshop for a select number of professional artists based in Canada. As one of its founders, Kenneth Lochhead, director of the Regina School of Art, explained, the aim of the program was "to provide an opportunity for painters and sculptors to work and exchange ideas ... under the leadership of an artist of contemporary reputation".[52] In the first decade and a half, workshop leaders included Will Barnet, Barnett Newman, Clement Greenberg, Jules Olitski, Lawrence Alloway and John Cage, Frank Stella, Donald Judd and RB Kitaj. In the late 1990s,

7idansuu James Hart, *Reconciliation Pole*, 2017 (detail)

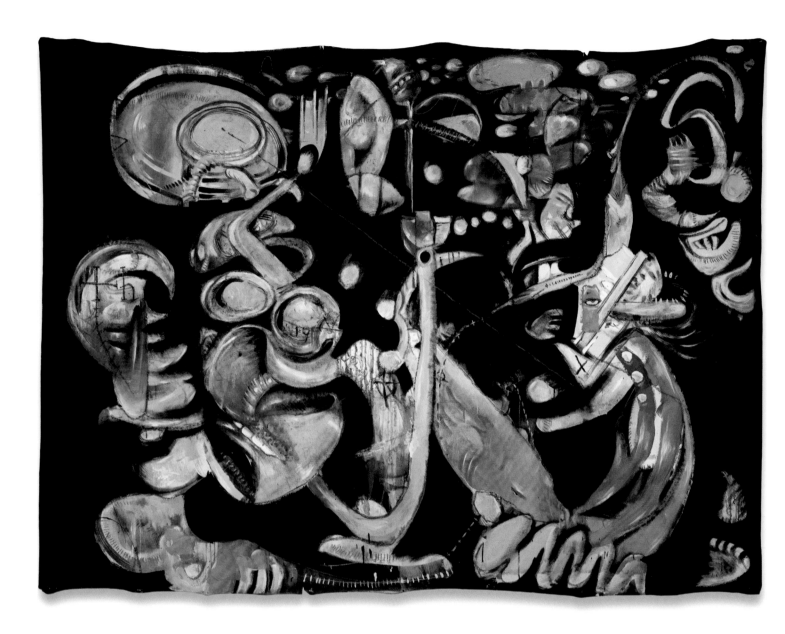

Michael Nicoll Yahgulanaas et al.,
Emma Lake collaboration,
Untitled, 2014

the program was expanded to include artists working in artisanal applied practice such as woodworking and blacksmithing as well as those specializing in "contemporary method". The weeklong intensive residency that brings together international and local practitioners, all of whom are invited to attend, is now more than ever predicated on a philosophy of collaboration and pushing the boundaries of artistic practice and creativity beyond the egocentric drive of the individual self. Participating artists are encouraged to relinquish their sense of ownership of the artwork, as the woodworker and sculptor Sylvie Rosenthal, who attended the 2014 workshop, explained: "I have learned to let go ... that while work is precious, risk is more important. Both letting go of a piece I started to let someone else work on it and also taking my turn on something that someone else has started".[53]

During Yahgulanaas' first residency in 2006, he experimented for the first time seriously with acrylic paints. Prior to this, watercolours and paper were his media of choice. The canvas he created during this workshop, *Mouldy Forehead*, 2006, departs from the liquid transparency of his watercolour and ink compositions to form strong, solid blocks of bright yellow paint, with two symmetrical rectangular

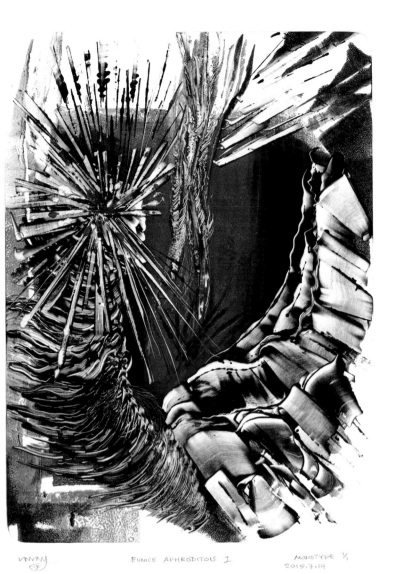

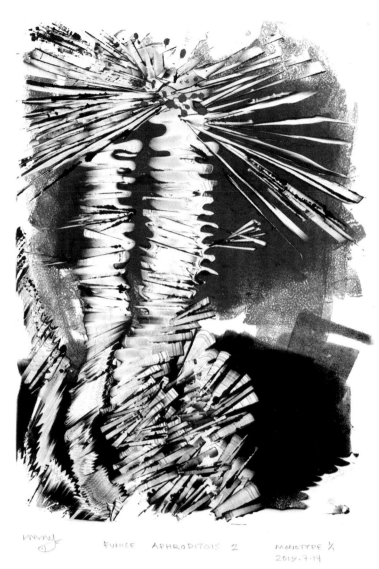

EUNICE APHRODITOIS 1 MONOTYPE ½
2019·7·14

EUNICE APHRODITOIS 2 MONOTYPE ½
2019·7·14

boxes and a horizontal band of white space. These structured fields, somewhat reminiscent of naaxiin, are filled with frameline designs of a face, a serpent, a humanoid figure and what looks to be part of a whale. Interestingly, although these elements are accented with red, they are primarily executed in different shades of green. The dominance of green indicates that Yahgulanaas was consciously forcing his practice outside of his comfort zone. He has noted elsewhere that he finds green a "challenging colour" and tends not to use it, preferring blues and yellows.

The large canvas he worked on during his 2014 residency at Emma Lake similarly captures a moment of heightened and intense experimentation. This work, *Untitled*, 2014, emerged through a collaborative and improvisational performance in which a number of artists would approach the canvas and modify or partially erase what had come before, creating a complex imagery. Toward the end of the residency, the canvas was radically painted over by a couple of guerilla artists with a taupe-coloured acrylic paint. In a desire to salvage the canvas in time for the annual auction of artworks created during the week, Yahgulanaas focused his energies on transforming

left *Eunice Aphroditois* 1, 2019, monotype series

right *Eunice Aphroditois* 2, 2019, monotype series

the monochromatic and featureless visual plane. While a number of artists added elements, the experimental impetus was largely fuelled by Yahgulanaas and Jeff Nachtigall.

Nachtigall is a multidisciplinary artist, curator and inspirational speaker who specializes in facilitating the artistic practices of others, collaborative projects and community-based creative activism. He adopted the role of facilitator at Emma Lake by effectively challenging Yahgulanaas to suppress his artistic ego and paint with an unmediated immediacy on the canvas. Nachtigall told Yahgulanaas to count to five while placing a chalk outline on the canvas, and then Nachtigall intervened to trace over the chalk frameline with black paint. They continued this quick-fire process of creating the five-count chalk-line, followed in quick succession by the black paint outline, for a substantial period of time. When a dense convoluted sea of black twisting lines and taupe-coloured pools emerged, Nachtigall departed to allow Yahgulanaas to continue working on the canvas. At a late stage in the collaborative production, Yahgulanaas recalls, the energetic Calgary artists Mark Orr and Tom Ray, aided and abetted by Daniel Newman "snapped" a number of chalk lines on the painted field. The result is a deep and textured cosmic composition, possibly a harbinger of the *Lé(d)gers*, which Yahgulanaas describes as "an underwater scene". He adds, "It feels like its taking place in the Gulf of Mexico because there is a figure redolent of a submerged Mayan sky deity gently nibbled by a shark while looking up through the surface of the water where we can see the pale sun. The watery depths contain a snorkeler and other marine elements".[54]

With their polyrhythmic variations—encompassing a cacophony of biomorphic forms, comic characters, realistic representations, surreal assemblages, symbolic structures and abstract motifs, including the telltale Haida frameline inflections—Yahgulanaas' artworks offer a multiplicity of constellations that invite mediations on being and experiencing in the present as well as reflections on the complexes of the past. Like the vodou altars described by Byrne, Yahgulanaas' mixed media compositions on canvas or new or repurposed paper exude an improvised aesthetic, a visual jazz that makes the eyes dance or move in an afocal manner to discover something elsewhere on the visible plane or the horizon of our consciousness. At the same time, this counterpoint aesthetic that can be likened to visual jazz betrays a deeper history of colonial contact and the syncretization or creolization of cultural beliefs and forms. It is the adaptability of human creativity that enables us to reimagine the structures of the past, to see colour in relation to music as a polymorphous magical substance or to view, as Yahgulanaas does, classic Haida art and its principles of frameline and palette as a positive opening for experimentation in the visual realm of colour, media, line and form.

1 Yahgulanaas, Michael Nicoll, Interview, McMichael Art Collection, February 2014, Michael Nicoll Yahgulanaas archives.
2 Cosentino, Donald, "On Looking at a Vodou Altar", *African Arts*, vol 29, no 2, 1996, p 67.
3 Cosentino, "On Looking at a Vodou Altar", p 67.
4 Adorno, Theodor, "On Some Relationships between Music and Painting", *Musical Quarterly*, vol 79, no 1, 1995, Susan Gillespie trans, p 73.
5 Kandinsky, Wassily, *Concerning the Spiritual in Art*, Michael TH Sadler trans, Gutenberg ebook, 2004, nn.
6 Levell, Nicola, "A Chronicle of the Marvellous Real: Through Five Dimensions of an Exhibition", *The Marvellous Real: Art from Mexico, 1926–2011*, Vancouver and Monterrey: Figure 1 Publishing, MOA at the University of British Columbia and FEMSA Collection, 2013, p 94.
7 Fry, Roger, *A Roger Fry Reader*, Christopher Reed ed, Chicago: Chicago University Press, 1996, p 153.
8 Kandinsky, *Concerning the Spiritual in Art*, nn.
9 Kandinsky, *Concerning the Spiritual in Art*, nn.

10 Adorno, "On Some Relationships between Music and Painting", p 78.

11 Storr, Robert, *Elizabeth Murray, New York*: The Museum of Modern Art, 2005, p 171.

12 Westfall, Stephen, "Elizabeth Murray: Scary Funny", *Art in America*, no 76, 2006, pp 80–81.

13 Quoted in Yablonsky, Linda, "Remembering Murray", *ArtForum*, August 2007, https://www.artforum.com/diary/linda-yablonsky-on-elizabeth-murray-15778.

14 Storr, *Elizabeth Murray*, p 184.

15 Michael Nicoll Yahgulanaas archives.

16 Griffin, Kevin, "Art Seen: Being Serious about Play Is No Joke for Michael Nicoll Yahgulanaas", *Vancouver Sun*, 29 April 2016, accessed 27 June 2021, https://vancouversun.com/news/staff-blogs/being-serious-about-play-is-no-joke-for-michael-nicoll-yahgulanaas.

17 *John Cage on the 5th de Mayo*, 2009, Note, Michael Nicoll Yahgulanaas archives.

18 Quoted in Brown, Richard H, "Breaking the Sound Barrier: Transparency and Cinematic Space in Works of Calder (1950) and Jackson Pollock 51", *Contemporary Music Review*, vol 33, nos 5–6, 2014, p 512; also quoted in Larson, Kay, *Where the Heart Beats: John Cage, Zen Buddhism, and the Inner Life of Artists*, New York: Penguin Press, 2012.

19 *Carbon Divers*, 2009, Note, Michael Nicoll Yahgulanaas archives.

20 Quoted in Kandinsky, *Concerning the Spiritual in Art*, nn.

21 Kandinsky, *Concerning the Spiritual in Art*, nn.

22 Kandinsky, *Concerning the Spiritual in Art*, nn.

23 Quoted in Fallon, Breann, "A(blue)nt: Beyond the Symbology of the Colour Blue", *Literature and Aesthetics*, vol 24, no 2, 2014, p 23.

24 Taussig, Michael, "What Color Is the Sacred?", *Critical Inquiry*, vol 33, no 1, 2006, p 47.

25 Temkin, Ann, *Color Chart: Reinventing Color, 1950 to Today*, New York: Museum of Modern Art, 2008, p 30.

26 Quoted in Taussig, "What Color Is the Sacred?", p 50.

27 Michael Nicoll Yahgulanaas, personal communication, 28 April 2015.

28 Berlo, Janet Catherine, "Arts of Memory and Spiritual Vision: Plains Indian Drawing Books", *Native Paths: American Indian Art from the Collection of Charles and Valerie Diker*, Allen Wardwell ed, New York: Metropolitan Museum of Art, 1998, pp 11–24.

29 *Lé(d)ger* series note, Michael Nicoll Yahgulanaas archives.

30 Regehr, Heidi, Michael Rodway, Moira Lemon, and J Mark Hipfner, "Recovery of the Ancient Murrelet Synthliboramphus Antiquus Colony on Langara Island, British Columbia, Following Eradication of Invasive Rats", *Marine Ornithology*, vol 35, 2007, pp 137–144.

31 MacDonald, George, *Ninstints: Haida World Heritage Site*, Vancouver: UBC Press, 1990.

32 Bell, John, *Invaders from the North: How Canada Conquered the Comic Book Universe*, Toronto: Dundurn Press, 2006, p 33.

33 Bell, *Invaders from the North*, p 33.

34 Michael Nicoll Yahgulanaas, personal communication, 23 April 2015.

35 Cage, John, *Silence: Lectures and Writings*, Hanover: Wesleyan University Press, 1973, p 99.

36 Joseph, Branden W, "The Gap and the Frame", *October*, no 117, 2006, p 45.

37 Joseph, Branden W, *Random Order: Robert Rauschenberg and the Neo-avant-garde*, Cambridge, MA: MIT Press, 2003, p 157.

38 Joseph, *Random Order*, p 157.

39 Cage, *Silence: Lectures and Writings*, p 103.

40 Cage, *Silence: Lectures and Writings*, p 106; Joseph, *Random Order*, p 169.

41 Cage, *Silence: Lectures and Writings*, p 100.

42 Cage, *Silence: Lectures and Writings*, p 100.

43 Quoted in Watson, Scott, "Introduction", *Witnesses: Art and Canada's Indian Residential Schools*, Scott Watson, Keith Wallace and Jana Tyler eds, Vancouver: Belkin Art Gallery, 2013, p 5.

44 Carr, Geoffrey, "Bearing Witness: A Brief History of the Indian Residential Schools in Canada", *Witnesses: Art and Canada's Indian Residential Schools*, Scott Watson, Keith Wallace and Jana Tyler eds, Vancouver: Belkin Art Gallery, 2013, p 10.

45 Carr, "Bearing Witness", p 15.

46 Carr, "Bearing Witness", p 16.

47 Michael Nicoll Yahgulanaas, personal communication, 8 May 2015.

48 "Speaking to Memory: Images and Voices from St Michael's Indian Residential School", exhibition text, UBC Museum of Anthropology, September 2013–May 2014, curated by Bill McLennan.

49 Susan, "Saddleman's Monster", *Divergent/Convergent: Journal of the University 102 Students*, Spring, 2014, pp 16–17.

50 Levell, Nicola, "Reconciliation Pole", *Memory,* Philippe Tortell, Mark Turin and Margot Young eds, Vancouver: UBC Press and the Peter Wall Institute for Advanced Studies, 2018, p 70.

51 Michael Nicoll Yahgulanaas, personal communication, 5 July 2021.

52 Quoted in King, John DH, "*The Emma Lake Workshops, 1955–1970*", thesis, Brandon University, 1972; also see O'Brian, John, "Introduction", *The Flat Side of the Landscape: The Emma Lake Artists' Workshops*, John O'Brian ed, Saskatoon: Mendel Art Gallery, 1989, pp 13–19.

53 Sylvie Rosenthal, "Media: Sculpture, Wood, Furniture", EMMA Collaboration, accessed 19 August 2021, http://www.emmacollaboration.com/past-events/2014-collaboration.

54 Michael Nicoll Yahgulanaas, personal communication, 2 April 2015.

Untitled, 2015, six tiles from the *Tell Tiles* series

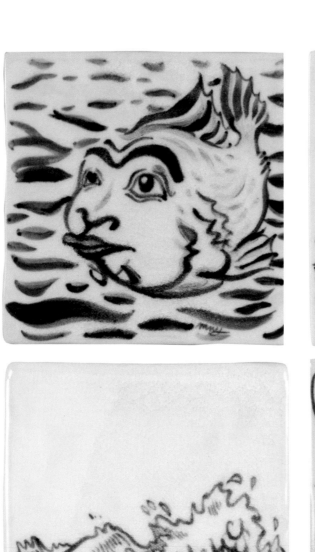
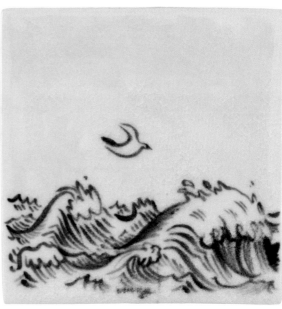

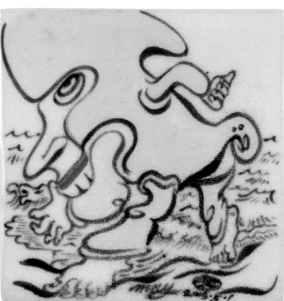

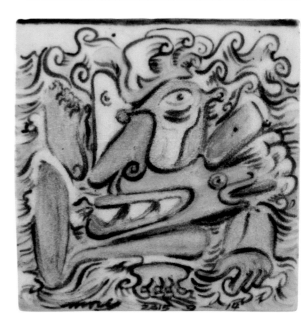

CREDITS

ACKNOWLEDGMENTS

This book is a testament to the generosity, creativity, enthusiasm and dedication of many individuals. Over the fourteen years in which I have been collaborating with Michael Nicoll Yahgulanaas, incredible people, both young and old, new acquaintances and familiars, have directly and indirectly, knowingly and unknowingly contributed to the materialization of *Mischief Making*. I thank the artists who have graciously allowed me to reproduce images of their art and interpretations of their creative practice: Chris Auchter Yahgulanaas, Ayman Baalbaki, Marcus Bowcott, Corey Bulpitt NaiKun Qigawaay, Gwaai Edenshaw, Guujaaw Nangiitlagada Gidansda, Lisa Hageman Yahjaanaas, Bill Holm, Masami Teraoka and Donald Varnell. My thanks extend to the gifted photographers who provided superb images of the artworks illustrated in the book: Christopher Fadden, Leonard Gilday, Robert Kereize, Farah Nosh, Tobyn Ross, Heather Saitz, Jeannie Taylor, Steve van der Woerd, Alex Waterhouse-Hayward, Connie Watts, Ming Wu, and Nadia Zheng. I am grateful to the following private collectors who have provided images and information relating to Yahgulanaas' artworks in their collections: Kim and Tony Allard, Andrew and Sandra Butt, Bea Calo, 7idansuu James Hart and Rosemary Hart, Rick Erickson, Barry Gilson, Judith A Janzen, David McCullum and Emily Erickson McCullum, James Edward and Linda Nicoll, Michael and Inna O'Brian, Gina Ogilvie and Ian Scott, Martine Reid and Wendy Wobester. Similarly, I am indebted to a number of institutions, museums, and galleries and their staff, who facilitated my research, providing insights and access to collections, archives and images. I especially acknowledge and thank Jill Baird, Alissa Cherry, Karen Duffek, Katie Ferrante, Laura Guglielmin, Fuyubi Nakamura, Anna Nielsen, and Tara Pike of the UBC Museum of Anthropology, Vancouver; Vincent Lafond of the Canadian Museum of History, Ottawa-Gatineau; Joanne Schmidt of the Glenbow Museum, Calgary; Kelly-Ann Turkington of the Royal British Columbia Museum, Victoria; Barbara Brotherton of the Seattle Art Museum; David Chaperon and Anita Cirillo of Gallery Jones, Vancouver; Danielle Currie of the Vancouver Art Gallery;

Michael Nicoll Yahgulanaas and the fabrication of *Sei*, 2015

Heather Darling Pigat of the University of Toronto Art Centre; Sarra Scherb of Stonington Gallery, Seattle; Raissa Alvero of Douglas Udell Gallery; Innis Pencarrick of Samco Printers, Vancouver; staff of the Donald Ellis Gallery, Vancouver and New York; Michelle Raino of the Fazakas Gallery, Vancouver; Catharine Clark and Aileen Mangan of the Catharine Clark Gallery, San Francisco; Peter Whiteley, Barry Landua and Rosaleen McAfee of the American Museum of Natural History, New York; and the Adachi Woodcut Institute, Tokyo. I also thank composer Maxime Goulet for generously sharing his images of *The Flight of the Hummingbird* dress rehearsal.

My gratitude is extended to the late Bill McLennan, curator emeritus of the UBC Museum of Anthropology, who was an incredible source of knowledge concerning Indigenous Northwest Coast art, and Maria Venne of the University of Tubingen, Germany, who assisted with the photographic research. I thank Richard Harrison for sharing his article on *Red*. I am immensely grateful to members of Yahgulanaas' devoted team, who work tirelessly behind the scenes, creating the infrastructure and archives, which were

indispensable to the research and visual content of this project. In this regard, a special thank you to Jake Litrell, who designed and manages the digital archive, and to the late Barry Gilson of Y Public Art. I am tremendously thankful to Simon Davies, a graphic designer, editor and artist living on Haida Gwaii, who contributed photographs and created a series of inspirational layouts when the project first began. On Haida Gwaii, I also want to thank Babs Stevens and the Skidegate Band Council for granting me permission to use an image, John Broadhead for sending an image and Jisgang Nika Collison and Saahlinda Naay/Saving Things House (Haida Gwaii Museum) for their inspiration and support. I also acknowledge Nobuhiro Kishigami for his scholarly work and collaborations with Indigenous peoples, including communities of the Pacific Northwest Coast, and I thank him for graciously agreeing to write the foreword to this book and for hosting me and my family when we were in Japan.

Mischief Making would not have transpired in its current form without the brilliant team at UBC Press: I especially want to thank Darcy Cullen and Ann Macklem for their editorial lead and support; Kerry Kilmartin, Brit Schottelius and Carmen Tiampo for their assistance; and Melissa Pitts and Douglas Harris for giving the go-ahead for this exciting venture. I also want to acknowledge and thank the typesetter Michel Vrana who magically transformed the look of the book, and the excellent proofreader Deborah Kerr. My gratitude also extends to the three anonymous readers for their incisive and constructive comments. I gratefully acknowledge the ongoing support of the academic community at UBC: Gage Averill, dean of the Faculty of Arts; Alexia Bloch, head of the Department of Anthropology; and Mary Chapman, director of the Public Humanities Hub, whose 2020 fellowship gave me the time to work on this project.

I am also immensely grateful to my family, for their unwavering support, inspirational input and unconditional love. I especially appreciate the mischievous and creative eccentricities of my three boys, Marcel, Felix and Lucien, and the intellectual and emotional grounding of my husband, Anthony Shelton, and parental anchors Angela and William (Popple) Levell. Lastly, I thank Michael Nicoll Yahgulanaas and his family, his wife Launette Rieb and their daughter Mirella Simjuaay Tsuaay Nicoll, who for over a decade have generously opened their home and studios and introduced me to a fabulous artistic realm populated by comic characters, twisting and colourful framelines and culturally modified forms, all suffused with a sense of seriousness and play.

BIOGRAPHY

Nicola Levell is an associate professor of museum and visual anthropology at the University of British Columbia Vancouver campus and an independent curator. Her research and publications focus on exhibitions, collections history, public and performing arts and storytelling. She has curated exhibitions and art installations in the United Kingdom, Portugal, the United States and Canada. Her latest show, Shadows, Strings & Other Things: The Enchanting Theatre of Puppets, and its digital counterpart (https://www.shadowstringthings.com/) won the 2020 Canadian Museum Association's award for outstanding exhibition of cultural heritage and led to the beautiful edited volume Bodies of Enchantment: Puppets from Asia, Europe, Africa and the Americas (2021).

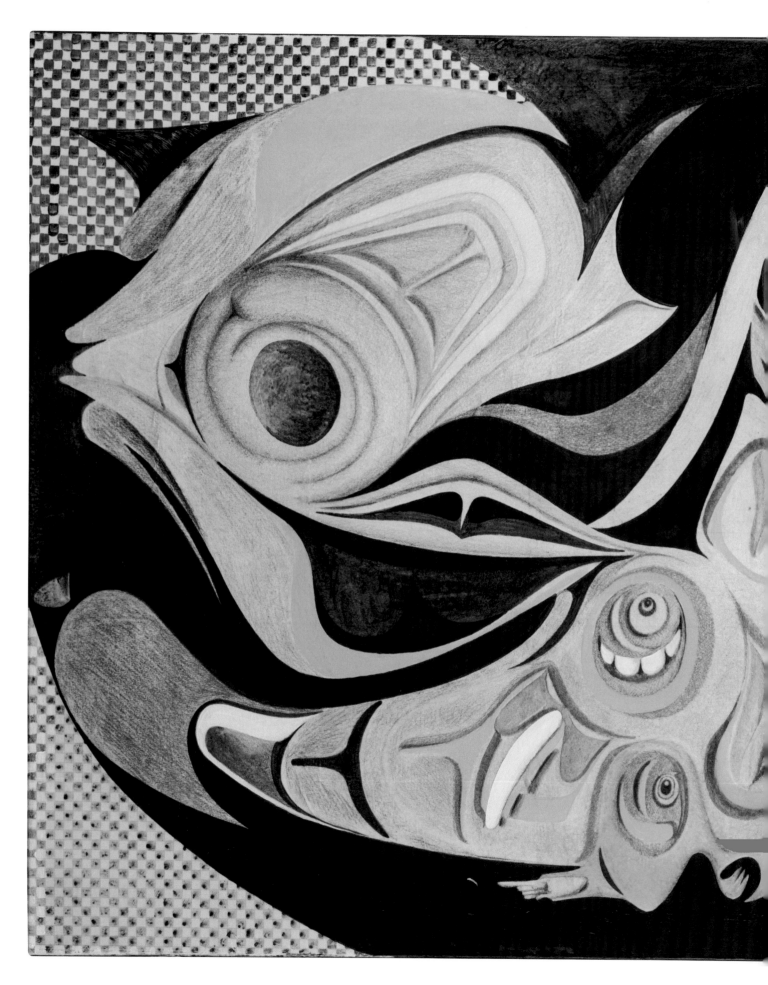

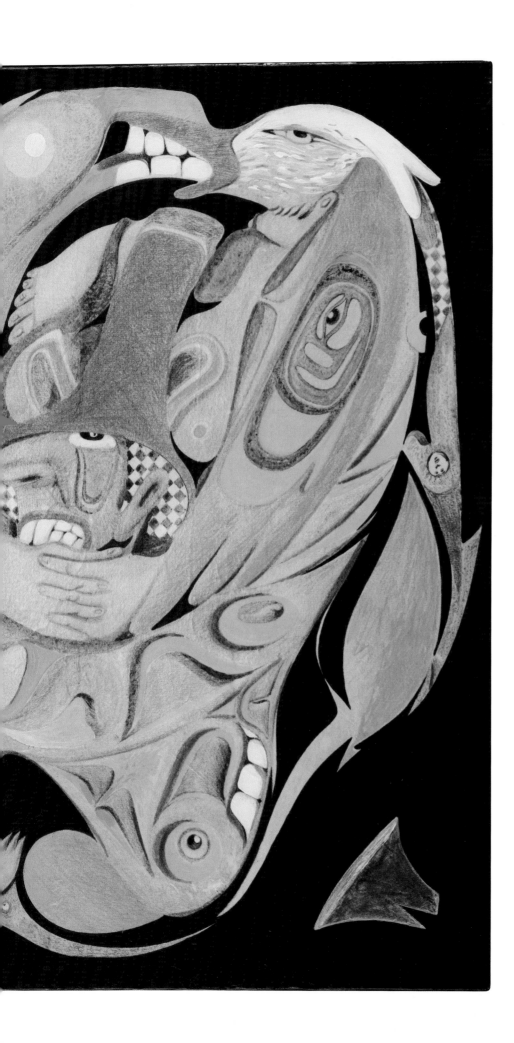

See Turtle, 2014

LIST OF WORKS

(front cover) Michael Nicoll Yahgulanaas (b 1954)
Sinking into the Ocean, 2020 (detail)
collage, paint, ink on wood, 76 x 61 cm
Photograph by Tobyn Ross
Image courtesy the artist
Copyright the artist
Private collection

p 2 Michael Nicoll Yahgulanaas (b 1954)
Cerebrum Cosmology, 2020
mixed media collage on board, gold leaf on frame,
57 x 62 cm
paper from a 1950 Russian engine manual
Private collection

p 9 Michael Nicoll Yahgulanaas (b 1954)
Master Chief, 2020
collage, mixed media on wood, 60.5 x 91 cm
Photograph by Tobyn Ross
Image courtesy the artist
Copyright the artist
Collection of the artist

p 11 Michael Nicoll Yahgulanaas (b 1954)
Master Chief, 2020 (detail)
collage, mixed media on wood, 60.5 x 91 cm
Photograph by Tobyn Ross
Image courtesy the artist
Copyright the artist
Collection of the artist

p 12 Michael Nicoll Yahgulanaas (b 1954)
Sinking into the Ocean, 2020 (recto and verso),
Lé(d)ger series
collage, paint, ink on wood, 76 x 61 cm
Photograph by Tobyn Ross
Image courtesy the artist
Copyright the artist
Private collection

pp 14–15 Michael Nicoll Yahgulanaas (b 1954)
Orcinus, Orca, SKAAnaa, 2019
ink, watercolour on kozo washi, 100 x 200 cm
Photo by Royal British Columbia Museum
Image courtesy the artist
Copyright the artist
Collection of the Royal British Columbia Museum

p 16 Michael Nicoll Yahgulanaas (b 1954)
Abundance Fenced, 2011 (detail and landscape)
steel, 42 x 140 cm (variable)
Photographs by Robert Kereize
Images courtesy the artist
Photographs copyright Robert Kereize
City of Vancouver Public Art Collection

p 17 Yahgulanaas working on *Red*, 2008
Photograph by Jeannie Taylor
Image courtesy Jeannie Taylor
Photograph copyright Jeannie Taylor

p 18 (top) Michael Nicoll Yahgulanaas (b 1954)
doodle on Christensen Fund letterhead, 2011
ink on paper, 22 x 20 cm
Photograph by Bea Calo
Image courtesy the artist
Copyright the artist
Collection of Bea Calo

p 18 (bottom) Charles Edenshaw (ca. 1839–
1920)
drawing of Wasgo (a supernatural sea wolf) on
letterhead of the American Museum of Natural
History, New York, 1897, 27.9 x 21.6 cm
Catalogue no: Z/25 F
Image courtesy the American Museum of Natural
History, New York
Collection of the American Museum of Natural
History, New York

p 19 (top) Michael Nicoll Yahgulanaas (b 1954)
Jungle Beach Morning, 1998
acrylic on canvas, 23 x 31 cm
Image courtesy the artist
Copyright and collection of the artist

p 19 (bottom) Michael Nicoll Yahgulanaas (b 1954)
Last one …eh? 1976
ink on paper
Image courtesy the artist
Copyright the artist
Collection of the artist

pp 20–21 Michael Nicoll Yahgulanaas (b 1954)
Haida Codex, concertina sketch book, 2020–2021
watercolour, pencil, ink, each page 9 x 14 cm,
unfurled 14 x 260 cm
Photo by Laura Guglielmin
Copyright the artist
Private collection

p 22 (top) Michael Nicoll Yahgulanaas (b 1954)
Looking Out 1, 2002
photocopy imprint, watercolour, graphite, oil paint on
paper, 23 x 31 cm
Image courtesy the artist
Copyright the artist
Collection of James Edward and Linda Nicoll

p 22 (bottom) Michael Nicoll Yahgulanaas (b 1954)
Looking Out 9, 2006
watercolour on paper, 23 x 31 cm
Image courtesy Wendy Wobester
Copyright the artist
Collection of Wendy Wobester

p 23 Yahgulanaas carving *The Respect to Bill Reid
Pole*, 1999
Image courtesy UBC Museum of Anthropology
Photograph copyright UBC Museum of
Anthropology

p 24 (top) Guujaaw Nangiitlagada Gidansda
(b 1953)
design for xuu.ajii (grizzly drum), 1984
Redrawn with digital vectors, 2021
Image courtesy of the artist and John Broadhead
Copyright the artist

p 24 (bottom) Canadian police talking to Michael
Nicoll Yahgulanaas, Athlii Gwaii protest, 1985
Photograph courtesy of Haida Gwaii Museum
Copyright Skidegate Band Council

p 25 Michael Nicoll Yahgulanaas (b 1954)
Packing Old Raven's Pole, 2005
watercolour on paper, 57 x 77 cm
Image courtesy the artist
Copyright the artist
Private collection

p 26 Bill Reid (1920–1998)
Go to Hell Honky, 1989
hand-cut letters, offset print
Collection of Michael Nicoll Yahgulanaas

p 28 Michael Nicoll Yahgulanaas (b 1954)
The Head Waiter, 2006
acrylic on canvas, 92 x 76 x 5 cm
Photograph by Christopher Fadden
Copyright the artist
Private collection

p 30 Michael Nicoll Yahgulanaas (b 1954)
Mortal Warrior, 2017, *Coppers from the Hood* series
Toyota Yaris car hood, copper leaf, paint, 86 x
129 cm
Photograph by Tobyn Ross
Image courtesy the artist
Copyright the artist
Private collection

pp 32–33 Michael Nicoll Yahgulanaas (b 1954)
Carpe Fin, 2018
ink, watercolour on kozo washi, 200 x 600 cm
Photo by Seattle Art Museum
Image courtesy the artist
Copyright the artist
Collection of the Seattle Art Museum

p 32 (bottom left) Michael Nicoll Yahgulanaas
completing *Carpe Fin*, 2018
Photograph by Leonard Gilday
Image courtesy Leonard Gilday
Photograph copyright Leonard Gilday

p 33 (bottom right) Michael Nicoll Yahgulanaas
(b 1954)
Carpe Fin, 2018 (detail)
ink, watercolour on kozo washi, 200 x 600 cm
Photo by Seattle Art Museum
Image courtesy the artist
Copyright the artist
Collection of the Seattle Art Museum

p 35 (top) Michael Nicoll Yahgulanaas (b 1954)
A Tale of Two Shamans 69, 2001
ink on paper, 33 x 25 cm
Image courtesy the artist
Copyright the artist
Private collection

p 35 (bottom) Michael Nicoll Yahgulanaas (b 1954)
and Launette Rieb (b 1962)
Carl Went Searching, 2015, *Tell Tiles* series
ceramic, pigment, 22 x 11 cm
Photograph by Michael Nicoll Yahgulanaas Studio
Image courtesy of the artists
Copyright the artists
Collection of Rosemary and 7idansuu James Hart

p 36 (top) Michael Nicoll Yahgulanaas (b 1954)
Untitled, 2011, *Papered Over* series
mixed media on paper, 99 x 64 cm
Image courtesy the artist
Copyright the artist

p 36 (bottom) Katsushika Hokusai (ca.
1760–1849)
Wrestlers from Denshin Kaishu: Hokusai Manga,
vol 3, ca. 1815
ink on paper
Image courtesy Corbis
Photograph copyright Corbis

p 37 Michael Nicoll Yahgulanaas (b 1954)
Looking Out 11, 2006
watercolour, graphite, ink on paper, 24.4 x 30.6 cm
Photograph by Trevor Mills
Image courtesy Vancouver Art Gallery
Copyright the artist
Collection of the Vancouver Art Gallery

pp 40–41 Michael Nicoll Yahgulanaas (b 1954)
Bone Box, 2007
acrylic on plywood, copper, steel, 180 x 240 cm
Photograph by Kyla Bailey
Image courtesy UBC Museum of Anthropology
Photograph copyright UBC Museum of
Anthropology, 2696
Collection of the UBC Museum of Anthropology

p 43 Roy Lichtenstein (1923–1997)
Whaam!, 1963
acrylic and oil paint on canvas, 172.7 x 406.4 cm
©Tate, London 2015
©Estate of Roy Lichtenstein/DACS 2015

p 44 Michael Nicoll Yahgulanaas (b 1954)
Deconstruction of the Box, 2003
digital image
Image courtesy the artist
Copyright the artist

p 45 (top) Albert Edward Edenshaw (ca.
1810–1894)
Haida bentwood chest
cedar wood, paint, 50 x 83 x 54 cm
Photograph by Jessica Bushey
Image courtesy UBC Museum of Anthropology
Photograph copyright UBC Museum of
Anthropology, A2443 Walter C Koerner Collection

p 45 (bottom) Bill Holm (1925–2020)
detail of the design from a painted box, from
Northwest Coast Indian Art: An Analysis of Form,
1965 Image courtesy Bill Holm
Copyright Bill Holm

p 46 (left) Donald Varnell (b 1973)
The Shape of Things to Come, 2009
red cedar, red cedar bark, pigment, 76 x 31 x 5 cm
Photograph by Hal Anderson
Image courtesy Donald Varnell
Copyright Donald Varnell
Private collection

p 46 (right) Donald Varnell (b 1973)
Logic Board, 2007
red cedar, acrylic, ink, watercolour, coloured
pencil, graphite, charcoal, crayon, 150 x 76 x 5 cm
Photograph by Hal Anderson
Image courtesy Donald Varnell
Copyright Donald Varnell
Private collection

p 48 (left) Michael Nicoll Yahgulanaas (b 1954)
Speak, 2009
acrylic graphite copper on wood, 66 x 66 cm
Image courtesy the artist
Copyright the artist
Private collection

p 48 (right) Michael Nicoll Yahgulanaas (b 1954)
Strands, 2009
acrylic graphite copper on wood, 66 x 66 cm
Image courtesy the artist
Copyright the artist
Private collection

p 49 (top) Michael Nicoll Yahgulanaas (b 1954)
Reflecting on (R)ed, 2009
acrylic on wood, 101 x 78 cm
Image courtesy the artist
Copyright and collection of the artist

p 49 (bottom) Michael Nicoll Yahgulanaas (b 1954)
The Wave, 2014
ink on paper, 36 x 26 cm
Photograph by SAMCO
Image courtesy the artist
Copyright and collection of the artist

p 50 (top) Michael Nicoll Yahgulanaas (b 1954)
Remember, 2008
acrylic on canvas, 45.7 x 35.5 cm each
Photograph by Trevor Mills
Image courtesy the artist
Copyright the artist
Collection of Mirella Simjuaay Tsuaay Nicoll

p 50 (bottom) Michael Nicoll Yahgulanaas (b 1954)
Overhead, 2006
watercolour on paper, 28 x 43 cm
Image courtesy the artist
Copyright the artist
Collection of Simon Davies

p 51 (top) Michael Nicoll Yahgulanaas (b 1954)
Orange (Lightning Bolt), 2010
acrylic on canvas, 101 x 76 cm
Photograph by Christopher Fadden
Image courtesy the artist
Copyright and collection of the artist

p 51 (middle) Michael Nicoll Yahgulanaas (b 1954)
West Nile, 2010
earth pigments, graphite, acrylic on canvas,
92 x 77 cm
Photograph by Christopher Fadden
Image courtesy the artist
Copyright the artist
Private collection

p 51 (bottom) Michael Nicoll Yahgulanaas (b 1954)
Ancestress, 2010
African pigments, graphite on canvas, 92 x 77 cm
Photograph by Christopher Fadden
Image courtesy the artist
Copyright the artist
Private collection

p 52 Michael Nicoll Yahgulanaas (b 1954)
Finding Space, 2014, Haida-Ukiyo-e series
ink on Echizen Kizuki Hosho Washi paper made by
living National Treasure Ichibei Iwano, 36 x 43 cm
Image courtesy of the artist
Copyright Michael Nicoll Yahgulanaas and the
Adachi Institute of Woodcut Prints, Tokyo

p 53 photos of Adachi Institute of Woodcut Prints
making *Finding Space*, a Haida–Ukiyo-e print, 2014
Copyright and photograph courtesy of Adachi
Institute of Woodcut Prints

p 54 (top left) Michael Nicoll Yahgulanaas (b 1954)
Water, 2002
acrylic on canvas, 91 x 46 x 2 cm
Photograph by Christopher Fadden
Image courtesy the artist
Copyright and collection of the artist

p 54 (top right) Utagawa Kunisada (1786–1865)
*Hitori musume ni muko hachinin (Eight
Bridegrooms for One Daughter)*
ink on paper, 45.4 x 60.8 cm
Photograph by Derek Tan
Image courtesy UBC Museum of Anthropology
Photograph copyright UBC Museum of
Anthropology N2.1163

p 54 (bottom) Michael Nicoll Yahgulanaas (b 1954)
Flesh Tones, 2014
watercolour ink on paper, 26 x 22 cm
Image courtesy the artist
Copyright the artist
Private collection

p 55 (top) Masami Teraoka (b 1936)
*McDonald's Hamburgers Invading Japan/Tattooed
Woman and Geisha III*, 2018
woodcut print, natural dyes on Echizen-Kizuki
hosho paper, 31 x 47 cm
paper made by National Living Treasure Ichibei
Iwano, 37 blocks of cherry wood carved by
Motoharu Asaka, printed in 43 colours by Satoshi
Hishimura and Keizo Sato assisted by Makoto
Nakayama
Courtesy of the artist and Catharine Clark Gallery,
San Francisco
Copyright the artist

p 55 (bottom) Masami Teraoka (b 1936)
31 Flavors Invading Japan/Today's Special,
1980–1982
woodcut printed in 35 colors from hand-carved
blocks of cherry wood with natural dyes and with
additional hand-colouring by the artist on handmade
Hosho paper, 28 x 42 cm
Cherry wood blocks carved by Hanpei Okura and
printed by Kanjiro Sato under the direction of
Tadakatsu Takamizawa, at the Ukiyo-e Research
Center in Tokyo, Japan
Published by Space Gallery, Los Angeles
Courtesy of the artist and Catharine Clark Gallery,
San Francisco
Copyright the artist

p 56 (top and bottom) Michael Nicoll Yahgulanaas
playing with *Bone Box*, UBC Museum of
Anthropology, 2021
Photograph by Tobyn Ross
Courtesy the artist and the UBC Museum of
Anthropology
Copyright the artist and the UBC Museum of
Anthropology

p 58 Michael Nicoll Yahgulanaas (b 1954)
Two Sisters, *Bone Box*, 2007 (detail)
acrylic on plywood, copper, steel, 61 x 61 cm
Photograph by Kyla Bailey
Image courtesy UBC Museum of Anthropology
Photograph copyright UBC Museum of
Anthropology, 2696
Collection of the UBC Museum of Anthropology

p 59 (top) Michael Nicoll Yahgulanaas (b 1954)
Sea Cliff, 2007
watercolour on cotton paper, 26 x 18 cm
Image courtesy the artist
Copyright the artist
Collection of Judith A Janzen

p 59 (middle) Michael Nicoll Yahgulanaas (b 1954)
Cliff, 2007
watercolour on cotton paper, 26 x 18 cm
Image courtesy the artist
Copyright the artist
Collection of Judith A Janzen

p 59 (bottom) Michael Nicoll Yahgulanaas (b 1954)
Poke, 2007
watercolour on cotton paper, 26 x 18 cm
Image courtesy the artist
Copyright the artist
Collection of Judith A Janzen

p 60 Michael Nicoll Yahgulanaas (b 1954)
Waa Haa, 2005
watercolour on paper, 57.5 x 75 cm
Image courtesy the artist
Copyright the artist
Collection of Martine Reid

p 61 (top) Michael Nicoll Yahgulanaas (b 1954)
English Bay, 2006
acrylic on canvas, 102 x 76 cm
Photograph by Tobyn Ross
Image courtesy the artist
Copyright the artist
Collection of Launette Rieb

p 61 (bottom) Michael Nicoll Yahgulanaas (b 1954)
Hiroshima in Kitsilano, 2007
acrylic on canvas, 92 x 61 cm
Photograph by Tobyn Ross
Image courtesy the artist
Copyright the artist
Collection of Dr Gina Ogilvie and Dr Ian Scott

pp 64–65 Michael Nicoll Yahgulanaas (b 1954)
Carpe Fin, 2018 (detail)
ink, watercolour on kozo washi, 2 x 6 metres
Photo by Seattle Art Museum
Image courtesy of the artist
Copyright the artist
Collection of the Seattle Art Museum

p 67 (top) Michael Nicoll Yahgulanaas (b 1954)
A Tale of Two Shamans, 2018 (front cover)
digital rendering of original (2001) ink on paper
artwork
Image courtesy the artist
Copyright the artist
Private collection

p 67 (bottom) Michael Nicoll Yahgulanaas (b 1954)
A Tale of Two Shamans, 1999
ink on paper, 30 x 21 cm
Image courtesy the artist
Copyright the artist
Private collection

pp 68–71 Michael Nicoll Yahgulanaas (b 1954)
The Last Voyage of the Black Ship, 2002
watercolour, ink, graphite, crayon on paper,
31 x 23 cm
Photographs by Derek Tan
Images courtesy UBC Museum of Anthropology
Photographs copyright UBC Museum of
Anthropology, 2574/70, 2574/69, 2574/79,
2574/77, 2574/87, 2574/89, 2574/91

p 72 Michael Nicoll Yahgulanaas (b 1954)
The Flight of the Hummingbird, 2008
digital image
Photograph by Greystone Books
Image courtesy the artist
Copyright the artist

p 73 (top) A scene from *The Flight of the
Hummingbird* opera dress rehearsal, 2020
Sarah Schabas as Dukdukdiya (Hummingbird)
Photograph by Nadia Zheng
Courtesy of Maxime Goulet and Nadia Zheng
Copyright Nadia Zheng

p 73 (bottom) A scene from *The Flight of the
Hummingbird* opera dress rehearsal, 2020
Jan van der Hooft as Bear, Evan Korbut as Owl and
Rebecca Cuddy as Bunny
Photograph by Nadia Zheng
Courtesy of Maxime Goulet and Nadia Zheng
Copyright Nadia Zheng

p 75 Michael Nicoll Yahgulanaas (b 1954)
Gone Fishing, 2003
crayon on paper, 14 x 43 cm
Image courtesy the artist
Copyright the artist

p 76 Michael Nicoll Yahgulanaas (b 1954)
Gutter Layout, 2000
graphite on paper, 21.5 x 16.5 cm
Image courtesy the artist
Copyright and collection of the artist

p 77 Michael Nicoll Yahgulanaas (b 1954)
In the Gutter, 2011
ink on paper, 41 x 31 cm
Image courtesy the artist
Copyright and collection of the artist

p 78 Michael Nicoll Yahgulanaas (b 1954)
Temperate Rain Forest, 1998
ink on paper, 28 x 21.5 cm
Image courtesy the artist
Copyright and collection of the artist

p 79 Michael Nicoll Yahgulanaas (b 1954)
Culturally Modified Trees, 1998
ink on paper, 28 x 13 cm
Image courtesy the artist
Copyright and collection of the artist

p 80 (top) Arthur Lismer (1885–1969)
Isles of Spruce, 1922
oil on canvas, 119.3 × 162.5 cm
Image courtesy of the Justina M Barnicke Gallery,
Hart House
Copyright Hart House
Permanent Collection, University of Toronto
Purchased by the Hart House Art Committee,
1927/1928

p 80 (bottom) Michael Nicoll Yahgulanaas (b 1954)
After Lismer, 1996
ink on paper, 22.5 x 29 cm
Image courtesy the artist
Copyright and collection of the artist

p 81 Michael Nicoll Yahgulanaas (b 1954)
A Lousy Tale, 2004
ink on paper, 25 x 19 cm
Image courtesy the artist
Copyright the artist

p 82 Michael Nicoll Yahgulanaas (b 1954)
The Strong Silent Type, 2002
ink on paper, 35 x 27 cm
Image courtesy the artist
Copyright the artist

p 83 (top) Takashi Murakami and Michael Nicoll
Yahgulanaas, Vancouver Art Gallery, 2018
Photograph courtesy and copyright of the
Vancouver Art Gallery

p 83 (bottom) Michael Nicoll Yahgulanaas (b 1954)
sketch of Takashi Murakami, 2018
ink on paper
Image courtesy of the artist
Copyright the artist
Collection of the artist

p 86 Yahgulanaas' Live Painting, Manga Wars at
the World Expo, Japan, 2005
Photograph by Launette Rieb
Image courtesy Launette Rieb
Copyright Launette Rieb

p 87 Michael Nicoll Yahgulanaas (b 1954)
The War of the Blink, 2006
watercolour, ink on paper, 184 x 142 cm
Image courtesy the artist
Copyright the artist
Collection of Kim and Tony Allard

p 89 (top) Michael Nicoll Yahgulanaas (b 1954)
Red, 2008 (detail)
watercolour, ink, pencil on paper, 174 x 462 cm
Photography by Douglas and McIntyre
Copyright and image courtesy of the artist
Collection of the UBC Museum of Anthropology

p 89 (bottom) Corey Bulpitt NaiKun Qigawaay (b 1978)
Reclaimed Spaces, 2020
latex, spray paint on birch panel, 213 x 122 cm
Photograph by Dana Qaddah
Image courtesy of the artist and Fazakas Gallery
Copyright the artist
Collection of Robert and Barbara Antoniades

pp 90–91 Michael Nicoll Yahgulanaas (b 1954)
Red, 2008
watercolour, ink on paper, 130 x 500 cm
Photograph by Douglas and McIntyre
Image courtesy the artist
Copyright the artist
Collection of the UBC Museum of Anthropology

p 93 (top) Chris Auchter Yahgulanaas (b 1980)
The Mountain of SGaana, 2018
digital paint
Image courtesy the artist
Copyright the artist

p 93 (bottom) Chris Auchter Yahgulanaas (b 1980)
What Lies Below, 2019
pencil on paper, digital paint
Image courtesy the artist
Copyright the artist

p 94 Michael Nicoll Yahgulanaas (b 1954)
Red, 2008 (detail)
mixed media on paper, 130 x 500 cm
Photograph by Douglas and McIntyre
Image courtesy the artist
Copyright the artist
Collection of the UBC Museum of Anthropology

p 95 (top and bottom) Michael Nicoll Yahgulanaas in his studio working on scaled sketches of JAJ, commissioned by the Humboldt Forum, Berlin, 2021
Photograph by Anna Nielsen
Courtesy and copyright of Anna Nielsen and the artist

pp 98–99 Michael Nicoll Yahgulanaas (b 1954)
Pedal to the Meddle, 2007
Pontiac Firefly car, autobody paint, argillite dust, copper leaf
Image courtesy the artist
Copyright the artist

p 100 Ayman Baalbaki (b 1975)
Destination X, 2013
Safar/Voyage: *Contemporary Works by Arab, Iranian and Turkish Artists* installation view, UBC Museum of Anthropology, 2013
Photograph by Blaine Campbell
Image courtesy Ayman Baalbaki
Photograph copyright Blaine Campbell /UBC Museum of Anthropology

p 102 Marcus Bowcott (b 1951)
Trans Am Totem, 2015
Photograph by Anthony Shelton
Image courtesy Anthony Shelton
Photograph copyright Anthony Shelton

p 107 (left) Michael Nicoll Yahgulanaas (b 1954)
Pedal to the Meddle, 2007, and Haida artist Corey Bulpitt KaiNun Qigawaay, BC Scene, National Arts Centre, Ottawa, 2009
Photograph by Ming Wu
Image courtesy Ming Wu
Photograph copyright Ming Wu

p 107 (right) Michael Nicoll Yahgulanaas (b 1954) and Greg Hill
Pedal to the Meddle, 2007, and *Cereal Box Canoe*, 2000, BC Scene, National Arts Centre, Ottawa, 2009
Photograph by Ming Wu
Image courtesy Ming Wu
Photograph copyright Ming Wu

p 109 (top) Yahgulanaas and *Two Sisters Copper*, outside the UBC Museum of Anthropology, Vancouver, 2007
Photograph by Alex Waterhouse-Hayward
Image courtesy the artist
Photograph copyright Alex Waterhouse-Hayward

p 109 (bottom) Chief NEnkaidsuglas, David McKay of the Ya'ku gitina'-I in front of his house in the village of Xaaya (Haina), ca. 1888
Photograph by Richard Maynard
Image courtesy Royal British Columbia Museum
Photograph copyright Royal British Columbia Museum, PN701

p 111 Albert Edward Edenshaw (ca. 1810–1894)
Copper *(t'aaGuu)*, ca. 1865
copper, paint, 116 x 75 x 5 cm
Photograph by Richard Garner
Image courtesy Canadian Museum of History
Photograph copyright Canadian Museum of History

p 112 Michael Nicoll Yahgulanaas (b 1954)
Stolen But Recovered, 2007, *Coppers from the Hood* series
Plymouth and Pontiac car hoods, copper leaf, paint, 185 x 140 cm
Image courtesy the artist
Copyright the artist
Collection of the Glenbow Museum

p 115 (top and bottom) Michael Nicoll Yahgulanaas (b 1954)
Untitled, 2014, *Coppers from the Hood* series
car hood (back and front), copper leaf, pigments, 58.4 x 135.9 x 8.9 cm
Photographs by Christopher Fadden
Images courtesy the artist
Copyright the artist
Private collection

p 116 Michael Nicoll Yahgulanaas (b 1954)
Wait of Water, 2020, in nine parts, *Flappes* series
paint, copper leaf on metal gas flap, 21 x 15 cm
Photographs by Tobyn Ross
Images courtesy the artist
Collection of the artist

p 117 (left, middle, right) Michael Nicoll Yahgulanaas (b 1954)
Untitled, 2012, *Volvoxii* series
Volvo sunroof panel, copper leaf, paint, 95 x 45 cm (each)
Photographs by Christopher Fadden
Images courtesy the artist
Copyright the artist
Collection of Camgill Enterprises Ltd

p 118 Michael Nicoll Yahgulanaas (b 1954)
Copper from the Hood, 2011
car hood, copper leaf, paint, 92 x 132 cm
Photograph by Christopher Fadden
Image courtesy the artist
Copyright the artist
British Museum Collection

p 119 Michael Nicoll Yahgulanaas (b 1954)
Naaxiin, 2013
car hood, copper leaf, paint, 142 x 94 cm
hood by Christopher Fadden
Image courtesy the artist
Copyright the artist
Collection of Rick Erickson

p 120 *Naaxiin* robe, Haida, before 1931
wool fibre, cedar bark, leather, hemlock bark, natural dye, 84 x 178 cm
Photograph by Derek Tan
Image courtesy UBC Museum of Anthropology
Photograph copyright UBC Museum of Anthropology, A7434

p 121 *Naaxiin* tunic, Haida, ca. 1800–1850
mountain goat wool fibre, yellow cedar bark, sea otter skin, wool fibre, cotton fibre, natural dye, 84.5 x 66.7 x 3.5 cm
Photograph by Kyla Bailey
Image courtesy UBC Museum of Anthropology
Photograph copyright UBC Museum of Anthropology, A7080

p 122 Michael Nicoll Yahgulanaas (b 1954)
Untitled, 2010
steel car hood, gold leaf, pigment, 132 x 92 cm
Photograph by Christopher Fadden
Image courtesy the artist
Copyright the artist

p 123 Albert Edward Edenshaw feaddress frontlet *(Sakíi.id)*, ca. 1870
maple wood, paint, abalone shell, 16 x 15 x 5.8 cm
Image courtesy Seattle Art Museum
Photograph copyright Seattle Art Museum Gift of John H Hauberg

p 124 Michael Nicoll Yahgulanaas (b 1954)
Yelthadaas, 2011
steel car hood, platinum leaf, paint, 132 x 92 cm
Photograph by Christopher Fadden
Image courtesy the artist
Copyright the artist
Modern and Contemporary Art Department, Metropolitan Museum of Art Collection, New York

p 125 (top) Michael Nicoll Yahgulanaas (b 1954)
Craft, 2012
rowboat, wood, fibreglass, copper leaf, platinum leaf, 524 x 524 cm
Photograph by Linda Nicoll
Image courtesy the artist
Photograph copyright Linda Nicoll
Collection of the Bill Reid Gallery

p 125 (bottom) Lisa Hageman Yahjaanaas
Raining Gold, 2017 (front and detail)
sheep wool and gold leaf, 119.6 x 155 cm
Photograph National Gallery of Canada
Image courtesy the artist
Copyright the artist
Global Affairs Canada-Visual Art Collection

p 126 (left) Michael Nicoll Yahgulanaas (b 1954)
Rivers, 2012
steel, anodized aluminum, copper leaf, oil paint, 10 m
Photograph by Christopher Fadden
Image courtesy the artist
Copyright the artist
Collection of the City of Kamloops

p 126 (right) Michael Nicoll Yahgulanaas (b 1954)
Rivers, 2012
steel, anodized aluminum, copper leaf, oil paint, 10 m
Photograph by Farah Nosh
Image courtesy the artist
Photograph copyright Farah Nosh
Collection of the City of Kamloops

p 127 Michael Nicoll Yahgulanaas (b 1954)
Take Off, 2010
Volvo car fenders, steel, copper, gold, pigments, 8 m
Photograph by Connie Watts
Image courtesy the artist
Photograph copyright Connie Watts
Collection of the University of British Columbia

p 128 The fabrication of *Sei* and the sculpture in situ, 2015
Photograph by Heather Saitz
Image courtesy Y Public Art

p 129 Michael Nicoll Yahgulanaas (b 1954)
Sei, 2015
steel, aluminum, copper leaf, 7 x 3 metres
Photograph by Farah Nosh
Image courtesy Farah Nosh
Photograph copyright Farah Nosh
Collection of Vancouver International Airport

pp 134–135 Michael Nicoll Yahgulanaas (b 1954)
Papered Over, 2011
mixed media on paper, 91 x 61 cm
Photograph by Christopher Fadden
Image courtesy the artist
Copyright and collection of the artist

p 137 (top) Michael Nicoll Yahgulanaas (b 1954)
Dancing Dragon, 2012, *Papered Over* series
mixed media on paper, 61 x 38 cm
Photograph by Christopher Fadden
Image courtesy the artist
Copyright the artist
Private collection

p 137 (bottom) Michael Nicoll Yahgulanaas (b 1954)
Faux Palindrome, 2012, *Papered Over* series
mixed media on paper, 61 x 38 cm
Photograph by Christopher Fadden
Image courtesy the artist
Copyright the artist
Private collection

p 138 (top left) Michael Nicoll Yahgulanaas (b 1954)
Untitled, 2012, *Papered Over* series
mixed media on paper, 61 x 38 cm
Image courtesy the artist
Copyright the artist
Private collection

p 138 (top right) Michael Nicoll Yahgulanaas
(b 1954)
Untitled, 2011, *Rotational* series
mixed media on paper, 61 x 38 cm
Image courtesy the artist
Copyright the artist
Private collection

p 138 (bottom) Michael Nicoll Yahgulanaas
(b 1954)
di-sect-ed, 2010, *Rotational* series
watercolour, graphite on paper, 56 x 76 cm
Photograph by Christopher Fadden
Image courtesy the artist
Copyright the artist
Private collection

p 139 (top left) Michael Nicoll Yahgulanaas
(b 1954)
Anti-Podes, 2010
watercolour, ink and graphite on paper, 76 x 56 cm
Photograph by Jeannie Taylor
Image courtesy the artist
Copyright the artist
Private collection

p 139 (top right) Michael Nicoll Yahgulanaas
(b 1954)
Up Down Play Reverse, 2010, *Rotational* series
watercolour, graphite, ink on cotton paper, 56 x
76 cm
Photograph by Jeannie Taylor
Image courtesy the artist
Copyright the artist

p 139 (bottom) Michael Nicoll Yahgulanaas
(b 1954)
Untitled, 2010, *Rotational* series
watercolour, ink on paper, 30 x 22 cm
Image courtesy the artist
Copyright the artist
Private collection

p 140 Michael Nicoll Yahgulanaas (b 1954)
A Sailing Light, 2015 (recto and verso)
collage, paint, ink on wood, 92.5 x 92.5 cm
Photograph by Tobyn Ross
Image courtesy of the artist
Copyright the artist
David McCullum and Emily Erickson McCullum
Collection

p 141 (top left) Michael Nicoll Yahgulanaas
(b 1954)
Hooked, 2020
collage, paint, ink on wood (a repurposed museum
storage tray)
52 x 61 cm
Photograph by Tobyn Ross
Image courtesy of the artist
Collection of the artist

p 141 (top right) Michael Nicoll Yahgulanaas
(b 1954)
Gunit, 2020
collage, paint, ink on wood (a repurposed museum
storage tray)
53 x 56 cm
Photograph by Tobyn Ross
Image courtesy of the artist
Collection of the artist

p 141 (bottom) Michael Nicoll Yahgulanaas
(b 1954)
Orpheus in the Underworld, 2015
watercolour on paper, 26 x 20 cm
Photograph by Tobyn Ross
Image courtesy the artist
Copyright and collection of the artist

p 142 (top) Michael Nicoll Yahgulanaas (b 1954)
John Cage on 5th de Mayo, 2009
watercolour and graphite on paper, 56 x 76 cm
Image courtesy the artist
Copyright and collection of the artist

p 142 (middle) Michael Nicoll Yahgulanaas
(b 1954)
Carbon Divers, 2009
watercolour on paper, 76 x 56 cm
Photograph by Jeannie Taylor
Image courtesy the artist
Copyright the artist
Private collection

p 142 (bottom) Michael Nicoll Yahgulanaas
(b 1954)
Tripudio #3, 2014
mixed media on paper, 97.2 x 76.8 cm
Photograph by Christopher Fadden
Image courtesy the artist
Copyright and collection of the artist

p 143 (left) Michael Nicoll Yahgulanaas (b 1954)
Untitled, 2013, *Blueprint* series
mixed media on paper, 77 x 57 cm
Photograph by Christopher Fadden
Image courtesy the artist
Copyright and collection of the artist

p 143 (right) Michael Nicoll Yahgulanaas (b 1954)
Cnidaria, 2012, *Blueprint* series
mixed media on paper, 77 x 57 cm
Photograph by Christopher Fadden
Image courtesy the artist
Copyright the artist

p 145 Attributed to Howling Wolf, Southern
Cheyenne, Central Plains *Cheyenne Medicine
Lodge*, ca. 1875–1878
ledger drawing
watercolour, graphite, coloured pencil on paper,
21.5 x 28.5 cm
Photograph by John Bigelow Taylor
Image courtesy Donald Ellis Gallery, New York and
Vancouver
Photograph copyright Donald Ellis Gallery, P4075d

p 146 (left and right) Michael Nicoll Yahgulanaas
(b 1954)
Untitled, 2015, *Lé(d)ger* series
watercolour, ink on paper, 29 x 36 cm
Images courtesy the artist
Copyright the artist

p 148 Michael Nicoll Yahgulanaas (b 1954)
Valiant, 2011
mixed media on canvas, 102 x 78 x 6 cm
Photograph by Christopher Fadden
Image courtesy the artist
Copyright the artist

p 150 (top) Michael Nicoll Yahgulanaas (b 1954)
Don't Bunch Up, 2009
mixed media on wood, 71 x 51 cm
Photograph by Medphoto
Photography and Digital Imaging at Queen's
University
Image courtesy Wendy Wobester
Copyright the artist
Wendy Wobester Collection

p 150 (bottom) Michael Nicoll Yahgulanaas
(b 1954)
Birds and Baby, 2010
acrylic on canvas, 91 x 61 cm
Photograph by Tobyn Ross
Image courtesy Barry Gilson
Copyright the artist
Collection of Barry Gilson

p 152 Michael Nicoll Yahgulanaas (b 1954)
Krygyz, 2013
acrylic, ink, graphite, paper on canvas, 92 x 60 cm
Photograph by Tobyn Ross
Image courtesy the artist
Copyright and collection of the artist

p 153 7idansuu James Hart, *Reconciliation Pole*,
2017 (detail)
Photograph by Steve van der Woerd
Image courtesy Steve van der Woerd
Copyright Steve van der Woerd

p 154 Michael Nicoll Yahgulanaas (b 1954) et al.
(Emma Lake collaboration)
Untitled, 2014
acrylic, chalk, graphite on canvas, 155 x 214 cm
Photograph by Tobyn Ross
Image courtesy the artist
Copyright and collection of the artist

p 155 (left) Michael Nicoll Yahgulanaas (b 1954)
Eunice Aphroditois 1, 2019, monotype series
ink on paper, 28 x 38 cm
Photograph by Anna Nielsen
Image courtesy of the artist
Copyright the artist
Collection of the artist

p 155 (right) Michael Nicoll Yahgulanaas (b 1954)
Eunice Aphroditois 2, 2019, monotype series
ink on paper, 28 x 38 cm
Photograph by Anna Nielsen
Image courtesy of the artist
Copyright the artist
Collection of the artist

p 158 Michael Nicoll Yahgulanaas (b 1954) and
Launette Rieb (b 1962)
Untitled, 2015, six tiles from the *Tell Tiles* series
ceramic, pigment, 22 x 11 cm
Photographs by Michael Nicoll Yahgulanaas Studio
Images courtesy of the artists
Copyright the artists
Private collections

p 161 Michael Nicoll Yahgulanaas and the
fabrication of *Sei*, 2015
Photograph by Heather Saitz
Image courtesy Y Public Art

pp 162–163 Michael Nicoll Yahgulanaas (b 1954)
See Turtle, 2014
Asian paper, acrylic, crayon on canvas, 61 x 91 cm
Image courtesy the artist
Copyright the artist
Private collection

p 168 Michael Nicoll Yahgulanaas (b 1954)
Untitled, 2016, *Papered Over* series
mixed media collage on canvas, 61 x 91 cm
Private collection

(back cover) Michael Nicoll Yahgulanaas (b 1954)
Milkit, 2020 (detail)
collage, paint, ink on wood (a repurposed museum
storage tray), 52 x 61 cm
Photograph by Tobyn Ross
Image courtesy of the artist
Collection of the artist

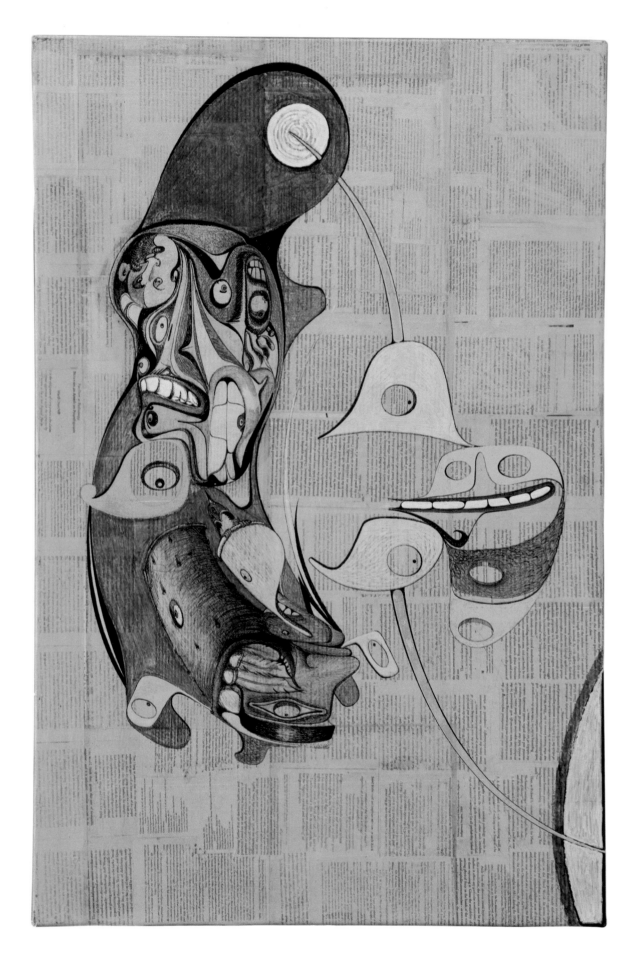

Untitled, 2016, *Papered Over* series